# Assembling ART

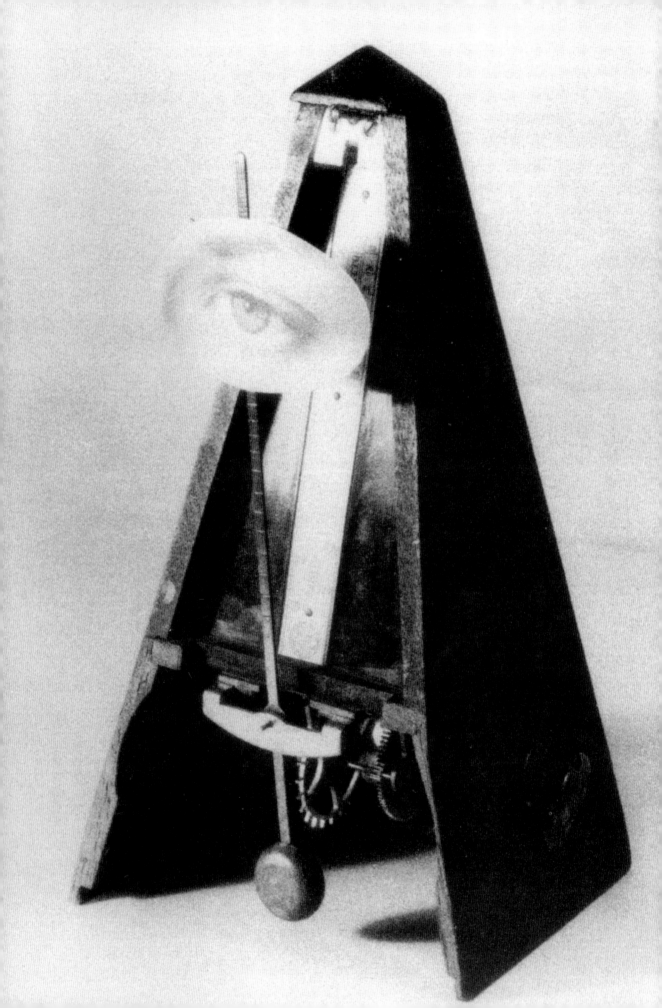

# Assembling

# ART

The Machine
and the
American
Avant-Garde

**Barbara Zabel**

University Press of Mississippi
Jackson

www.upress.state.ms.us

The University Press of Mississippi is a member of the Association
of American University Presses.

11 10 09 08 07 06 05 04 03     4 3 2 1
∞
Library of Congress Catalogoing-in-Publication Data

Zabel, Barbara Beth.
    Assembling art : the machine and the American avant-garde / Barbara Zabel.
       p.cm.
Includes bibliographical references and index.
    ISBN 1-57806-595-X (alk. paper)
    1. Art and technology. 2. Machinery in art. 3. Avant-garde (Aesthetics)—United States—
History—20th century. I. Title.
    N72.T4Z33 2003
    701'.05'0973—dc21                                                  2003005788

British Library Cataloging-in-Publication Data available

For Tom

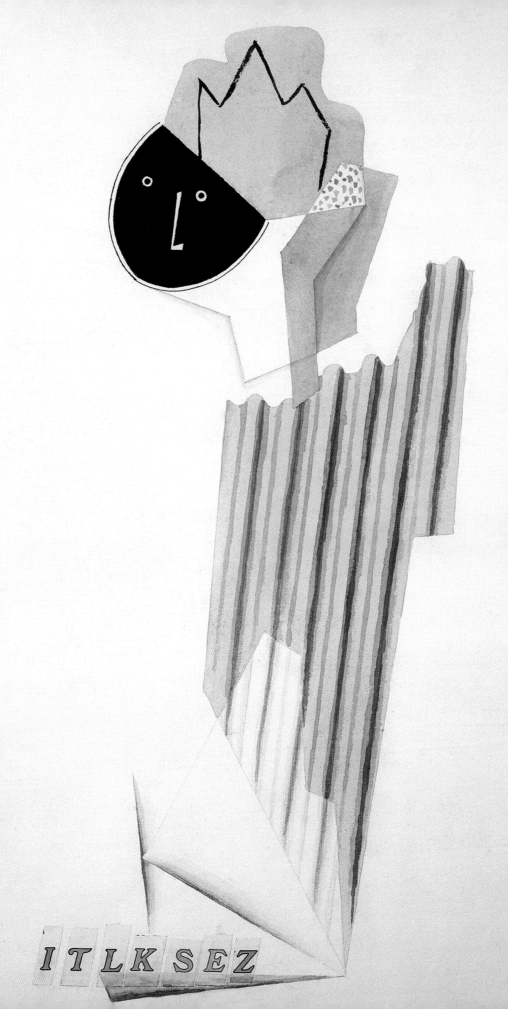

ITLK SEZ

# Contents

# Acknowledgments

What continues to intrigue me about the artists of the American avant-garde is that, despite their diverse, ironic, and individualistic approaches to art, one phenomenon does seem, if not to unify the American avant-garde, to inform much of the work produced in this era: the pervasiveness and power of machine technology. In order to uncover the multiple manifestations and meanings of machine-age art, I have chosen four diverse topics or themes: the automaton, jazz, and the genres of still life and portraiture. All four merit, and indeed have received, book-length discussions, and much credit goes to those scholars who have explored these subjects before me. I only hope I have given them sufficient credit in the text that follows. The thematic chapters are fleshed out by "case studies" centered on the work of four artists: Man Ray, Stuart Davis, Alexander Calder, and Gerald Murphy. The writing of these chapters, too, depended on the expertise of many scholars and the cooperation of numerous institutions.

My greatest debts are to Erika Doss, Tom Couser, and the readers for the Press, who offered thoughtful and extended critiques of the entire manuscript. The text also benefited greatly from the careful reading of individual chapters by Donna M. Cassidy, Gerald D. Silk, Christopher B. Steiner, and Alan Trachtenberg. Other colleagues and friends have contributed their knowledge and support in significant ways, including Daniel Abramson, Robert Baldwin, Martin Berger, Susan Fillin-Yeh, Maureen McCabe, and the late Nancy Rash. For invitations to present early stages of my research, I also want to thank Wanda Corn, Robin Frank, Ellen Landau, and Elizabeth H. Turner.

Earlier versions of several sections of the book have been previously published, and I would like to acknowledge the scholars who worked with me on those essays: Lisa Rado, Naomi Sawelson-Gorse, and William Chew, who edited anthologies published by Garland, MIT, and Rodopi Presses, respectively; and Darcy Tell at the Archives of American Art, Migs Grove and Lisa Siegrist at the Smithsonian American Art Museum, and Sheila Schwartz at the Whitney Museum of American Art, who gave keen editorial advice regarding journal and exhibition essays. I would also like to express my appreciation to the staff of the press, especially Craig Gill for his enthusiasm for the project and Bob Burchfield for his astute editing.

Important collections, including curatorial files, artists' papers, and sound recordings, were made available to me by Judith Cousins at the Museum of Modern Art, John C. Donnelly of the Estate of Honoria Murphy Donnelly, Garnett McCoy at the Archives of American Art, Lulen Walker at the National Portrait Gallery, and Kent Underwood at the Avery Fisher Media Center, New York University. Much appreciation

goes to Alexander S. C. Rower, director of the Alexander and Louisa Calder Foundation, for access to information in its extensive archives. PaceWildenstein and Salander O'Reilly Galleries and Art Resource also graciously provided photographic resources. I carried out much of my research in the libraries of the Smithsonian Institution and I thank the staff there, particularly Cecilia H. Chin and Pat Lynagh. I am also grateful for the assistance of librarians at Connecticut College, especially Mark Braunstein, Beth Hanson, and Caroline Johnson.

I received financial support from Connecticut College in the form of research grants from the R. Francis Johnson Faculty Development Fund. I am grateful, too, for the generosity of Helen B. Regan, who provided a subvention from the Dean of the Faculty Fund to cover permission fees for the illustrations. A visiting scholars' grant from the Smithsonian American Art Museum and a summer research grant from the National Endowment for the Humanities also supported research for the book.

Boundless respect and appreciation go to my parents, Carroll and Grace Zabel, who nurtured my dual interests in technology and art and provided unwavering moral support from the beginning. For their love and infectious good humor, I thank my sister, Ellen, and my brother, Garry. Finally, my deepest gratitude is to Tom Couser, who has sustained me throughout, lending a fine-tuned intelligence to the text and a human face to my prolonged immersion in the machine age.

# Introduction

## *The Mechanical Muse*

In a recent interview, filmmaker Godfrey Reggio, of *Koyaanisqatsi* fame, commented, "I do believe that technology is not something we use, but something we live" (qtd. in Burr). Artists of the machine age have given us numerous visual manifestations of technology as lived experience. In their work they have tried on new concepts, as one would a new coat or hairstyle, so as to devise new identities to suit changing realities. This aspect of machine technology is most intriguing to me: how American modernists cohabited with technology—lived with it and lived through it.

As usually defined, the machine age came into being in the second and third decades of the twentieth century as a result of new technologies, means of transportation, and modes of production. As previous scholars have well established, the invention of steel revolutionized building construction, the harnessing of electricity transformed communication as well as the workplace and the home, and major developments in the petroleum industry sparked the revolution in transportation.[1] Machines that had not existed twenty-five years earlier came to be regarded as indispensable: newly electrified products for the home—washing machines, vacuum cleaners, refrigerators, and so forth—and automobiles, which were rolling off assembly lines at an unprecedented pace; indeed, people's lives seemed pervasively and profoundly changed by machine technology. As Siegfried Giedion famously put it, mechanization had "impinged upon the very center of the human psyche, through all the senses" (42). In his seminal and encyclopedic study, *Mechanization Takes Command*, the Swiss author took his cues from America, remarking that "the role of mechanization can nowhere be observed better than in the United States, where the new methods of production were first applied, and where mechanization is inextricably woven into the pattern of thought and customs" (v).

Key to the pivotal role of mechanization was mass production. American industry, newly configured by principles of scientific management developed by Frederick Winslow Taylor and buoyed by postwar prosperity, manufactured products with unprecedented efficiency. The preoccupation with mass production also spilled over into the advertising industry. Invigorated by the deluge of consumer goods, advertising firms churned out visual advertising—promotional displays on billboards and posters and layouts in magazines and newspapers. American industry depended on the proliferation of ads to create a demand for the products flooding the markets.

Part of the fallout of this dramatic swell in production and consumption was a major structural change in the professional labor force, specifically, the increase in

numbers of managerial positions. Along with this expansion of professional positions came a new respect for a new class of experts. Efficiency experts, factory managers, engineers, industrial designers, and advertising executives took center stage in American culture. Those garnering such respect were not laborers but thinkers and designers, those who conceptualized and imagined new strategies for American industry, whether it be the automobile or advertising industry. A new "managerial ethos" thereby informed machine-age America (Banta 8).[2]

The art world, too, adopted this new ethos, identifying with the cerebral orientation of those who invented and imagined rather than with the manual skill of those who actually did the work of industry. This ethos was manifested most conspicuously in the groundbreaking "Machine Age Exposition" held in New York City in May 1927. Spearheaded by Jane Heap, an editor of *The Little Review*, the exhibition included "actual machines . . . in juxtaposition with architecture, paintings, drawings, sculpture, constructions, and inventions by the most vital of the modern artists" (36). Studebaker crankshafts, meat slicers, and airplane engines and propellers mingled with representations of skyscrapers by Charles Demuth and John Storrs and drawings of machinery by Louis Lozowick, along with works by European artists. Through its illustrations and essays, the catalogue for the show, published as a supplement of *The Little Review*, placed the makers of the art included in the show firmly in the camp of the designers of buildings and industrial products; indeed, it celebrated this coming together of these two worlds—of the engineer and the artist, of modern industry and modern art.

That the machine age coincided with the advent of modernism is, of course, not news. Indeed, this is the basic assumption of cultural historians of the machine age, here nicely summed up by Richard Guy Wilson: "The machine in all its manifestations—as an object, a process, and ultimately a symbol—became the fundamental fact of modernism" (23).[3] The rise of modernism and the preeminence of machine technology were not, however, just a matter of coincidence. Rather, machine technology was inextricably bound up with the development of modernism; furthermore, there are multiple points of interconnection between American modernism and technology that call for further attention. That is, while we acknowledge the crucial role of the machine in the conception of modernism, we need to look more closely at the junctures between the two. In particular, we need to examine the tensions reflected in and growing out of such junctures—tensions of gender, class, and race; tensions between management and labor; and tensions between elite and popular cultures. An interrogation of these charged interconnections serves, then, both to enrich and to complicate our understanding of American culture in the machine age.

In recent decades, a resurgence of interest in the machine has embraced a greatly expanded understanding of American machine culture. Scholars have begun to reexamine linkages between works of art, stylistic and thematic vocabularies, and artistic practices, on the one hand, and surrounding institutions, economies, political structures, social practices, and ideas about the body, gender, class, and race, on the other.[4] While most of this renewed attention has focused on problems in the history

of technology, literature, and popular culture, I hope to offer a view of the complex transactions between the visual arts and machine culture; such a view depends on a multidisciplinary interrogation of American visual culture in the machine age.

Machine technology was not just a backdrop to the development of modernism or merely a subject of modernist representation; rather, it informed the means of artistic production itself. A reevaluation of the radical changes in the practice of art-making in the modern era may be the best way of getting at the centrality of machine technology to modernism. The collage technique—and by extension the collage aesthetic—is arguably the most revolutionary development in twentieth-century art and the epitome of the modernist aesthetic. In its broadest sense, the collage aesthetic can be defined as a mode of art making predicated on the placement, displacement, and juxtaposition of ready-made or mass-produced images, such as fragments of newspapers, cigarette packages, advertisements, and popular illustrations (or painted simulations thereof), transposed into artistic compositions without regard to cohesive syntax. Such appropriation of disparate materials introduced a fundamental shift in art-making practice. In large part, collage grew out of the realization that art need not be based on traditional notions of mimesis but could be a matter of construction, a realization that called into question modes of representation that had existed since the Renaissance (Plottel x). As a construction—an art assembled from parts—collage can be said to encode machine technology.[5] Metaphorically, it aligns the art-making process with industrial fabrication and the artist with the industrial designer, a profession gaining considerable respect in postwar culture.

Early collagists such as Georges Braque and Pablo Picasso were well aware that their new technique initiated a radical break with the past; however, they did not consciously comprehend the analogy with mechanical production implicit in this new technique. Not until the postwar years did artists address the issue head on. The Berlin Dadaists, for example, invented photomontage, the practice of constructing collage exclusively of photographs, magazine advertisements, and typography. Artists such as Raoul Hausmann, John Heartfield, and Hannah Höch labeled their works "constructions" and referred to themselves as engineers or *monteurs*, which in a mechanical sense means "fitters or assemblers." John Heartfield even became known as "Monteur Dada" (Ades 22–23).

In the years during and following World War I, the notion of artistic creation as a process analogous to mechanical fabrication presented a great challenge and stimulus to American artists and writers as well. Joseph Stella called his collages *Macchine Naturali*, and Stuart Davis wrote in his journal, "A picture becomes a thing of construction like any other thing that is made. Drawing inspiration from whatever source, the picture has to be built just like an automobile" ("Journal" 43). Literary figures, too, invoked this analogy: poet William Carlos Williams referred to the poem as "a machine made of words" (256). These and many other vanguard artists and writers began to inscribe the dominant machine culture into their works by positing a virtual interchangeability of the collage aesthetic and the machine aesthetic. Their works are evidence that the machine age involved a revolution in the arts as well as in engineering.

Because of its countermimetic impulse, collage would appear to move toward abstraction, which, of course, is one powerful impulse in modern art. However, this impulse is complicated by the metonymic nature of collage; the component pieces, whether they be newspaper clippings, photographic fragments, or tobacco packages, are frequently redolent with significations of the everyday world of commerce and the marketplace. While no longer mimetic in the illusionistic sense, modernist collage nonetheless literally incorporates bits of the "real world," thus creating a dialogue with that world, whether intended or not, by virtue of its technique.[6] This interchange between things in the world, on the one hand, and the constructive process, on the other, opens up a rich, multilevel discourse. Collage constructions thus engage consumer culture—the world of advertising and mass-produced consumer goods— as well as the mechanics of machine technology.

Take, for instance, Man Ray's *New York 17* (ill. 1). To make this work, the artist stacked strips of wood (cast in bronze in the refabrication illustrated here) in a configuration that suggests both a carpenter's collapsed yardstick and the profile of a setback skyscraper; he then fastened them together with a carpenter's C-clamp. By so assembling found objects, goods from a building supply store, Man Ray modeled the constructive process itself. The profound transformation in art practice implicit in Man Ray's work is especially pronounced when viewed in relation to its counterparts in premodern painting, for instance, Childe Hassam's *The Hovel and the Skyscraper* of 1904. Both works represent the building of New York City, but while Hassam gives us a scene of city building that he may have actually viewed outside his studio window, Man Ray mimics the silhouette of a skyscraper as well as the process of construction itself. (In a sense, then, the work performs a double mimesis.) Furthermore, by appropriating the tools and materials of a builder or carpenter, the artist implicates himself as a participant in the building process. The representational schema of Hassam's impressionist painting has given way to one based on the process of construction itself. *New York* enters into a new relationship with the actual transformative process of urban building. It seems to participate in rather than merely record that transformation.

The progressiveness of Man Ray's gesture is, however, undermined by his own observation that "Dada cannot live in New York. All New York is dada, and will not tolerate a rival,—will not notice dada" (qtd. in Foresta 83). The artist seems to acknowledge that his art could not match what New York already is. If the rakish slant of the work expresses Man Ray's dada impulse, the C-clamp, which simultaneously squeezes and dwarfs the skyscraper, may comment on the relative ineffectuality of his anarchic spirit in New York. The artist's construction is contained by something much larger and more powerful than himself. The interplay between materials thus models the interaction between the artist and his machine environment: in this way the work becomes an unorthodox self-portrait. Building technology both creates and threatens identity, both stimulates and outdoes artistic creativity. A work that may be at once self-portrait and cityscape is a work that expresses a complex sense of interaction between the self and the constructed environment. In Man Ray's hands technology is

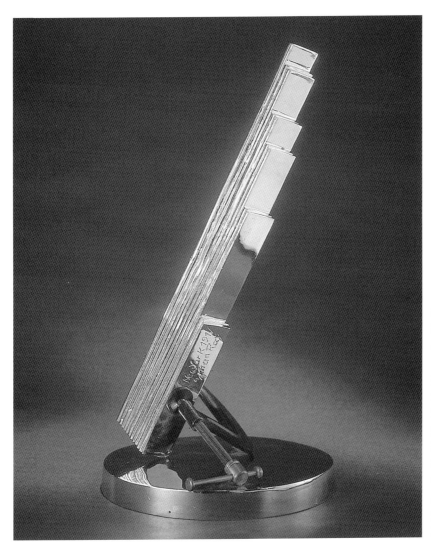

1. Man Ray, *New York 17*, 1917, re-fabricated 1966. Chrome-plated bronze and brass and painted brass vise, 17 3/8 × 9 1/4 × 9 1/4 inches. Hirshhorn Museum and Sculpture Garden, Smithsonian Institution, Gift of Joseph H. Hirshhorn, 1972. Photographer, Lee Stalsworth. Copyright © 2003 Man Ray Trust/ Artists Rights Society (ARS), New York/ADAGP, Paris.

not so much something "used" as something "lived," to paraphrase Godfrey Reggio. The artist deliberately selected objects—as well as titles—not just to comment on American culture but to try to find a place for himself in that technological culture—a way to live, or compete, in a new world.

The avant-garde's definition of art in terms of technology also inevitably introduces gender issues, which have been largely ignored in critical writing on machine-age art. The domain of technology was highly valued at this time as a realm in which Americans excelled. As Lisa Steinman has argued, various disciplines borrowed from technology so as to appropriate its prestige and to proclaim a place for their own work in America (2). In order to validate their art—indeed, to valorize themselves—artists embraced a machine aesthetic whose attributes of efficiency, structure, and architectonicism derived from the engineered environment, from structures like bridges, factories, and skyscrapers. Artists accommodated themselves to the new environment—and to new myths about American identity—by appropriating basic principles from the man-made environment.

My use here of the adjective "man-made" is deliberate, for although individual machines were often characterized as female, the engineered environment was largely masculinized. The new hero of the postwar years was unquestionably the engineer. At this time, the myth of the cowboy as a "symbol of rugged individualism, egalitarianism and heroism" was replaced by the myth of the engineer as "a symbol of efficiency, stability, functionalism and power . . . a new hero who enacts the values of civilization" (Tichi 98). In inscribing the dominant machine culture into their works through a constructive mode of art-making, artists of the avant-garde were complicit in forming this masculinist national myth and identity.

It is not just art practice but also the metonymic nature of collage itself that invites gender analysis, since the bits of the real world which collage incorporates are often gender coded. A close reading of these works can thus reveal gender conflicts being played out. It is worth noting, for instance, that the found objects selected by Man Ray, though not terribly high tech, are implicitly gendered in that they allude to male-coded occupations—carpenter, builder, engineer. Once we understand how the engineer became the model for the autonomous artist as a constructor of artistic real-ities, we can see how American modernism was implicitly engaged with a variety of larger problems and changes.

The great irony here, however, is that although many American modernists of this period were interested in the "man made," the working man is largely absent from their art. This is one cultural issue that is largely erased in the art under discus-sion here. Furthermore, while the artists' identification with technological content and modes of construction would seem to indicate a distinctly antielitist stance, their preference for engineers over workers, for those who conceptualize rather than those who actually work in the trenches of industry, suggests otherwise. What does this tell us about the artists' attitudes regarding the working class and, equally important, about the artists' attitudes about themselves? Such questions are key to the kind of art that gets made and to what meanings the artists are trying to generate in American modernism.[7]

Not surprisingly, those artists most drawn to machine technology during the modern period are male, including Louis Lozowick, Morton Schamberg, and Paul Strand, as well as the key figures of this study, Man Ray, Stuart Davis, Gerald Murphy, and Alexander Calder—all of whom produced art that embraces highly masculinized content and art practice. If we accept the notion that modernism is wrapped up with machine technology, this mode of art-making would seem to be hostile to women and their art production. Does this mean that there is no place for the art of women in the machine age? To some extent women were devalued because they were less likely to participate in a dialogue with machine culture. While female artists including Elsie Driggs and Georgia O'Keeffe did grapple with industrial and urban content in works of the 1920s, most women tended to keep their distance from such themes. However, even O'Keeffe's greatly enlarged paintings of flowers and bones, which would seem to have nothing to do with technology, can be understood in terms of a machine aesthetic. O'Keeffe's renditions of flowers are so magnified that they seem

to embody a kind of model building in the way that she has dismantled and reconstructed them part by part, so that the resulting abstractions seem to mimic constructive principles of the machine as much as they do of nature. One could argue, then, that her art was shaped, albeit very differently, by the same cultural forces of the machine age.

In order to examine the implications for American art of the emergence of the machine as a modern icon, this study focuses on artists who adopted a particularly technological orientation to the world; that is, their artistic production encodes a deliberate structuring of objects, invoking a technological model. It is this "nuts-and-bolts" model, rather than the more abstract level of scientific discourse, that is foregrounded here. Though scientific discoveries such as the X-ray will be examined, I am most concerned with the practical applications and concrete manifestations of such discoveries. I have therefore adopted the understanding of machine technology as applied science that became current by the end of the nineteenth century.[8]

Each of the artists of this study created work that reflects very different relationships to machine culture. Indeed, the machine assumes four very distinct roles in the art products as well as in the process of art-making or production of art. In Gerald Murphy, who represents the literal nuts and bolts of technology, the machine is the works' explicit subject. In contrast, Calder's works do not represent machinery itself; rather, he takes as his medium a vernacular industrial material, iron wire. The machine provides him with a pliable material that enables him, paradoxically, to dematerialize sculpture, suggesting his subjects by outlining them—abstracting them from the world and from their actual substance. For Man Ray, the machine is a found object—raw material, fact—but also metaphor. Ultimately, his machines are really antimachines, extracted from their functional context. Finally, for Stuart Davis, the machine serves as a model for the practice of art-making, freeing it from its association with the personal touch of the artist's hand. These are, to my mind, the most telling ways in which technological values were inscribed in both the imagery and more fundamentally in the procedures of art-making of American modernists.

Gerald Murphy tended to make visual the physicality and aggressive presence of the machine itself; as one critic put it, his work conveys "a feeling for mass" (qtd. in Rubin 20). *Engine Room*, of 1922 (ill. 2), for example, is a dramatically lit and large-scale display of incipient movement and power unleashed by cogwheels, gears and fan belts—all presided over by the huge circle of the turbine casing with its highly tactile nuts and bolts. In rendering the imposing power of the machine, Murphy recalls the sentiments of Henry Adams, for whom "the dynamo became a symbol of infinity." Yet unlike Adams, who, in the Hall of Machines at the Great Exposition of 1900 "began to feel the forty-foot dynamos as a moral force, much as the early Christians felt the Cross," Murphy takes a more down-to-earth approach (380). Rather than probing the metaphysics of the machine, Murphy imbues his own work with a nuts-and-bolts pragmatism. Where Adams's instinct had been "to pray to it: inherited instinct taught the natural expression of man before silent and infinite force," Murphy's focus on the materiality of the machine demystifies (or desacralizes) technology (380). No longer the sublime force it was for

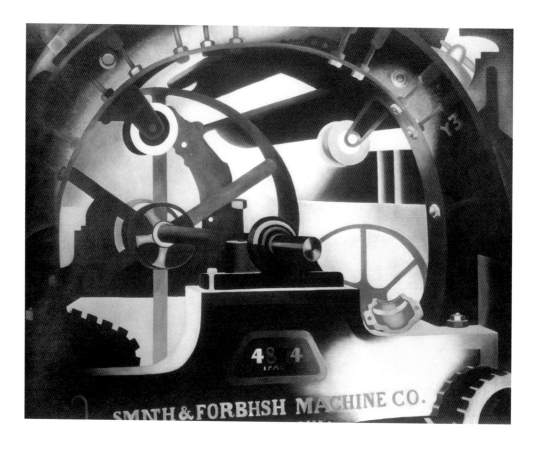

2. Gerald Murphy,
*Engine Room*, 1922
(location unknown).
Oil on canvas,
ca. 44 × 60 in.
Copyright © 2003
Estate of Honoria
Murphy Donnelly.

Adams, the machine for Murphy was evidence of human ingenuity and agency. The physicality of Murphy's turbines serves to reinscribe the work of the engineer in constructing it and, by extension, of the artist in representing it. Murphy thus validates his art by aligning himself with the mythos of the machine. Originally titled *Turbines*, the painting was very likely inspired by a visit to the engine room of one of the European ocean liners on which Murphy had crossed the Atlantic, perhaps the *Paris*, which served as the model for the slightly later painting, *Boatdeck* (ill. 64). Murphy's painting alludes to the machine as the site of power generation but also to the engineer/builder. Interestingly, the inscription on the machinery, "SMNH & FORBHSH MACHINE CO.," refers not to ocean-liner turbines but to a Philadelphia company, Smith and Forbush, which made textile machinery (Rubin 20). *Machine Room* is not a picture of a particular functioning machine but Murphy's own appropriation and reconstruction of different machines to create a powerful composite image. Murphy has deconstructed and reconstructed machinery with an eye toward an inventive aesthetics of the machine.

In the case of Alexander Calder, nowhere does the machine appear in his works. Indeed, his playful creations may seem the antithesis of the mechanical. Even Calder's innovation, the use of wire in sculptural representations of conventional subjects like figures, faces, and animals, may seem unrelated to issues of mass production and collage aesthetics. Yet it is precisely his appropriation of a material produced by mechanical means and used largely for industrial, not artistic, purposes that lends a technological note to Calder's works. Rather than representing machines themselves,

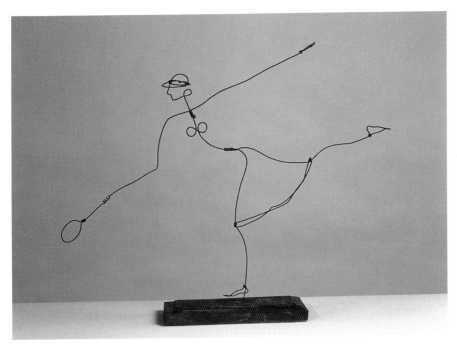

3. Alexander Calder, *Helen Wills*, 1928. Wire and wood, 13 1/8 × 16 × 3 1/4 in. Private Collection. Copyright © 2003 Estate of Alexander Calder/Artists Rights Society (ARS), New York. Copyright © Art Resource, NY.

then, the wire sculptures allude to the machine at one remove. The machine is present in the medium rather than in the content.

Alexander Calder was "hardwired" with a markedly pragmatic sensibility from the beginning. One of his favorite possessions as a child was a pair of pliers, which he used to "improve" his toys, or so he wrote in his autobiography (21). Armed with a degree in mechanical engineering and a couple of years of study with George Luks at the Art Students League, he arrived in Paris in 1926, where he further developed this "handyman" approach to art-making. As he told his sister, "I think best in wire," and so, trading paintbrush for pliers, he began to bend, twist, and coil wire to fashion portraits of friends, circus performers, jazz singers, and animals, in the process becoming known as "the wire king" of Montparnasse (qtd. in Lipman 238, 234). Practical, too, was Calder's eminently efficient approach to preparing works for exhibitions. As the story goes, the artist would appear at his gallery "carrying shears and pliers, with a roll of wire hung over his shoulder and produce an entire show of wire sculptures on the spot" (Lipman 238). No packing, no shipping!

Calder's *Helen Wills*, a wire work of 1928 (ill. 3), represents the American tennis star of the 1920s and 1930s, who was also an accomplished painter of still lifes. Calder's sculpture engages recurrent themes of this study—gender, certainly, and also *américanisme*, the French enthusiasm for things American, which extended to the realm of sports. Wills was a gold medalist in women's singles and doubles at the 1924 Olympics in Paris and the top female competitor in the world for seven straight years, beginning in 1927. The French press labeled Wills "The American Girl," a name which had particular resonance in postwar France. As *la jeune fille américaine*, she took on a great deal of symbolic baggage in the 1920s. Wills represented not only the energy and youth of democratic America but also many qualities of the New Woman—that

free spirit, who, newly emancipated by war work and suffrage won in 1920, broke away from conventions of Victorian culture. She became an outspoken champion of the rights of self-determination for female athletes in seeking independence from male-dominated organizations that controlled tennis (Engelmann x).

As an American artist working abroad, Calder was very much aware of the rich symbolism of such a star's presence in France, her embodiment of the *jeune fille améri-caine*, and he manages to give the image of this celebrity a sense not only of reserved elegance but also of bold daring. The line of action is beautifully rendered in wire, yet Wills seems precariously balanced on the edge of awkwardness, a probable allusion to her reputation for fearlessness in attempting to reach the ball at all costs.[9] This work is a playful tribute to a highly accomplished New Woman of the sports world, an icon whose work was essentially play; as serious as it was for Wills, tennis was still just a game. Calder delights in the oppositions this subject offers, the blurring of gender distinctions in the New Woman and of leisure and labor in competitive athletics. The artist has extracted wire from its usual technological uses and has imbued it with a sense of whimsy. We see in Calder's work an infusion of humor into that weighty realm of the mechanical.

Man Ray complicates the issues surrounding machine art by taking artistic practice to new levels of resourcefulness in works such as *Object to Be Destroyed*, ca. 1923 (ill. 4), a conjoining of a metronome and a photographic cutout of a human eye. In this work, one of American modernism's more arresting objects, the artist has presented something that *is* a machine but which is removed from its functional context. *Object to Be Destroyed* is, like Calder's work, serious yet playful, simple yet multileveled; it incorporates the ready-made materials of Dada, the unexpected overtones of Surrealism, and the radical manipulations of modernist photography. The lone eye can be read as a symbol of the "seer," one who sees through and beyond, and Man Ray's love for punning and puzzles tempts us to read the eye as the first-person pronoun and to interpret the work as a self-portrait. Man Ray presents himself as an American photographer, object-maker, and visionary, as an observer as well as participant in the Parisian avant-garde.

The photograph from which Man Ray excised this eye pictured his model Kiki. (A later version substituted the eye of Lee Miller.) The effect of the woman's eye on the moving arm of the metronome is hypnotic and mesmerizing; the female entrances and controls the assumed male viewer. However, in wrenching a female eye from its anatomical context and transferring it to the realm of machine control, the artist could also be commenting on modern technology as a masculinist fantasy of male power over nature and the female body. Especially at a time when traditional gender arrangements or hierarchies were profoundly threatened by the emergence of the suffrage movement and the New Woman, such a work uncovers the ways in which technological developments within modernism might work to reinforce traditional gender relations. Such an image, which embodies seemingly contradictory or opposing meanings—both self and other, male and female—may also, however, suggest that the machine may be used to mock itself and to carry subversive messages.

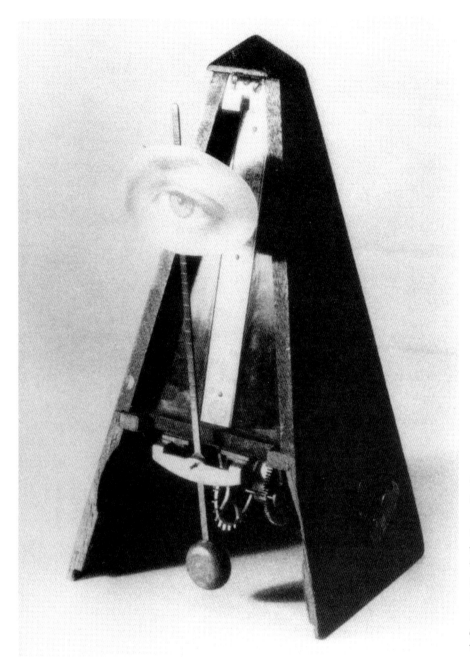

4. Man Ray, *Object to be Destroyed*, ca. 1923. Mixed media, metronome with photograph, 9 in. Copyright © 2003 Man Ray Trust/Artists Rights Society (ARS), New York/ADAGP, Paris.

For Stuart Davis, the machine served not as something for art to make an image of, or as a provider of material or found objects but as a model for the practice of art-making. In his journal, Davis insisted on the practicality of artistic expression and frequently made utilitarian claims for his art. In 1921, for example, he wrote, "An intelligent picture is a utilitarian object of great magnitude" ("Journal" 149). His belief that "America is pure practicality and utilitarianism" is thus less a complaint than an acknowledgment of the terms an artist must confront if American art was to have real significance, or in his words, "aesthetic utility" (qtd. in Wilkin 114; in Kelder 33). Davis's early tobacco paintings can be seen as the embodiment of these pragmatic ideas. Davis

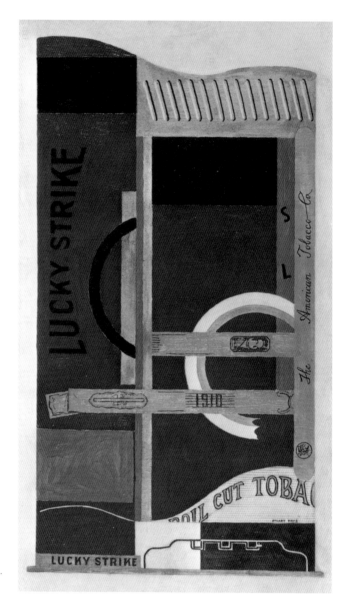

5. Stuart Davis, *Lucky Strike*, 1921. Oil on
canvas, 33 1/4 × 18 in. Collection,
The Museum of Modern Art, New York.
Gift of the American Tobacco Company, Inc.
Copyright © Art Resource, NY.

based such paintings as *Lucky Strike* of 1921 (ill. 5) on an accumulation of data from the
everyday experience of living in an environment saturated with advertising and com-
mercial products. Such paintings thus enter into a dialogue with the mundane clutter
of contemporary life. Davis's subjects often engage aspects of everyday life having to
do with mass production: for example, cigarette packaging, cigarettes themselves, and
advertising posters—all products cranked out by the machine. In extracting principles
from advertising, packaging of products, and from commercial objects themselves, and
by making utilitarian claims for his art, Davis proposed a remedy for what he saw as a
cultural anemia caused in large part by the separation of art from life.

Davis sought ideas for his works that could be tested in reality; that is, he
wanted to establish an intellectual system that "only waits to be fired by reality to be
put into motion" ("Journal" 107). The reality Davis had in mind, of course, was the

man-made environment. Perhaps Elaine de Kooning, an artist of a later period, best grasped the significance of Davis's subjects. For her, Davis's paintings represented "the experience not of our natural landscape but of America as man made. In our common public existence, this is the land of layout and lettering, of engineering and industrial design, of big cities and long roads that somebody built" (41). Davis himself wrote, "nothing exists but what is made" ("Journal" 20). To express this affinity for the new environment Davis turned to new models of artistic creation. Though he is not usually identified with a machine aesthetic or ideology and rarely painted machine imagery as such, Davis appropriated principles of machine technology as the basis for a new constructive mode of art-making. The machine thereby fueled Davis's thinking about his own work as well as the place of modern art in American society in the postwar years.

While such exaggerated assertions of masculinity through artistic practice grew in part out of threats of the New Woman, a powerful force after World War I, they also respond to another historical pressure of the war: the extraordinary pressures to fight in the Great War—and the masculine anxiety resulting from failure to do so. This, and World War I in general, has been a topic largely ignored by scholars of American art. As Amelia Jones noted, "While the war has, for obvious reasons, been a key reference point for studies of European Dada, it has never been acknowledged (beyond passing references) as a context for the New York group" (272). Jones is most concerned with the effect of the noncombatant status on artists working in New York during the war and cites Man Ray, Francis Picabia, and Marcel Duchamp as examples. I would extend that list to the other artists of this study, none of whom actually fought in the war, this at a time when patriotic pressures to do so were impossible to ignore. American artists' aggressive alliance with constructive processes and masculine role models can be seen as defensive measures conditioned by such an intimidating environment. Even though the great majority of works discussed here were done in the postwar years, the war served as a significant formative event that continued to impact artists' conceptual and creative practice well into the next decade. Though distant, the Great War thus provided an ever-present backdrop not only for the Europeans residing in New York whose lives were uprooted by the war but also for American artists who had to contend with the prevalent disapproval of their own avoidance of military service.

Through this preliminary survey of the historical context and practice of art-making of these four American modernists, we can begin to understand how ideas about both human and artistic identity were shaped by machine technology. Although their art may seem very different, in each case the inscription of technological values in both the imagery and more fundamentally in the procedures of art-making reinforces the larger, paradigmatic importance of the machine for modern artistic representation and for American culture at large.

In the chapters that follow, the art of these four artists will be addressed in the context of four key subjects or genres—the automaton, still life, portraiture, and jazz—each of which helps to reveal and recover the complex influence of machine culture on American modernism. These particular topics also uncover how marginalized modes of

expression or cultures (for example, female, African American, and popular cultures) have shaped mainstream culture during the machine age. In four "case studies," which follow the more general topical chapters, I examine the impact of the machine on each of these artists and on their production in a range of media, including photography, painting, sculpture, and stage production. The case studies are intended to give nuanced readings of particular works of art and of artistic agency operating, with some measure of freedom, within larger cultural, social, and institutional constraints.

Part I explores the coupling of the machine and the human body in modern art, or what I have called the avant-garde automaton. As conceived in art, the automaton becomes the site of what seems a major shift in metaphoric paradigms in machine culture. Stuart Davis and Man Ray constructed works in which machines and human anatomy become analogues of each other; Alexander Calder utilized a technological medium to define human figures; and Gerald Murphy fashioned himself into something of an automaton, situating the human-as-machine analogy in a more performative context. There are several possible readings of the analogical relationships established by these artists. The collapsing of the distinctions between the human and the machine can be read as spelling out the eradication of human difference and value, indeed, of humanity itself, a reading that encapsulates the fear of machine control. However, it was by this very coupling of body and machine that artists infused humanity into a something nonhuman. Mechanistic metaphors did not so much replace bodily ones as complement them, in some ways even enriching them. Perhaps, then, what occurred was not so much a paradigm shift as it was an expansion of the range of possible metaphors. In renegotiating the relationship between the human and the mechanical, avant-garde artists thus sought an emphatic if subversive reassertion of human values in the machine age.

An examination of Man Ray's rayographs, a series of works produced by placing objects on photographic paper and exposing them to light, serves as the case study for the discussion of the avant-garde automaton. This collagelike process of assembling objects simulates a mechanical or constructive mode of production; as well, the resulting white impressions have a remarkable affinity to X-rays, newly discovered in the late nineteenth century. Building on Bettyann Kevles's cultural history of X-rays, I discuss Röntgen's discovery of X-ray technology, the public's fascination with its ability to reveal the core structure of the human body, and subsequent allusions to this new technology by modern artists. Man Ray's rayographs establish a particularly provocative dialogue with X-ray technology. They don't just assume the look of X-ray images; they also implicitly engage the sometimes controversial issues surrounding the discovery of X-rays, including the invasiveness of their gaze into the human body, their allusions to sexuality, the occult, and inevitably to death. Above all, however, I am interested in the ways in which the invention of X-rays unsettled, then reshaped, artistic conceptualizations of the human body.

The question of what happens to the genre of still-life painting in the machine age is the focus of Part II. Instead of the mimetic representations of food and household objects characteristic of traditional still life, we find highly abstracted and

geometricized renditions of a wide array of objects, some associated with the home but others with industry and advertising. I am interested in how the reconceptualization of still life in the machine age affected thinking about everyday objects, how that thinking embodied the emerging paradigm of the modern artist as engineer and constructor, and, more pertinent, why this paradigm governed so much of cultural production at this time. Still-life painting was informed by the same forces that shaped Taylorism, that all-encompassing efficiency craze that infiltrated first American industrial production and then every other aspect of American postwar culture and which reached its peak of influence in postwar years. The key questions here are why this zealous drive to impose order surfaced at this time, and, more to the point, why was this need for order so urgent? These impulses and the questions they raise must be viewed against the backdrop of postwar conditions, including widespread labor unrest, the "Red Scare," and changes in the national constituency of immigrants, all of which threatened to undermine, even to contaminate, core values of postwar America. In order to engage the complex social and political realities of the time, some artists "Taylorized" their still-life paintings through adopting constructive art-making practice, while others deconstructed such ordering principles by picturing nonfunctional machines. In so doing, the avant-garde used this time-honored genre to comment on the dominant ordering impulse of the machine age, both endorsing and calling into question the prevalent desire for a monolithic social structure governed by a Taylorist search for the "one best way."

Stuart Davis's series of collagelike paintings based on tobacco products and packaging serves as the case study for still-life painting. The artist's choice of tobacco products clearly refers to modes of consumption pitched to a male audience: to plug, or chewing, tobacco; to burlap sacks used for storing tobacco; and to leather pouches and packages of loose tobacco, ready to be rolled into cigarettes or used in pipes. Such machismo will be examined against societal expectations regarding male behavior during and after World War I, as well as in the context of the potential threats posed by the emergence of the New Woman. At issue here, too, are the ways in which the tobacco series illuminates the increasingly blurred boundaries between fine art and popular culture. In magnifying small-scale packages to the size of advertising posters, Davis celebrates the audacity and vibrant energy of advertising while at the same time exposing its manipulative powers. Through his scrutiny of quotidian visual culture, Davis renegotiated the boundaries between high and low culture while also reinvigorating the genre of still-life painting as a valid avant-garde enterprise.

The genre of portraiture, and through it the search for identity in the machine age, is the focus of Part III. Since portraiture traditionally valorizes the individual by revealing character and personality through a recognizable relationship to its subject, this genre would seem to be the least amenable to the incorporation of a machine aesthetic. However, a new mode of portraiture emerged in response to the machine, one that rendered distinctive attributes of individuals through abstract, or mechanical elements or through words and images resembling ads. "Object portraits," as they are called, may seem to efface personality; in fact, they tend to encode a more

Introduction

profound knowledge of the subject's identity while at the same time engaging larger cultural issues. Rather than presenting technology as obscuring or threatening the traditional nature of portraiture, these works invoke technology to reassert individual identity. It was through this kind of portraiture that American artists were able to work through a crisis in individual and cultural identity brought on in part, at least, by the ascendancy of the machine.

One particularly challenging subject of portraiture was Josephine Baker. An examination of Alexander Calder's wire portraits of Baker is useful as a case study because it considers issues of race, gender, and "primitivism" in establishing identity. The discourse on machine-age modernism has tended to ignore the impact of both gender and race. Through a discussion of these portraits, it becomes clear that the roles of the female as well as the male, the African American as well as the Euro-American, were constitutive elements in the formation of American cultural identity (Lemke 144). It is at this point, too, that expatriation comes into play. Both Calder and Baker were expatriates in Paris in the 1920s, and each responded to European fascination with American culture. Europeans were captivated not only with American sports and technology but also with its popular culture, which in the postwar years meant African American culture and especially jazz and jazz singers, dancers, and musicians. This exaltation of both the machine and black culture gave rise to a "technological primitivism," a duality that informs Calder's portraits of Baker. Indeed, Baker became a means for the artist to address key issues regarding both the redeeming force of technology in elevating "primitive" impulses and the rejuvenating power of the primitive in recovering human agency in a world increasingly governed by technology. Both Josephine Baker's fashioning of an identity as a Jazz Age icon and Alexander Calder's construction of machine-age portraits thus engage the crucial ideological issue of the expatriate experience: the interchange between the French and the American, as well as the black and the white, in the construction of a new identity for the modern era.

This line of reasoning is continued in Part IV with a discussion of jazz. Especially because of its supposed spontaneity and its African roots, jazz may seem, like the genre of portraiture, inimical to a discussion of machine-age art. Yet from its beginnings, jazz was also seen as the product of urban and industrial America. For the avant-garde, especially, the rhythmic base of jazz took on reverberations of the industrial environment. By appropriating jazz into a collage aesthetic, American artists including Man Ray and Stuart Davis industrialized the jazz reference. Rather than deny the origins of jazz, however, the avant-garde affirmed both the technological and the primitive, creating a "technological primitivism" which reflects the duality—and vitality—of jazz itself. Through an engagement with both the mechanical and the primitive foundations of jazz, the American avant-garde entered into a fruitful dialogue between cultures: Euro-American and African American, high and low, Western and non-Western.

Gerald Murphy and Cole Porter's 1923 jazz ballet, *Within the Quota*, provides the case study for an analysis of the significance and influence of jazz on American

cultural forms. Commissioned to create an "American" ballet, Murphy wrote a scenario based on a Swedish immigrant's arrival in New York, and Cole Porter provided the ballet's jazz-based musical score. Through its story and music, and through a heavy dose of irony, *Within the Quota* humorously critiqued American culture, particularly targeting American stereotypes, sensationalist journalism, immigration quotas, and the recent passage of the Eighteenth Amendment instating Prohibition. Murphy and Porter's ballet premiered at the Théâtre des Champs-Élysées in Paris along with another production, Fernand Léger and Darius Milhaud's *La Création du monde*. What may seem an odd pairing of the contemporary and the primitive offers insights into the appropriation of jazz by the American as distinct from the European avant-garde. In particular, while both productions conjoin the primitive and the mechanical visually and thematically, they do so in ways that imply very different attitudes toward jazz and black culture. The French production reflects the African roots of jazz and thus a history of European colonialism, and the American, the cultural politics of the contemporary city and thus the more progressive underpinnings of this musical form.

Through close attention to these four topics and case studies of the four artists' work, this study attempts to show how subtly and complexly works of art register the ambiguities, contradictions, and multiple impulses of historical moments. By enlisting methodologies adopted from cultural studies, gender studies, African American studies, and ethnomusicology, I hope to complicate our view of the negotiations between art and the machine in the formation of modernism. By discussing particular artists, I have tried to engage issues of human and artistic agency, social interaction, and cultural exchange across group and national boundaries, and by close analysis of works of art to uncover the social complexity and historical meaning of modern American art and the basic attributes of American culture. The development of machine-age art was deeply embedded in contemporary social issues, anxieties, hopes, and fears of an American culture struggling to come to terms with the machine. Whether object of straight representation or of deconstruction, whether fact of modern life or metaphor for modern culture, the machine was crucial to the development of American modernism—in one way or another, its mechanical muse.

# AUTOMATA

# 1

# The Avant-Garde Automaton

Philosophers tell us that we are metaphorical beings who make the world in our image, the image of the human body. According to such an "embodied" philosophy, we begin with our bodily experience and then create ever more elaborate metaphors to make sense of who we are and to construct our realities. Bodily metaphors are fundamental to our comprehension of the world. This is the argument, much simplified, that George Lakoff and Mark Johnson make in their book *Philosophy in the Flesh*. Taking their lead from cognitive science, the authors call into question many assumptions of the Western philosophical tradition. They argue, for instance, that "reason is not, in any way, a transcendent feature of the universe or of disembodied mind. Instead, it is shaped crucially by the peculiarities of our human bodies, by the remarkable details of the neural structures of our brains, and by the specifics of our everyday functioning in the world" (4). The body thus provides key metaphors for intellection; for instance, we talk of "grasping an idea" and of "wrestling with a concept." Even internal organs are called into service; we want to get to the "heart of the matter," or we cannot "stomach" something. The nature of these metaphors is, of course, conditioned by the course of history; as the world changes, so, too, do our metaphors (Rothstein 25).

The advent of the machine and machine culture brought about a major shift in metaphoric paradigms. As the machine assumed an increasingly important role in our lives, it became a potential rival to the body as a source of metaphors. Indeed, in literature and the arts, the machine was a key cultural icon that threatened to usurp the place of the body as a fundamental trope of the new century. Metaphors for people and human activities were increasingly drawn from the realm of mechanical components—gears, sprockets, and crankshafts; thought processes were characterized as "wheels going around," and eccentrics were said to have a "screw loose" (Tichi xi–xii). Quite remarkably, however, the machine did not usurp the body. Rather than being displaced by the machine, the body became conflated with it. The body remained a powerful metaphor, though now coupled with the machine. And this coupling reconceptualized our place in the world.

Both artists and writers were quick to exploit the metaphoric possibilities of machine-age culture; body-as-machine metaphors proliferated. Many works by Man Ray, Stuart Davis, Arthur Dove, and Alexander Calder, among other American modernists, suggest that machines and bodies are functional analogues of each other. Although this was an idea first introduced into New York Dada by Marcel Duchamp and Francis Picabia, the Americans' fixation on—and metaphoric construction of—the human figure as a kind of anonymous automaton illuminates much that is distinctive about American culture and its problematic relation to the machine. An editorial statement in *291* written by Paul Haviland, a wealthy French writer and photographer who was an important backer and contributor to Stieglitz's *291* and who was living in New York at the time, encapsulates this body-as-machine metaphor: "We are living in the age of the machine. Man made the machine in his own image. She has limbs which act; lungs which breathe; a heart which beats; a nervous system through which runs electricity" (n. pag.). Through such machine-age metaphors artists and writers found ways to conceptualize a rapidly changing America, which had undergone a quite radical shift from an agrarian to an industrial economy and had by this time become the major industrial leader in the world.

In the discussion that follows, I use "automaton" not in its original narrow sense to mean a mechanism that is self-moving or powered (derived from the Greek for a self-acting or robotic figure that appears to imitate the motions of men or animals). Instead, I use the term in a broader sense to mean an image of the human body as robotic or machinelike. Rather than actual automata or robots, my focus is on images that conflate body and machine—that is, images of anthropomorphic machines or mechanomorphic human beings. Scholars of European art of this period occasionally adopt the term "cyborg" to characterize such images; however, the derivation of this term—cyb(ernetic) + org(anism)—denotes control more by electronic than mechanical devices. Automaton seems preferable for a discussion of the machine age.[1]

Body-as-machine metaphors were increasingly common in late nineteenth-century literature.[2] Artists, too, began to devise new mechanistic images to come to terms with the radical changes wrought by the industrial revolution. Thomas Eakins's rowing paintings—for instance, *John Biglin in a Single Scull* of 1874—came out of a society very much aware of the cultural coupling of man and machine. Sportswriters of the day noted the interplay between rowers and the machines that they maneuvered. In 1872 one writer noted that single-scull champion John Biglin was a "tough, sinewy specimen of human mechanism." Other writers described rowers as "machines," "watch springs," and "pistons" (qtd. in Berger 120). And artists such as Eakins promoted such a connection, portraying Biglin, in David Lubin's words, as "primed at the instant of energy release" (47). As Martin Berger has argued, in visually rendering the analogy between body and machine, Eakins effectively allies the rower's masculinity with the male world of industry. Significantly, however, Eakins's man-as-machine representations take place not in the domain of industrial production but in the world of leisure (123).[3] Viewed against the backdrop of the work ethic and the repetitive actions demanded in factory production, this particular leisure

activity, with its mathematical precision of movement, takes on new meaning. In transferring the requisite requirements of work to leisure activity, Eakins provided an antidote to the dehumanization of that work environment. It is this idea of agency, of choice, that separates Eakins's rowing paintings from earlier fusions of man and machine in art and that makes these works relevant to the cultural context of the twentieth-century avant-garde.

Eakins's rowing paintings have no real precedent in nineteenth-century art; in fact, they propose a reversal of the chilling images of what John Kasson has called the "technological sublime" in earlier depictions of industrial settings (162). Images of workers whose every movement seems governed by the mammoth machines they tend began to appear in American painting. John Ferguson Weir's *The Gun Foundry* of 1866, for instance, features mechanical cranes with great arms and huge cauldrons with belching flames. Here the machine itself emerges "as a kind of fabulous automaton" that dwarfs and enslaves the human workers and elicits this sense of the "technological sublime" (Kasson 162). Though grounded in a recognition of technological achievement of the time, such images also communicated widespread fears of machine domination.

While Eakins's portrayals of rowers are worlds away from such sublime evocations, they are not removed from the specter of machine control. The artist worked at a time when most manufacturing relied on human labor and muscle, sometimes augmented mechanically by levers, winches, and blocks and tackles. And he lived in Philadelphia, a major center of such human-driven manufacturing. Dubbed the "Workshop of the World," Philadelphia was by the 1870s an industrial city filled with small shops and factories devoted to producing everything from locomotives and ships to tools, stoves, and textiles. Almost a third of its population of 700,000 worked in manufacturing at this time (Kanigel 97).

In 1874 a young man named Frederick Winslow Taylor (1856–1915) entered this world of manufacturing as an apprentice machinist in Enterprise Hydraulic Works, a small firm that made steam pumps and other hydraulic machinery and which was located in the industrial heart of Philadelphia along the banks of the Schuylkill River (Kanigel 195–199). And so it was that in the same year and on the same river that Thomas Eakins painted *John Biglin in a Single Scull*, Frederick Winslow Taylor began an apprenticeship that would lead to the writing of his famous book, *The Principles of Scientific Management*, published a few decades later in 1911, and eventually to his designation as the father of the efficiency movement. Taylor carried out time-and-motion studies to determine the "one best way" to organize labor, to link human to machine in the most efficient way possible so as to increase productivity.

When viewed in terms of such efforts to optimize efficiency, Eakins's rowing paintings can be seen as engaging values not unrelated to those involved in factory labor. As increasing numbers of people were enmeshed in the impersonality of factory systems that demanded repetitive and rote actions and as efficiency experts such as Taylor and manufacturers such as Henry Ford worked to better coordinate the movements of body and machine, many began to see the danger of making men and women into machines, into nonthinking robots. These tendencies became more and

more manifest in the early years of the twentieth century. One author alert to such dangers was John Dos Passos; in his great trilogy, *U.S.A.*, Dos Passos described "the Taylorized speedup" at the Ford Motor Company: "reach under, adjust washer, screw down bolt, shove in cotterpin, reachunder, adjustwasher, screwdownbolt, reachunderadjustscrewdownreachunderadjust until every ounce of life was sucked off into production and at night the workmen went home gray shaking husks (Part III, 55)."[4]

As mentioned earlier, Eakins's models are engaged in motions involved not in factory work but in leisure activity, in sport. Not just any sport, but rowing, which was decidedly egalitarian. In America, rowing was not limited to the elite, as it was in England, where gentlemen rowers typically were depicted wearing yachting uniforms. In the United States, rowing attracted participants from all classes who adopted more casual attire, clothing more suitable to the rigorous demands of the sport itself and which Eakins represented in his rowing paintings. As Helen Cooper noted, while rowing continued to appeal to the upper classes, it increasingly attracted an urban middle class who sought an escape from an increasingly sedentary city life; as well, through the formation of clubs, it became an increasingly accessible form of amusement for the working classes. Significantly, John Biglin himself was a working-class rower, a mechanic and laborer (Cooper 25, 39). The sport that Biglin practiced, and which Eakins chose to represent, demanded a focused concentration, practiced skill, and repetitive movements, precisely those capabilities demanded in factory labor. By transferring such talents to the new context of sport and pleasure, rower and artist alike created a more positive context for such skills. Furthermore, Eakins represents Biglin in a single scull, under Biglin's own control. But even in Eakins's paintings of paired or multiple rowers, the images work against the carry over from factory work, in which labor is managed and controlled by rigid production procedures. Whether representing single or paired skulls, Eakins's rowing paintings provide a counterpoint to the prevalent fears regarding the robotization of the modern worker.

This new model for understanding Eakins's work has particular relevance for artists' engagement with technology in the early twentieth century. Implicit in Eakins's coupling of human and machine is an emphasis not on domination by the machine but on human agency. What Eakins proposes, then, is a more positive coordination of the body and the machine, which can be seen as an infusion of a human presence—a human mind and body—into the machine world. In this respect, there is direct link between Eakins and painters of the early twentieth century, particularly, the so-called Ashcan painters and their followers. The paintings of such artists as Robert Henri, George Bellows, and later Stuart Davis represent an attempt not only to counter the "feminized" culture of the Victorian era but also to confront urban culture directly and on its own terms. The artistic response to an increasingly industrialized world proposed by Eakins is thus not a vision of robotic workers but a reassertion of the human in a world governed increasingly by the machine.

Philip Fisher, for one, sees great significance in this recognition of linkages between the world of machines and the human body, and he, too, sees it as an attempt to discern a human face in the machine world or, in his words, "to free from

inside man-made things the fact of their humanity." Fisher makes a case against the conventional reading of the loss of the human in "our entanglement with objects." He argues that "any combination of materials could be joined to create a sign of the human figure." Fisher sees this kind of artistic recovery as a "fundamental act of connection," a connection essential for survival in a humanmade world (*Recovery* 141, 145–146). Not until the second decade of the twentieth century, however, was the longstanding rhetoric of body/machine correlations—and the artistic recovery proposed by Fisher—explicitly translated from literary to visual descriptions. To a degree much greater than in Eakins's works, the mechanomorphic metaphors constructed by the American avant-garde in the early twentieth century constitute this process of recovery—the recovery of human identity within the realm of the machine.

Alexander Calder's major artistic innovation of the 1920s, the use of iron wire, freed the artist from traditional conceptions of the human figure. While his subjects remained conventional—circus performers and animals, entertainers and athletes— his use of such an unorthodox artistic material represents a radical shift in artistic and ideological perspective on the human body. The introduction of wire, a medium produced not for artistic but largely for industrial uses and by mechanical means, lends a technological note to the artist's human representations. Calder's wire sculptures are worlds away from sculptures he made from the more conventional medium of wood. *Nymph*, a wood carving of 1928, for example, features a nude woman emerging from a naturalistic background. In switching from wood to wire, Calder found a way to liberate the figure from the organic world—indeed, from gravity itself—and to initiate a dialogue with the new world of technology. Take, for instance, *Wire Sculpture by Calder* (ill. 6), a work that functioned as the sign for the artist's first show of wire works at the Weyhe Gallery in New York in 1928. Suspended upside down over the entrance to the gallery, an acrobat seems to fly through the air. Wire delineates strands of hair and outlines the muscular legs, buttocks, torso, and finally the arms, which hold the sign for the show: "Wire Sculpture by Calder." The taut lines of wire defining this athletic figure confer a sense of control and discipline to a body in the midst of a difficult midair maneuver. The characterization of Eakins's rowers as "watch springs" or as "pistons" is fitting here; this tightly wound acrobat enacts physical feats high above the sidewalk, announcing feats of artistic innovation awaiting the viewer inside the gallery.

Calder's first career was as an engineer; in 1919 he received a degree in mechanical engineering from the Stevens Institute of Technology in Hoboken, New Jersey. (Interestingly, this was the school which Frederick Winslow Taylor attended beginning in 1881 and from which he, too, received a degree in mechanical engineering two years later.) After his graduation, Calder worked for three years as an automotive, hydraulic, and efficiency engineer, a timekeeper and draftsman—all positions drawing on his engineering training. By 1923, however, he had given up engineering to follow in the family tradition; his mother, Nanette Lederer Calder, was a painter, and his father and grandfather, Alexander Stirling Calder and Alexander

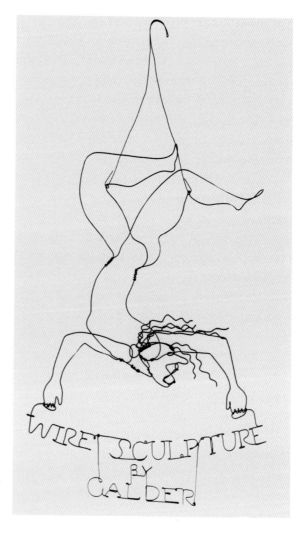

6. Alexander Calder, *Wire Sculpture by Calder*, 1929. Wire, 48 1/4 × 25 7/8 × 4 7/8 in. Purchase, with funds from Howard and Jean Lipman. Photograph Copyright © 1998: Whitney Museum of American Art, New York. Copyright © 2003 Estate of Alexander Calder/ Artists Rights Society (ARS), New York.

Milne Calder, were well-known figurative sculptors. However, as Calder said, "I could never forget my training at Stevens" (qtd. in Turner, *American in Paris* 42). Calder applied his knowledge of new materials and constructive practices learned at Stevens Institute not to the expected realm of engineering but to the world of art.

Nor could Calder forget his love of sports. He had played both football and lacrosse at Stevens Institute. According to Calder, he excelled at neither but was glad to be a participant: "In spite of my enthusiasms for lacrosse, I was not very agile" (Calder 46). His agility manifested itself not in practicing but in observing and drawing sports activities. In 1925 the *Police Gazette* hired Calder as an illustrator. Sketch pad in hand, Calder attended various sporting events, making quick "action sketches" of athletes involved in horse shows, boxing matches, track meets, and circus performances (68–69). In 1925 he also took a job decorating the walls of A. G. Spaulding sporting goods store with drawings of athletes.

After arriving in Paris in 1926, Calder made the transition from drawing on paper and walls to drawing in three dimensions, in wire. Among his favorite subjects for these sculptures were athletes: baseball players, golfers, tennis players, boxers,

and competitors in track and field events. Americans and Europeans alike viewed sports as one of many phenomena, including jazz, skyscrapers, and factories, that announced the new century. The Italian Futurists, especially, relished linking sports to the new forces unleashed by technology, and Calder may well have been aware of their obsessions. As Joan Marter pointed out, Calder's interest in the Futurists began with his first exposure to their works at the Panama-Pacific Exposition in San Francisco in 1915, where his father, Alexander Stirling Calder, was the supervisor of all sculptural programs for the Exposition (53). In their manifestos, the Futurists announced new subjects for art and literature: "We shall extol aggressive movement . . . the somersault, the box on the ear, the fisticuff." And they used sports analogies to celebrate new technologies: "We shall sing of . . . bridges leaping like gymnasts over the diabolical cutlery of sunbathed rivers; . . . of broad-chested locomotives prancing on the rails, like huge steel horses bridled with long tubes." (qtd. in Taylor 124). Such pronouncements set the stage for the mechanomorphism of such paintings as Umberto Boccioni's *Dynamism of a Cyclist* of 1913, which communicates the excitement and energy, the speed and competitive spirit, of sports as well as of the new century.

A mechanomorphism defines Calder's sports figures as well, but in terms very different from the Futurists. For instance, in *Shot-Putter* of 1929 (ill. 7), rather than representing force and movement abstractly as a blur from one position to another as did Boccioni, Calder enlisted a very taut wire, which locates the dynamic energy within the athlete. Outlining the athlete in wire, Calder effectively reduced the body to its motion. Like a vector, the wire signifies the force of movement itself. Through his use of wire, Calder encapsulates the moment of greatest expenditure of energy—the explosive moment when the shot is released from the athlete's hand. Every ounce of energy is propelled along the diagonal trajectory of wire to that point of release. The tightly wound wire at the division between torso and legs accentuates the pivotal point of maximum tension. Furthermore, the action leading up to this moment—the slow coiling of the athlete—is implicit in this image. Calder perceived this athlete in much the same way as did the nineteenth-century critic who described a rower as a "tough, sinewy specimen of human mechanism" (qtd. in Berger 120). Yet, as in all of his wire works, Calder tends to temper this body-as-machine metaphor with the injection of humor. The wire refuses a strictly functional role and deviates here and there from strict efficiency; the way the wrist is cocked, the quirky flare of the suspended leg, and the block head of *Shot-Putter*, for instance, lend a whimsical note to the image.

While Eakins's world of sports is one of utmost seriousness, Calder's is one in which such competition is seen as fair game for satire and wit. And where Eakins's seriousness resonates with the masculine engineering endeavors of the day, Calder's affords a counterpoint to those high- and serious-minded pursuits. As Calder told a *New York Times* reporter in 1929, he wanted a wire line that "jokes and teases" (qtd. in Sperling, "Calder in Paris" 23). The looping wire delineating the acrobat above the gallery entrance—especially the exaggerated facial features and unruly hair—lends a

7. Alexander Calder, *Shot-Putter*, 1929. Wire on removable base, 27 1/2 in. Musée National d'Art Moderne, Centre Georges Pompidou, Paris, France. Copyright © CNAC/MNAM/ Dist. Réunion des Musée Nationaux/Art Resource, New York. Copyright © 2003 Estate of Alexander Calder/ Artists Rights Society (ARS), New York. Photograph, Adam Rzepka.

quirky humor to that work as well. And in caricaturing John D. Rockefeller as a geezer of a golfer in another work of 1927, Calder injects a humorous and satirical note into that serious leisure pastime so closely linked to the world of high finance.

Calder acknowledges and gives tribute to the grace and elegance of his athletic subjects and implicitly recognizes the training and determination it takes to excel in sports. At the same time, he foregrounds the absurdity of our tendency to place so much importance on what should be recreation and play. Perhaps drawing on his own experience as a failed athlete (and, judging from his autobiography, sometimes as the butt of jokes), Calder acknowledges the unpredictability and fallibility of all human endeavor. According to Taylorism, "the human element" was inherently unruly and thus constituted a major obstacle in the rush to achieve high productivity and ultimate perfection through application of the scientific principles of management (Banta 26). By exaggerating the wit and unruliness of human nature, Calder gives this human element a positive value; indeed, he celebrates the resistance of the body to mechanical discipline. As one early critic recognized in a review of the show at Weyhe Gallery, "He is able to treat art itself as a grand plaything" (Haskell 56). In infusing humor into his industrial materials, Calder pokes fun at a culture in thrall to Taylorism. Calder thus praises athletic prowess while at the same time questioning that fervent desire of the day to coordinate body and machine in the pursuit of maximum efficiency.

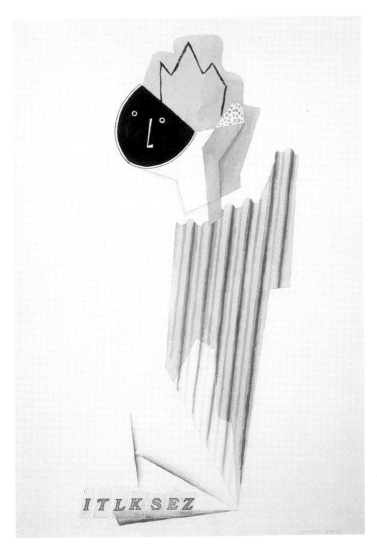

8. Stuart Davis, *ITLKSEZ*, 1921. Watercolor and collage on paper, 22 × 16 in. William H. Lane Collection. Courtesy of the Museum of Fine Arts, Boston.

*ITLKSEZ* of 1921 (ill. 8), a work executed in watercolor and collage, announces Stuart Davis's entry into the domain of metaphoric figure construction. The work features abstracted shapes that describe a black-faced figure whose crown, striped costume, and jaunty stance suggest popular entertainments such as minstrel shows, vaudeville, and jazz. Below the figure Davis has collaged the stenciled letters of the title. A decade earlier, Picasso had likewise stenciled "MA JOLIE" across the bottom of a painting, the phrase functioning simultaneously as a title, a reminder of the painting's flatness, and a clue to the painting's source in popular culture, in this case a popular song. Rather than paint the letters as did Picasso, Davis cut out and pasted stenciled letters on the surface, where they likewise functioned as a title and as an indicator of both flatness and meaning. But what could the artist mean by this seemingly nonsensical jumble of letters? Once decoded as shorthand for "it looks easy," the question arises: what looks easy? Perhaps the title alludes to the domain of commercial lettering and entertainment, that is, to popular culture. But could it also refer to the popular putdown of modernism in America? Or to the collage technique itself

with its appropriations of ready-made forms, in this case stenciled letters?[5] After seeing the Armory Show, Davis wrote, "That settled it. I would be a modern artist. So easy. Except for one small matter: how?" (qtd. in Blesh 13). Through the use of collage Davis has satirically exposed the prevalent attitude—as well as his own initial reaction—to modern art in this country, while at the same time formulating a way of working that would be expressive of what he called "the widened consciousness of the age" ("Journal" 68).

For Davis, this "widened consciousness" was grounded in the mechanical ethos of the time. Just as the title *ITLKSEZ* requires decoding, since its meaning is not at first transparent, the figure also must be processed in a new way. Even though the figure itself is not composed of actual collage elements, the effect is that of collage; that is, a sense of disjunction results from the artist's juxtaposition of discrete component parts. With its innovative mode of construction based on the collage aesthetic, *ITLKSEZ* can thus be seen as a kind of automaton, an embodiment of the emergent machine culture.

Stuart Davis has conceived of the human image not in traditional terms, as a vessel of human sentiment, but as a construct of the mind. In attempting to acknowledge the contemporary world, he rejected a subjective for an intellectual response to that world, demanding, "Don't emotionalize. Don't 'feel'. . . . Instead of 'SENSATIONS' why not symbolize CONCEPTS." Accordingly, Davis's figures of this period are invariably expressionless and in several cases totally featureless; furthermore, rather than being illusionistically modeled, these figures are constructed of flat forms and collaged elements. As such, they can be seen as satires on the traditional rendering of the figure. As Davis wrote, "The question persists as to the use of tin cans, letters, fabric, etc: for building a satiric figure." It is therefore not the title alone but also Davis's mode of representing the figure that assumes ironic meaning. By embracing "architectural structure and satire" as his primary interests, Davis found a way of working free from the constraints of traditional figure painting. Instead of acknowledging human subjectivity and emotive faculties, he proposed "building" forms made up of "ideal impersonal units" ("Journal" 18, 132, 25). Implicit in such reactions against the past—and in the collages themselves—is a satiric irony, a sensibility that would continue to inform Davis's mode of juxtaposing words and symbols throughout his career.

Another Davis collage of 1921, *Untitled (Figure)* (ill. 9), features a figure constructed from simulated and actual collage elements: a wavy pattern of lines made to feign wood graining (an inevitable allusion to Braque's collages) suggests hair; a shape cut out of wallpaper indicates the torso; the right hand is cut from this torso, and the resulting void signifies the left hand. The artist selected a circular form, a logo for Gold Seal Congoleum, the trade name for a rubberized floor covering popular at the time, and glued it strategically on the hip where it functions as the main pivot of the body.[6] Like an axle or gear, it suggests mobility for this faceless automaton. Davis also exploits the metonymic implications of collage. By appropriating this advertising logo, with its printed promise of "satisfaction guaranteed or your money back," Davis satirically exposes the overstated claims of advertising, a theme further explored by

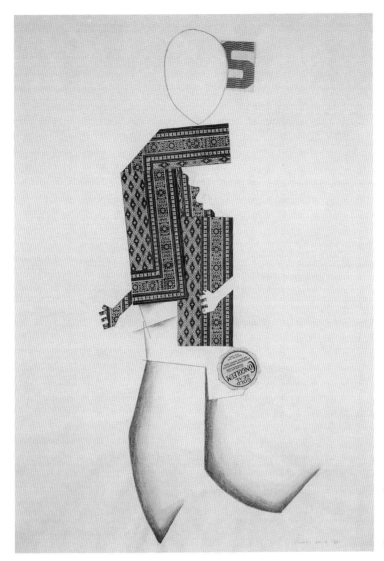

9. Stuart Davis, *Untitled (Figure)*, 1921. Pencil and collage on paper, 22 1/2 × 16 1/2 in. Courtesy Salander-O'Reilly Galleries, New York.

the artist in his series of "tobacco pictures," the topic of a later chapter. And, like *ITLKSEZ*, the automaton-like figure also implicates the world of machine technology by virtue of its construction.

Somewhat later, Arthur Dove joined Stuart Davis in satirizing American culture via this new genre of automaton construction. In the 1920s, Dove executed several figurative collages; the most revealing in this context is *The Critic* of 1925 (ill. 10), a collage of cardboard, newspaper, and magazine advertisements featuring a critic equipped with a vacuum cleaner, roller skates, and a magnifying glass. The irony here is that while the magnifying glass hanging around the critic's neck implies attention to detail, the roller skates and the vacuum cleaner suggest hasty and indiscriminate consumption of information—even of trash. Furthermore, the body of the critic is fashioned from a newspaper review extolling traditional landscape—the kind of art such a critic would unthinkingly embrace but which Dove would likely dismiss. Through such juxtapositions, Dove has satirically exposed this figure as a kind of

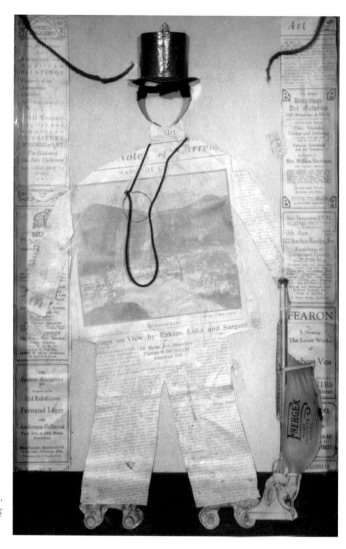

10. Arthur G. Dove, *The Critic*, 1925. Collage,
19 3/4 × 13 5/8 × 3 5/8 in. Collection of
Whitney Museum of American Art, New York.

dehumanized product of the machine age, functioning more like a robot outfitted
with mechanical appendages than a critic endowed with insight and thoughtfulness.

For Davis, as for Dove, irony was a means of destroying old standards of what
constituted valid artistic expression, thus clearing the way for a more modern, more
constructive, model of art-making. Such a model is invoked by Davis in his journal
entries of the early 1920s: "A picture is a thing in itself and has to be built out of col-
ored shapes in as certain a way as a mechanic puts an automobile together" (111).
Such a statement sheds light on Davis's coming to terms with the idea, new to him,
of a work of art as a construction. Made up of parts that could be assembled, disas-
sembled, and reassembled, the artist's newly conceived figurative works can be said
to engage the world of machine technology. Like a machine made of interrelated
parts, this is an art of construction rather than mimesis, an art of design or assem-
blage rather than replication, let alone expression.

For the American avant-garde, the machine and the collage aesthetic were
thus interlinked. And this conflation is crucial to American artists' conception of an

indigenous modernism. Whereas the collage technique itself is unmistakably European in origin, the collage and simulated-collage elements that Davis employed, such as the Congoleum logo and the black face, allude specifically to American products and entertainment, respectively. Furthermore, Davis took great pains to define collage as a mode of construction similar to mechanical fabrication. In drawing analogies with the realm of American entertainment and the highly esteemed domain of engineering, Davis gave the technique an American inflection. It is worth reiterating here that, as a result of the new prominence of the domain of engineering, the engineer attained almost heroic status in American culture, appearing frequently as hero in countless advertisements, best-selling novels, and silent movies.[7] By constructing figures that personified attributes valued in the engineer—rationality, efficiency, and so on—Davis and other modernists encoded dominant values of the day and in so doing effectively defined themselves as artist-engineers. The collage aesthetic applied to figurative subjects thus provided the artist with a means of naturalizing European modernism and of elevating art so that it might rival the prestige of engineering in American culture.

This art also imparted value to that part of our surroundings not traditionally deemed relevant as art. The black-faced figure in *ITLKSEZ*, for instance, gives tribute to black entertainers in such popular diversions as vaudeville and jazz. And the inclusion of the Congoleum logo in *Untitled* and appliance ads in Dove's work serve to entangle art with the world of advertising. The artists' commerce with such popular forms reveals a deeply ingrained anti-elitist impulse, and such collages represent the inauguration of a markedly impure aesthetic. In their confounding of the distinction between high and low culture and in their new mode of picture-making, they constitute an attempt to match the dynamics of the contemporary environment as well as to challenge existing criteria for making art. Such goals are, of course, attributes of Dada, and the elevation of machine technology, advertising, and popular culture in the avant-gardists' figurative works of this period is also unmistakably Dada in spirit.

Davis was by no means a central figure in the New York Dada scene; in fact, he was very much on its fringes. He did not participate in the activities of the Arensberg circle as did Joseph Stella and Man Ray; nor was he a member of the Société Anonyme, founded by Katherine Dreier and Marcel Duchamp. However, Davis lived in close proximity to Man Ray and Duchamp and was a keen observer of the New York art world. That he gave considerable thought to Dada and to Duchamp's anarchistic activities in New York is quite apparent in Davis's journal entries. He singled out Duchamp as "not a painter at all but a thinker who expresses himself in unintelligible symbols" and the Dadaists in general as "European Jugglers with whom we have been acquainted in vaudeville for some years." Although at times critical of Dada, he also praised it for its repudiation of subjectivity: "Is it possible that the Dadaists are operating on the aesthetic emotion as a surgeon does on a diseased organ?" He goes on to say, "It is now necessary to express tin cans, chicken wire and the *Evening Journal* which . . . have a thickness in the mind" ("Journal" 87, 39, 30, 34).[8] Such privileging of the role of the intellect in artistic creation recalls Duchamp's attempts to

place art in an intellectual context. As well, the idiosyncrasies of Davis's statements—and of his collage constructions—suggest the operation of a Dada sensibility.

Also of note in these works is Davis's paradoxical allusion to both machine and "primitive" cultures. This linking of the technological and the primitive informs numerous works of this period and will be discussed in further depth in later chapters. Suffice it to say at this point that, while the collage aesthetic embraces processes of construction and thus machine technology, the masklike face in *ITLKSEZ* inevitably evokes African sculpture and thus "primitivism." And the patterning on the collaged torso in *Untitled* resembles African textiles, a form of "primitive" or folk culture. This conflation of opposite impulses can be termed technological primitivism—a primitivism that is at once futuristic and atavistic. This seemingly contradictory impulse to link the primitive and the technological also implicates Davis as a Dada conspirator, a technological primitive in an America newly defined in terms of the machine. His works also point up the technological primitivism endemic to America itself—an America typically characterized as ultra-advanced in technological terms but ultra-naive, unsophisticated, even primitive, in other realms.

Like Stuart Davis, Man Ray gravitated toward figurative collage in the teens, as seen in works such as *Dance* of 1915 (ill. 11). Whereas Davis's involvement with the human figure all but ended in the early 1920s, Man Ray continued to garner metaphoric meaning from the human image throughout his career. Even though not actually collaged, the planar forms of *Dance* are beginning to look as if they were cut out with scissors and pasted on the canvas. "I changed my style completely," he later wrote, "reducing human figures to flat-patterned disarticulated forms" (Man Ray, *Self-Portrait* 52). The joints of the arms and legs are abruptly angled—as if cut, or "disarticulated." Even if made by hand, the parts of the dancers seem to be prefabricated, separable, and manipulatable. The artist continued to experiment with such ostensibly mechanical means of structuring figures in the following year, most definitively in a series of ten collages entitled *The Revolving Doors*. The first work in the series, *Mime* (ill. 12), with its head and outstretched arms now constructed of strips of colored paper, still signifies the anthropomorphic; yet more explicitly than in *Dance*, the method of fabrication refers to the mechanical. We are reminded that collage is an art of construction rather than replication, an art of design made up of related parts analogous to the functionally interrelated parts of machines.

*The Revolving Doors* proved seminal in Man Ray's coming to terms with new modes of representing the human figure. Described by one critic as "geometric-anthropomorphic fantasies" and by Man Ray himself as "pseudo-mechanistic forms, more or less invented, but suggesting geometric contraptions that were neither logical nor scientific," *The Revolving Doors* collages tend to collapse the distinction between the mechanical and the human (Shattuck 330; Man Ray, *Self-Portrait* 59). This is particularly true of the fourth work in the series, *The Meeting* (ill. 56), in which highly abstracted, vaguely figurative shapes are interwoven with a mechanical spiral or drill-like form. This dance of the human and the mechanical, the animate and the

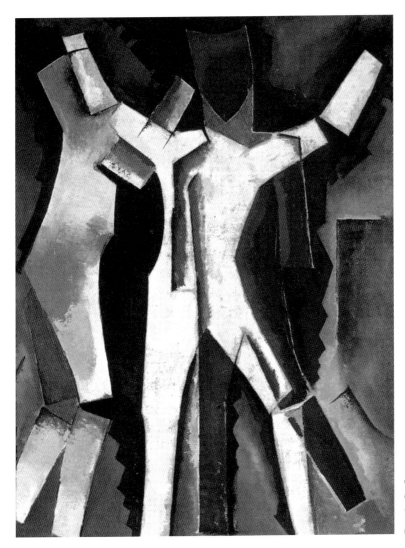

11. Man Ray, *Dance*, 1915. Oil on canvas, 36 × 28 in. Copyright © 2003 Man Ray Trust/Artists Rights Society (ARS), New York/ADAGP, Paris.

inanimate, projects a metaphorical alliance between the two that suggests how avant-garde artists could both construct and comment on new realities.

In the next several years, as Man Ray's figurative imagery became more specifically mechanical, he formulated ways of working derived more directly from the machine. In the late teens, Man Ray developed an unconventional collage-inspired technique that he called aerography, which involved the use of spray guns and cut-out stencils, as seen in a work begun in 1920 entitled *Danger/Dancer* (ill. 13). Here, not only has the human content (a dancer) become a machine image (a tripartite arrangement of gears), but the process itself has become mechanical: the spray gun as painting machine. The artist seems to have banished the human from the image as well as the hand or the tactile element from the process. Man Ray experimented with such unconventional techniques in part to free himself from the "aesthetic implications" of traditional painting. As Man Ray wrote, "It was thrilling to paint a picture hardly touching the surface—a purely cerebral act, as it were" (*Self-Portrait* 73, 67). Like Davis, he aligns himself with Duchamp, who, because of his disillusionment with

12. Man Ray, *Mime*, from the portfolio *The Revolving Doors*, 1926 (original collages, 1916-17). Pochoir on paper, 22 × 14 7/8 in. Smithsonian American Art Museum, Museum. Copyright © 2003 Man Ray Trust/Artists Rights Society (ARS), New York/ADAGP, Paris.

his contemporaries for their reliance on technical facility, wanted to restore the intellect to art, to produce "something where the eye and the hand count for nothing" (qtd. in Pach 62). Man Ray has used a painting machine to produce revolutionary images of the human figure. The machine thus served to transform art away from mere crafts-manship, away from the celebration of manual skill in representing the human body, and toward a more intellectual conception of the human form. Such images encode not so much attempts to banish the human as they do efforts to establish a more trenchant understanding of what it means to be human in machine-age America.

The prevalence of sexual content in this seemingly cerebral machine-age art may seem contradictory, but, again, such content serves to underscore the persist-ence of human agency. While the aerographic gun and use of stencils allowed Man Ray to achieve the hard-edged mechanical feel of *Danger/Dancer*, such a technique also became a means of exploring the effect of the machine on human, and especially sexual, behavior. *Danger/Dancer* was inspired, according to Man Ray, "by the gyra-tions of a Spanish dancer I had seen in a musical play. The title was lettered into the composition: it could be read either DANCER or DANGER" (*Self-Portrait* 79). The

13. Man Ray, *Danger/Dancer* or *L'Impossibilité*, 1920. Airbrush on glass, 25 3/4 × 14 1/8. Copyright © 2003 Man Ray Trust/Artists Rights Society (ARS), New York/ADAGP, Paris.

work signifies both things: the swirling motion of the automaton-dancer, on the one hand, and the danger the dancer represented, on the other. But Man Ray gave the image an ironic twist—he interlocked the three gears, making any functional interaction or rotation an impossibility. As the mechanic who helped the artist assemble the gears pronounced, "Oh! you're crazy, these wheels won't work" (qtd. in Schwarz, *Man Ray* 214). To underscore the irony and ambiguity of the image, Man Ray gave the work an alternate title: *L'Impossibilité*.

Such a conflation of machine aesthetic and sexual content informs the art of Duchamp and Picabia, as well. In *Machine tournez vite* begun in 1916 (ill. 14), for example, Picabia identified cog No. 1 as "Femme" and No. 2 "Homme," the gears standing for robotic figures endeavoring highly mechanized sexual maneuvers. Unlike the complications and dangers implicit in Man Ray's *Danger/Dancer*, however, Picabia's freewheeling automata present uncomplicated meshings and meanings.

14. Francis Picabia, *Machine tournez vite (Machine Turn Quickly)*, 1916/18. Gouache and metallic paint, 19 1/2 × 12 7/8 in. National Gallery of Art, Washington, D. C. Patrons' Permanent Fund. Copyright © 2003 Artists Rights Society (ARS), New York/ADAGP, Paris.

Man Ray's work suggests a closer parallel to Duchamp's *Large Glass* of 1915–1923, on one level at least, also a metaphor for frustrated physical love. The implied sequential action of *Large Glass* is never completed, and the union between the mechanized bride above and the bachelors below becomes an impossibility.

The fact that Man Ray and Duchamp have both featured female automata in these works, which are characterized by sharp geared "teeth," is not without significance. Unlike the woman in Picabia's *Machine Tournez Vite*, who is already engaged in what seems an uncomplicated sexual coupling, the women in Man Ray's and Duchamp's works stand apart, as objects of both fear and desire for the male artist. It is the positioning of the gears in both *Danger/Dancer* and *Large Glass* that heightens the implicit threat of these images. In *Danger/Dancer*, the interlocked gears positioned below the large "torso" gear menacingly allude to the *vagina dentata*. Likewise, Duchamp's bride is equipped with a womb represented by a gear wheel.[9] The male observer (or groom) is thereby faced with a double threat: that of machine control, on the one hand, and of

the unspeakable dangers represented by the mechanized love-object, on the other. The creation of such female automata provided a new language with which to address both the hazards presented by the machine itself and by the newly empowered New Woman of the postwar years.

In these three works, we see the recognition of the machine as a new model of beauty and a new resource with which artists could engage social issues. Endowing machines with human qualities represents an exertion of power, even a sign of potency. The irony here is that while we may think we are extending our power over the material world, we may only be impoverishing our own experience and threatening our uniqueness. However, the metaphoric union of human and machine may also represent an attempt to counter that potential for impoverishment. Even though tinged with irony, Francis Picabia's statements in the press imply as much. In 1915 he proclaimed, "The machine has become more than a mere adjunct of human life. It is really part of human life—perhaps its very soul" (qtd. in Kuenzli, *New York Dada* 131).

The complex social negotiations of machine culture also manifest themselves in more performative contexts. In the spring of 1924, Count Étienne de Beaumont, a wealthy Parisian who supported the theater, held a benefit gala with an "automotive theme."[10] Man Ray memorialized two of the guests, Gerald and Sara Murphy, in a photograph in which Gerald appears as a mechanized man, an automaton. Murphy sports a jacket of tin armor equipped with what looks like a rearview mirror attached to his armored shoulder and a tin headdress to which a gyroscope and other objects were attached. The artist thus transformed himself into an automaton equipped to pilot the new high-speed automobiles of the day. By fashioning himself as an automaton, Murphy assumed the appearance of figures in paintings of the time, especially the metallic-looking soldiers painted by Fernand Léger during World War I. Through such a performative gesture, Murphy breathed life into Léger's robotic figures, endowing them with flesh and blood. Concurrent with Murphy's robotic impersonation, other European artists, especially those involved in the German Bauhaus and Russian Constructivism, were also experimenting with robotic movement in experimental theater. Like these artists, Murphy grappled with new realities by enacting the robotic future; however, because of the sense of agency in such a transformation of self, Murphy posits a machine-age future in which the human element endures. Given the artist's self-consciousness in constructing a life as an American in Paris, indeed, in constructing his life as art, this presentation of self can be seen as a significant artistic gesture. In assuming the role of robot in such a performance, Murphy thus personifies the reclamation of the human in the machine that also informs his paintings.

Because many of the automata discussed here are dehumanized, devoid of human expression and feeling, they may seem to present a bleak vision of a world controlled by the machine. Indeed, the artists' allusions to the threats posed by the new machine culture serve to challenge the sometimes misplaced priorities of a technological society. However, through their art-making practice, artists also exalt basic principles of mechanical construction and by extension machine technology itself. But whether this art embraces or critiques the prevailing technological ethos of the time

is only part of the picture. We need to recognize how the conflation of bodies and machines was part of an attempt to renegotiate the relationship between the human and the mechanical, to recover human agency. The artists' radical manipulation of bodies and machine elements can be considered itself a model of such agency.

The four artists of this study, Man Ray, Stuart Davis, Alexander Calder, and Gerald Murphy, among other modernists, appropriated principles of machine technology to construct works that implicitly defend human values, indeed, that find a human face in a force threatening to take control. American artists of the postwar years thus illustrate the multiple reconciliations that informed the technological-cultural nexus of the time. They also reveal the complex challenges involved not only in defining art, but also in configuring the body in the machine age.

# 2

## Stripped to the Core

*Man Ray's X-ray(ted) Automata*

By the early years of the twentieth century, a revolutionary change in the perception of the human body was well under way. Underlying this change was the sense that the body was no longer an impenetrable boundary. As Tim Armstrong has argued, modernism itself is "characterized by the desire to *intervene* in the body" (6). The author sees medical intervention as a primary impetus here and cites new and safer surgical and diagnostic techniques; for example, instead of using phrenology and other pseudomedical techniques to "read" interior states from exterior signs, "a barrage of devices," including the stethoscope, speculum, electricity, and X-rays, were developed to probe beyond the skin to the normally invisible interior of the body. Other disciplines, too, from behavioral psychology to literary and artistic expression exhibited a growing concern with the "nonperceptible." Remembering back to the prewar period, Gabrielle Buffet-Picabia noted "an ebullience of invention, of exploration, beyond the realm of the visible and the rational in every domain of the mind—science, psychology, imagination. . . . It would seem, moreover, that in every field, the principal direction of the 20th century was the attempt to capture the 'nonperceptible' " (258).

Modernist artists began to look beyond surface reality, opening up the body to new scrutiny and in doing so established new conventions for visualizing the human figure. The works that resulted raise questions regarding modernist engagement with new scientific modes of intervention, as well as with the occult, with n-dimensionality, and most notably with the male gaze and gender issues. An examination of Man Ray's rayographs serves to address these questions.

Shortly after settling in Paris in 1921, Man Ray developed, very much by chance, his rayographic process, which resulted in an array of white impressions on an otherwise black print—images that were sometimes bold and hard-edged, sometimes mysterious and strangely three-dimensional. In his autobiography, the artist recounted his discovery:

> **One sheet of photo paper got into the developing tray—a sheet unexposed . . . —and as I waited in vain a couple of minutes for an image to**

appear, regretting the waste of paper, I mechanically placed a small glass funnel, the graduate and the thermometer in the tray on the wetted paper. I turned on the light; before my eyes an image began to form, not quite a simple silhouette of the objects as in a straight photograph, but distorted and refracted by the glass more or less in contact with the paper and standing out against a black background, the part directly exposed to the light. . . . I made a few more prints, excitedly, enjoying myself immensely. (*Self-Portrait* 128–129)

This technique was not, of course, terribly original, as Man Ray himself acknowledged: "I remember when I was a boy, placing fern leaves in a printing frame with proof paper, exposing it to sunlight, and obtaining a white negative of the leaves. This was the same idea, but with an added three-dimensional quality and tone graduation" (*Self-Portrait* 129). Much earlier, in 1835, British photographer William Henry Fox Talbot had made photographs without a camera, which he called photogenic drawings. However, it was not until the years after World War I that a resurgence of interest in such a method occurred among artists. In Switzerland, Christian Schad began creating his Schadowgrams in 1918, and a few years later Hungarian artist Laszlo Moholy-Nagy "invented" his photograms. The revival of interest in this rather basic photographic process at this time has a corollary in another—not unrelated—fascination of the day: the X-ray.

In many of Man Ray's rayographs, light seems to outline objects as well as to reveal their interiors. The artist wanted to avoid simple silhouettes of objects, and so he typically moved both the light source and the objects while exposing them to light. The resulting white shadowy impressions take on a striking resemblance to the reductive images created by X-rays.[1] Particularly evocative of X-rays are those rayographs that feature figurative and/or anatomical elements. In *The Manikin* of 1923 (ill. 15), for instance, the artist employed a small wooden manikin as his rayographic model, adding what appear to be a cane and the bridge of a stringed instrument. The starkly simplified figure suggests an X-raylike process of penetrating beyond all details of clothing, facial features, and flesh to reveal the inner skeletal core of a human body (perhaps his own, since the title puns on "little Man").

The rayographs are also inextricably bound up in machine-age modes of art production; like collage, the technique involves a constructive procedure in assembling objects. Man Ray even titled one of his rayographs of 1923 *Monsieur . . . , Inventeur, Constructeur, 6 Seconds* (ill. 16), underscoring his identification with industrial fabrication. The artist constructed this rayograph by placing disparate objects—a notched collar and a strip of folded paper—on photographic paper. His powers of manipulation as artist-engineer are foregrounded here by the priapic semblance of the resulting image and also by the inclusion of his own hand in the process of positioning the parts. However, as Merry Foresta has observed, he also alters the form by scratching the negative to suggest two eyes (29). The rayograph thereby becomes a portrait of the artist as inventor/constructor. When recognized as such, the artist's

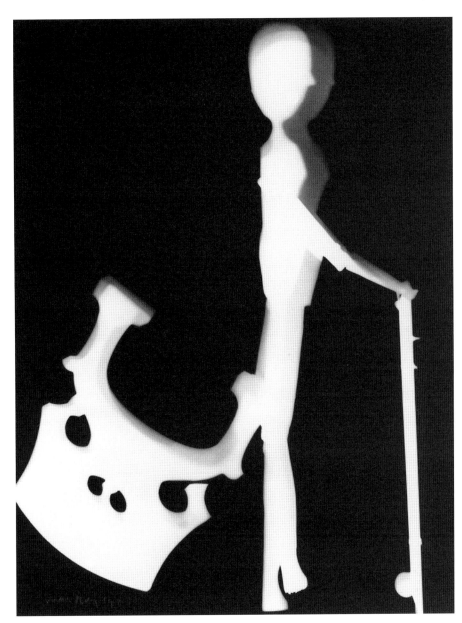

15. Man Ray, *The Manikin*, 1923. Rayograph, 9 3/8 × 7 1/8 in. Yale University Art Gallery, Gift of Collection Société Anonyme. Gift of the Artist, 1937. Copyright © 2003 Man Ray Trust/ Artists Rights Society (ARS), New York/ADAGP, Paris.

hand now seems to rest on the side of his face and lends a quality of thoughtfulness to the image. This equation of artist and inventor has the effect of foregrounding the intellect in the practice of art making.

Like Man Ray in his discovery of cameraless photography, physicist Wilhelm Conrad Röntgen discovered X-rays serendipitously. In the process of investigating the properties of cathode rays in 1895, Röntgen wrapped the cathode-ray tube (or Crookes tube) in opaque material. After turning on the electric current, he noticed a faint glow emitted by the cathode-ray tube on a screen lying nearby, which was coated with a fluorescent material then used to develop photographic plates. Since cathode rays—or any other known rays—could not explain this phenomenon, he knew that he had discovered an entirely new ray that could pass through opaque material. Röntgen

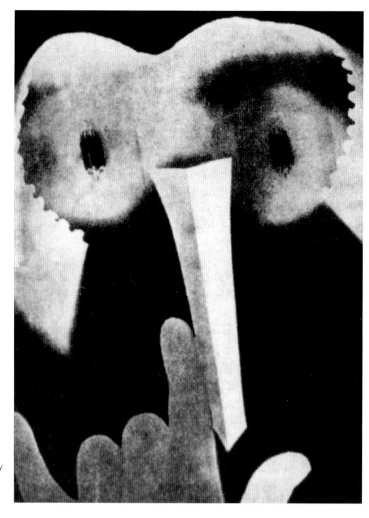

16. Man Ray, *Monsieur . . . , Inventeur,
Constructeur, 6 Seconds*, 1923.
Rayograph. Copyright © 2003 Man Ray
Trust/Artists Rights Society (ARS),
New York/ADAGP, Paris.

soon subjected parts of the body, first his own hand and then that of his wife, to this "new light." The Röntgens, as well as those who subsequently experienced X-rayed images firsthand, begin to comprehend their own bodies in a radically new way and to understand that their world had been irrevocably altered (Kevles 116).

X-ray technology captivated the scientific, artistic, and popular audience like no other breakthrough in the early years of this century; so intense was the response that it was called "X-ray mania." As Kevles pointed out, the announcement of this major discovery in physics was in the form of a "mathematics-free paper" and so was accessible to the general public—perhaps the last breakthrough in science that was (20). Especially for the public, this major scientific discovery validated the growing suspicion in all realms of discourse—scientific, artistic, and popular culture—that "surface" or perceptual reality was only one aspect of reality. A statement made in 1900 by the astronomer Camille Flammarion sheds light on the intensity of enthusiasm surrounding this major breakthrough:

> The late discovery of the Röntgen rays, so inconceivable and so strange in
> its origins, ought to convince us how very small is the field of our usual

observations. To see through opaque substances! to look inside a closed box! to see the bones of an arm, a leg, a body, through flesh and clothing! Such a discovery is, to say the least, quite contrary to everything we have been used to consider certainty. This is indeed a most eloquent example in favor of the axiom: it is unscientific to assert that realities are stopped by the limit of our knowledge and observation. (qtd. in Henderson, *Duchamp in Context* 6)

Those in the artistic avant-garde, too, were caught up in the excitement. In 1913, after viewing the Armory Show—and interviewing Francis Picabia—American critic Christian Brinton wrote:

There is no phase of activity or facet of nature which should be forbidden the creative artist. The X-ray may as legitimately claim his attention as the rainbow, and if he so desire [*sic*] he is equally entitled to renounce the static and devote his energies to the kinetoscope. . . . there is scant reason why those [discoveries] of von [*sic*] Röntgen or Edison along other lines should be ignored by Expressionists and Futurists. . . . The point is that they will add nothing [thereto] unless they keep alive that primal wonder and curiosity concerning the universe, both visible and invisible . . . which has proved the mainstay of art throughout successive centuries. (qtd. in Henderson, *Duchamp in Context* 14)

Such affiliation of artistic practice with a popularly acclaimed invention served to bring the artist into the sphere of excitement surrounding the invention of this new phenomenon, thereby validating the artist as a relevant force in a time of accelerated change. More important, of course, it opened up exciting possibilities for a new kind of visual art.

X-rays, typically applied to human anatomy, were invented just at the time that artists were beginning to investigate new modes of representing the human body. The Cubists, and especially Picasso and Braque, were the first artists to devise innovative visual codes with which to depict—really to see inside—the human body; in the process, the artists began to explore phenomena not perceptible through the senses in a manner evocative of X-rays. As Stephen Kern observed, "X-ray must have had something to do with the Cubist rendering of the interior of solid objects" (147). Especially in the paintings Picasso executed around 1910, for instance, *Girl with Mandolin*, the artist not only represents different perspectives of the girl's body (the top as well as the front of her shoulder, for example), but he also penetrates through the surface of her skin to reveal the inside surface of her facetted back. Furthermore, the planes fluctuate ambiguously, so that uncertainty results as to whether one sees an inside (concave) or an outside (convex) view of her upper arm—or both. The Cubist body is faceted so that the space around it penetrates into it and it into surrounding space. As if equipped with X-ray vision, the artist sees through the surface, through

the skin to a deeper reality. Critics tried to make sense of this new aesthetic of transparency by invoking the idea of the fourth dimension. As Maurice Raynal wrote in 1913: "Instead of painting objects as they *saw* them, they painted them as they *thought* them, and it is precisely this law that the Cubists have . . . codified under the name of 'The Fourth Dimension' " (129–130). Central to contemporary speculations regarding the fourth dimension was the notion that beings of a greater dimensionality could see inside bodies occupying lesser dimensions (Henderson, "Francis Picabia" 118). Picasso's cubist figures are thus conceived as if viewed from the fourth dimension.

Picking up on the Cubists' inventive language of transparency, the Italian Futurists proclaimed an extreme distrust in the "opacity of bodies" and openly embraced the influence of X-rays in their "Futurist Painting: Technical Manifesto" of 1910. Recognizing the potential of new technologies to extend sense perceptions, they proclaimed, "Who can still believe in the opacity of bodies, since our sharpened and multiplied sensitiveness has already penetrated the obscure manifestations of the medium? Why should we forget in our creations the doubled power of our sight, capable of giving results analogous to those of the X-rays" (rpt. in Taylor 126). In works such as *Woman on a Balcony*, for instance, Carlo Carrà achieved an effect of simultaneity as the woman's image fragments into translucent planes, through which the balcony itself, along with city forms beyond, can be seen. The Futurists sought not so much to represent the look of X-rays as to exploit the aesthetic of transparency to render new sensations of twentieth-century life, sensations resulting from the proliferation of new forms of transportation, factory production, and power—all of which competed for attention in the new urbanized landscape.

The Dadaists' appropriation of X-rays was more unorthodox and their commentary on the interchange between new forces of science and the human body and psyche consequently more incisive than that of either the Cubists or the Futurists. Not surprisingly, then, the discourse surrounding Dada tends to focus even more strongly on the human body and the realm of figurative representation. Like the Cubists and Futurists, Dada artists effected a confounding of the boundaries between the exterior and the interior; however, the Dadaists extended this polarity to include a radical dissolution of the distinctions between the public and the private.

In the years just prior to World War I, Marcel Duchamp began a process derived from X-rays, that of "stripping" his figures to reveal their structural core. In *Nude Descending the Staircase* of 1912, for instance, the artist dissected the figure to reveal the dynamics of movement. As he wrote, "There is no flesh, only a simplified anatomy. . . . Reduce, reduce, reduce was my thought" (qtd. in Sweeney, "Interview" 20). In this he was inspired by experiments in chronophotography, particularly those of French physiologist Étienne-Jules Marey, who developed a means of taking multiple, overlapping photographs so as to dissect movement. Because chronophotographs typically feature white images on a black background, Marey's images have a striking similarity to X-ray photos. In appropriating Marey's experiments, however, Duchamp did not attempt to replicate the overall appearance of X-ray (or Marey's) images; rather, as Henderson observed, he devised a "painterly equivalent to the

transparent and fluid reality suggested by x rays" ("X Rays" 336). What he sought was a reductive image analogous to an X-ray image but more mechanical in feel. While allusions to the visual properties of X-ray images of the human body (for instance, repeated representations of the pelvic cavity) are apparent in *Nude Descending the Staircase*, the movement itself is suggested by a quick succession of transparent yet rather metallic-looking planes. By mechanizing the nude in this manner, Duchamp not only exploits the novelty of the X-ray image but achieves a multileveled social commentary on the depersonalizing power of machines.

Duchamp's impulse to "reduce, reduce, reduce" his subject—which happens to be a female nude—provides a further clue to his commentary. What he has done is to describe the nude—a highly revered artistic convention—as an interconnected panoply of planes and pelvic bones, reducing her to the status of a machine. At the same time, however, he adds a note of mystery and ritual. While defining the image with all the finesse of the best Cubist painter, Duchamp also accentuates the gold color in order to evoke a more ritualistic aura, a sign of the artist's fascination with the pseudoscience of alchemy. Speculation about the seemingly unlimited potential of X-rays revived what Nancy Knight has called "old alchemical dreams," dreams of transmuting base metals into gold. Alchemists had high hopes that these newly discovered rays would finally make such transmutation possible (21).[2] Duchamp seems to have adopted this updated view of alchemy, alluding as he does to X-rays, alchemy, and robotics—and generating ambiguity in the process. In the end, it remains unclear whether we are to revere this ritualized bride or to fear her as a mechanical aberration; whether the "stripping" of the nude eroticizes or de-eroticizes her; whether her mechanization enhances or deflates her power.

Francis Picabia tends to be more straightforward in appropriating this newly discovered phenomenon. In his earliest "object portrait," a drawing entitled *Mechanical Expression Seen through Our Own Mechanical Expression* of 1913, Picabia represents Stacia Napierkowska, an exotic dancer he had met on the ship en route to New York, as an actual machine: a Crookes tube modified so as to emit X-rays.[3] In portraying Napierkowska as a schematized X-ray tube from which sparks fly, the artist lays bare Napierkowska's sexual vitality as revealed in her uninhibited dancing. At the time, her dancing was considered exceedingly lewd, so much so that she was eventually deported (Bohn, "Picabia's" 676). Like the voyeuristic gaze of the dancer's audience, looking at X-rays of the interior of another person's body was considered extremely indecent; indeed, from the beginning X-rays were associated with sexuality. For instance, in 1896 one writer in London reported on "the revolting indecency" of X-rays' ability to penetrate beyond the skin and suggested that "the best thing would be for all civilized nations to combine to burn all works on the Röntgen rays, to execute all the discoverers, and to corner all the tungstate in the world and whelm it in the middle of the ocean. Let the fish contemplate each other's bones if they like, but not us" (qtd. in Kevles 116). Not surprisingly, cartoons proliferated that played on the capability of X-rays to penetrate through both clothing and flesh. In likening Napierkowska to X-ray apparatus, Picabia lampoons the public's prurient

scrutiny of the dancer, which was as intense and penetrating as that of X-rays. Typically, Picabia used the machine, here the equipment used to produce X-rays, not so much to expound on the technology itself but instead to mock human behavior.

In the art of Man Ray, we find a more extended discourse on X-ray technology. Of all the art produced by the New York Dadaists, only Man Ray's mimicked the look of X-ray plates. This may well be a function of his increasing attachment to photography in the postwar years; indeed, his interest in painting declined abruptly as he began experimenting with photographic processes. As he wrote in a letter to his patron Ferdinand Howald in 1922, "You may regret to hear it but I have freed myself from the sticky medium of paint, and am working directly with light itself" (qtd. in Turner, *American Artists* 124). With his preference for a medium often considered nonartistic, Man Ray was very likely more receptive than many artists of the time to the idea of translating the look of nonartistic scientific discoveries like X-rays into his art.

A question particularly germane to Dadaist discourse inevitably arises regarding the use of X-rays as source material. In light of the significance for Dada of the ready-made (the substitution of the real thing for the painted version of reality), why didn't Dada artists use actual X-ray photographs? After all, by the time Man Ray stumbled upon rayography, X-ray images were no longer photographic novelties. By the 1920s, in large part as a result of their widespread use during World War I, a considerable number of people had either been X-rayed themselves or knew someone who had been. Furthermore, X-ray photography was a topic of lively discussion among photographers at the time. Why, then, wouldn't artists have appropriated actual X-ray images for their art? For one thing, X-ray photos were still quite costly and not easy for nonphysicians to get their hands on (Kevles 120). Furthermore, by simulating the look of X-rays rather than appropriating actual X-rays, artists maintained control over process, over the manipulation of their images, thereby maintaining a greater freedom—while also maintaining their health. As noted by Knight, "the danger of burns and the possibility of induced carcinoma were well established [by] 1903–04" (22).

Man Ray's new rayographic technique provided a way of conceiving of the human body as a stripped down automaton, as seen in *The Manikin*. What appears on the photographic paper is a shadowy figure stripped of clothes, even of skin. Man Ray has used light to reveal the mechanical core of the human physique. As in X-rays, all features—all distinguishing characteristics—are erased, and what is left is an anonymous automaton. This automaton is not, however, static; the artist infuses it with "life" by implying movement. The robotic image in *The Manikin*, for instance, seems to shift positions by virtue of the repeated shadowy profile. Such repetition combined with the stripped-down white figure summons to mind the chronophotographic experiments of Étienne-Jules Marey. Where Duchamp transforms Marey's moving images into painted images of repeating planes and dotted arcs, Man Ray's manipulations of objects on the photographic plate allude more directly to Marey's experiments.

In the 1880s, Marey had a special background constructed, a kind of open shed, the back wall of which he covered with black velvet to cut down on reflective

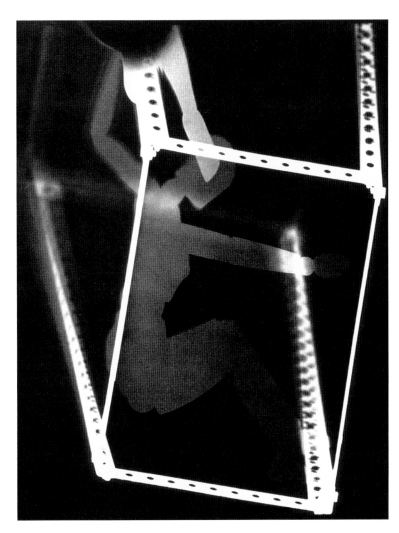

17. Man Ray, *Rayograph (wooden figure)*, 1925. Rayograph. Copyright © 2003 Man Ray Trust/Artists Rights Society (ARS), New York/ADAGP, Paris.

light and in front of which he posed his models dressed in white. Another method he used, one more evocative of X-ray imagery, was to clothe his subjects all in black, marking their joints with "shiny buttons" and linking them with "metal bands." Since Marey's goal, according to Marta Braun, "was to remove the imprint of flesh and skin so as to reveal the moving parts of the animate machine—the joints, levers, and fulcrums, the rods and pistons of the human body—he concocted a moving skeleton, denuding the body of its flesh and volume" (75, 81). For Marey, such a stripped-down image was a means of isolating and analyzing movement and ultimately of making visible the fundamental dynamics of the human figure, thus imparting a truth that lay behind surface appearances.

Such a drive to penetrate beyond physical barriers also informs other of Man Ray's figurative rayographs for which he employed the same wooden manikin as model. *Rayograph (wooden figure)* of 1925 (ill. 17), for instance, pictures the wooden automaton whose legs and arms seem to be attached to the miniature steel girders of what looks very much like an Erector Set. With its girders, bolts, pulleys, and motors, the Erector Set, patented in 1913, was marketed as a "Structural

Steel & Electro-Mechanical Builder" that promised to be "Educational, Instructive and Amusing" (O'Brien 81). Erector Sets were designed to initiate young boys in the principles of engineering and construction. As such, the Erector Set revealed the core construction, or skeleton, of a building, just as X-rays expose the bones and the basic structure of a human body. In contrast to the figure in *The Manikin*, this automaton recedes into the shadows, while the "limbs" of the Erector Set, with its bolted joints, are starkly silhouetted. The wooden automaton seems superseded—and controlled—by a steel construction, by something stronger, larger, and more important than himself. Furthermore, the girders seem almost to signify the mechanics of the manikin, as if the inner workings have been externalized and made visible by an X-ray-like process.

This idea of exposing the inner mechanics of the body is more explicitly stated in other rayographs such as *Rayograph (shoe tree)* of 1923, in which a shadowy shoe tree becomes a kind of stand-in for an X-rayed foot. Instead of the living bones of an X-ray, however, Man Ray peels off skin, muscle, and flesh to reveal mechanical simulations of human anatomy—nuts and bolts and adjustable rods. Such intrusion of the mechanical into the realm of the biological suggests a perspective on the role of the machine in modern life not unlike Duchamp's. Once again we sense in this body/machine nexus the potential for changing existence for the better (after all, the human body might gain strength and durability if it had a mechanical substructure) as well as for the worse (implicitly stated is fear of machine control).

These questions are complicated, however, by the fact that the shadowy images of the rayographs, like those of X-rays, evoke a sense of mystery as much as they do a machine aesthetic. The discourse of machine-age art, which posits a kind of competition between the human and technological realms, is tempered by the recognition of another, fundamentally more mystical, realm of experience. Keep in mind that the outcome of the rayographic process was in part determined by chance; that is, Man Ray could not predict precisely the final configurations of his prints. In large part, chance functioned for the Dadaists as a way to achieve freedom from rationality, logic, and order. This disengagement from the world of rational thinking was undertaken so that we might, in the words of Hans Richter, "listen to the voice of the 'Unknown'" (50). The role of chance in such a process was to uncover secrets analogous to those unveiled by X-rays. The attraction of the X-ray for avant-garde artists, then, was not entirely unconnected from the appeal of this new technology for occultists and spiritualists. Indeed, occultists at the turn of the century wholeheartedly embraced the discovery of X-rays as "a scientific confirmation of clairvoyant vision" (Henderson, "Francis Picabia" 118).

The mystical reverberations of Man Ray's shadow-bound rayographs also relate to a trend in art of the late nineteenth century, that of the transformation in thinking regarding shadows themselves. The goal of Symbolist artists and writers, in particular, was to explore immaterial aspects of being. Nancy Forgione has shown how this aspiration led to a "valorization of the shadow," especially in the form of the silhouette, as a means of making internal truths visible. As she put it, "the widespread

thematization of shadow . . . implied a new aim—to impart the truth behind appearances." In drawings by Seurat, posters by Bonnard, and paintings by Gauguin; in experimental theater and shadow puppet plays; in the chronophotographic experiments of Muybridge and Marey, as well as in X-ray prints, "shadow and silhouette offered a means to make visible the artist's apprehension of the internal" (Forgione 508). For Man Ray, such a recognition of inner forces was less a conscious identification with the spiritualists (at least, there is no evidence in his writings to suggest this) than it was a valorization of "the internal," the unknown. As Man Ray proclaimed, "the shadow is as important as the real thing" (qtd. in Schwarz, *Man Ray* 234). The shadow is bound up in a Dada strategy to undermine technological and scientific positivism, the belief that through perception and rational thought processes the mechanics of the world can be known.

From the time X-rays were invented, there was much speculation about their potential in revealing the workings not only of the body but also of the human brain. Thomas Edison, for one, predicted that X-rays would be able to penetrate the human skull to image the brain and thereby unlock its secrets. "Thought photography," as it was called, was a hot topic for scientists as well as for occultists who believed that X-rays might give them the power to record thoughts or dreams as "psychic emanations." Interestingly, the mysterious nature of X-rays compelled many members of the scientific community to believe in spiritualism. As Henderson noted, the distinction between pure science and occultism was not nearly as clear as it is today. For instance, even Sir William Crookes (1832–1919), the British physicist who perfected the Crookes tube designed to study cathode and X-rays, got involved in psychical research and spiritualism as a result of the discovery (Henderson, *Duchamp in Context* 11, 40–43).

From the beginning, too, cartoonists amused themselves by drawing objects inside the outlines of their subjects' heads that best characterized their personalities. For instance, in 1896 one cartoonist caricatured several well-known personalities under the title *Some Interiors*, including a senator with an electric fan as the sole contents of his brain and another man with a whiskey barrel for a brain. Below the cartoon was written, "By Prof. Röntgen's process we shall soon be able to verify the above surmises as to the contents of certain bodies" (ill. in Henderson, *Duchamp in Context* 11). The human brain itself, however, remained impenetrable until the 1920s, by which time more sophisticated X-ray equipment had been developed that could capture better images of gray matter.[4]

Since the machine was the central metaphor for mental activity during this era, the brain naturally took on machine attributes—interconnected gears, springs, and rods. Furthermore, mental activity was metaphorically characterized as "wheels going around" much as in a clock (Tichi xi). Not surprisingly, artists devised metaphorical visualizations of brain activity, and in this context, Man Ray's *Clock Wheels* of 1925 (ill. 18) becomes an analogue for the working of the human brain. However, Man Ray has turned this metaphor on its head in a typical Dada subversion. While the rayographic gears of *Clock Wheels* seem capable of spinning around, the component parts

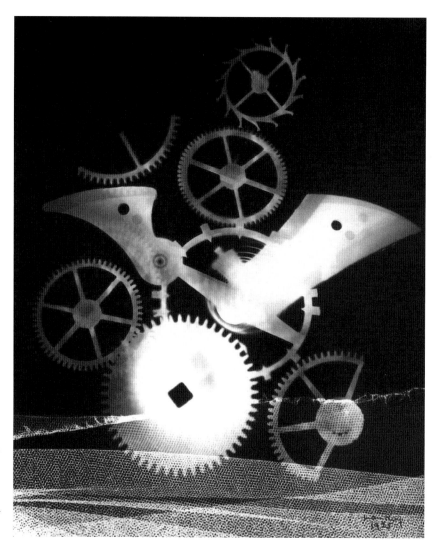

18. Man Ray, *Clock Wheels*, 1925. Rayograph, 11 1/8 × 9 in. Yale University Art Gallery. Gift of Collection Société Anonyme. Copyright © 2003 Man Ray Trust/Artists Rights Society (ARS), New York/ ADAGP, Paris.

ultimately fail to connect, giving the lie to the precision engineering of a real clock—or the complex machinations of a real brain. With mock seriousness, Man Ray has probed the recesses of the human brain only to reveal an illogical, malfunctioning machine. Perhaps this was his way of countering rational thinking, in particular, the prevailing belief that if the brain was indeed clocklike, it could then be decoded. Through this rayographic image, Man Ray subverts this paradigm by attesting to the ultimate impenetrability of the secrets of the brain, either by scientific or by spiritualist use of the X-ray. *Clock Wheels* thus affirms the mystery of the brain; in spite of attempts to wrest its secrets via X-rays and telepathy, its intricate workings ultimately remain beyond comprehension.

Man Ray's portrait photography, too, explores this conceptual domain. In a photograph from about 1920, *Marcel Duchamp with "Large Glass"* (ill. 19), the subject's face has faded into the background; on this shadowy image the artist has superimposed the stark white silhouette of Duchamp's *Water Mill*, a work in oil and lead wire on glass of 1913–1915, later incorporated into *Large Glass*. The human subject

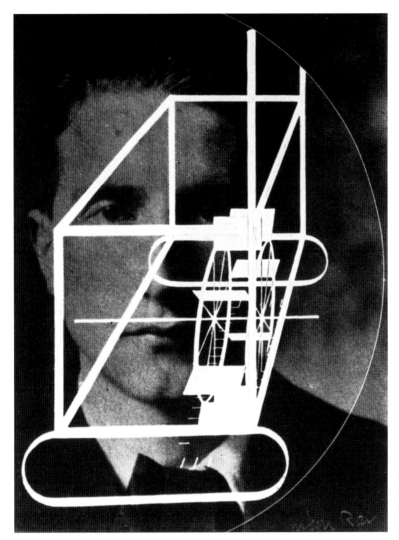

19. Man Ray, *Marcel Duchamp with "Large Glass"*, ca. 1920. Photograph. Copyright © 2003 Man Ray Trust/Artists Rights Society (ARS), New York/ ADAGP, Paris.

is thereby superseded by his mechanical creation. As in Duchamp's *Portrait of Chess Players* of 1911, in which chess pieces are liberated from the board to float between the two players' heads, Man Ray has prioritized thought process over likeness by fore-grounding a study for the *Large Glass*, Duchamp's principal philosophical and artistic preoccupation during his New York years.

X-rays were, of course, more commonly used not to explore mental activity but rather to examine bodily functions below the neck. Indeed, the ability of X-rays to expose not just skeletal structure but also internal organs aroused great interest both in the medical profession and in art circles at the time. Soon after the discovery of X-rays, researchers began experimenting with coating internal organs and passageways with substances such as barium or bismuth which were impervious to X-rays, making internal organs visible on X-ray prints (Cartwright 131–132). The early uses of X-rays show that the organs examined most frequently were those of women and that, as Kevles pointed out, the "unveiling" was done largely by men (118–119). This kind of "visual deflowering" extends into the realm of art—and raises some intriguing gender

issues. In art as in medicine, it was largely men who adopted what Cartwright has called "the perverse spectatorial pleasure of X-ray researchers" (108). And the internal organs examined belonged primarily to women. Duchamp led the way in such artistic unveiling with his *The Bride* of 1912. The subject here consists of a network of seemingly well-oiled tubes, gears, rods, and bulbous beakers—all interlinked to suggest a sequence of biomechanical events. By displaying a woman's internal organs as a kind of chemistry experiment, Duchamp effectively depersonalizes the female body. Similarly, in *Passage from Virgin to Bride*, also of 1912, and even more so in the *Large Glass*, the artist effected a transmutation of the sex act, exposing sex itself as a mechanical ritual rather than a strictly romantic one. The ritual also involves the X-raylike process of subjecting the most private parts of the female anatomy to the scrutiny of the male gaze.

Man Ray, too, suggests an invasive gaze in his famous *Le Violon d'Ingres*, a photocollage of 1924 that represents his model Kiki, turbaned and posed like the harem woman in Ingres's *The Turkish Bath*. The artist has superimposed the decorative shapes of sound holes (like those of stringed instruments) onto his model's bare back. By suggesting a piercing of the human torso in this manner, Man Ray hints at this new capacity to see into the female body. Some of the artist's rayographs also seem to extend the voyeuristic male gaze into the body itself. In one untitled work of 1922, for instance, a drill seems to penetrate the contour of a light bulb alluding to the mechanics of sex. As in Duchamp, we sense a pronounced ambiguity in this intrusion of the mechanical—and of the male gaze—into the realm of female sexuality.

Is such use of the female anatomy by male artists simply a sign of their prurient desires and a transgression of the limits of propriety? Or could it be an attempt to understand "female mysteries"? If the latter, is this attempt sympathetic, or is its goal an exertion of control over the opposite sex? Although, in Dada fashion, these questions remain unresolved, such a positing of female organs in the form of machines—things that are man-made and therefore (presumably) under the control of their makers—effectively removes the mystery, as well as eliminating the potential threat, of female power. As in X-rays, such art had the effect of demystifying the private by making public what had been of utmost intimacy. Such a strategy may have served male artists' need to reassert control over the opposite sex at this time of changing gender relations.

The X-ray image was viewed not only as indecent and invasive of one's privacy but also as a sign of death. Skeletal remains have, of course, always contained reverberations of death. And the fact that X-rays came into widespread use during World War I exacerbated such reverberations. Wartime X-rays made visible not skeletal "remains" exactly but bones that were still alive but shattered or punctured. Since X-rays were used on the war wounded, they necessarily addressed the impact of human suffering and loss caused by that event. The prevalence of, indeed, the obsession with the shadow among the New York Dadaists necessarily alludes, not only to concern with the unknown in the sense discussed earlier but also to the terrible death toll and the void left by those who died in that conflict. Both Man Ray and Duchamp made works that included not objects themselves but shadows of objects: for example,

Duchamp's *Tu m'* of 1918 includes both painted and real shadows of ready-mades, and Man Ray's rayographs depend on the removal, the absence of objects for their imagery. Amelia Jones sees this absence in terms of a crisis in masculinity brought about by the war and especially by the artists' noncombatant status. As she wrote, for artists such as Man Ray and Duchamp, the shadow was a means of referencing "some kind of melancholic trace linked to their equivocal position (as 'shadows' of properly masculine soldiers) relative to an increasingly war-obsessed culture" (181). The shadow is, however, more conclusively linked to the void of death. Though Jones foregrounds its implications regarding "the tenuousness of masculinity," she rightly acknowledges that ultimately the shadow marks a fascination with "the fragility and transience of corporeality" and a "fascination with death" (183–185).

In this context, the use of skeletal imagery as a pedagogical tool in the medical profession provides an interesting parallel to artistic practice. By the 1920s, for instance, a certain kind of X-ray image was created specifically for teaching anatomy to medical students. Using a cyanotype process, more familiarly employed to make blueprints, images were made of thin slices of cadavers. Such a cyanotype, *Cross Section of Human Body*, created by an unknown artist in the 1920s, is in the collection of the Metropolitan Museum of Art. This unusual print simultaneously maps both the body's hard (bone) and soft (organ) tissues. The wall label in the museum speculates that "this photograph was probably made from a thin, perhaps frozen human cross section." X-rayed and then printed as blue cyanotypes, these extremely thin body sections "reveal the various structures of bone, muscle, sinew, and organs at a precise vertical plane through the body." The bones—the pelvis and vertebrae—appear as black shapes, while the organs are blue and more blurred and thus harder to identify. Presented in an art museum, such images assume other meanings more in keeping with that of rayographic imagery produced at the same time; indeed, these two modes of representing the human body attest to the fascination with X-rays and their capacity for revealing mysteries of life and of death. According to texts written for an exhibition at the Yale University Art Gallery in which such cyanotypes were also displayed, "Death is everywhere in these works, and we are stunned by its seductiveness" (Sherman and Lister n. pag.).

The "seductiveness" of such images suggests, too, how X-rays became the site of distinctly fetishistic obsessions. By fixating on signs both of death (skeletal structure) and of life (organs) within bodies, X-rays tend to eroticize the targets of their gaze. As Cartwright notes, perhaps the most famous example of the literary employment of X-ray as fetish object, or "skeletal erotics," as she calls it, is Thomas Mann's *The Magic Mountain* of 1927, in which the main character becomes sexually aroused while looking at X-ray images of his beloved's body (123–125). Such fetishism also informs the paintings of Duchamp, the photographic experiments of Man Ray, and even the pedagogical cyanotypes discussed above.

While X-rays may have created images that satisfied fetishistic and/or controlling propensities of male observers, their invention also proved to be liberating for women in the early years of the century. For one thing, women found in X-ray

imagery evidence of the harmful effects of corseting. "Those who needed evidence found that the X-ray images supported their demands to free themselves from the unhealthy constraints of corsets," wrote Kevles. "Ardent feminists saw the rays as dissolving the barriers of all obstructing clothing" (121). The New Woman's liberation from the constraints of the Victorian era manifested itself most explicitly, if superficially, in the styles of women's clothing. Instead of the outmoded curvaceous norms made possible by corsets and petticoats, new fashions favored "stripped-down" designs featuring straight lines, short hemlines, and sleeveless tops. The new designs allowed unprecedented freedom of movement and also minimized gender distinctions. In regard to this move toward androgyny, Cartwright sees the X-ray as a metaphorical site of major importance. "The X-rayed body, stripped of its overinscribed gender- and race-encoded epidermis and organs, is an apt figure . . . for utopian fantasies of a social order no longer predicated on typologies of the organic body" (107). Such a transgressive dissolution of sexual identity seen both in X-rays and in fashion thus became a call for equality of the sexes.

Georgia O'Keeffe, an artist who thrived in the era of the New Woman, entered this dialogue by appropriating the invasive male gaze of X-ray technology for her own purposes. O'Keeffe's flower paintings, such as *Black Iris* of 1926 or *Jack-in-the-Pulpit No. IV* of 1930 (ill. 27), feature what can be seen as genital imagery couched in the language of nature or still-life painting. While her male contemporaries tended to expose the female interior via mechanical imagery, O'Keeffe did so via organic imagery. As Anna Chave has written, "The parts of the body she engaged were mainly invisible (and unrepresented) due to their interiority, but she offered viewers an ever-expanding catalogue of visual metaphors for those areas, and for the experience of space and penetrability generally" (119). While "the men," as O'Keeffe called her male comrades, depicted sexual processes quite overtly (even if framed in mechanical terms), O'Keeffe intended a more covert body language. Because her flowers were ostensibly magnifications of still-life subjects, a denial of sexual allusions could seem plausible. And O'Keeffe did at times insist on a reading of the images as miracles not of the body but of nature. However, she also expressed a "desire to make the unknown—known" and to be "magnificently vulgar" (qtd. in Chave 118). Our view of O'Keeffe is enhanced when her paintings of flowers are viewed in the context of the X-ray's capacity to expose the internal, to bring the private into the realm of public display.

Traditional paintings and photographs of the female nude had maintained a sense of mystery, both because women's genitals are internal and because the artist's gaze surveyed only the body's external attributes. But X-rays made possible a remarkably invasive gaze. What O'Keeffe has done, then, is to surreptitiously reclaim this penetrating gaze for her own purposes. Once seen in this context, O'Keeffe's paintings assume a considerably more radical stance than the renditions of sexual organs and processes couched in machine terms offered up by male artists. In appropriating the ability of the X-ray to probe the recesses of the female body, artists such as Picabia, Man Ray, and Duchamp are complicit in the subjugation of women's bodies.

At least in part, this may help to explain O'Keeffe's radical reclamation of the female anatomy by exposing it in a more organic way. Hers was a defensive or protective response to machine art in general as well as to the invasive gaze of X-rays themselves. Perhaps, then, we can see the obsession with reducing women to their organs in science and with mechanizing those organs in art as signs not only of the threat that newly empowered women posed to men but also of the threat that men posed to women in these years of social upheaval.

Yet all of these artists participated in the great excitement of the discovery of a new perceptual apparatus. X-rays were seen at the time as unleashing a new and mysterious force of nature. This new force allowed avant-garde artists to speculate on a radically changed world. With their shadowy images, Man Ray's rayographs in particular elicit a sense of mystery akin to the enigmatic powers evoked by X-rays themselves. Like the technology of X-ray emission, the process of creating rayographs was also mysterious—in some measure determined by chance and therefore revealing secrets for the artist analogous to the secrets unveiled by X-rays. Such experimentation also cuts to the heart of larger issues of the day, including the catastrophic loss of life in world war as well as the ways in which new perceptions of the body, gender, and cultural identity interact with scientific knowledge.

## Postscript

The fact that artists in more recent years have continued to engage X-ray technology in their work attests to the enduring fascination with the expressive potential of this invention. William Wegman's photograph *Fay Ray X-Ray* of 1993 (ill. 20) chronicles a postmodern dialogue with earlier art and ideas.

The photograph features Wegman's weimaraner Fay Ray, famous for her appearance in the hundreds the artist's humorous photographs. Here the dog stands before a portable X-ray machine so that the viewer sees a rectangular section of her skeletal structure. Given the work's dialogue with earlier photography, it is worth mentioning that Fay Ray is the female successor to the artist's most famous canine model, Man Ray. The invasiveness of this gaze into Fay Ray's middle section is intensified by virtue of the fact that the rest of her body—head, legs, and rear end—appears in the photograph as flesh (or fur) and blood. This strategy of combining an X-ray with body imagery brings to mind contemporary advertising campaigns. For instance, a recent advertisement for Total cereal (ill. 21) featured an X-ray image of a woman's body from shoulders to calves sandwiched between photographic images of her smiling face and stylishly shod feet, the implication being, of course, that eating this particular brand of cereal would keep a woman's bones nice and strong: "There are 206 solid reasons you need calcium . . . One bowl, one great source of calcium" (General Mills ad in *Health* 45). The advertisement, with the model's hands placed confidently on jauntily tilted hips (or pelvic bones), also wittily interjects the tacit skeletal erotics of such X-rays. *Fay Ray X-Ray* may also elicit an erotic effect, at least from a dog's

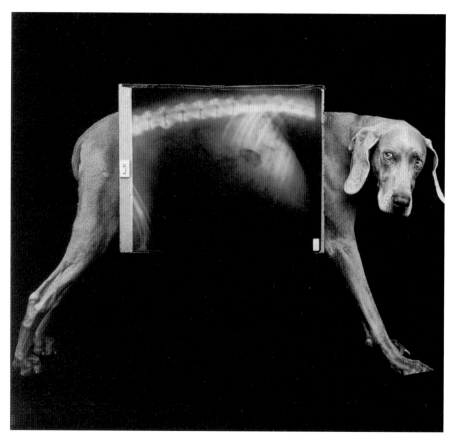

20. William Wegman,
*Fay Ray X-Ray*,
1993. Color
polaroid, 24 × 20 in.
Copyright
© William Wegman.

point of view. In any case, Wegman's is a witty commentary on the dialogue that Man Ray first established with X-rays seventy years earlier.

Gender issues are also foregrounded in Barbara Kruger's untitled photograph of 1982 that features the words "Memory is your image of perfection" superimposed over a full-body X-ray of a woman. Her identity as female is indicated by the high heels and jewelry she wears, which are opaque enough to show up on the X-ray plate. The appearance of jewelry particularly is a throwback to the early years of X-ray technology, when the process of being X-rayed was all the rage. Especially for women, it was considered the height of fashionability, and many subjected their hands—jewelry and all—to the rays and gave the resulting images as gifts to loved ones (Cartwright 115). More directly, however, Kruger's commentary engages contemporary gender issues having to do with the image of "perfection" proffered by advertising, that is, an exceedingly thin body. She also invokes the subjectivity of memory in creating a perfected image of self. Kruger's work is then a commentary on the internalization of the image of perfection. While the Total ad comments on contemporary society's concern with ingesting enough calcium to avoid osteoporosis, Kruger's image invokes another gendered medical condition, that of anorexia. Allusions to death, always present in skeletal imagery, are particularly resonant in this image because of the charged relationship between word and image, pointing as it does to the dangerous consequences of such skeletal ideals of perfection.

21. General Mills, Inc. Advertisement for Total Cereal in *Health* (July/August 1998): 45.

Even though more sophisticated techniques for medical imaging such as ultra-sound and magnetic resonance imaging (MRI) have been invented, X-ray technology itself has not been rendered obsolete; it still plays an important role in medical imaging of the body. And the intrigue and mystery of X-ray images continue to captivate artists as a way of addressing the larger issues regarding the role of machine technology in our culture.

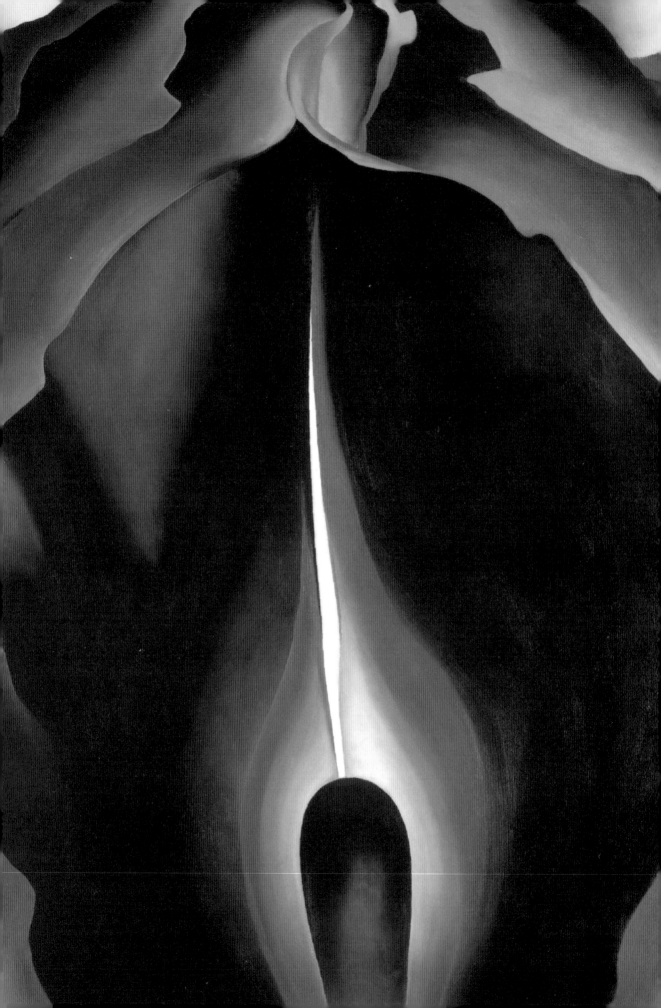

Part Two

# STILL LIFE

# 3

# The Gendering of Still Life in the Machine Age

Critics have recently positioned the genre of still life at the "cutting edge of modernism" and have argued that it is a "paradigm of modernism" (Stevenson 83). Such declarations announce the rehabilitation of a genre that has been much maligned in the last several centuries. Traditionally designated as the lowliest of genres, still life was at the bottom of a hierarchy first established by the French Academy in the seventeenth century. To some extent, such prejudices persist: Norman Bryson sees it as "the least theorised of the genres, . . . still marginalised in today's professional art history" (8, 10). In part, this low esteem may well be a holdover from the prevalent notion of still life as a kind of feminized or dilettantish endeavor. However, in the last decades increasing attention in articles, books, and especially exhibitions has been accorded to still life and its central role in the modernist enterprise.[1] An examination of the American avant-garde's employment of this overlooked genre sheds light on the process by which a historically feminized mode of art-making was masculinized; how a denigrated genre was recast as the "paradigm of modernism"; and how still life became a major vehicle for addressing larger social issues in postwar America, gender issues and the rise of Taylorism especially, but also changes in American identity and understanding of culture.

The American avant-garde produced still lifes typically characterized by highly abstracted geometric forms meticulously placed for greatest economy of design. Such attributes suggest an art-making process analogous to industrial fabrication. The modernist still life was informed by the same forces that shaped Taylorism, the rage for efficiency that reached its peak of influence in the years following the Great War. The reconceptualization of still life at this particular moment was, in fact, part of the fallout of the war. The war had created a sense of impending disorder and inefficiency, and American response was an aggressive reassertion of order, efficiency, and pride in technological prowess.

However, World War I also marked for many the bankruptcy of rational systems of belief; this was especially the case for the New York Dadaists, who preferred cynicism

and irony to anything the "rational" world had to offer. Although they appropriated a Taylorized language of precise design, these artists used this language to pit their art against the ordering impulses of times, deconstructing Taylorist thinking by painting still lifes that turn such thinking on its head. This chapter will investigate how the American avant-garde used this time-honored genre both to uphold and to critique the underlying principles of scientific management, both endorsing and, in Dada fashion, undermining the dominant ordering impulse of the machine age.

Most significantly, however, American modernists, whether constructing or deconstructing the new Taylorized still life, effected a radical expansion of the language and the content of still-life painting. Once confined to the depiction of familiar domestic objects such as flowers, books, and kitchen items, still life in the modern era was radically expanded and opened up to admit a wider range of objects, experiences, and societal references. And such an expansion of materials and cultural references goes a long way in explaining the centrality of the genre to the modern enterprise.

Discussion of specific examples should illuminate how and why the most adventurous American modernists—artists as diverse as Morton Schamberg, Man Ray, Georgia O'Keeffe, Gerald Murphy, and Stuart Davis—formulated a modernism thoroughly grounded in the genre of still life. On the surface, these artists' perception of this genre was anything but revolutionary. They adopted the traditional definition of *nature morte*, as the French termed it, as a composition of inanimate objects chosen and arranged by the artist; however, they recognized that, given the infinite possibilities implicit in such a definition, still life could be anything the artist wanted it to be. And this sense of control and freedom goes a long way in explaining why still life took center stage in the modernists' redefinition of art. Take, for instance, the *Egg Beater* series that Stuart Davis embarked upon in 1927 (ill. 22). In his words, "I nailed an electric fan, a rubber glove and an eggbeater to a table and used it as my exclusive subject matter for a year" (qtd. in Sims 188). The resulting drawings and paintings are not what is customarily expected from still-life painting; instead of presenting clearly identifiable three-dimensional objects on a tabletop, Davis has flattened the forms almost beyond recognition, retaining only cryptic signs and schematized contours of the named objects—eggbeater, glove, fan, and table. Consequently, more often than not, these works have been read as abstractions. The valuation of abstraction in the modern period has tended to mask the identity of paintings as still life—and the larger meanings thereof. For instance, critics have insisted on the "neutrality" of the objects Davis chose, which "allowed him to investigate space and structure in new ways" (Wilkin 52).[2] Such compositions, and modernist still life in general, have been seen largely in the context of abstraction rather than in relation to the "lowly" genre of still life.

Nonetheless, Davis's modernist presentation of mundane objects belongs to the long tradition of still-life painting going back to the 1600s, when this genre became an independent category of painting—and when its contents mattered. Granted, the results are dramatically different from still-life paintings by Chardin, which appeal to the sense of touch and vision and even taste. Perhaps Bryson best describes the sensuousness of Chardin's paint as "an almost comestible substance," which mimics the texture

not only of terra-cotta but also of "cream cheese." He goes on to describe the tactility of a Chardin: "Inside the painting, one sees objects which are constantly being touched: polished metal, familiar plates and cups, linen freshly pressed and tables swept and cleaned" (94–95). In contrast to Chardin's, Davis's still-life paintings are what you could call antitactile, appealing not to the sense of touch (or taste for that matter) but to the intellect. Davis divorces still life from the sensuous world of Chardin and opts for a more rigorous cerebral approach, writing that "an intelligent picture is a utilitarian object of great magnitude" and comparing his occupation with that of an architect: instead of making "a house you can live in . . . a picture maker is an artist who builds a construction which your mind can live in" ("Journal" 149). This is certainly a dramatic clash of sensibilities, however, Chardin's and Davis's basic aims are not radically divergent. Still life in the modernist era remains, as it always has been, a means for artists to engage in quiet contemplation of reality—the reality of the forms themselves, certainly, but also of the uses of objects and their receptivity to the wider culture outside the domestic site of their existence. It is that cultural context that explains the chasm between the two, as elaborated on below.

In the cultural climate of a postwar America infused with technological values, this resurgence of interest in a genre that traditionally featured domestic, and thus female-identified, subject matter may seem paradoxical. However, the prevalence of still life in the modernist era has more to do with its relevance to, and encoding of, the machine age than with domesticity. Intent upon defining art in terms of technology, the avant-garde created works increasingly informed by what Philip Fisher has called an

22. Stuart Davis, *Egg Beater No. 4*, 1928. Oil on canvas, 27 × 38 1/4 in. The Phillips Collection, Washington, D.C. Copyright © Estate of Stuart Davis/ Licensed by VAGA, New York, NY.

"ethos of construction," an ethos determined in large part by the elevated status of technology (*Making and Effacing Art* 209). Inherent in this elevation of technological principles was the promotion of "masculine" as opposed to "feminine" values, as they were culturally defined. Traditional notions of the "feminine" posited an elemental kinship with nature and the body in opposition to the "masculine," which embodied the more technological and cerebral aspects of culture. It is worth reiterating in this context that the engineer was enthroned as the new culture hero of the day, standing for technological achievement. "There is a great new race of men in America: the Engineer," wrote Jane Heap. "He has created a new mechanical world" ("Machine Age Exposition" 36). Artists and writers alike were challenged by this new world and began to see themselves as technicians and their art as a kind of visual or verbal technology, a strategy that, according to Lisa Steinman, offered the American avant-garde a way of defending and elevating their art "in a culture that respected most the work of engineers or industrial designers, in short, the work of practical men" (5). And, not unrelated, it was a way of participating in the all-consuming postwar drive to impose order on every aspect of culture. In order to validate their art, American artists allied themselves to the "new mechanical world" by appropriating basic principles from that world. Stuart Davis, for instance, repeatedly invoked the idea of art as an engineered construct in journal entries of the early 1920s: "A picture becomes a thing of construction like any other thing that is made" (43).

Meyer Schapiro may have offered the most incisive rationale for the elevation of still life in an era of technological ascendancy; indeed, he was one of the first to identify the metaphoric potential of still life for the machine age in his famous essay "The Apples of Cézanne." He wrote that still life "consists of objects that . . . are subordinate to man as elements of use, manipulation and enjoyment; these objects . . . owe their presence and place to a human action, a purpose. They convey man's sense of his power over things in making or utilizing them." And elsewhere he argued that "still-life is an extension of our being as masters of nature, as artisans and tool users" (14). For Schapiro, Cézanne's apples—or more precisely, Cézanne's mode of constructing his still lifes with their tightly interwoven planes and amalgamation of spacial relations— signaled what Fisher has called a new "industrial attitude towards the world." That is, Cézanne saw the world "as raw material for purposes beyond itself, subject to meltings and fusings, transportation and recombination into an arbitrary technological space." Building on Schapiro, Fisher sees Cézanne's still life as a manifestation of "the technological will and its domination of the world." Neither author, however, grapples with the gender issues implicit in such a model of artistic creation. And while Fisher acknowledges Cézanne's importance in preparing the way for further developments in the "industrialization of the picture surface," and though he touches briefly on Picasso and a few other artists, his primary focus is not modern America, where the ethos of construction reached its climax (*Making and Effacing Art* 219).

Along with Stuart Davis, Man Ray takes on this new agenda of fabrication, as manifested most powerfully in his unconventional technique of rayography. As we've seen, to make rayographs, Man Ray arranged various objects on photographic

paper—gears and springs in *Clock Wheels* (ill. 18); hair comb, sewing needle, and feather in one work; lightbulb, drill, and utensils in yet another work. He then exposed them to light, removed the objects, and developed the print. For each of his rayographs, Man Ray prepared for his art-making by assembling objects in much the same way as did Stuart Davis for his *Egg Beater* series or as would any other painter of still-life compositions. Instead of painting the arrangement, however, Man Ray exposed it to light. This process tends to abstract the still life, collapsing depth to create white impressions on an otherwise black print. As in Davis's case, however, abstraction is not the point here. These imprints become an instantaneous record not only of the objects themselves but also of the artist—of his actions on the surface, his manipulative strategies. The artist left his mark not as a painter but as a designer or builder. Rather than marking the surface with brush strokes, traditional signs of the artist's subjective presence, Man Ray strove for "a purely cerebral act" (*Self Portrait* 67). Furthermore, with their stark juxtaposition of schematized shapes, the rayographs suggest industrial blueprints. As early as 1923, a *New York Times* article picked up on this similarity: "Popularly, perhaps [rayographs] seem to borrow from the commercial blue-printing process" (qtd. in Foresta 32).

This cerebral alignment with technological content and modes of construction, phenomena not traditionally the purview of art, would seem to indicate a distinctly anti-elitist stance, and in part this is the case. However, seen against the great esteem accorded technology at this time, such a preference for engineers over workers, for those who invent and conceptualize rather than those who actually do the work of technology, indicates the persistence of a rather elitist stance. Furthermore, the switch from mucking about in the "sticky medium of paint," to use Man Ray's expression (*Self Portrait* 67), to the cleaner and more cerebral techniques of collage and rayography also suggests a more elevated involvement in the management of ideas, even in management itself—white- rather than blue-collar work.

The transformation in modernist art-making practice and the alliance with the "cleaner" work of the managers of industry suggests what Banta called a "managerial ethos," which emerged in the age of Veblin, Taylor, and Ford, when "professional elites and technocrats [were] produced in the mass" (17). A dramatic shift took place in the teens and twenties from manual labor to professional labor, that is, to a class of highly respected experts—factory managers, efficiency experts, and engineers. In this climate, the avant-garde's adoption of a "managerial ethos" in their art-making becomes a means of elevating their art and of holding their own in a culture under the dominion of the machine.

The prestige of Taylorism and the timing of its ascension to a position of great influence are crucial factors in all of this. After the publication of Taylor's *Principles of Scientific Management* in 1911, Taylorism became a powerful force; some historians maintain that Taylor should be ranked with Darwin and Freud as principal architects of the modern world. As Peter Drucker put it, Taylorism is perhaps "the most powerful as well as the most lasting contribution America has made to Western thought since the Federalist Papers" (280). With America's entry into the war in 1917, the nation's

embrace of efficiency had become an all-encompassing value, even considered "a patriotic duty" (Haber 119). And after the war this "obsessive need to create 'rationalizing' models" intensified and broadened to affect all aspects of everyday reality, from factory production to kitchen design to personal hygiene (Banta ix). Though Taylor was a key force in all of this, his life coincided with the phase of America's most intense industrialization, and, as Robert Kanigel concludes, "The coming of Taylorism made our age what it was going to become anyway—only more so, more quickly, more irrevocably" (570). It is worth reiterating here that the dramatic rise of Taylorism was also propelled by the fervent need to reestablish order in the aftermath of the Great War, which had created havoc in Europe and threatened to disrupt progress in America. Artists who conceived of still life as a model of efficiency and order were, of course, responding to the same social pressures and historical circumstances.

When examined more closely, the theories of Frederick Winslow Taylor elucidate this nexus between modernist still life and Taylorism. In hopes of revolutionizing factory production, this founder of efficiency engineering advocated the reevaluation of each step involved in the production process, whether of automobiles or sewing machines. Stated in the simplest terms, Taylorism involved breaking a process down to its component parts, examining the relationship between them, and with the help of time-motion studies reassembling the process with an eye toward greater efficiency of production.

With its emphasis on measurement of time—and speed of execution—the title of Man Ray's *Monsieur . . . , Inventeur, Constructeur, 6 Seconds* of 1923 (ill. 16) alludes to the model of efficiency advocated by Taylor. The very process of quickly assembling objects on a tray in front of the artist—placing component parts in relation to one another—mimics factory-line assembly (albeit on a conceptual level). Man Ray's engrossment in minute measurements of time (apparently the work was constructed in "6 seconds") also parallels time-and-motion studies; Taylor was interested in what could be done not in hours but in seconds. Man Ray's *Clock Wheels* (ill. 18), too, reflects a Taylorist fixation on instruments of measurement. After all, the instruments of time-and-motion studies included stopwatches, which measured how much time it took to perform a certain task. The artist commented some time later that "everyone will tell you I am not a photographer. . . . It's true. . . . My works are pure metrophotography" (qtd. in Foresta 32). The artist adapted this term from metron, Greek for measure, and/ or from metrology, the science that deals with systems of measurement. Here the allusion may also be to another of Man Ray's devices for measuring time, his infamous metronome, *Object to Be Destroyed* (ill. 4). While evoking precisely gauged intervals of time, these works also perform radical subversions of Taylorist efficiency, as we'll see below.

Perhaps the artist most enmeshed in a Taylorist approach to painting was Stuart Davis. The artist filled notebook after notebook with drawings, diagrams, and discourse pertaining to his obsessive search for a "sure fire" system or method of working. As Davis wrote in 1921, "Let it be understood, first comes the subject of the picture which is independent of the technical procedure. That is to say a human face or a package of cigarettes must alike be dominated by the laws of plastic expression. . . . My method is then to analyze the subject for qualities of line, shape, and color and to then synthesize

them into a plastic unit" ("Journal" 40). The artist went so far as to evoke factory assembly, noting that if he followed his system "this machine should work" (41).

His obsession with a "sure fire" system of analysis and construction, however, indicates an ethos that is utterly managerial. In his drive to discover an overarching system, his Taylorist search for the "one best way," Davis necessarily distances himself from the laborer who actually makes that machine work. Like an industrial designer or engineer, his focus is on cerebral invention, not messy fabrication. In spite of his populist leanings, to be discussed in the chapter that follows, Davis remains on a plane above the working classes, a stance quite removed from that taken by Thomas Eakins. As we've seen, Eakins explicitly represented working class athletes in his rowing paintings and implicitly recognized what the sport offered them: if not escape, at least a positive transference of the repetitive robotic movements from factory to leisure activities (Berger 123). Likewise, Davis ignores what his contemporary John Dos Passos so vividly narrates in his *U.S.A.* trilogy; that is, the numbing machinelike repetition of movements demanded by "the Taylorized speedup": "reach under, adjust washer, screw down bolt, . . . reachunder, adjustwasher, screwdownbolt" (55). Instead of awareness of the human costs of Taylorization of the workplace, Davis is most concerned with adapting Taylorist principles to studio practice, that is, with finding the most efficient means to a modernist end. The final products of his investigations, paintings such as *Egg Beater No. 4*, are carefully constructed paintings governed by "laws of plastic expression." Impugning Davis and his colleagues for their insensitivity to the plight of the worker is not the point here; the intent is rather to interrogate the motivations of the American avant-garde in order to better understand the making of the modern in machine-age America.

What may not immediately be apparent in these artists' engagement with Taylorism is that the content of their work, too—their selection of such mundane items as rubber gloves, lightbulbs, mixers, combs, among other unassuming objects—is informed by its principles. Taylor had made the world of the commonplace into the stuff of a new science of efficiency, and in the process he discovered great drama in the mundane (Will 8). Any human practice, even the most ordinary activity of wielding an eggbeater, could be analyzed in order to find a better, more efficient technique. Any object, be it an electric fan or a clock, could be designed with an eye for greater efficiency. The prominence of Taylorism, with its emphasis on the practical functioning of all manufactured objects, thus validated the artists' selection of ordinary objects of everyday use.

Another master of unorthodox still life, Morton Schamberg, looked not to ordinary objects but to the virtual birth site of Taylorism, the factory floor, where he found the machines that populate his compositions. In 1916, Schamberg initiated a series of drawings and paintings representing machines used in the textile industry in his native Philadelphia (ill. 23). The city was then an important textile-manufacturing center, and Schamberg had a direct connection to the managerial side of the industry through his brother-in-law, who manufactured women's cotton stockings (Wolf 30). Schamberg's content is thus doubly masculinized, alluding as it does to the machine itself and to the factory, the site of production—then a decidedly masculine domain. Whereas the

home remained the conventional site of female work (this in spite of the fact that unprecedented numbers of women went to work in factories during World War I), the factory was deemed the proper site of masculine labor.

The still-life objects Schamberg has chosen are relatively small tabletop machines, which he has extricated from the factory in order to examine their form and function as he would any other still-life object. Significantly, the function of these particular machines was to make products for the home, the traditional site not only of women's work but of still-life painting. The machines represented in the series range from those designed to make textile products such as napkins and tablecloths to mechanical stitchers used to bind books (Agee, "Notes" 72–74). Allusions, subtle as they are, to things that have served the artist for centuries as still-life subjects thus persist in Schamberg's art. Relevant here, too, is the fact that Philadelphia had been the center of still-life painting during the nineteenth century, a situation determined in large part by the presence there of the Peale family, particularly the children of James and Charles Wilson Peale and their wives: Anna, Margaretta, Raphaelle, Sarah, and Rubens Peale—all preeminent painters of still life. Schamberg's works in this genre both continue and challenge this well-established Philadelphia tradition.

Schamberg executed many of his machine paintings in pastel, a rather curious choice for such content. A striking incongruity exists between the soft texture and muted color of the pastel medium and the hard, mechanical nature of the content— of camshafts, drive wheels, and spools. Furthermore, as an artistic medium pastel was stigmatized as rather inferior; it was seen as feminized, as appropriate for dilettantes and female artists, perhaps, but not for "serious" artists—or for serious subjects.[3] While Schamberg's appropriation of machinery from the factory floor would seem to rescue still life from the realm of domesticity, his choice of medium represents a reversion back to that sphere. Furthermore, the muted colors and the blurred texture of pastel, while intended perhaps to denote a machine in motion, ultimately have the opposite effect of suggesting sensuousness, thus undermining the machinery's functionality and further feminizing the content.

Concurrent with the machine pastels, Schamberg executed a series of mechanical abstractions in the medium of oil paint, and these paintings tend to be less ambiguously gendered. The style and medium of such works as *Painting (formerly Machine)* of 1916 (ill. 23), now derive from the content itself, from mechanical forms and principles; characterized by hard edges, interconnected parts, and smooth surfaces, these works now evoke materials like steel. Though the machines represented are still those of the textile industry—those designed to stitch book bindings and to manufacture other products for the home—signs of domesticity are largely banished; instead, Schamberg gives us emblems of the masculine world of engineered perfection. Like Davis's still lifes, Schamberg's visualize a particularly aestheticized world on a level far above the gritty factory floor. Unfortunately, Schamberg's early death during the influenza epidemic of 1918 put an end to his experimentation with machine content, but his creation of gender instability in machine-age still life persists in the art of many of his compatriots in the 1920s.

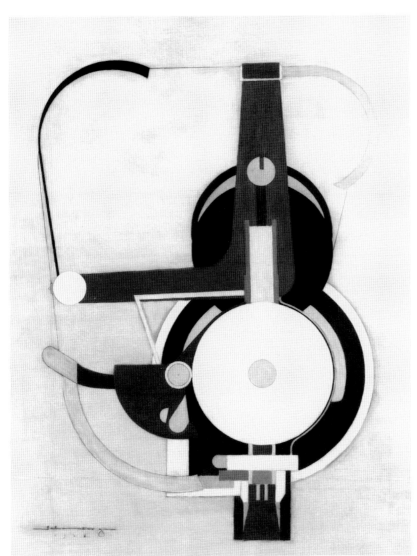

23. Morton Schamberg, *Painting (formerly Machine)*, 1916. Oil on canvas, 30 1/8 × 22 3/4 in. Yale University Art Gallery. Gift of Collection Société Anonyme.

In ways very different from Schamberg's, Gerald Murphy's paintings reveal a provocative play between the feminine and the masculine. An inventory of objects in his paintings includes safety razors and fountain pens, cigars and corkscrews—all implements of the home with allusions to domestic activities. However, his works engage distinctively male actions and habits in that domestic site, such as smoking cigars in the drawing room, shaving in the bathroom, or writing in the study. In *Cocktail* of 1927 (ill. 24), for example, Murphy presents an arrangement of bar accessories—cocktail shaker, corkscrew, glass, lemon, and olive, along with a box of cigars—all the implements for enacting the traditional male ritual of mixing drinks and enjoying after-dinner retreat in a drawing room complete with Cuban cigars. From Murphy's interviews, it is clear that such a practice had personal meaning. Recalling the gentlemanly habits of his father, he noted, "As a boy I was apparently impressed by the assembly of the various objects which were usually standing in evident juxtaposition" (qtd. in MacAgy 57). Murphy also sets up a dialogue with other works of art; for instance, the corkscrew brings to mind

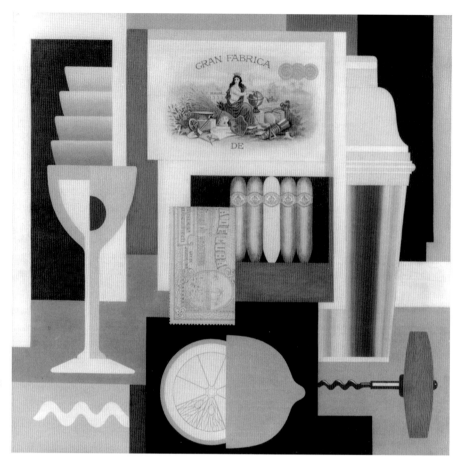

24. Gerald Murphy, *Cocktail*, 1927. Oil on canvas, 29 1/16 × 39 1/8 in. Collection Whitney Museum of American Art, New York. Copyright © 2003 Estate of Honoria Murphy Donnelly.

the image of the same tool in Duchamp's *T'um*, a painting that could also be considered an unorthodox still life with personal meaning for the artist. Here Duchamp replicates his favorite ready-mades or their shadows. (Never an actual ready-made, the corkscrew existed only as a painted shadow in *T'um*.) While Duchamp often selected ready-mades as a way of probing French perceptions of American cultural practices, Murphy's choice of objects for his still-life compositions, especially in *Cocktail*, provided a way of thinking about his own culture from a perspective across the Atlantic.

Painted during Prohibition, Murphy's *Cocktail* subtly critiques the passage of the Eighteenth Amendment, which was ratified in 1920, and which Murphy cites as one of the reasons for his expatriation in France beginning in 1921: "You had the feeling . . . that a government that could pass the Eighteenth Amendment could, and probably would, do a lot of other things to make life in the States as stuffy and bigoted as possible" (qtd. in Tomkins 21). After settling in France, Murphy was able to indulge in activities proscribed in his own country and thoroughly enjoyed the ritual of mixing drinks for his friends. Like jazz, cocktails were then identified with America—and were wildly popular in postwar Europe.

In another work, *Razor* of 1924 (ill. 25), Murphy implicitly exalts prosaic objects of American design—"the first Gillette razor and the first Parker pen." The artist noted that these commodities "suggested a Nature Morte to me though American made"

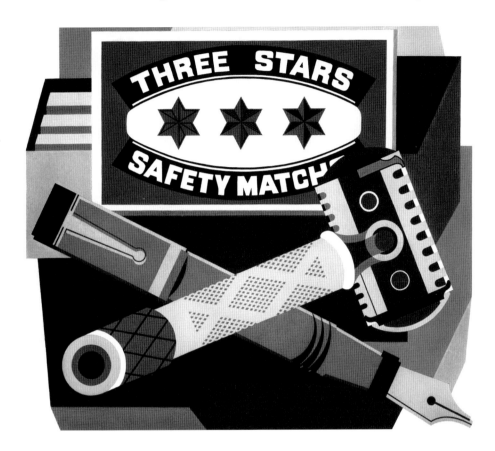

and stated his desire to present these objects in "heroic scale" (qtd. in MacAgy 55). Parker pens had always been black, but, as Wanda Corn noted, "in the early 1920s, the company issued its Duofold model, an oversized pen with a vivid orange-red barrel which advertisements claimed 'rivals the beauty of the Scarlet Tanager' " ("Identity" 162).[4] The fountain pen in *Razor* is unmistakably this fashionable, brightly colored Duofold model, targeted to a male audience. While ads of the time mentioned "Duofold Jr." and "Lady Duofold Pens," they invariably illustrated the larger, bolder (and at $7.00, the most expensive) model marketed for men (ill. in Corn, "Identity" 163). Another sign of masculinity here is the prominent position of a box of "Three Stars Safety Matches" suggesting the traditionally male activity of smoking.

As did the accoutrements in *Cocktail*, the razor in Murphy's painting had personal reverberations for Murphy. After graduating from Yale, the artist worked for Mark Cross, the family business in New York, and while there he briefly worked on patenting a safety razor (Corn, "Identity" 169). For this painting, however, Murphy chose a competitor's product, a Gillette razor, which by the 1920s dominated the international market. While implicitly acknowledging Gillette's victory in this competition, Murphy's elevation of a Gillette razor also comments on the company's advertising strategy. Ads featured the razor as a beautiful instrument of efficient grooming and lauded the many advantages of the throwaway blade, especially the speed with which one could shave (Corn 160–162). That Murphy has fully grasped advertising's agenda in promoting this new product can be seen by comparing *Razor* with a cubist collage by Georges Braque,

25. Gerald Murphy, *Razor*, 1924. Oil on canvas, 32 5/8 × 36 1/2 in. Dallas Museum of Art, Foundation for the Arts Collection. Gift of the Artist. Copyright © 2003 Estate of Honoria Murphy Donnelly.

*Still-Life on a Table: "Gillette"* of 1914. The French artist extracted an actual Gillette logo from a package of safety razors; he then inserted this scrap of paper into a cubist still life where it appears as a small accent in a complex array of objects. Murphy, however, confronts advertising head-on—and on its own terms, appropriating the style, scale, and chutzpah of advertising itself. In taking on definitive principles of advertising, Murphy thus ratchets up the visual authority and the seductive power of his imagery.

Murphy's presentation on such a macho billboard scale also discloses the objects' intended consumers. Like the Duofold Parker pen, safety razors were designed and marketed specifically for men. This, too, is manifested in contemporary advertisements; for instance, one billboard pictures a Gillette safety razor propped against an elegant velvet-lined box designed for this special instrument of grooming (ill. in Corn, "Identity" 163). The advertising copy—"The new 'big fellow' "—guarantees the maleness of product and packaging. In exaggerating the product's size and importance, Murphy boldly asserts an American—and masculine—identity; as well, he celebrates the growing American hegemony in the fields of industrial design and marketing. While Davis retains allusions to the domestic in *Razor*—to the site where the act of shaving occurs—in order to legitimate his subject, he also references the larger realm of action outside the home where billboards compete in the urban environment.

An examination of modernist still life can also generate a huge inventory of female-identified objects: eggbeaters, percolators, and rubber gloves in Stuart Davis; hair combs and utensils in Man Ray; a sewing machine in Arthur G. Dove; and, of course, flowers and fruit in paintings by nearly every painter of modernist still life. The treatment of these subjects, however, often reveals the same imposition of a Taylorist model of art-making. Furthermore, a study of Taylorism reveals how male principles such as factory production and scientific management began to be applied to the domestic realm of the home. As Banta observed, "language formerly associated with male enterprises taking place outside house boundaries" was appropriated in order to promote the model home of the future (245). Advertisements for modern appliances frequently referred to the home as "woman's factory" or "her work-shop" (Marchand 188; Banta 247). In a book written in 1914, *The New Housekeeping: Efficiency Studies in Home Management*, Christine Frederick, an ardent advocate of the application of Taylorism to the domestic realm, glorified the new kitchen as a modern machine featuring materials that would "assure efficiency"—spotless tile floors, zinc or porcelain work surfaces—"all essential to the sanitation of the standardized kitchen" (qtd. in Banta 238).

Implicit in such a Taylorist model of modern home design and management was a moral imperative not only to run an efficient and sanitary home but to manage the human body in the same way. The pursuit of cleanliness—in Lears's words, the attempt "to eliminate all signs of organic life from a pristine home environment"—extended to the body, reflecting a new "ethos of personal efficiency." This linkage between the scientific management of the home and matters of personal hygiene is particularly evident in advertising; by the 1920s, "[a] sanitized, uniform image of attractiveness pervades the world of advertisements" (Lears, *Fables* 165).[5] Advertisements made wild promises of romance and success to those with sweet breath and no body odor.

Perhaps Stuart Davis's *Odol* of 1924, a painting of a container of breath freshener set against a pristine tiled background, best illuminates advertising's attempt to sell personal hygiene via modernist design principles. Advertisements for Odol typically featured the distinctive Odol bottle blown up to enormous proportions and placed in a space outside the home—atop classical columns, silhouetted against a romantic night sky, or set on a plinth in front of the Great Sphinx at Giza.[6] Instead of adopting such advertising strategies, Davis returns the Odol bottle to its rightful place in the bathroom, a pristine interior of geometric clarity, a domestic utopia in which personal behavior and physical environment mesh to sustain an image of sanitized perfection.

The fact that art, advertising, and industry were so thoroughly attuned to notions of cleanliness, efficiency, and order raises the question of why these notions were so needed in America at this time. This almost fanatical obsession can be located in certain social and political conditions taking hold in the postwar years. For one thing, America experienced a dramatic increase in labor agitation in the late 'teens when striking workers threatened to sabotage industrial production. Not unrelated was the "Red Scare," the fear that there was, in Frederick Lewis Allen's words, "another danger on the horizon: Bolshevism." The success of the Bolshevik Revolution in Russia gave rise to fears that Communism would spread from Russia across Europe and eventually to the United States. These anxieties led to "a long series of post-war anti-Red riots" (17). Exacerbating this sense of unease and the belief that American culture was in various ways being polluted was the dramatic increase in the numbers of immigrants from eastern and southern Europe, many of whom held socialist beliefs. These "non-Americans" became the target of anti-Red sentiment: witness the fate of Nicola Sacco and Bartolomeo Vanzetti, Italian-born American immigrants who were falsely arrested and sentenced to death in 1921. Given this charged political climate of intolerance, immigrants came to be viewed as disordering, even contaminating, elements, and such perceptions led to the passage of new laws limiting immigration. In their rather zealous embrace of the ordering principles of Taylorism, the American avant-garde aspired, if not exactly to compensate or correct, at least to comment on the forces threatening postwar cultural and political stability.

Although not to the extent of immigrants, women also presented a potential threat to societal order; conventionally allied with intuition rather than reason, women "added yet another disordering element to disrupt the hope of installing efficient management systems" (Banta 27). The extension of male values of management into the home, while serving to validate domestic material as still-life content, also signified attempts to control women by placing the domestic sphere under male dominion. In Bryson's words, "as long as painting's mode of vision would be constructed by men, the space in which women were obliged to lead their lives would be taken from them and imagined through the values of the 'greater' existence from which they were excluded" (178). Accordingly, artists of the American avant-garde appropriated things and spaces usually associated with women and imposed on them the values of the outside world.

Ironically, this occurred during the postwar years when numerous social forces, including the demand for an expanded labor force during World War I, encouraged

women to assert their independence by venturing into that outside world. In greatly escalating numbers, women entered domains traditionally occupied by men, in the process threatening male hegemony in the work force and destabilizing normative gender roles. Works like Davis's *Odol* suggest resistance—conscious or not—to this development. In the face of this threat to male dominance, avant-garde artists, including Man Ray and Gerald Murphy, reconfigured items associated with the domestic sphere—eggbeaters, electric fans, and breath fresheners—as building blocks of an engineered construction. Through this process of appropriation and reconfiguration, artists advanced the idea of the artist as engineer and placed this constructive mode of art-making in a male context.[7]

A case can thus be made that the genre of still life was thoroughly entangled in the masculine identities and national myths of the postwar era. This argument has perhaps not sufficiently acknowledged the subversive impulse or Dada spirit lurking behind these willfully masculinized constructions. Significantly, Dada thrived in avant-garde circles in America beginning in the war years, in large part spurred on by the arrival of Dada émigrés like Marcel Duchamp and Francis Picabia. These artists sought to escape the disruptions of World War I, which for them represented the death of belief in progress and ultimately led to a cynicism and irony that informed the Dada movement. Inevitably, the European Dadaists were both impressed and repelled by the prevailing obsession for order in machine-age America. For them, the machine itself became both a positive symbol and a favorite Dada target—extolled as a new source of inspiration and attacked as a malevolent force. Such ambivalence informs the many beautiful but malfunctioning machine constructions devised by French artists resident in America in the teens, as well as by the American avant-garde. Nonfunctional—and sardonically funny—works such as Picabia's *Amorous Parade* and Man Ray's *Danger/Dancer* (ill. 13) come to mind.

Significantly, attacks on the machine, and by extension on Taylorism, extended well beyond artistic circles. Taylor's thinking so permeated modern life that we no longer realize there was a time when it was controversial or that Taylor confronted much hostility when *The Principles of Scientific Management* was first published in 1911.[8] The seductive power of Taylorism engendered a widespread and intense resistance to a theory that claimed to be applicable to "every detail of quotidian existence." And such claims gave rise to what Banta has called "an authoritarian antiauthoritarianism." Taylorism as a paradigm for contemporary society was, in her words, "marked by strong traces of . . . resistance to any damn-fool notion that there ever can be 'one best way' " (x).

When viewed against such resistance, Gerald Murphy's *Watch* of 1925 (ill. 26) partakes of this "authoritarian antiauthoritarian" impulse. The timepiece, a railroad pocket watch whose cover has been removed to reveal its workings, is painted in gleaming gold and silver and is magnified to the enormous dimensions of six by six feet. Such a rendition might seem an outright exaltation of principles of scientific management and an affirmation of a culture under the spell of Taylorism. However, by so exaggerating the dimensions of this timepiece, and by unveiling its inner mechanisms, Murphy also critiques the control over our lives engendered by America's

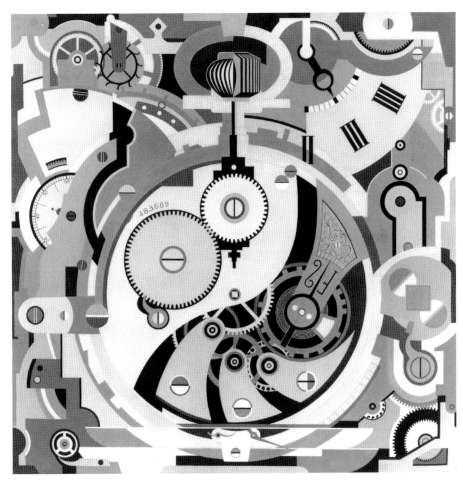

26. Gerald Murphy, *Watch*, 1925. Oil on Canvas, 78 1/2 ×78 7/8 in. Dallas Museum of Art, Foundation for the Arts Collection, Gift of the Artist. Copyright © 2003 Estate of Honoria Murphy Donnelly.

overblown obsession with principles of time management. As did the safety razor, this railroad watch, designed especially for the Mark Cross family business, had personal meaning for Murphy.

The fact that Murphy was able to escape a life controlled by that watch (at least for the 1920s) gives the painting particular resonance in this context. His was actually a dual escape from highly regimented situations; he refused a career in the family business, and he also managed to escape service in World War I, which has been referred to as the "first Taylorized war" (C. Jones 154). Murphy's stunningly meticulous reconstruction thus both registers and resists Taylorist principles. Tinged as it is with irony, *Watch* remains an ambivalent testament to the postwar summons to order.

Man Ray's rayograph *Clock Wheels* (ill. 18) carries Murphy's ambivalence further, implying a greater subversion. The artist dismantled and then reassembled the component parts of a clock so that the cogs no longer mesh properly, thus disabling the timepiece as a monitor of time. Furthermore, the technique of rayography itself implies resistance to the dominant thrust in scientific management. Man Ray's *Clock Wheels* has a striking resemblance to Francis Picabia's *Alarm Clock* of 1919 and may well be indebted to it. To create this work, Picabia had dipped a clock's mechanisms into black ink and imprinted them on paper. Through rayography, Man Ray has reversed the

A s s e m b l i n g   A R T

process. After exposure to light, he removes the gears and other objects, and white images appear during the developing process. In Picabia's drawing, the application of ink to paper via metal objects implies their materiality; however, in Man Ray's rayograph, images of objects appear because they prevent light rays from hitting the paper. In effect, then, Man Ray dematerializes the mechanical. Furthermore, it is the purely natural—that is, light—that literally exposes the machine parts. The implication becomes antitechnological as the relation between the organic and the mechanical is inverted. While both artists have created utterly useless, nonfunctional timepieces that fly in the face of Taylorist ideal of clockwork precision, Man Ray intensifies and further complicates his statement of resistance to that ideal by alluding to absence or loss, specifically the human loss and the lives that were dematerialized by World War I.

Although in very different terms, this inversion of the natural and the mechanical as a means of undermining the technological also informs Georgia O'Keeffe's still-life compositions. Though in more subtle ways than Gerald Murphy's timepiece, O'Keeffe's greatly enlarged flower paintings, such as *Jack-in-the-Pulpit IV* of 1930 (ill. 27), embody both principles of model-making and of time. O'Keeffe's still-life subject, associated as it is with the traditionally feminine realm of flower arranging and gardening, seems situated as far from the machine world as one can imagine. However, the machine metaphor can be seen to inflect even this content. When O'Keeffe presents an extreme close-up of a flower, it is as if she dismantles it and reconstructs it, part by part, so that the resulting abstraction seems more a collection of separable units juxtaposed against one another than a traditional, mimetic rendition of a typical still-life subject. Writing about O'Keeffe in 1924, critic Paul Rosenfeld recognized the mechanical underpinnings of such a process: "Much of her work has the precision of the most finely machine-cut products" (qtd. in Lynes 206). Though she does not mention O'Keeffe, Tichi also suggests this connection between nature paintings and machine technology: "Even art about flowers or fishing . . . could enact the defining technology in its very form" (16).

O'Keeffe's paintings also imply mediation by technological devices that assist in enlarging images, especially the camera, suggesting the vogue for close-up photographs by her contemporaries Paul Strand and Edward Weston. Such enlargement also implies mediation by another, albeit not so modern technological device, a magnifying glass. (Interestingly, magnifying lenses appear in several rayographs by Man Ray and collages by Arthur Dove.) No longer simply transcriptions of nature, O'Keeffe's flowers become implicitly technological enhancements. When examined in this context, it becomes clear that this image is dependent on a highly technological culture.

In part at least, O'Keeffe has appropriated machine culture so as to validate a private language based on human anatomy and body identification, as discussed in the preceding chapter. Rather than providing a counterimage to the prevailing technological world, O'Keeffe conceived of a kind of image-making, a technique of construction that encodes that world, while at the same time making explicit the persistence of human presence within that world. O'Keeffe has effectively united the female and the male, the anatomical and the technological, in order to construct a new kind of still life

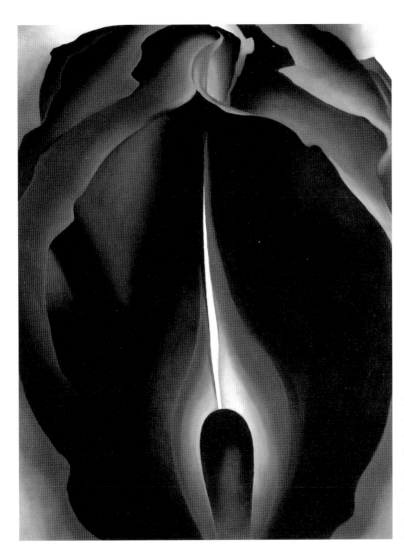

27. Georgia O'Keeffe, *Jack-in-the-Pulpit No. IV*, 1930. Oil in canvas, 40 × 30 in. National Gallery of Art, Washington, D.C. Alfred Stieglitz Collection, Bequest of Georgia O'Keeffe. Copyright © 2003 The Georgia O'Keeffe Foundation/Artists Rights Society (ARS), New York.

for the machine age. In different ways, then, both Murphy's *Watch* and O'Keeffe's flower paintings, though indebted to modern technology, are at the same time critiques of that technology, subtle subversions of its power over our lives.

Reference to time is also embedded in these works, mechanical time in Murphy's and natural time in O'Keeffe's; indeed, O'Keeffe affirms the natural cycles of living things like flowers, trees, and cattle. As Murphy's work makes clear, time implicates the future, suggesting—but also interrogating—technological "progress"; in his words, *Watch* represents, "man's grasp at perpetuity" (qtd. in MacAgy 54). But O'Keeffe's injection of natural time into the increasingly regimented life of the twentieth century reminds us of the inevitability of death and decay, that is, time in a more cyclical sense. As Paul Rosenfeld observed in 1924, "the artist seems to bring before one . . . mysterious cycles of birth and reproduction and death" (qtd. in Lynes 207). O'Keeffe's flowers effectively conflate machine-age principles and traditional memento mori in an attempt to counter the dominant ethos of the time and to sustain an alternative mode of expression in the machine age.[9]

Such a conflation also informs works by Man Ray, especially *Untitled* of 1931, a photograph of an apple whose stem has been replaced with a metal screw. For this work, Man Ray assembled a still life and then photographed it in such a way that this conjunction of mundane objects was transmuted into a sexual pun. The fruit in Man Ray's photographs are "stand-ins for the female body—luscious, edible, depersonalized" (Phillips 217). Man Ray represents an object of desire, but he places that desire in the context both of the time-honored Vanitas theme and of machine-age still life. But when Man Ray substituted a screw for the stem of an apple, he also brings the mechanical into dialogue with the theological. In so doing, Man Ray has added an implied narrative to his still life. Not only will a luscious apple rot and a beautiful body age, but a collaboration between them (woman and apple) may have disastrous consequences. This Edenic fruit inevitably evokes resonances of good and evil, and these resonances are complicated by the apple's mechanical component: Does such a violation of the organic by the mechanical reenact the Fall? What exactly is the machine's role in this reenactment? With its intrusion of the mechanical into the organic, Man Ray's unorthodox still life is calculated to foster ambiguous meanings.

Whether their works imply an embrace or a critique of machine technology or an ambiguity toward it—that is, whether they are essentially Taylorist, anti-Taylorist, or somewhere in between—the avant-garde was still governed by the dominant paradigm of machine culture. Though they might have made works with anti-Taylorist implications, Taylorism was such a dominant paradigm that it set the terms of the discourse. Artists like Man Ray, Gerald Murphy, and Georgia O'Keeffe may have tried to deconstruct Taylorism, but they were still working within its authority.

Largely as a function of the rise in prominence of machine culture, modernist still life became almost unrecognizable in terms of traditional notions of the genre. Even when still life seems to endorse a language of abstraction and a studious avoidance of the machine, the genre can be seen as inflected by the dominant ethos of the machine age. The American avant-garde enlisted the still-life genre for the contradictory aims of elevating art to the status of engineering while also undermining the technological values inherent therein. In no case, however, did this subversion take the form of an identification with those people of the working classes who were most effected by this Taylorist model of industry. Concern of this sort among the avant-garde would have to wait until the major shift in perspective triggered by events of the late 1920s. In the decade immediately following World War I, while most artists responded to the widespread call for order by embracing the machine and reconfiguring still life as a model of engineered perfection, others created works in this genre that reveal a gender instability and a strong note of resistance to the dominant ordering impulse of the machine age. The masculinized art of the postwar years was, in fact, a highly conceptual and conflicted response to an era of machine ascendancy.

# 4

# Stuart Davis's "Tobacco Pictures"

In the early 1920s, Stuart Davis embarked on a series of paintings based on the smoking, packaging, and advertising of tobacco products, which he called his "tobacco pictures" ("Journal" 39). Like other still-life paintings of the postwar period, these paintings foreground masculinity in ways that illuminate core values of the machine age. *Bull Durham* of 1921 (ill. 28), for example, features a side view of a Durham bull (the massive mascot of the tobacco brand), a trompe l'oeil leather thong with a disk also featuring the bull, the words "Zig Zag" (a popular rolling paper), a patch of simulated burlap, and a square of plug, or chewing tobacco. The painting's collagelike layout invokes advertising and packaging practices as well as modes of consumption pitched to a male audience: tobacco processed in square tins for chewing, merchandised in burlap sacks, or stored for personal use in leather pouches ready to be rolled into cigarettes or used in pipes. Scrutiny of Davis's tobacco paintings as machine-age still lifes serves to uncover their relation to changing modes of advertising, to social habits of tobacco consumption, and to larger realms of postwar culture.

Dramatically different from anything produced during his formative years, Davis's tobacco series announces his inauguration of a mature modernism. Early in his career, Davis had been attracted to the socialist politics of Robert Henri and contributed illustrations to the leftist periodical the *Masses*. By 1920, Davis had jettisoned his Ashcan origins, calling the idea of the artist as " 'the poet of the alleys' . . . a bit of nonsense." He talks of "the necessity of a new point of view, a happier, livelier out-look [*sic*]. It means the getting away from the old *Masses* point of view which is as dead as a thousand devils but still persists" ("Journal" 176, 113).[1] Like many American artists who felt inadequate after seeing paintings by European artists in the Armory Show of 1913, Davis felt the need to "catch up" and so turned to an experimentation with European modernism. At the same time, Davis wanted to retain a distinctive Americanness in his painting. This impulse, too, was widespread in the years immediately following the Armory Show as American artists became increasingly aware of their national identity. A corollary of this awareness was the recognition of certain phenomena as uniquely American;

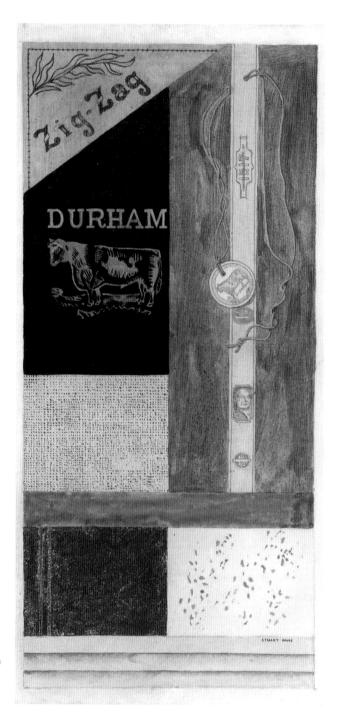

28. Stuart Davis, *Bull Durham*, 1921. Oil on canvas, 30 1/4 × 15 1/4 in. The Baltimore Museum of Art, Edward Joseph Gallagher III Memorial Collection.

the canonization of bridges and skyscrapers, machines and factories, product packaging and advertising provided a means of reasserting a sense of Americanness. Ironically, the presence in New York of European artists such as Francis Picabia, Marcel Duchamp, and Albert Gleizes, among others, fostered an openness to native subjects among American modernists.

World War I provided a powerful boost not only to this newly enhanced American identity but also to the economy; the postwar economic boom spurred on the

development of advertising, which took off like never before.[2] Perhaps more than any other modernist, Davis became thoroughly engaged in the new advertising environment, appropriating the powerful visual appeal of advertising as well as its message for his art. He wanted his paintings to encapsulate "a new point of view [which] says 'What will sell?' " Davis also sought a way to be "rigorously, logically American." He said of his tobacco paintings: "I feel that [they] are an original note without parallel so far as I can see . . . really original American work" ("Journal" 113, 39). These paintings represent his first successful adaptation of European modernism to a distinctively American idiom.

While fully engaging the contemporary world, Davis's tobacco paintings also perpetuate certain elements of the American still-life tradition, particularly the trompe l'oeil tradition of John Peto and William Harnett.[3] Davis's trompe l'oeil allusions in *Bull Durham*—the shadow of the tobacco pouch draw string and the convincingly rendered textured burlap and chewing tobacco—do bring to mind the illusionistic renderings of Peto and Harnett. Like them, Davis attempted to mimic something that is already two-dimensional, the better to deceive the eye as to the material reality of the objects represented; also like them he featured the implements of smoking. However, Peto and Harnett give personal interpretations of smoking's connotations of passing pleasures and thus evoke the tradition of Vanitas paintings, especially those of seventeenth-century Dutch and Flemish painters (Mitchell 27). For example, in *Lincoln and Star of David* of 1904, Peto painted a lit cigarette whose glowing tip and faint train of smoke inevitably evoke a sense of dwindling time, an attribute of the Vanitas theme. Davis's tobacco paintings, on the other hand, forego these contemplative nuances; they are emphatically impersonal, reflecting Davis's exhortation to "copy the nature of the present days—photographs and advertisements" ("Journal" 18). Rather than meditating on the personal theme of mortality, Davis exploited the public values of contemporary advertising—virility, self-reliance, autonomy—values more characteristic of the machine age than the Gilded Age.

European modernism, and particularly Cubism, provided a more forceful model for Davis. Alfred Stieglitz had exhibited recent collages of Georges Braque and Pablo Picasso at his 291 gallery in the winter of 1914–1915, and Davis was quick to absorb their lessons and equally quick to move beyond them. Braque and Picasso's collages—for example, Braque's *Glass and Cigarette Pack* of 1914—include actual cigarette labels, newspaper fragments, and other collaged and drawn elements, all suggesting the cafe environment where artists typically congregated. While he exploits similar content, Davis has banished specific reference to the cafe milieu. In *Lucky Strike* of 1921 (ill. 5), for instance, instead of referencing wine glasses, guitars, tables, and so on, he presents a greatly enlarged tobacco package. Davis created a radically new context for still life—one that is commercial rather than personal. Davis came to his subject through the medium of advertising and packaging; that is, he has taken the techniques of Cubism out of the café and into the world of commerce, American commerce. This recontextualization highlights the message of advertising itself, which, as we'll see in the case of wartime promotion of tobacco, advocated a macho "roll your own" mentality anticipating Marlboro advertisements of more recent vintage.

29. Kurt Schwitters, *Merzz 19*,
1920. Paper collage, 15
15/16 × 11 1/4 in. Yale
University Art Gallery, Gift of
Collection Société Anonyme.
Copyright © 2003 Artists Rights
Society (ARS), New York/VG
Bild-Kunst, Bonn.

With their audacious allusions to the commercial world, Davis's unorthodox still-life compositions also serve to critique Cubism. "After producing some of the finest works of all time Cubism is academized," wrote Davis. "Cubism is dead. Dead of what—Dada." His attacks on Cubism echo those of Duchamp, who lamented Cubism's obsession with technical facility at the expense of intellectual rigor. Or as Davis put it, "the technical processes well understood, it becomes necessary to plot the direction of the idea" ("Journal" 130, 118). The Dadaist of most relevance to Davis's work was the German artist Kurt Schwitters, whose works were featured at the galleries of the Société Anonyme in New York in 1920 and again in 1921. Schwitters also created works on the theme of smoking: *Merzz 19*, a collage of 1920 (ill. 29), for example, incorporates actual cigarette labels and wrappers but without specific allusions to the cafe milieu. Rather, Schwitters presented these paper scraps simply as themselves: the detritus of a throwaway society. Like Schwitters's work, *Lucky Strike* encodes essential information about a society through such insertions of its consumer products. An anonymous *New York Times* critic, reviewing Davis's 1921 show at the Whitney Studio Club, understood

this when writing, "Mr. Davis is . . . keenly interested in all things made by man, for he believes that it is possible to understand people only by viewing their products. For this reason he says he finds more interest in a tobacco can than a blossoming tree" (clipping in "Journal" 31). However, Davis was captivated by an entirely different phase of the cycle of producing, consuming, and discarding than was Schwitters. In *Lucky Strike*, Davis magnified brilliantly colored, highly designed images whose allusions are not to the discarded but to the brand new, to promises of a jazzy present and a bright future; indeed, these are allusions fostered by tobacco advertising itself.

The early years of the century witnessed close bonds between modern art and advertising, a reciprocity based on similar modes of visual communication. As Jackson Lears has written, in the teens ad makers became increasingly concerned about the clutter of the consumer's "perceptual landscape." The accelerated attempt to attract attention, "to stop the busy viewer in his tracks," led to a new precision in advertising, which manifested itself in a collagelike juxtaposition of forms. Concurrently, avant-garde artists also sought eye-catching boldness and efficiency of design. The desire of both progressive advertisers and modern artists was, as Lears concluded, "not to tell a story but to create a cluster of images that would resonate with a reader or viewer" ("Uneasy Courtship" 137). Davis attempted just such a resonance in his tobacco paintings. In the artist's words, "The best adds [*sic*] to-day have as their dominant assets—high visibility and that is a quality for which I have long striven" ("Journal" 56).

Davis's tobacco paintings were not, of course, intended as advertisements. In fact, these works display an ironical edge; they embraced the new advertising environment while at the same time critiquing advertising's sway over American consumers, a paradoxical situation succinctly explained by Lears: "The artist may appropriate, reinterpret or recombine image fragments from that realm, but the tension between the art work and the advertising remains" ("Uneasy Courtship" 151). To express his own rather cynical conflicted response to advertising's inflated power, Davis drew an analogy between the persuasive force that religion held in earlier times and that of contemporary advertising. "According to all reason," wrote Davis in his journal, "there . . . still are thousands of Christs but they came at a time when advertising is given to tobacco" (87).

In linking Christ to contemporary advertising, Davis anticipated the wildly popular book published in 1924 by Bruce Barton (1886–1967), *The Man Nobody Knows*, in which the conventional story of Christ is reinterpreted in modern terms. Barton characterizes Christ as a kind of George F. Babbitt, "the friendliest man who ever lived, . . . [who] would be a national advertiser today, I am sure, as he was the great advertiser of his own day" (58, 140). As Steven Fox wrote, "The book offered a very masculine Jesus, strong from carpentry, laughing, convivial, the most popular dinner guest in Jerusalem." Significantly, Barton was an adman himself, the head of one of the hottest advertising agencies in New York: Barton, Durstine and Osborn, or BDO as it was called. In his position at the pinnacle of power in the advertising world, Barton seems to have had delusions of grandeur. He described himself as a writer as well as an adman, and he published articles, interviews with public figures, editorials, and "snappy homilies about success and happy living, often with a religious moral." Believing that Christ's stories

exemplified "all the principles of modern salesmanship," Barton may well have seen himself as a Jesus-like figure, proselytizing for a new cause (Fox 107). The book was a huge success, selling 250,000 copies in eighteen months. In its elevation of the adman (along with the engineer, a new superstar of the 1920s) and in its veneration of the commercial world, Barton's book seemed to endorse the proliferation of commercial products aggressively promoted by new advertising campaigns.

Whereas Barton's espousal of commerce as the new religion was written in all seriousness, Davis's was tongue-in-cheek satire. As such, it provides a corollary to *God* (ill. 45), a still life of sorts comprised of a plumbing trap mounted on a miter box and created in 1918 by Elsa von Freytag-Loringhoven and Morton Schamberg. With ironical detachment, the artists have elevated of a piece of plumbing, a mass-produced commodity, to the status of God and in so doing have recognized a radical new force which was galvanizing the populace's attention and replacing traditional systems of belief. Very much in the same spirit, Davis deemed advertising the new religion and the adman the new Savior.

The growing prestige of advertising also led many culture critics to lambaste its penchant for manipulation and exaggeration. J. Thorne Smith, writing in Harold Stearns's 1922 anthology, *Civilization in the United States*, identified advertising as "America's cruelest and most ruthless sport, religion, or profession, or whatever you choose to call it. . . . It coddles and toys with all that is base and gross in our physical and spiritual compositions." He went on to parody advertising copy: "There would be . . . days when I should ride in a motor of unrivalled power with companions of unrivalled beauty, across canyons of unrivalled depth and mountains of unrivalled height" (382–383). Sensing not only the seductive lure but also the aggressively macho side of advertising, he warned, "Let it never be forgotten that advertising is a red-blooded, two-fisted occupation" (384). Though largely critical of advertising as responding "most readily to the appeal of selfishness and snobbery," Smith acknowledged the positive effects that advertising has had on our consumer environment, conceding that "advertising is largely responsible for the remarkable strides we have taken in the art of typography" (384, 391). Smith also contended that advertising could provide a model of sorts for writers. Taking issue with the assertion that "advertising is injurious to literary style," he wrote, "If anything, it has forced a number of writers to say a great deal in a few words, which is not in itself an undesirable accomplishment" (391).

While Smith's endorsement of advertising is not entirely without irony, Matthew Josephson's enthusiasm was quite genuine. In his well-known essay "The Great American Billposter," published in *Broom* about the same time, Josephson also advocated a greater sensitivity among younger writers "to the particular qualities in their material environment," urging them to take "fresh stimulus . . . [from] the literature of the billposter" (312). He also compares an "adroit line" from Keats, "The beaded bubbles winking at the brim," to an advertising slogan written by an "anonymous genius": "MEATY MARROWY OXTAIL JOINTS": "The motives of these two young men . . . are superficially different, since the latter was written for the glorification of Campbell's soup and the former for that of Psyche, but they both arrive at the same end, a line of pure poetry, by the same mental process" (310).

On one level both Davis and Josephson openly embraced the new advertising environment. The economy and efficiency of advertising copy for Josephson and of its imagery for Davis are precisely what these two found so attractive about advertising. However, their regard is inflected with a critical edge. During this period the relation between advertising and art remained an adversarial one largely because of what Lears has called their "bedrock differences of purpose": whereas ad makers function as "cogs in a vast cultural apparatus that justifies and celebrates the existing economic system," the artist seeks "some vision—however fleeting—of a world elsewhere, beyond the inane logic of getting and spending" ("Uneasy Courtship" 151). In injecting their admiration with irony, artists and writers thus critiqued the world of advertising. If they did not exactly provide a concrete vision of an alternative world, at least they warned of the pitfalls of complete surrender to the dominant one provided by commercial advertising.

Davis elaborated on the subversive intentions of his tobacco paintings in his journal entries of the early 1920s, which often take on a playfully iconoclastic spirit. At one point, he proposes filling in "the outline of a head . . . with a tobacco label"; at another, filling in "the outline of a figure . . . with the advertising copy of Campbell's soup. . . . It seems to me that this would be screamingly funny and would satisfy any perverse tendencies one might have in the bargain" ("Journal" 18). When it came to painting a series based on advertising, Davis made a significant choice: he opted for tobacco over Campbell's soup, which would have to wait forty years for Andy Warhol's attention. This decision is notable because, whereas Campbell's soup was an unobjectionable subject, tobacco was surrounded with a fair amount of controversy, especially in the early 1920s. This was the era of fervent attempts at prohibition—not only of alcohol but also of prostitution and smoking. As soon as the Eighteenth Amendment was ratified in 1920, prohibitionists revived the antitobacco movement. "Prohibition is won; now for tobacco" became the motto of tobacco abolitionists (Wagner 46). Davis's introduction of such a theme in 1921 suggests his self-proclaimed perversity in addressing controversial issues of the day. The artist's formative Ashcan years had conditioned his resistance to restrictions on any freedom, whether concerning definitions of art or personal habits like drinking and smoking.

Perhaps more than commentaries on American advertising, the tobacco paintings serve as celebrations of such personal freedoms as tobacco consumption. By linking advertising to tobacco, Davis acknowledged the seductive power as well as the pleasure he derived from both. Given the fervent demonization of tobacco in the present cultural climate, it is hard to appreciate the unconstrained—and unapologetic—praise directed toward tobacco in the early years of the last century. Such adulation was not universal, as the prohibition movement makes clear, but the criticism of tobacco consumption in the 1920s came nowhere near the extremes of the censorious fervor of present-day antitobacconism. What has been ignored in past discussions of Davis's tobacco series (my own included) is the fact that these paintings are not solely testaments to and critiques of advertising cleverness. Rather, their beauty bespeaks Davis's own appreciation of tobacco products, indeed, his enjoyment of smoking itself. At least one contemporary critic identified this love for tobacco as a significant source for Davis.

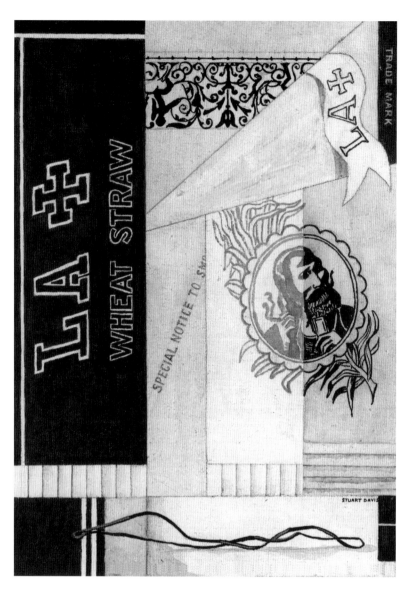

30. Stuart Davis, *Cigarette Papers*, 1921. Oil, bronze paint, graphite pencil on canvas, 19 × 14 in. The Menil Collection, Houston.

Reviewing Davis's 1921 show at the Whitney Studio Club for the *New York Sunday Herald*, Henry McBride wrote, "Mr. Davis's cubism seems to have been induced by good smokes. At least, in most of them he sounds cubistic praise of well known brands of cigarettes." Davis pasted a clipping of this review in his journal, next to which he added: "Music to the ears" ("Journal" 31).

Davis's unorthodox still-life paintings also make reference to the transformation of social habits—to the changing social patterns of tobacco consumption during the postwar years. Cigarette papers are prominently displayed in *Bull Durham* and in *Cigarette Papers*, Zig Zag in one, La Crosse in the other (ills. 28 and 30). These references attest to the growing popularity of cigarette smoking as distinct from other forms of tobacco consumption—pipe and cigar smoking and chewing tobacco. After the war, men who had smoked cigars and pipes or had chewed plug were switching to cigarettes at a rapid rate. As Schudson notes, "Cigarette tobacco outsold pipe tobacco for

the first time in 1919; it passed cigars in 1921, and it outsold chewing tobacco for the first time in 1922" (184).[4]

While gaining in popularity prior to World War I, cigarettes were not the hot commodity they became thereafter; in fact, they were regarded by some as "a debasement of manhood." Boys were warned, "With every breath of cigarette smoke, you inhale imbecility and exhale manhood" (qtd. in Wagner 43). Advertising campaigns tried to counter this prevailing image. One of the more outrageous attempts was the copy for a Bull Durham advertisement of 1914:

> **ENVIRONMENT doesn't make a man—or a "Bull" Durham smoker. There are red-blooded, self-reliant, energetic "men" in every walk of life—and these are the *millions* of men, of *all* classes and occupations, who find thorough *satisfaction* in the *fresh*, fragrant cigarettes they *roll for themselves* from "Bull" Durham tobacco. The rugged millionaire sportsman and his able-bodied guide in the great North woods are at opposite ends of the false social scale; but in the true *measure of manhood* they meet on an *equal footing*—share the same sack of "Bull," and *Respect* each other for being *men*. (ill. in *"Sold America!"* 56)**

Designed to counter the lingering associations of prerolled cigarettes as somehow feminized, such ads implied that if you rolled your own cigarettes (using Bull Durham tobacco, of course), cigarette smoking could be a manly enterprise. As noted above, allusions to cigarette papers and tobacco pouches in *Bull Durham* refer not to packages of cigarettes but to packages of loose tobacco marketed for those who roll their own. In fact, all of Stuart Davis's tobacco paintings refer to packages of tobacco rather than to prerolled cigarettes. As indicated by the stenciled lettering, even *Lucky Strike*, often mistaken for a package of cigarettes, features loose "roll cut" tobacco. Davis's engagement with the supposedly more manly activity of rolling one's own cigarettes certainly illuminates something of the changing social habits of the postwar years; more important, it also reveals his need to establish his identity as a modern painter by association with an activity considered distinctly masculine.

The entry of the United States into World War I in 1917 did more than advertising campaigns to change the image of cigarettes—to legitimate cigarette smoking as a masculine habit. General John J. Pershing cabled Washington, D.C., "You ask what we need to win this war. I will tell you, we need tobacco, more tobacco—even more than food." And he wrote directly to R. J. Reynolds, "Tobacco is as indispensable as the daily ration; we must have thousands of tons of it without delay" ("*Sold America!*" 56). The result was a mad rush to send tobacco to the soldiers overseas. Significantly, the date on the tobacco sticker in Davis's *Bull Durham* reads 1917, marking America's entry in the war and Bull Durham's mass shipping of tobacco to France. The railroad boxcars used to transport the tobacco to shipping ports provided a highly visible site for advertising copy. Much as Burma Shave ads were placed along the

highway, catchy slogans lauding Bull Durham were emblazoned on each boxcar. But where Burma Shave ads were static, small in scale, and meant to be read by passing motorists, Bull Durham's were giant billboards in motion. Boxcar after boxcar displayed such slogans as:

**AMERICA'S BEST FOR AMERICA'S BRAVEST!**
**THE "MAKINGS" OF A NATION**
**THE SMOKE THAT FOLLOWS THE FLAG IS ALWAYS GOOD OLD BULL**
**WHEN OUR BOYS LIGHT UP, THE HUNS WILL LIGHT OUT SMOKING OUT**
**THE KAISER**
**ROLL YOUR OWN INTO BERLIN! (*Sold America!*" 56–57)**

Magazine ads, too, show the patriotic zeal of tobacco advertising. An ad in *Harper's Weekly*, for instance, depicts several soldiers in the act of smoking and rolling cigarettes as they strategize in a bunker, and features the caption: "Roll 'Bull' Durham into a cigarette and you have a smoke with all the vim, vigor and dash of Uncle Sam's fighting men. That's why the American Army is an Army of 'Bull' Durham smokers. 'Bull" Durham puts snap into their action and 'punch' into their systems. For a virile, lively, manly smoke, 'roll your own' with 'Bull' Durham" (*Harpers Weekly*, February 12, 1916). Such macho declarations served not only to elevate cigarette smoking to hypermasculine level but also (and most significantly from the perspective of advertising) to sell more tobacco by making it an indispensable part of the war effort.

Also in 1917, the American Tobacco Company launched Lucky Strike cigarettes as a competitor to Camels, perhaps the most popular brand among soldiers in France. A new package was designed, which took as its departure the design (and name) of a brand of chewing tobacco, or "sliced plug," licensed in 1871 by the R. A. Patterson Company of Richmond, Virginia.[5] The package's colors, dark green for the background with a central red target, were no doubt chosen for the vibrant visual dynamic of complementary colors often favored by advertising artists; however, Lucky Strike was soon to promote an identification between the dark green of the packaging and the color of American soldier's uniforms—affectionately called "Lucky Strike Green."[6] Such brands as Lucky Strike and Bull Durham so aggressively pushed their cigarettes as contributors, indeed, as major actors in the war effort that almost overnight the cigarette became a potent symbol of American patriotism; a new slogan "Tobacco is American" also promoted the idea. So zealous was the public's position on this issue that opponents of tobacco were considered anti-American, even treasonous (Wagner 44–45).[7]

Tobacco advertising thus sought to insinuate itself into the discourse of wartime heroism and patriotism. By constantly reiterating the linkage between cigarettes and the masculine virtues of the soldier—"the vim, vigor and dash of Uncle Sam's fighting men"—advertising copy sanctioned hugely inflated ideals of masculine behavior. And by appropriating and thereby endorsing the almost bellicose masculinity of wartime propaganda, advertising exacerbated what Amelia Jones has called the

sense of "equivocal masculinity" of those who did not fight in the Great War (162). It should be noted that Stuart Davis served in the army, but he remained in this country working as a cartographer in the U.S. intelligence department and preparing materials for the peace conference. He did not see action in the trenches abroad. Perhaps the artist's focus on tobacco in his paintings not only referenced tobacco's enormous role in the war but also his own need to compensate for not having had a more active role in the war effort and to shore up his own compromised masculinity.

Davis's *Sweet Caporal* of 1922 alludes more specifically to the military, and to military rank, as a way of glorifying the cigarette habit. Sweet Caporal was marketed by the American Tobacco Company as a slightly upscale tobacco. Its name alone has an elitist tinge: as defined in the *American Heritage Dictionary*, "caporal" is "a strong, dark cigarette and pipe tobacco derived from the French *tabac de caporal*, Corporal's tobacco, (superior to *tabac de soldat*, soldier's tobacco)." Even though caporal, or "black" tobacco, as well as the Sweet Caporal brand had been on the market in America since the late nineteenth century, the popularity during World War I of "Sweet Caps," as they were called, may speak to their timely military associations. Davis's painting *Sweet Caporal*, featuring a torn-open tobacco package and the words "U.S. America," puts the French name of this tobacco into an American advertising context.

Embedded in these "tobacco pictures" are also signs of significant transformations occurring in American marketing and advertising practices. *Bull Durham* and *Lucky Strike*, for instance, document the change from bulk packaging in large barrels to the packaging of products in smaller quantities. The reference of the trompe l'oeil burlap in *Bull Durham* is to bulk packaging, which was in the process of being phased out at this time. *Lucky Strike*, however, alludes not to burlap sacks but to a strikingly designed individual package; indeed, designers began to feature the package itself as a form of advertising. Davis himself extolled "the beauty of [this kind of] packing. Where a few decades ago everything was packed in barrels and boxes, they now are packed singly or in dozen or half-dozen lots as the control over distribution increases. This symbolizes a very high civilization in relation to other civilizations" ("Journal" 38). And, of course, it also demonstrates advertising industry's savvy in finding new ways to reinforce brand names and manipulate its audience.

Davis's enlargement of the package itself in *Lucky Strike* inevitably anticipates Warhol's *Campbell's Soup* paintings. Like Warhol, Davis approximates the scale not of what he represents but of billposters. By blowing up the package, he emphasizes the "high visibility" that he so admired in contemporary ads. Interestingly, Davis's choice of Lucky Strike indicates a greater affirmation of the present than does Warhol's. As Adam Gopnik has pointed out, Warhol "remained attached to an extraordinarily . . . old-fashioned cast of characters," the Campbell's soup can being "an object that dates from the turn of the century, from the first flowering of American commercial design" (111). Warhol seems governed by nostalgia for a product whose producer, too, often used nostalgia as a means of marketing; for instance, in a Campbell's soup advertisement from the late 1920s (ill. 31), the image inspires the fantasy of a return to a simpler, more rural America. Rather than Warhol's (or Campbell's) nostalgia,

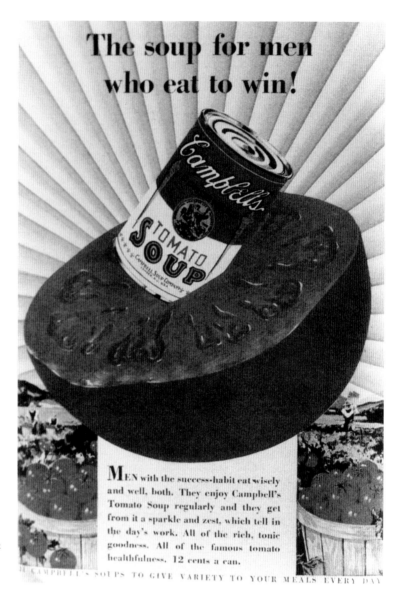

The soup for men
who eat to win!

MEN with the success-habit eat wisely
and well, both. They enjoy Campbell's
Tomato Soup regularly and they get
from it a sparkle and zest, which tell in
the day's work. All of the rich, tonic
goodness. All of the famous tomato
healthfulness. 12 cents a can.

CAMPBELL'S SOUPS TO GIVE VARIETY TO YOUR MEALS EVERY DAY

31. Campbell's Soup advertisement
in *American Magazine* (October
1929): 75.

Davis's offers an emphatic contemporaneity. Who could be nostalgic about a Lucky
Strike logo just redesigned in 1917?

Noteworthy, too, is the fact that Davis selects for his subject Lucky Strike
instead of such brands as Camel (Lucky Strike's major competitor at the time) or
Murad, Fatima, or Omar, other popular American brands whose use of Turkish blends
is manifest in the brand name itself. With their images of pyramids (Camel) and reclin-
ing harem figures and Egyptian goddesses (Murad), these brands promised the thrill
of Near Eastern exoticism with its concomitant escapism and eroticism; such advertis-
ing played on cigarettes' link to transgressive behavior in a faraway paradise (ill. 32).
In contrast, the Lucky Strike package—and Davis's painting—offered a "strikingly"
American visual experience. Rather than escape to a far-off land of untold pleasures,
the allusions of Lucky Strike are distinctively American, linked not to the exotic but
to the color of American soldiers' uniforms and more indirectly to the American

32. Murad advertisement in *Harper's Weekly* (19 February 1916): back cover.

frontier—to the 1849 Gold Rush, when Lucky Strike was a brand name of chewing tobacco (Klein 51).

Even *Sweet Caporal*, the only painting in the series with a hint of the Near East, avoids such exoticism. Unlike Camel or Murad, whose advertising logos pointedly elicit exotic fantasies, Sweet Caporal packaging buries such allusions under markedly modern design principles. The centralized bell shape does recall the traditional red felt fez worn by the Zouaves, the Algerian tribesmen who fought with the French in the Crimean War in the 1850s. However, in Sweet Caporal packaging—and in Davis's more stylized adaptation—the bell-shaped cap is abstracted to such an extent that it is hardly recognized as such.[8] Furthermore, during the Civil War the colorful uniforms of the Zouaves were adopted by several Union regiments, which have been well documented in Winslow Homer's paintings (Simpson 167–169). Especially in the nationalist climate of the postwar years, Davis's cryptic reference to such a costume points to an American rather than an Algerian source, and his desire for contemporaneity dictates a masking of exoticism in favor of a strikingly modern composition.

Stuart Davis's works are worth considering in relation to Joseph Stella, an Italian-born American modernist who enlisted the theme of tobacco for several collages, including *Mecca* and *Black Descending*.[9] While Davis's embrace of urban and contemporary America insinuated a note of irony, Stella's was even more conflicted. He was torn between allegiance to the historical and to the contemporary, to the human-made and to the natural environment. And whereas Davis came to advertising content from the streets of New York, Stella approached this same material with one foot still in the Old Country, Italy, with all its historical baggage. The powerful hold that both the old and the new, the natural and the industrial, had on his imagination, is evident in the dichotomous title he gave to his collages: *Macchine Naturali*, usually translated as "natural constructions."[10]

Unlike the simulated packaging represented in Davis's paintings, which seems fresh and new, the paper Stella selected for his collages invariably shows signs of having been used and then discarded, tossed aside as worthless scrap. To a greater degree than Davis's, Stella's works engage Schwitters-like evocations of a commercial culture enmeshed in the pseudobiological cycle of production, consumption, and abandonment. Industrially processed from natural tree fiber, this paper was then transformed into commercial advertising, after which it was exposed to natural processes of decay and decomposition (Moser 79). This is, of course, a reiteration of the age-old cycle in which all human-made objects are ultimately reclaimed by nature, and Stella injects a distinct nostalgia for a state of nature from which civilization has clearly fallen. In spite of his praise for technological icons, especially the Brooklyn Bridge, which Stella saw as "the shrine containing all the efforts of the new civilization of AMERICA," Stella constantly sought refuge in nature (Moser 87). Embedded in the imagery and the materials of his *Macchine Naturali* is a yearning for a world restored to a pure and almost precivilized condition.

Even though Stella used unorthodox material, "ready-made" objects from the gutter, his collages ultimately suggest a more Symbolist than Dadaist direction. With their subtext of decay, Stella participates in the strong Symbolist current in early-twentieth-century American art, also found in the art of Dove, O'Keeffe, and Weber, among others. At least in part, this may be a function of the artist's Italian heritage and his admiration for his compatriots, the Italian Futurists, whose own roots and works exhibit undercurrents of Symbolism. Like O'Keeffe's work discussed in the previous chapter, Stella's intimation of the passage of time also calls to mind the Vanitas theme found in Italian paintings going back to Caravaggio.

The subtext of time passing and decay embedded in Stella's tobacco collages also—and inevitably—implicates the destruction wrought by tobacco itself. While Davis's *Lucky Strike* holds out the promise of a bright future, Stella's *Macchine Naturali*, especially perhaps a work entitled *Black Descending*, suggest descent into decay. The main feature of this latter work, a once bright green package of Lucky Strike tobacco, has blackened with age, rendering the lettering on the red logo only partially legible: "a blend of Burley and Turkish Tobacco." Instead of the resolute youthfulness of advertising suggested by Davis's painting, *Black Descending* more closely resembles

Man Ray's *New York 1920*, a straightforward, unelevated photograph of the contents of an ashtray overturned in a gutter: a couple of cigar and cigarette stubs, ashes, and burned matches and paper. Instead of anticipating the slick pop of Andy Warhol, as does Davis, Stella foreshadows Claes Oldenburg's drawings for *Fag Ends* in the mid-1960s, his proposed colossal monuments to cigarette butts, and even more so, Irving Penn's 1972 black-and-white photographs of cigarette and cigar butts in various stages of disintegration. British artist Damien Hirst's more recent presentation of actual crushed cigarette butts in an installation called *Party Time* perhaps best sums up the powerful resonance of these artists' presentation of the dregs of smoking. He sees the cigarette as a universal metaphor for life—"beginning pure and white, burning down to ash and a crushed butt" (Vanderlip). In the current climate, the implied health threat surrounding these works looms large. From our perspective, Stella's focus on decay also, and necessarily, gives rise to such fears. Davis, on the other hand, never acknowledged the detrimental effects of smoking, and his paintings resonate with the positive aura of health and well-being conveyed by tobacco advertising itself.

During his entire career Davis was an emphatically urban artist. He extolled the nitty-gritty aspects of the city, the visual and aural rhythms of the urban world, from jazz and the congestion of streets to neon signs and billboards. Cigarette smoking, too, increasingly acquired urban associations in the postwar years and quite naturally took its place as a central theme in Davis's art. Clues to the cigarette's urbanity can be found in texts of the period. For instance, in a story appearing in *Ladies Home Journal* in 1922, John Smith, a regular cigar smoker, switches to cigarettes on arrival in New York, "a transition of taste charged to the metropolitan life" (qtd. in Schudson 198). The fact that cigarette smoking, more than other forms of tobacco consumption, was thought to be cosmopolitan and "citified" no doubt affected Davis's decision to paint such a series; with their bold graphics, the tobacco paintings partake of such urban associations.

Davis gravitated toward tobacco for another reason as well, the democratic appeal of this product. By the 1920s advances in mass-production methods made goods and luxuries that had been unobtainable a generation earlier available to large numbers of people. This democratization of goods in part explains the expanding use and popularity of cigarettes in the 1920s and the fact that smoking was increasingly seen as a distinctively democratic activity (Schudson 180). Mass-produced and heavily advertised, cigarettes were cheaper and more readily available than ever before. Anyone could buy and smoke cigarettes, and smoking was becoming an increasingly communal experience. Davis felt that painting, too, should participate in this process of democratization, and he expressed this sentiment time and time again in journals kept in the early 1920s: "I desire to have on the canvas a picture of America to-day that everyone can understand . . . to express everyday American life in vigorous art" ("Journal" 49, 51). With such calls for the democratization of art, Davis redefines the relationship between high and popular culture, while also redefining his relationship to the audience. Davis at once rejects conventional content and elitist patronage; he wanted his paintings to be understood by everyone. However, his adoption of the

dual role of aesthetic innovator and adversarial critic of contemporary culture ren-
dered such a goal unattainable. Though successful in meshing popular content, aes-
thetic innovation, and cultural commentary in his tobacco paintings, the artist was
unsuccessful in attracting a broad public. While 1921 marks Davis's first appearance
in a group show at the Whitney Studio Club, which, as we've seen, attracted reviews
from major critics like Henry McBride, this attention did not translate into sales and
widespread attention among the art elite much less the broad American public he
had in mind. This lack of attention—and his consequent lack of commercial success—
seems to have greatly perplexed Davis at this point in his career.

By infusing his tobacco paintings with a democratic spirit, Davis also perpetuates
a nativist—and populist—tradition going back to Walt Whitman, an earlier hero of
American culture. Whitman was held up as an inspirational model by many American
modernists, including Joseph Stella, Louis Lozowick, and John Storrs. In the early
decades of the century, so many artists and writers invoked his name in their attempt to
carve out a distinct national identity that in 1923 Malcolm Cowley exclaimed, "before
Walt Whitman America hardly existed" (qtd. in Baigell, "Walt Whitman" 121).

Davis quite explicitly expressed a kinship with Whitman: "I, too, feel the thing
Whitman felt—and I too will express it in pictures—America—the wonderful place
we live in." He lauded Vachel Lindsay, Edgar Lee Masters, Carl Sandburg, and William
Carlos Williams as "all in some way direct descendants of Whitman our one big
artist" ("Journal" 39). Davis admired Whitman's poetry largely for its populist appeal.
In "Song of Myself," for instance, Whitman wrote: "Whatever interests the rest inter
ests me . . . politics, churches, newspapers, schools, / Benevolent societies, improve-
ments, banks, tariffs, steamships, factories, markets, . . ." (74). Like Whitman, Davis
favored everyday subjects: "let each picture . . . deal with purely local, transitory sub-
ject matter. . . . I desire to express everyday American life in vigorous art. A common
subject such as 'businessman and skyscraper,' 'Babe Ruth,' 'Sporty Automobiles,'
etc." Unorthodox though these subjects were, they were ideally suited for Davis's
indigenous expression of America. Again invoking Whitman, Davis proclaimed: 'Let
us have in conjunction with the 'popular song' and the 'popular book' the 'popular
picture' " ("Journal" 35, 51).

Both men sought to introduce unexalted content as well as to bring the artist
off a pedestal. Davis, for instance, wrote that the artist is "a man with a definite place
in the commerce along with the merchant and the bootlegger. No better, no worse"
("Journal" 137). And Whitman referred to the great poet as "the equalizer of his age
and land. . . . We [great poets] are no better than you" (13).[11] In invoking the name
of Whitman to justify his own identification with the common man and his own
rebellious artistic spirit, Davis thus keys into a populist tradition in American intellec-
tual thought that Baigell terms "radical, disjunctive, and subversive" ("Walt
Whitman" 123).

Key to such populism, of course, was an embrace of the contemporary world,
signified by new developments in the engineered environment. Davis's connection
with that environment through a constructive mode of art-making has been well

established. Whitman, too, often addressed identification with contemporary techno-logical developments in his poetry. In "Passage to India," for instance, Whitman wrote:

> *Singing my days,*
> *Singing the great achievements of the present,*
> *Singing the strong light works of engineers,*
> *Our modern wonders, . . . (411)*

For Davis and the American avant-garde, Whitman clearly personified what was most highly valued: an energetic embrace of the contemporary and of the democratic ideals of America.

This populist dimension finds its fullest expression in the final work of the tobacco series, *Lucky Strike* of 1924 (ill. 33), a painting in the Hirshhorn Museum. With its horizontal rather than vertical format and its more complex array of still-life objects, the painting seems quite anomalous. Rather than simulating a billposter, as does the painting of the same title in the Museum of Modern Art, this version suggests an immense billboard in a landscape setting as if seen from the perspective of a passing automobile. Such a conflation of billboard and landscape brings to mind the pronouncements of Fernand Léger, an artist whom Davis greatly admired and who prepared the way for Davis's commentary on the advertising environment: "The advertising billboard, dictated by modern commercial needs, that brutally cuts across a landscape is one of the things that has most infuriated so-called men of . . . good taste. . . . And yet, this yellow or red poster, shouting in a timid landscape, is the best of possible reasons for the new painting" (12). As if echoing Léger, Davis's billboard-like conflation of images—a Lucky Strike package, cigarette papers, and pipe—dominates the landscape indicated by subtle brown and blue bands of color. Interestingly, the painting also anticipates actual Lucky Strike advertisements in which the cigarette package is seen floating in space against a landscape background (ill. 34). Instead of advertising copy, however, Davis included a page from the *New York Evening Journal*, imparting a sense of the interchangeability of mass media. Davis himself identified equally with advertising and news media: "I do not belong to the human race but am a product made by the American Can Co. and the New York *Evening Journal*" ("Journal" 28). As in his earlier tobacco paintings, Davis refers here to a package of loose tobacco, alluding to the more masculine activity of rolling one's own cigarette or smoking a pipe, the implements of which Davis has also included here.

As an additional pointer to masculinity, Davis has included the front page of the sports section of the *New York Evening Journal*. Such implicit appreciation of this popular diversion (that is, reading the sports pages) was shared by contemporary critic Gilbert Seldes. In his 1924 book, *The Seven Lively Arts*, Seldes applauded the writing of Bugs Baer, a popular sports journalist of the time. "The truth is," wrote Seldes, "Baer is one of the few people writing for newspapers who have a distinct style. . . . His daily commentaries on sport are concise and entertaining. . . . His language is syncopation. His points of reference are all the common life" (85–87). The particular

33. Davis, *Lucky Strike*, 1924. Oil on paperboard, 18 × 24 in. Hirshhorn Museum and Sculpture Garden, Smithsonian Institution. Museum Purchase, 1974. Photographer, Lee Stalsworth. Copyright © Estate of Stuart Davis/Licensed by VAGA, New York, NY.

sports page that Davis used as a source features a column and a comic strip by "TAD," the pseudonym of another sportswriter of the day, Thomas Aloysius Dorgan, also a cartoonist. TAD's cartoon included euphemisms for alcohol and drinking: "that ice cream last night poisoned me," clearly a satire of the hypocrisies of Prohibition.[12] Davis's painting retains only "poisoned" from the original, but seen in relation to the smoking paraphernalia nearby this reference invokes the relationship between the Prohibition and antitobacco movements of the day. As noted earlier, buoyed by the passage of the Eighteenth Amendment, prohibitionists renewed efforts, also spearheaded by women, to outlaw tobacco. As in Gerald Murphy's *Cocktail*, implicit in Davis's elevation of male diversions of rolling cigarettes and smoking pipes and cigars is a rebuke of the largely female attempts to limit those enjoyments. Furthermore, Davis locates these objects not in the expected home interior; instead, they loom large as if depicted on an enormous billboard. Davis has extracted still-life components from the domestic sphere, so that they might engage the larger world of advertising and mass culture.

The five tobacco paintings discussed above make up a series unto themselves; however, there is an "amazing continuity," to use Davis's jazzy phrase, between this series and later works. The artist continued his love affair with tobacco iconography for the rest of his career. Paintings on this theme include—to mention only a few painted within the next decade— *Matches*, 1927; *Barber Shop*, 1930; *Magazine and*

34. Lucky Strike advertisement in *American Magazine* (September 1930): 129.

*Cigar*, 1931; and, perhaps the most blatantly macho painting, *Mural (Men without Women)*, commissioned for the men's smoking lounge of New York's Radio City Music Hall in 1932. This mural continues the theme of the outdoor still life begun in the Hirshhorn *Lucky Strike* but on a grander scale; at approximately eleven by seventeen feet, this is the artist's largest painting to date. On a lofty stage that is at once a smoking room and a sea-, city-, and landscape, greatly enlarged still-life objects (matches, pipe, playing card, cigar, cigarette pack, and pouch of Stud tobacco) successfully compete with other male-coded artifacts (barber-shop poles, gas pumps, sailboats, and architecture). Especially given its title, this painting greatly amplifies the machismo of the earlier tobacco paintings; indeed, the works of the 1920s are subtle in comparison. *Men without Women* also reeks of male entitlement, in part because of its placement in a male preserve of the single-sex smoking lounge of Radio City Music Hall. There is a sense, too, that this exaggerated maleness may reflect Davis's misgivings that such male sanctuaries were being increasingly threatened. As Davis himself complained, "the flappers had taken over. Only McSorley's Ale House was left. But they couldn't get into the Men's Room . . . to see my mural" (qtd. in Kachur,

"Stuart Davis and Bob Brown" 73).[13] Art Deco designer Donald Deskey had provided the overall design for the interior of the music hall, and he also selected Stuart Davis to do the mural for the men's room. With its focus on tobacco products, *Men without Women* displays a thematic resonance with other elements of Deskey's design—particularly, the second-floor "Nicotine" lounge which, appropriately, was covered in cigarette foil provided by the R. J. Reynolds Tobacco Company and then embossed with a Deskey pattern (Iovine 1).[14]

Given his fixation on the implements and the practice of smoking, it bears noting that the artist continued his cigarette habit for the remainder of his life. Judging from the photographs of Davis in his studio, smoking was an essential part of his modus operandi—facilitating the process of painting itself, sharpening his concentration, and enhancing his artistic deliberations. However, such long-term addiction had its consequences; Davis paid the heavy price of a shortened career, dying of a stroke in 1964. Though smoking proved destructive to his health, it provided the inspiration for the "tobacco pictures," perhaps his most stunningly provocative series, and, in the years that followed, for many additional notable works. Stuart Davis's revolutionary tobacco paintings celebrate the audacity and vibrant energy of advertising in the machine age. But more than a simple veneration of American popular culture, these works document the transformation of social habits of the postwar years while at the same time exposing the manipulative practices of advertising. As well, through his embrace of the visual imagery that pervades everyday life, Davis renegotiated the boundaries between high and low culture while also reinvigorating the genre of still-life painting as a valid avant-garde enterprise. Most striking, however, are the ways that Davis and his compatriots recontextualized this genre by seeking out and privileging male-coded subjects such as tobacco, in the process certifying their own masculinity and validating modern painting.

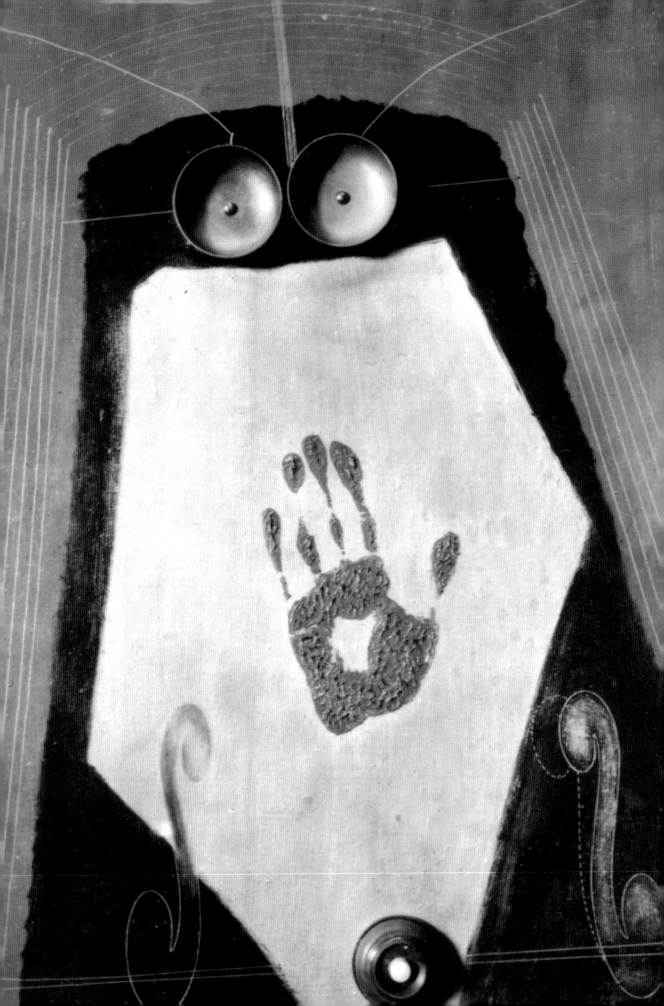

Part Three

# PORTRAITURE

# 5

# The Constructed Self

*Machine Age Portraiture*

The genre of portraiture is, as Richard Brilliant noted, "especially sensitive to changes in the perceived nature of the individual in Western society" (8). It is not surprising, therefore, that in an era of machine domination, mechanical symbolism intruded more aggressively into the realm of self-representation than into any other genre. Many of the portraits of the American avant-garde have little, if any, recognizable relationship to their subjects. No longer based on mimesis, these new portraits, usually called "object portraits," feature words, images, shapes, and sometimes even found objects selected and juxtaposed so as to signify distinctive attributes of each individual. The process of decoding such portraits, which have no or very little mimetic resemblance to their subjects, is quite different from making sense of conventional portraiture. Even if nothing is known about the subject of a traditional portrait, the viewer can learn from the painted likeness; for instance, character can be read in the face, social status inferred from the clothing, and so on. But since "object portraits" do not give us a legible face—or clothing or setting or even an identifiable human being—their decoding is a more difficult task. Object portraits depend more on the knowledge the viewer brings to the portrait. Consequently, this kind of portraiture may seem less accessible, even hermetic. At the same time, once the requisite knowledge is acquired, such portraits can achieve a kind of intimacy. So, while they seem to be effacing personality, they depend on and encode innermost knowledge of the subject's identity. Furthermore, in that such portraits are more constructed objects than semblances of their subjects, they can also attest to the effect of mechanization on the artist's consciousness.

These machine-age portraits raise key questions about the role of the machine in creating ideas of personal identity during and just after World War I. On the surface, these works represent the dehumanization—even the erasure—of self, in Linda Nochlin's words, "the loss of the tradition of the self in an age of mechanical reproduction" (121). But one could argue that the presence of the mechanical reflects a new mode of rendering identity and individuality in the modern world. In other words, rather than presenting technology as obscuring or threatening the traditional

nature of portraiture, these works may invoke technology to reassert those values in an oblique way.

In any case, it is clear that both the European and the American avant-garde were intent upon defining self in terms of technology in this period. The European Francis Picabia was certainly one of the first artists to recognize, and to alert the American avant-garde to, the machine's centrality in American culture—and its role in generating new modes of identity construction. "Almost immediately upon coming to America," Picabia stated in an interview, "it flashed on me that the genius of the modern world is machinery, and that through machinery art ought to find a most vivid expression" (rpt. in Kuenzli, *New York Dada* 131). Picabia responded to this challenge with machine portraits published in Alfred Stieglitz's journal *291* in 1915. All five portraits feature images of various machine parts, mostly automotive components such as gear shifts, combustion cylinders, camshafts, and sparkplugs. Picabia's renderings are very schematic; in fact, he appropriated images from diagrams in books on product design.[1] Picabia appropriated the language of industry, rather than subjecting this content to his own artistic handprint or style. (Or perhaps the industrial becomes his handprint.) More like mechanical drawings or "blueprints for production" than traditional portraits, these images encode the world of engineered mass production (Nesbit, "Ready-Made" 59).[2]

Picabia's nonmimetic portraits thus picture their subjects through implicit correspondences between machines and individual personalities. The complex network of component parts in *De Zayas! De Zayas!*, for example, which has been decoded as representing the electrical and lubricating systems of an automobile, alludes to de Zayas's role in generating ideas and in keeping things running smoothly as editor of *291*. (Silk, *Automobile* 77–78). In another work in the series, a self-portrait entitled *Le Saint des Saints*, Picabia superimposed an automobile horn on a cross section of a combustion chamber in a manner suggestive of sexual intercourse, playing on his own reputation as a womanizer. This impulse to create analogies between individuals and machines announces the radical transformation of identity construction in the machine age.

Inspired by Picabia's object portraits, Paul Haviland, a contributor to *291* and another of Picabia's portrait subjects (represented as a portable electric lamp), also explored this crucial innovation of metaphoric portraiture. "We are living in the age of the machine," Haviland declared in 1915. "Man made the machine in his own image. She has limbs which act; lungs which breathe; a heart which beats; a nervous system through which runs electricity." Haviland goes on to describe the machine as being "yet at a dependent stage. . . . She submits to his will but he must direct her activities. . . . Through their mating they complete one another" (n. pag.). Haviland seems to perceive the relationship of the human and the mechanical as one of mutual completion; Picabia's machine portraits, too, present this relationship as one of interdependency, perhaps not so much threatening human impulses as extending them.

As in the many depictions of automaton-like figures, implicit in the conception of portraiture based on such mutual dependence is a process of recovery—the recovery of human identity within the realm of the machine. As we've seen, Philip Fisher sees great significance in this recognition of linkages between the world of machines

and the human image—this "effort to free from inside man-made things the fact of their humanity." If applied to portraiture, this theory suggests a reading of these machine portraits not in terms of a loss of individuality but rather as a renewal of self in the machine age. It is through this recognition, this "fundamental act of connection," that a new identity takes form (Fisher, "Recovery" 141, 145–146). Such a theory tends to divert attention away from the threats posed by the machine; however, the American avant-garde's search for a new identity within the world of the machine was instigated by the fears of the machine somehow taking over their identity. The resulting condition of mutual dependence may thus explain the acute ambiguity running through so much of this art, as well as the duality, indeed the plurality, of possible readings of the works themselves.

For the New York Dadaists, the terms of this renewal were highly gendered and invariably quite regressive. Picabia's machine portraits reveal his passion for automobiles, which—especially in the early European literature of automobile culture by Octave Mirbeau and Filippo Tommaso Marinetti, among others—are often characterized as female sex objects. As Marinetti so graphically puts it in his founding statement of Italian Futurism: "We . . . lay amorous hands on their torrid breasts." He goes on to say that "a roaring motor-car . . . is more beautiful than the *Victory of Samothrace*," a comparison that further emphasizes the gendering of the automobile as female (40). Similarly, throughout Haviland's essay, he refers to man's machine creation as "she" and in terms that implicitly endorse the domination of women: "*she* submits to his will . . . *he* must direct her activities" (n. pag., emphasis mine). In a period when the machine threatens to overpower people, one understandable response is to portray people as being in control of the machine. Not surprisingly, at such times the machine tends to be gendered as female. While the gendering of the machine as female may seem to humanize machine culture, it also serves to reinscribe patriarchal values.

This mode of gendering content is further amplified and complicated in Picabia's *Portrait d'une jeune fille américaine dans l'état de nudité* (Portrait of a young American girl in the state of nudity), also from the *291* series (ill. 35). The artist has extracted a mass-produced sparkplug from its automotive function to represent the generic "young American girl." Inscribed "FOR-EVER" she becomes a perpetual flirt or "kindler of flame," in the words of Gabrielle Buffet-Picabia (258). Invented to ignite a motorcar's engine, here this mechanical component sparks erotic interest in her male audience. Unlike the other works in his series, Picabia does not give this portrait a definite identity; nonetheless, several scholars have intuited specific individuals from the information Picabia has given. William Homer has argued quite convincingly that the subject is Agnes Ernst Meyer, who was an inspirational figure for the *291* circle (110); Steven Watson agrees, especially since Meyer "drove an automobile up and down Fifth Avenue at a time when women were not identified with 'motoring' " (n. pag.); however, Gerald Silk has hypothesized that the portrait refers to several women who inspired and "sparked" his art: Gertrude Stein, Katherine Nash Rhodes, Mabel Dodge, as well as Agnes Ernst Meyer ("Object Portraits" 12). Especially because Picabia quite deliberately left the work unnamed and since the portrait is so richly evocative of an

35. Francis Picabia, *Portrait d'une jeune fille américaine* in *291*, No. 5/6, 1915. Philadelphia Museum of Art: Arensberg Archives. Copyright © 2003 Artists Rights Society (ARS), New York/ADAGP, Paris.

American type, Elizabeth Turner's interpretation of *Portrait d'une jeune fille américaine* in even broader generic terms is most convincing ("*La jeune fille américaine*" 4–21).

Picabia shared an obsession with the *jeune fille américaine* among the Parisian avant-garde; for such writers as Alfred Jarry and Jean Cocteau, the young American girl became a catalyst for change and artistic liberation. In 1917, Cocteau and Erik Satie wrote this new heroine into the ballet *Parade*; Satie composed a *Ragtime du Paquebot* (Steamship rag) for her, and Cocteau described her as "catching a train, cranking up and driving a Model T Ford, peddling a bicycle, playing cowboys and indians, snapping the new shutter of her new Kodak, [and] doing a Charlie Chaplin" (qtd. in Turner, *American Artists* 59). Such a script calling for action and independence, mobility and embrace of the new, announced a radical break with traditional expectations regarding behavior considered appropriate for a young lady. In Turner's words, "her sheer lack of physical inhibitions" was electrifying but also quite unnerving to the French audiences who attended performances of *Parade* ("*La jeune fille américaine*" 8).

Young women's fashions changed dramatically so as to accommodate such redefined and active roles in the world; the voluminous dresses and constricting corsets of the Victorian era were jettisoned in favor of straighter lines and simpler, more functional styles. Much like women's fashions of the time, the silhouette of Picabia's sparkplug is altogether lacking in womanly curves, rendering this *jeune fille américaine* remarkably androgynous. In a radical departure from traditional feminine guise and demeanor, the machine-woman asserts a manly appearance and an active sexual role. In this work, then, Picabia may be responding to the erosion of traditional gender positions. His machine-woman acknowledges a new machine aesthetic and with it the blurring of gender distinctions in this era of the New Woman.

The young American girl generated a great deal of enthusiasm in America as well, especially among writers and artists; however, like the Parisian audience of *Parade*, Americans were a bit unnerved by her audacious behavior—and by her new visibility in society, a result of World War I and numerous social forces. In greatly escalating numbers, women asserted their independence and in the process threatened male hegemony in the work force and destabilized normative gender roles. Such transgressions gave rise to fears of a "newly autonomous female type" (Hopkins 324). Picabia's portrait of the young American girl generated responses from American critics that reveal such fears. One newspaper critic, clearly taken aback by her rigid exterior, viewed the sparkplug as Picabia's critique of the young American girl as "a hard, unchangeable creature without possibilities" (qtd. in Turner, "*La jeune fille américaine*" 13). It would be a mistake to read Picabia's *jeune fille* in such negative terms; however, the work does not altogether affirm this new liberated woman—nor were many of his other works without ambivalent feelings toward the New Woman. Contemporaries who speculated on Picabia's conflicted response to the newly assertive woman include Juliette Roche, wife of Albert Gleizes and close colleague of Picabia's. Roche is known to have admired Picabia's "iconoclasm"; nonetheless, as Carolyn Burke has observed, "she was disturbed by the misogyny that she saw in [his works]—where woman as 'la machine' was at best a manipulable object, at worst the butt of a private joke" (556–557).[3] While Picabia's conception of *la jeune fille américaine* reflects the forging of new roles for postwar women, it also signals the threat of control by this newly liberated female.

The new models of representing identity posited by Picabia also informed the members of the American avant-garde, none more strongly than Man Ray, whose works were likewise highly conflicted responses to machine culture. Perhaps the underlying impulse to represent basic human traits using machine forms can best be discerned in Man Ray's self-portraits. Three years after Picabia characterized himself as an automobile horn in *Le Saint des saints*, Man Ray turned a photograph of an egg-beater into a self-portrait, punning on his own first name by entitling it *Man* (ill. 36). Male identity is also implied by the phallic shadow cast by the beater's handle. On one level, both artists identify with the essence, or the function, of the objects they represent—Picabia with the horn's capacity for announcing presence, attesting to the artist's bombastic personality, and Man Ray with the beater's ability to stir things up, alluding to his anarchic spirit. However, Picabia's conflation of horn and combustion

36. Man Ray, *Man*, 1918. Silver print, 19 15/16 × 15 1/8 in. Copyright © 2003 Man Ray Trust/Artists Rights Society (ARS), New York/ADAGP, Paris.

chamber invokes far more sophisticated mechanical processes than a simple hand-powered eggbeater. Man Ray's household tool displays a closer kinship with Marcel Duchamp's chocolate grinder than with Picabia's automotive components. Also a self-portrait of sorts, *Chocolate Grinder No. 2* of 1914 signified onanism for Duchamp; as the artist stated, "The bachelor grinds his chocolate himself" (qtd. in Sanouillet 68). Both hand-manipulated contraptions thus encode male masturbation; paradoxically, however, they were extracted from the distinctively domestic (that is, feminine) domain of the kitchen. Such a ransacking of the domestic to portray masculine identity raises intriguing questions: does this kind of appropriation suggest a valuation of the "feminine" realm, or does it represent an intrusion into that arena as a means of asserting authority over it? Or does it reflect fears of feminization of men in a period of assertive women? Where Picabia had asserted control—and his male identity—via a bulbous automobile horn, here Duchamp and Man Ray have formed more ambiguous self-images via female-identified devices.[4] As if to underscore such ambiguity, Man Ray titled a later print of the eggbeater *Femme*. This dual identification of the eggbeater as both "man" and "woman"—self and other, machine and

human—suggests not only simple identity confusion but also an anxious positioning of the self in relation to the dominant and highly mechanized worldview.

In their search for identity, Man Ray and the New York Dadaists borrowed not only from the domain of the mechanical and the domestic but also from the "primitive." James Clifford's observation that African sculpture is often characterized by "a segmented stylization suggesting a strangely mechanical vitality" is particularly relevant here (170). Likening something premodern to something modern can be seen as a means of making the latter less threatening. However, this link between the technological and the primitive can also be viewed not so much as taming technology as pointing out its "primitive" side, that is, its wild and uncontrollable potential. This association of the handcrafted and "primitive" with the mass produced and mechanical served the avant-garde not as a means of retreating from modern civilization but rather as a way of asserting a human dimension within it, and in doing so coming to terms with the world of the machine.

The merging of the technological and the primitive also served as a reassertion of the spiritual dimension of identity. This is apparent in an abstract caricature of Alfred Stieglitz executed in 1912 by Marius de Zayas (ill. 37), which pictures the photographer as a series of circles paired on either side of a vertical line and accompanied by mathematical symbols. As De Zayas explained, his subject's "material self" was to be represented by "geometric equivalents" (qtd. in Bohn, "Visualizing Women" 253). The repeated circular forms allude to Stieglitz's wire-rimmed glasses and camera lens. We know through de Zayas's writings that the portrait was intended to capture the photographer's spiritual self as well. De Zayas was fascinated with tribal art; his specific inspiration here was a "Soul-Catcher," an artifact from Pukapuka in the Pacific that de Zayas had seen in the ethnographic collection at the British Museum. By conflating camera lens with a spirit catcher, the technological with the primitive, de Zayas underscores what he saw as Stieglitz's mission as a photographer, "to catch souls and to be the midwife who brings out new ideas to the world" (qtd. in Bohn, "Abstract Vision" 435).[5] De Zayas seems to be saying that portraiture in the modern era is as much concerned with the spiritual as with the mechanical. The primitive provides the avant-garde with a means of infusing the spiritual into the world of machines, thus redeeming the machine from impersonality and, by extension, the self from dehumanization.

Such a redemption, however, is problematic in that it depends on a fundamentally essentialist view of the primitive, the notion that tribal artifacts express an elemental kinship with nature and basic human instinct as well as with the realm of the spirit. As such, the "primitive" is closely allied with essentialist conceptions of the "feminine."[6] Such attempts to engage the "feminine" and the "primitive" as well as the mechanical in the construction of self imply the redemption of the human within the machine world; but at the same time they necessarily posit an uneasy imbalance in a series of implied oppositions, such as pragmatic/spiritual, mechanical/tribal, civilized/savage, culture/nature, and—crucial to the argument presented here—male/female. This implicit privileging of the one over the other constitutes more an assertion than a critique of Western and masculine authority.

37. Marius de Zayas, *Abstract Caricature of Alfred Stieglitz*, 1912. Charcoal, 24 1/4 × 18 3/8 in. The Metropolitan Museum of Art. The Alfred Stieglitz Collection.

Man Ray's earliest machine-assemblage, *Self-Portrait* of 1916 (ill. 38), encodes such a disequilibrium in its main components: an imprint of the artist's hand, centered on a reflective silver surface between two electric bells and an electric buzzer. The three mechanical elements signify eyes and mouth but also (female) breasts and genitals (the outlines of sound holes of a string instrument become the hips). Where the technological elements resemble a kind of masklike face, or segmented body, the handprint invokes prehistoric cave paintings. Like the prehistoric hunter, Man Ray leaves the imprint of his hand to mark his presence (his signature) as well as to imply control over his prey (the woman). And because of the reflective surface, the observer's gaze is incorporated into the work, implicating the viewer as a co-conspirator in this agenda of mastery. This collapsing of self and subject intensifies the frustration that results from the artist's willful confounding of expectations. In Man Ray's words, it "made people furious. They pushed the electric button and nothing happened. They thought if you push the button the bell should ring. It didn't" (qtd. in Schwarz, "Interview" 119). The machine/woman remains inert and silent. Because she refuses to "turn on" in response to the viewer's touch, perhaps the female maintains some control after all. But of course this is also a self-portrait and thus ultimately under the control of Man Ray. It is the artist who has manipulated the work and through

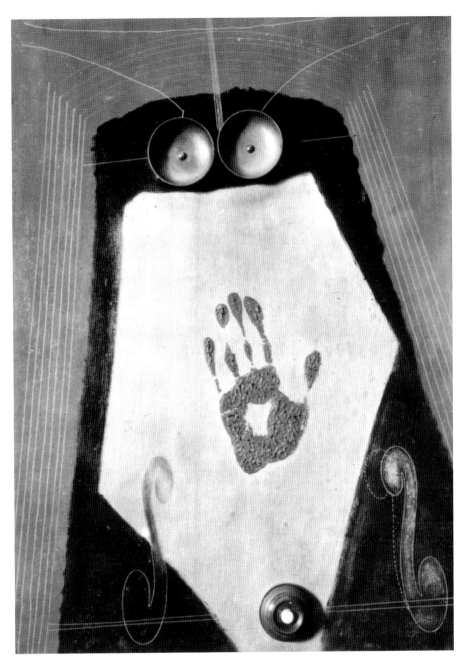

38. Man Ray, *Self Portrait*, 1916. Gelatin silver photograph, 3 3/4 × 2 3/4 in. (Original assemblage lost). The J. Paul Getty Museum, Los Angeles. Copyright © 2003 Man Ray Trust/Artists Rights Society (ARS), New York/ADAGP, Paris.

it his female alter ego as well as the viewer. In the end, then, this narrative signifies male mastery of technology as well as of the domains of the primitive and the feminine.

In 1928, Gerald Murphy painted his only self-portrait, simply titled *Portrait* (ill. 39); at first examination, this work is as impersonal an assertion of self as Man Ray's assemblage first seems. The centerpiece of the work is an oversized eye, which is framed by several measuring devices, an imprint of Murphy's own foot, three magnified thumbprints, a pair of disembodied lips, and a schematic profile of a man's face. The immediate effect of the gargantuan eye, whose iris measures approximately seven inches across, is quite startling. However, our encounter with it reveals nothing; this is not an individual eye, not Murphy's own, but an archetypal representation. Similarly,

39. Gerald Murphy,
*Portrait*, 1928-29.
Oil on canvas,
32 × 32 in.
Destroyed.
Copyright © 2003
Estate of Honoria
Murphy Donnelly.

the outline of a man's face is but another archetype, in the artist's words, a "conglom-
erate standard facial profile of Caucasian Man from the archives of the Bibliothèque
Nationale" (qtd. in Rubin 42). The "real" physical presence of the artist resides not in
the eye or the profile but rather in the thumb- and footprints.

Just as Man Ray's handprint served as a signature in *Self Portrait*, Murphy's
imprint of his own foot directly onto the canvas announces his presence. Because of
the foot's rudimentary function, this gesture takes on a basic, one could say "primi-
tivist," significance. Murphy's thumbprints, however, assume a greater complexity
because of the intricacy—and uniqueness—of the patterning made visible through
enlargement. These are not, of course, actual imprints, but much enlarged replications
of his thumbprint meticulously copied with a brush made up of a single camel's hair
(Rubin 42). Like an X-ray, this thumbprint is intimately linked to the body, suggesting a
knowledge of the self that is, especially in the pre-DNA era, legalistic and authenticat-
ing. These prints are significantly more revealing than the other elements that make up
the portrait. The foot- and fingerprints thus become counterpoints to the eye and
profile: the real and revealing versus the invented and concealing.

Prominently displayed, too, are several measuring devices, each with a different scale of measurement. One resembles a yard- or meterstick, complete with hole for hanging—something both artists and engineers might depend on for precise measurement. However, Murphy's "yard" stick is only about twenty inches long. The artist includes two additional, equally misleading, measuring devices; neither of their demarcations conform to the standards of measurement of either the United States or the metric European system. As in *3 Standard Stoppages* of 1913–1914, for which Duchamp let fall to the ground meter-lengths of string to create new standards of measurement, Murphy has established his own illogical rulers. Both artists are pitting their own idiosyncratic standards against a culture that highly valued the rational as the governing principle of the modern world and the engineer as the master of that world. Though seemingly rational, Murphy's art—like his life—is thus invented on the basis of rules that conform to an altered sense of the rational, rules not of machine culture but of his own making. Murphy was not a true nihilist (to my mind, neither was Duchamp), but someone who regarded established conventions with a critical and ironical eye.

The hugely scaled eye, extracted from its facial context, gives us additional clues as to Murphy's ironical exposure of self. Disembodied eyes have, of course, a long history in art going back to St. Lucy, patron saint of eye affliction. However, in this century, unanchored eyes have taken on more complex symbolism. They can refer to the eye of the mind, to visionary insight (as in Symbolist painting), or to the viewer's gaze incorporated into the subject matter of the portrait (Brilliant 8). Or eyes might simply stand for what they do, thus referring to vision itself; after all, to look or to observe is emblematic of artists themselves. Murphy's single eye can accommodate all of the above, although its visionary capabilities are masked by the artist's brash presentation and impersonal execution.

The "nonart brashness" of Murphy's portrait has, in the words of Calvin Tomkins, "a declarative impact," which mimics the brightly colored, eye-catching quality of postwar billposters ("Found Generation" 72). Murphy never exhibited *Portrait*, and the painting was destroyed during World War II, so no record of its colors survives. We can assume, however, that the colors of *Portrait* were similar to those in his other paintings, that is, often quite brilliant. And from the painting's eye-catching and carefully designed components, we can also detect a strong advertising ethos. Like Stuart Davis's tobacco paintings, Murphy's *Portrait* collages larger than life-size objects with an iconic insistence that invokes an identification with principles of both advertising and machine culture.

By appropriating the public form of advertising and the constructive mode of technology, Murphy seems to disguise the private self. Where portraits are usually assumed to reveal something of the private or psychological life of the subject, here that aspect of self is masked (Roskill 87). However, Murphy's use of nonart sources to define self should not be taken at face value, so to speak, but rather as Murphy's way of critiquing materialism and its commodification of self. Murphy's expatriation was at least in part an attempt to escape from the excessive materialism of his New York existence. In his notebooks, he acknowledged that Americans are a "race of romantic materialists," and he noted a desire to make a painting in which the "colossal scale"

of the objects would dwarf people. Such was Murphy's way of coming to terms with what he described as "man's good-natured tussle with the giant material world." But Murphy also acknowledged, and was disconcerted by, "man's unconscious slavery to his material possessions" (qtd. in Corn, "Identity" 165). Here Murphy's fixation on advertising and mass-produced products (not to mention the magnified eye) brings to mind F. Scott Fitzgerald's *Great Gatsby* of 1925, in which, as Corn has written, "the giant eyes of Doctor T. J. Eckleburg on the roadside billboard function as a metaphor for the tawdry god of modern materialism" ("Identity" 165). Murphy and Fitzgerald were fellow expatriates and friends; however, Murphy was never as cynical about the commercialism of American life as was Fitzgerald.

This masking of self—and of one's cynicism—may result from French expectations as to what an American of Murphy's status should produce. Corn rightly points out that Murphy "fulfilled many of the French stereotypes of the quintessential American: he was rich, stylish, and extremely modern; his manner was joyous and youthful. . . . Indeed, the glamour and social success of Murphy's life in the 1920s stemmed from his ability to dramatize precisely what the French had come to believe were exotic American traits" ("Identity" 158). On one level at least, Murphy's painting epitomized and supported these stereotypes, the seeming innocence and freshness of Murphy's paintings meshing perfectly with the French perceptions of America. However, when carefully scrutinized, the gaze of Murphy's giant eye reveals a distinct irony, a critique of American culture most explicitly stated in *Within the Quota*, the "American" ballet by Murphy and Cole Porter, discussed in the final chapter.

Murphy once remarked, "for me, only the invented part of life . . . is what has meaning" (qtd. in Vaill 226). On the one hand, Murphy encodes an invention of self via a masculinist construct of geometric shapes and advertising imagery; on the other, he balances that construct with a "primitivism" evoked by the foot- and thumbprints. These imprints seem to serve as curatives or compensations for the dominant materialism of Murphy's existence—as an attempt, then, at redemption from the world of commerce and materialism.

In his works, Man Ray even more forcefully encodes the "feminine" and the "primitive" in machine-age portraiture. In *Rebus* of 1925 (ill. 40), a photograph of a metal section of a dismantled rifle, the artist produces an effect of resemblance by exploiting a visual pun. He photographed the mechanical component so that it strikingly resembles African sculpture, here illustrated by an example from the Ivory Coast (ill. 41). The artist has thus reconfigured a mass-produced object as a modern fetish. As the title indicates, the image is also a rebus, a puzzle consisting of pictures of objects or signs whose names suggest words. Insofar as the object resembles a man, the object itself puns on the artist's first name, while the first syllable of the title, pronounced in French (Man Ray's adopted language), puns on his last name.[7] *Rebus* is, however, an ambiguously gendered self-portrait. To solve the rebus we identify this object as a seated man, but the protuberant shapes can also be read as signs for two breasts above an extended belly. Interestingly, a tradition for such a collapsing of gender distinctions exists among African cultures; for instance, certain Dogon figurative

"Rebus"                                        man Ray Paris.25

carvings include characteristics of both sexes.[8] Is it possible that Man Ray is taking his cues from that tradition, updating it by framing the dual sexuality in mechanical terms?

For Man Ray, such a blurring of gender distinctions represents a gesture of self-definition. At the time, Man Ray was living in Paris, where he had relocated in 1921; therefore, the French language may provide an additional key to the meaning of *Rebus*, in that rifle (or carbine) is a feminine noun. Although the cultural meanings of objects are not necessarily determined by their grammatical classification (as masculine, feminine, or neuter), language-based designations do carry more weight in languages other than English and may not be entirely irrelevant here. More to the point, perhaps, are the gendered allusions of the mechanical element itself. *Rebus* presents a part of a rifle that needs special care in oiling the chamber for smooth insertion of ammunition. Even though the basic configuration of *Rebus* and its status as a self-portrait initially point to masculine gender, Man Ray enlists both form and

41. *Seated Male Figure*, Baule, Ivory Coast. Wood,
15 1/4 in. Private Collection. Photography Jerry L.
Thompson. Courtesy The Museum for African Art,
New York.

language to undercut that gender affiliation in order to suggest a more ambiguous
self-identity. Through a double collapsing—of the tribal and the mechanical, of the
female and the male—Man Ray devised a language for constructing a new identity for
the modern world. The potentially deadly rifle is in a sense humanized or domesticated
by its identification with principles of the "feminine" and the "primitive." And the
work itself becomes an embodiment of Fisher's contention that "the object world in
general exists as a rebus, spelling and re-spelling the human name" ("Recovery" 146).

Marcel Duchamp further embellishes the contradictions implicit in such mechano-
tribal portraiture, and he does so most provocatively in *Fountain* (ill. 42), a close relative
of *Rebus*. Duchamp's selection of a piece of plumbing for his ready-made and his
engagement in the domain of mass production to explore identity construction raise
questions similar to those raised by Man Ray. From its first unveiling (behind the scenes)
at the inaugural exhibition of the Society of Independent Artists in 1917, *Fountain* elicited
anthropomorphic and gendered readings. Contemporaries variously characterized the
upside-down urinal as "the legs of the ladies by Cézanne," as "a lovely Buddha," and as
"Madonna of the Bathroom" and invariably underscored the sensuality of the object
(Norton n. pag.; Wood 30). Even though a urinal is an object of male use, its smooth,

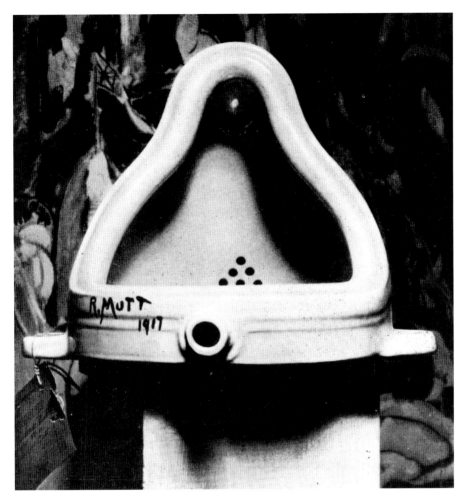

42. Marcel Duchamp, *Fountain*, 1917. Photograph by Alfred Stieglitz, reproduced in *The Blind Man*, no. 2 (May 1917): 4. The Philadelphia Museum of Art, Louis and Walter Arensberg Collection. Copyright © 2003 Artists Rights Society (ARS), New York/ADAGP, Paris/ Succession Marcel Duchamp.

pristine curves evoke female forms and its concavity female sexuality. Furthermore, as William Camfield observed, in converting a banal urinal into a fountain the artist transformed a receptacle for human waste into "a fountain of life-giving water," an object of male use into a metaphor for female generativity ("Marcel Duchamp's *Fountain*" 83).[9] Through such an inversion of meaning, Duchamp not only served avant-garde discourse but also imbued a mass-produced object with human meaning.

Like *Rebus*, *Fountain* can also be read as a self-portrait. A later tribute to Duchamp, Bruce Nauman's *Self-Portrait as Fountain* of 1966, lends some credence to this idea. In impersonating a water-spewing fountain, Nauman reenacts Duchamp's ironic attempt at self-definition in more literal—and performative—terms. But more germane to such an identification is the resemblance between the inverted urinal and certain African masks. The dominant features of *Fountain*—the ovoid shape, sunken cheeks, protruding tubelike mouth, and even the perforations—also characterize some African masks. Furthermore, both Duchamp's urinal and African masks (when exhibited) are decontextualized in similar ways. Duchamp has detached an ordinary urinal from its original function as a bathroom fixture in the same way that Western culture typically stripped African masks of their function in tribal ritual.[10] Both modern and tribal

artifacts have been extracted from their normal contexts to effect a radical redefinition of art as well as of self. Duchamp's conflation of the technological and the tribal hints at his dual identity: ultramodern (like American plumbing) and at the same time ultra-primitive (like African sculpture).[11] Once again, it is the primitive that mediates the artist's relationship to the technological, in this case, the striking modernity of New York.

Alexander Calder's *Kiki of Montparnasse* of 1929 (ill. 43) touches on some of these issues, particularly the redefinition of self as both "primitive" and modern. Born Alice Prin in 1901, Kiki made a name for herself as an artist's model and singer in Montparnasse as early as 1920, but she is perhaps best known as Man Ray's compan-ion and the model for some of his most striking photographs. Calder, too, was intrigued by Kiki and invited her to pose for him on the occasion of the shooting of a short fea-ture by Pathé Cinema in 1929. Calder had just had two successful shows in Paris that received considerable media coverage, and this success inspired Pathé Cinema to docu-ment Calder's unusual mode of art-making on film. As is clear from the film stills, Calder first made a quick drawing of Kiki on a sketch pad before "drawing" her in space with wire. The result is an uncanny likeness of Kiki, which gets her expressive eyes, angular nose, and curlicues of hair peeking out of her cloche just right. However, because her features are rendered so schematically, the portrait also resembles an African mask. The lines of forehead, nose, and mouth are stylized in the manner of African artifacts; fur-thermore, the head seems disembodied and the eyes simplified in a masklike manner. As in the case of *Rebus*, such a sculptural rendering would be unthinkable without a knowledge of, and openness to, African art. Calder's interest in African art, though sel-dom discussed, is manifested in wood carvings executed in the same time period as his portraits in wire, works such as *African Head* of 1928.

In addition, the process of fabricating *Kiki of Montparnasse* seems an enactment of a kind of ritual. From his magical twistings of a single wire emerges a unique face full of vitality and life; Kiki seems to come alive in Calder's hands. In fact, this visage in wire seems more alive—more like the flesh-and-blood Kiki in action, performing in a Montparnasse club—than the Kiki sitting motionless for her portrait. It is, then, more evocative of an African artifact in its original context of ritual dance than a mask extracted from that context and hung on a white wall, the usual practice of displaying African artifacts. Of course, the final destination for this portrait *was* a gallery wall, but even when so anchored, *Kiki of Montparnasse* seems curiously alive as a function of the looping rhythms of wire that imply movement. In describing the effect of Calder's wire sculptures, John Baur wrote that it is "as if a tremor of life ran through them" (qtd. in Lipman 237). Implied—and actual—motion is also a function of the thin wire from which she is suspended. Because of this tenuous tethering, the work responds to the slightest touch, which causes her wire eyes to shift, her mouth to move, her hair to vibrate. Calder thus suggests a performative context for this masklike work. The use of a technological material encourages a reading of this work that inscribes both the primitive and the modern, very much in tension with one another.

Calder's work is not, however, without nuances of male control; the artist has manipulated Kiki to his own specifications, severing her head from her body and

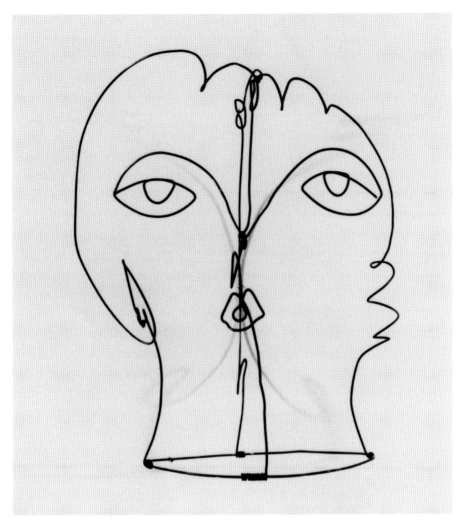

43. Alexander Calder, *Kiki of Montparnasse*, 1929. Wire, 12 3/4 in. Musée National d'Art Moderne, Centre Georges Pompidou, Paris, France. Copyright © CNAC/MNAM/ Dist. Réunion des Musées Nationaux/ Art Resources, NY. Copyright © 2003 Estate of Alexander Calder/Artists Rights Society (ARS), New York.

dangling her visage from the wall so that she might perform for the spectator. However, in spite of such treatment, the context Calder provides for Kiki is one that stresses principles of liberation and freedom. After all, Calder characterizes her as a New Woman imbued with freedom of movement and with modern—that is, technological—values by way of defining her with wire. And it is the masklike allusions that imply such a positive spin. The mask had special reverberations in the culture of the time; it was seen as lifting inhibitions and as restoring a vital connection with a more intuitive, even spiritual realm. Although an imbalance of cultural relations persists in Calder's *Kiki of Montparnasse*, the artist's appropriation of "the primitive" can also be seen as an attempt to counteract the heavily masculinized and technologized values of the postwar years.

What of the portraiture done by female artists associated with New York Dada? Are similar contradictions to be found in their works? Although quite a few female artists produced images in the genre of portraiture—Florine Stettheimer, Katherine Dreier, and Beatrice Wood, among them—none executed portraits significantly informed by machine ideology.[12] An exception is Elsa von Freytag-Loringhoven, a German national living in New York during the teens, who established close links with

the New York Dadaists; indeed, she was considered by some of her contemporaries as "the first American dada." According to Jane Heap, "She is the only one living anywhere who dresses dada, loves dada, lives dada" ("Dada" 46).[13] Freytag-Loringhoven participated in Dadaists' activities, wrote poems, made art objects, and assisted other artists in selecting objects (most notably Morton Schamberg and very likely Duchamp). Freytag-Loringhoven also embellished her own androgynous body with an assortment of found objects. She wore spherical metal tea infusers and iced tea spoons as jewelry, and a coal scuttle lid as a hat; in a gesture invoking Picabia's *291* portraits, she fashioned a battery-powered taillight as a bustle, explaining, "Cars and bicycles have tail lights. Why not I?" (qtd. in Reiss 87).

Known only through a photograph taken by Charles Sheeler, Freytag-Loringhoven's *Portrait of Marcel Duchamp* of around 1920 (ill. 44) suggests provocative connections to both *Rebus* and *Fountain*. Freytag-Loringhoven's portrait is a sculptural assemblage consisting of mechanical gears, clock spring, and fishing lure embellished with feathers, chicken bones, and other materials. In dressing—or crossdressing—Duchamp in this way, Freytag-Loringhoven seems to be defining him in her own androgynous image while at the same time alluding to Duchamp's female persona, Rrose Sélavy. The artist thus establishes a linkage between self and other, male and female. Given Freytag-Loringhoven's infatuation with Duchamp, this conflation of herself and Duchamp may project a bit of wishful thinking. In a poem entitled "Love—Chemical Relationship," she proposed such a union between "Un Enfant Français: Marcel (A Futurist)" and "Ein Deutsches Kind: Elsa (A Future Futurist)" (58–59). More pertinent, the disintegration of the boundaries between self and other raises a basic issue of all portraiture—how it tends to collapse into self-portrayal.

The feathers and the general disposition of objects in *Portrait of Duchamp* also lend a tribal dimension to this intriguing assemblage. While the machine parts stand for Duchamp's preoccupation with making machine art, the feathers and bones transform the portrait into a machine-age tribal headdress. The conflation of the technological and the primitive, the embrace of both the mechanical and the ritualistic, can be seen as another recovery of the human in machine-age portraiture. Yet unlike *Rebus* and *Fountain*, here the handmade and the organic predominate. The feathers and bones seem to engulf the gears and clock springs, subsuming the mechanical. The work thus takes on overtones that challenge the dominant machine mode to a greater degree than works by male artists.

Scholars of Dada now generally agree that Freytag-Loringhoven was, if not the principal artist behind the creation of *God* in 1917 (ill. 45), at least an equal partner with Morton Schamberg, to whom sole credit was originally given (Naumann, *New York Dada* 171). A piece of plumbing stuck in a miter box, *God* is as ironical and irreverent a commentary on the preeminence of the machine in modern America as any work produced at this time. As such, it stands out as a testament to Freytag-Loringhoven's subversive spirit (and an unlikely work of Schamberg's sole authorship). This representation of God as a section of plumbing continues a dialogue begun by Picabia when he inscribed *Fantasia*, a work of 1915, with the phrase, "Man created God in his

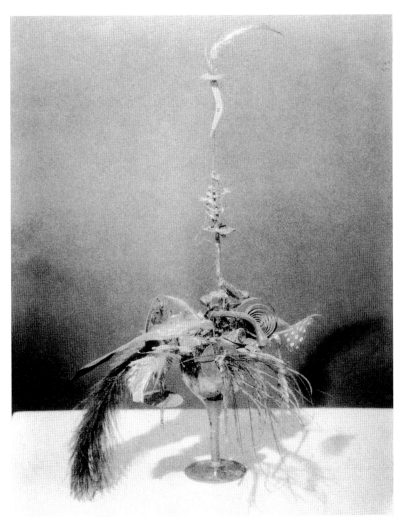

44. Elsa von Freytag-
Loringhoven (1874–1927),
*Portrait of Marcel Duchamp*, ca.
1920. Photograph by Charles
Sheeler, reproduced in *The Little
Review* 9.2 (Winter 1922): 40.

own Image." The deification of the machine has thus resulted in humans becoming
more like machines. *God* can also be viewed as Freytag-Loringhoven's direct response
to Duchamp's *Fountain*—and to Duchamp himself; as such, the work presents itself
as another unorthodox portrait of Duchamp. Camfield's discussion of the work points
in this direction: "The element 'missing' from *Fountain*, namely the pipe or plumbing,
is featured here" (*Marcel Duchamp* 58). In providing "plumbing," the artist gives
Duchamp a funky, even visceral and explicitly sexual presence, especially since the pipe
seems to have had a previous life; that is, it has clearly been salvaged from some apart-
ment or junkyard rather than selected pristine and new from a plumbing showroom,
the source of Duchamp's urinal. Given this distinction between the used and the new,
junk metal and gleaming porcelain, perhaps this portrait can be seen as Freytag-
Loringhoven's means of countering what she apparently felt was Duchamp's overly cere-
bral disposition; in a sense, then, the Baroness has humanized Duchamp so as to make
him more like herself—and more accessible to her. As Margaret Morgan observed, this
sculpture "stubbornly remains an ungainly object, a bit like the figure of the Baroness
herself" (65). Again we see a collapsing of identities in this salvaged object.

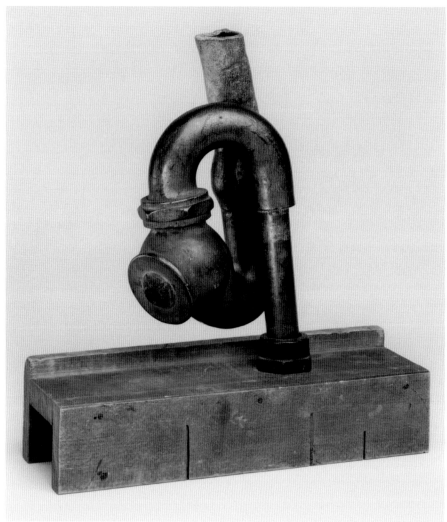

45. Morton
Schamberg and Elsa
von Freytag-
Loringhoven, *God*,
ca. 1918. Wooden
miter-box and cast-
iron plumbing trap,
10 1/2 in.
Philadelphia Museum
of Art: The Louise
and Walter
Arensberg
Collection.

*God* is, however, not only a means of chiding Duchamp for prioritizing the cere-
bral over the physical, it is also a condemnation of what Freytag-Loringhoven felt was
Duchamp's selling out to the shallow and superficial values of American culture. As
Kuenzli has written, the Baroness created this work to express her "disappointment
with her former 'God' " and to critique the Frenchman's "accommodation to American
values," values that were personified in Americans' preoccupation with the bathroom,
with sanitation, convenience and cleanliness ("Baroness" 453).

Unquestionably, Man Ray's *Object to be Destroyed* of 1923 (ill. 4), a metronome
with a photograph of a human eye attached to its swinging arm, best exemplifies the
paradoxical combination of the mechanical and the human to explore modern subjec-
tivity. The work is susceptible to a number of conflicting, even contradictory, readings.
In the first and most manifest reading, it offers a strong critique of the hegemony of the
machine. Insofar as its construction involves fastening an image of a human eye to a
metronome—a mechanical monitor of artistic (musical) creation—the work suggests
that the machine has come to control, even to set the tempo of modern life. The effect

of the unblinking stare of the eye as it relentlessly measures time, while at the same time placing artist and viewer under interminable surveillance, is exceedingly disconcerting. As Man Ray reported, this object "watched as I painted," and "its ticking noise regulated the frequency and number of my brushstrokes. The faster it went, the faster I painted." When he could no longer tolerate it, he "smashed it to pieces." (qtd. in Schwarz, *Man Ray* 205–206). Like the factory worker whose every movement is governed by rules of scientific management, the painter's actions are closely monitored. The object's intense psychological reverberations, destined ultimately to trigger its destruction, mark this work as a powerful indictment of the machine's power over our lives.

However, if we explore its gendering, an alternative reading of the work as a kind of artist's muse emerges. The fact that Man Ray clipped the eye from photographs of women (Kiki is presumed to be the model for the first version, and Lee Miller for the 1932 version) suggests that the machine is female. The woman may function as the very soul of the machine, as a humanizing agent in a creative partnership with the machine. If so, the woman becomes a kind of muse, once again enlisted in an attempt to retrieve the human from within the machine. Yet Man Ray has appropriated an organ symbolizing the soul of another and has compelled it to endlessly gaze at him, to inspire him. In so doing, he has transformed machine control into a narcissistic fantasy that posits Man Ray himself as the center of his lover's world; his every move becomes the subject of her obsessive gaze. The artist has thus consigned Kiki to play a subordinate role to his own visionary genius.[14] The work itself becomes a kind of modernist parody of the female muse—a conflation of the muse and the machine—a mechanical muse.

A third reading, moreover, might explore the implications of the process by which the monitoring machine is made a muse. The fact that a woman's eye is presented as disembodied, as severed from her body, suggests mutilation and fragmentation, as does the process of cutting the image from a photograph with sharp scissors. Her subsequent entrapment within the machine becomes a sign of her subjugation, and the mundane metronome is thereby transformed into, or recoded as, a machine of torture.

The identity of the victim of this torture, however, remains ambiguous; it is unclear whether abuse is directed toward the female muse or the male artist. In one sense, this machine-woman can be seen as refusing all agendas of submissiveness. Unlike many of Man Ray's photographs of women who are deprived of sight and action, this machine-woman actively engages the viewer, thus refusing subjection to the masculine gaze. Rather than invite a voyeuristic scrutiny, she returns the gaze with hypnotic intensity, insistently making her presence both felt and heard (if the metronome is in action). Presented as autonomous, she inspires admiration; however, she also provokes fear. In this sense, she is manipulative, even castrating. The revolving teeth-rimmed gears, given their position relative to the other "body" parts, take on a distinctly menacing presence. The portrait of the male artist as "bachelor machine" is effectively recast as the portrait of the female as *vagina dentata*.[15] In spite of Man Ray's attempts to subdue or tame the feminine, then, perhaps this work is an implicit acknowledgment of his incapacity to do so. By extension, could it also imply that technology itself is ultimately uncontrollable?

Given Man Ray's propensity for punning and puzzles, the eye can also be read as the first-person pronoun, which points to the work's autobiographical dimension. As a metaphor for the expatriate artist, the disembodied eye could indicate Man Ray's own sense of detachment as an American in Paris; it might also signify the artist's visionary insight. Or it could simply stand for vision itself or even photographic vision. As a photographer, Man Ray may be suggesting a visual simile, since the camera is sometimes compared to an eye. In any case, if the work is seen as a self-portrait, then Man Ray has subsumed both the female and the mechanical into himself as a way of coming to terms with these two forces.

These multiple readings of Man Ray's work thus represent a number of ways in which the machine can be seen as representing power: it is, on the one hand, an enabling device (enabling creativity by setting the beat and serving as a muse), while, on the other, it is a controlling mechanism (asserting power over the creative process, over life itself). While Man Ray has created a portrait that embodies both self and other, male and female, machine and body, he does not try to resolve them into a new unity. By presenting polarities as polarities Man Ray generates an uneasiness, indeed, a disruption of expectations. The result is an utterly unsettled construction of modern subjectivity. Here, rather than using art as an attempt to establish a definitive self-identity in the perplexing age of machine ascendancy, the artist uses the genre of portraiture to point to this era's crisis in individual and cultural identity.

The possibilities of self-representation were vastly complicated and enriched by the advent of the machine. With its mix of conflicting impulses, portraiture in the machine age worked through a crisis in identity. While many avant-garde portraits seem to resolve the crisis by denying, or at least diminishing, differences between male and female, machine and human, civilized and primitive, others—perhaps the more powerful portraits—acknowledge and exploit these very differences. Furthermore, while many portraits seem to erase gender by doing away with clearly recognizable human features, these portraits are nevertheless saturated with gender codes. Similarly, while some portraits try to ameliorate the technological by embracing the primitive, such a strategy ultimately absorbs the primitive into a Western patriarchal and colonialist narrative (H. Foster 62). A decoding of such portraiture thus reveals the avant-garde's attempt to forge a new identity through an appropriation of the other. In some cases, this appropriation constitutes a challenge to the existing order; in others, a reinforcement of traditional gender positions and Western notions of primitivism. The construction of modern identity reveals itself as a complex mix of ambiguities and contradictions determined by an avant-garde in search of human meaning in the increasingly inhuman world of the machine.

# Expatriate Portraiture

*Alexander Calder and Josephine Baker in Paris*

Expatriate portraiture, that is, portraiture done by Americans living in Europe, was often affected by what the French called *américanisme*, the European fascination with the "new" America, the America of technological achievement and of innovative popular culture, which in the postwar years mainly meant black culture. Not surprisingly, then, jazz musicians, singers, dancers, and other black American entertainers and sports figures took center stage as heroes of American popular culture. As we've seen, this widespread exaltation of both the machine and black culture—seemingly opposite phenomena—gave rise to what has been termed "technological primitivism." This duality informs some of the most intriguing portraits of expatriate artists, especially those done by Alexander Calder of Josephine Baker, which are the focus of this chapter.

In July 1926, Calder arrived in Paris, remained there for over a year, returned for two additional extended stays in the late 1920s, and then became a part-time resident of France for the rest of his career. Paris inspired an adventurousness not evident in the paintings of city life he had executed in New York. It was in Paris that Calder began to draw in space, using wire to delineate the forms of circus animals and acrobats, jazz dancers and musicians, boxers and other sports figures. One of Calder's first subjects for his unorthodox sculpture was the African American entertainer Josephine Baker. Between 1926 and 1930, Calder executed five portrait tributes to this fellow expatriate.[1]

Josephine Baker (1906–1975) had begun her career traveling the black vaudeville circuit in the South but did not receive significant recognition until the early 1920s, when she joined the chorus line of *Shuffle Along*, Eubie Blake and Noble Sissle's wildly popular "Negro musical," which opened on Broadway in 1921 and toured the country from 1922 to 1924. Sissle and Blake then gave Baker a more consequential role in *Chocolate Dandies*; her several solos in this production received high praise from New York critics and writers. In his review for *Vanity Fair*, for instance, poet e. e. cummings described the eighteen-year-old in the *Dandies* chorus as resembling

"some tall, vital, incomparably fluid nightmare which crossed its eyes and warped its limbs in a purely unearthly manner" (161). It is clear from this and other descriptions of her early performances that vaudevillian conventions informed the roles Baker was given in New York. Not until Baker arrived in Paris in September of 1925 did she begin to forge a style and identity more in keeping with the "New Negro" of the Harlem Renaissance, the New Woman of the postwar years, and machine-age modernism. In Paris, she became the star of La Revue Nègre at the Théâtre des Champs-Élysées and then went on to sensational success at the Folies-Bergère. She is often credited with introducing jazz dances like the Charleston and the Black Bottom to Parisians and with sustaining the vogue for jazz, which had been introduced to Parisians by the bands of black American army regiments beginning in 1917 (Emery 230).

While still evoking stereotypes of vaudeville, Baker's Parisian performances also, and increasingly, featured a sexual allure and uninhibited dancing that transcended those stereotypes. The very first performance of La Revue Nègre initiated this transition away from vaudevillian conventions. The curtain rose on a riverboat scene in the American South, complete with jazz band and barefoot dancers wearing bandannas, a scene that summoned images of port activity in the old rural South. At one point the cast broke into a Charleston, and Baker hammed it up, playing into established stereotypes as a "cross-eyed ragamuffin minstrel or a rubber-legged waif (Wiser 169).[2] However, by the show's closing act, the tenor of the performance had changed radically. The southern setting had been dismantled in favor of a Harlem nightclub with a backdrop of the spectacular New York skyline. Against this set, Sidney Bechet played a clarinet solo, and then, to the beat of drums, a minimally befeathered Baker was carried on stage on the back of her partner, Joe Alex, a dancer from Martinique. Lowered to the ground, she proceeded to perform a sensuous and increasingly frenzied *danse sauvage*.

The progression from rural South to urban New York that occurred on the Paris stage signifies a significant break from tradition for Baker; however, it also represents the replacement of one set of stereotypes with another, which was, as we will see, determined more by French than American culture. Baker very quickly adapted to French perceptions of both Africa and America, and in the process she and her managers created new images of black identity. The conjunction of "primitive" abandon and black body with skyscrapers and jazz made it possible for Baker to negotiate the differences between American and European racial ideologies.

Calder was quick to pick up on Baker's savvy agenda, creating his first portrait of Baker within a year of her arrival in Paris (ill. 46). In order to capture the pulsating energy of "La Bakaire," as she was affectionately called, Calder defined her features and body, as well as her accessories—multiple bracelets and earring hoops—with taut lines and tightly wound spirals of wire. The work, a modest twelve inches high and mounted on a wood stand, effectively communicates the coiled energy of the dancer. For subsequent versions, the Museum of Modern Art's *Josephine Baker* (ill. 47), for instance, Calder greatly enlarged the figure; furthermore, he devised an unorthodox way of displaying these works: dispensing with the sculptural base, he suspended

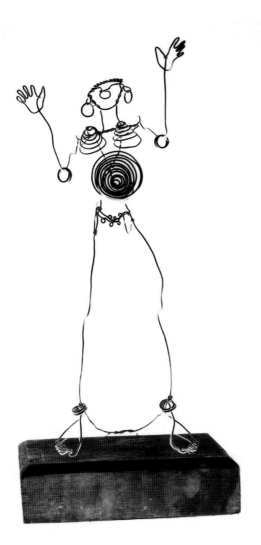

46. Alexander Calder, *Josephine Baker*, 1926. Wire, 12 in. Location unknown. Photograph, Peter A. Juley & Son Collection, Smithsonian American Art Museum. Copyright © 2003 Estate of Alexander Calder/Artists Rights Society (ARS), New York.

them from the ceiling with a single wire, giving them a quirky kineticism akin to Baker's own wound-up energy. As Joan Marter described them, "Calder intended the supple wire body to be free to quiver, sway, and rotate at will, a fitting parallel to the agility and sensuality of actual performances by the show-stopping 'Ebony Venus' " (60).

Such an encoding of the black body of Josephine Baker in iron wire was, however, more than a simple celebration of a jazz dancer and the Parisian jazz scene of the 1920s. Much more than New York, postwar Paris experienced a "negrophilia," a craze for things "negro"—and especially for black jazz entertainers and jazz music. This postwar rage was not limited to black American culture but also included African culture—African dance and particularly African sculpture. African art had been a major source of inspiration for artists as early as 1904, when Matisse and the Fauves began to appropriate into their art the "barbaric fetishes" they "discovered" in the Musée d'Ethnographie du Trocadéro (now Musée de l'Homme) in Paris. But this rage for African artifacts intensified considerably in the postwar years. Both sources—African and black American culture—seemed to satisfy the widespread desire for artistic and

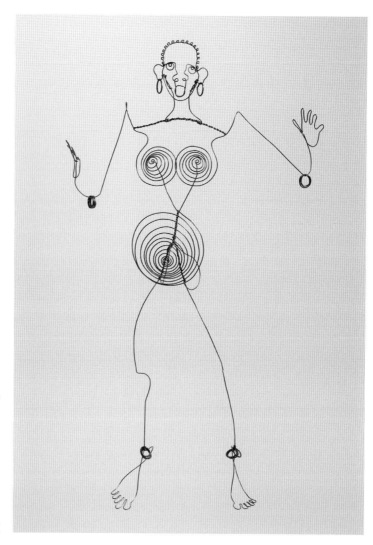

47. Alexander Calder, *Josephine Baker*,
1927-29. Wire, 39 × 22 3/8 × 9
3/4 in. (99 × 56.6 × 24.5 cm).
The Museum of Modern Art. Copyright
© 2003 Estate of Alexander
Calder/Artists Rights Society (ARS),
New York. Digital Image Copyright
© The Museum of Modern Art/
Licensed by SCALA/Art Resource, NY.

spiritual renewal in the wake of World War I. Many viewed industrialization as a fac-
tor in the social and political unrest and the economic turmoil that followed the war.
Both sources, then, provided an antidote to the rational ethos of an increasingly
industrialized world, suggesting models for a more natural and spontaneous mode of
expression.

The French typically perceived the African and black American not, however, as
distinct cultures but as inextricably intermeshed; as Laura Rosenstock has stressed, the
two cultures were identified with one another so closely that "they were often con-
fused in the popular mind, even though traditional African society and contemporary
black American life constituted very different cultures" (478). Given French colonial-
ist history, it is not surprising that this linkage involved an imposition of stereotyped
notions of Africa onto African Americans. As Tyler Stovall has written, "When the
French looked at black Americans, they saw a new version of the sensuous, sponta-
neous African" (33). And Europeans in general projected an "ethnic exoticism" onto
celebrities such as Baker in their quest for postwar rejuvenation. Writer Erich Maria

Remarque acknowledged such a role for Baker, saying that she brought "a blast of jungle air, elemental power and beauty to the weary Western civilization" (qtd. in Lemke 101).[3]

Baker herself knew very little about Africa or about French colonialism when she arrived in Paris; however, exoticism was soon to inform her performance style. This newly minted exoticism was certainly a function of the projection of colonialist values onto Baker by the French; however, Baker herself had much to do with determining her new identity on the Paris stage. Prior to arriving in Paris, Baker had performed for American audiences in New York where her black body had been coded more in terms of the recent history of slavery than in terms of Africa. At least in part, her eagerness to escape this association explains her immediate cultivation of an image of exoticism and primitive sexuality; indeed, Baker fully exploited this colonialist penchant for linking contemporary black American culture with Africa. And she did so by capitalizing on popular notions concerning the association of the black body with primitivism—and particularly with tribal artifacts. Her dances promoted this association, inspiring critics such as Janet Flanner, who reported on Paris for the *New Yorker*, to describe her as "an unforgettable female ebony statue" (xx). And after witnessing the finale of a 1925 performance at La Revue Nègre, "the *pas de deux* of the savages," dance critic André Levinson observed: "Certain of Miss Baker's poses, back arched, haunches protruding, arms entwined and uplifted in a phallic symbol, had the compelling potency of the finest examples of Negro sculpture. The plastic sense of a race of sculptors came to life and the frenzy of African Eros swept over the audience" (qtd. in Rose 31). Through such poses set against jungle settings, Baker successfully played into the myths of black bodies entertained by the French, who praised her as *sauvage*.

The famous *danse sauvage* to which Levinson refers, in which Baker appeared topless, wearing a satin thong embellished with feathers around her hips and a collar of feathers around her neck and ankles, was clearly intended to evoke the context of an African jungle full of feathered birds and other exotic creatures. Commercial images of Baker also foreground this connection. One famous publicity photograph, for instance, features a nude Baker face to face with a carving of an ebony elephant, which she holds in her hands. In a famous photograph by Man Ray, *Noire et blanche*, Kiki also holds a tribal artifact; however, while Man Ray's pairing of a white woman with an African mask evokes considerable tension between opposites, the photograph of Baker is meant to establish her identification, even communion, with the tribal. Further distinctions arise from the nature of the artifacts themselves. Whereas Man Ray selected a highly prized Baule artifact already elevated to the status of "high art," Baker holds an ebony elephant that is clearly a cheap carving produced for the tourist trade.[4] Such a choice sheds light on the artifice of Baker's gesture; the tribal carving is just a cheap prop which tends to expose the artifice of her staging an affiliation with primitive Africa.

Paul Colin, who was hired to create promotional posters for La Revue Nègre, also capitalized on such jungle associations. In 1927, Colin created *Le Tumulte Noir*,

48. Paul Colin. *Woman Dancer Behind Bars (Josephine Baker)*, 1929. Lithograph with pochoir coloring on paper from *Le Tumulte Noir*, 47.1 × 31.9 cm. National Portrait Gallery, Smithsonian Institution. Copyright © 2003 Artists Rights Society (ARS), New York/ADAGP, Paris.

a portfolio of forty-five hand-colored lithographs celebrating Baker as well as the incredible infusion of energy generated by black performers in Jazz Age Paris. Baker is represented in the portfolio by quite a few images and by a short preface in which she jokes, "its [*sic*] getting darker and darker in Paris" since the arrival of La Revue Nègre (qtd. in Colin n. pag.).[5] One of Colin's prints features a nearly nude and "barbaric"-looking Baker behind bars, caged like a wild animal (ill. 48). Such an image inevitably references the French practice of displaying their African colonial subjects in cages in various expositions and even in zoological gardens where they could be viewed in comparison to exotic animals caged nearby.[6] This practice goes back to the early nineteenth century when Sarah Bartmann, known as the Hottentot Venus, was persuaded to leave her native Africa and travel to London and then to Paris where she was displayed in a cage. When she arrived in Paris, she acquired a new manager or "guardian," who also showed wild animals. Spectators paid three francs to see the Hottentot Venus's most unusual physical characteristic, her greatly protruding buttocks. Such a mode of display and Bartmann's habit of pacing in her cage led to her identification with primitive animality and by extension to black inferiority (Sharpley-Whiting 16–31).

A century later, Baker undoubtedly wanted to escape this stereotype as well. And she did so by toying with that stereotype in such a way as to inject a note of wit and irony. For one thing, she often danced with knees bent and her behind extended, which called attention to her posterior. As Phyllis Rose noted, "She handled it as though it were an instrument, a rattle, something apart from herself that she could shake" (164). Critics were quick both to praise and to denounce Baker's unabashed flaunting of her derrière, and Baker was equally quick to respond to such criticism, "The rear end exists. I see no reason to be ashamed of it" (qtd. in Rose 164). By acknowledging and comically reframing stereotypes, Baker was able to construct a primitivity that ironized and humanized such historical stereotypes as the Hottentot Venus. In confronting such stereotypes head-on, she found a way of banishing such negative codings of the black female body as objects on display.

Calder's representation of Baker's body also plays into this dual desire to link the black body to colonial stereotypes while at the same time freeing it from that context. The artist's portrayal of Baker suggests a minimally attired African dancer; he has adorned her wire body with hoops—through her ears and on her arms and legs—decorative implements that likewise foster associations with the primitive, as does the nakedness of her wire body. Like Colin's caged woman/beast, Calder's Baker sculptures are very much on display, tethered as they are to the gallery ceiling. Also like Colin's, these portraits serve the voyeuristic needs of the Parisian audience. However, Calder managed to imbue this largely negative "primitivism" with more positive implications. It should be noted that Colin, too, tempers the barbaric bare-breasted image of the caged entertainer by pairing it with a more "civilized" (though still caged) image of a fully and cross-dressed Baker. Seen in this context, then, Baker embodies both poles: the primitive as well as the civilized, the African and the American, the female and the male, dualities elaborated on below.

Judging from the visual images we have of Baker—both by artists and by commercial photographers—it is clear that the black body in 1920s Paris was, in the words of James Clifford, "an ideological artifact," embodying coded perceptions that emphasized its "vitalism, rhythm, magic, erotic power, etc." (170). To some degree, Baker was a victim of such coded notions; however, she was also very adept at exploiting the Parisians' perceptions in order to advance her career. In turn, avant-garde artists and commercial photographers commandeered the black body of Baker in order to create a fantasy world through which the audience could reassert a basic connection with nature and human instinct, untainted by the corruptions of civilization. Certainly this identification of Africa with nature—along with the attempt to find salvation through the appropriation of another culture—constitutes an exploitative, or as Clifford has called it, "a negative primitivism of the irrational, the savage, the base, the flight from civilization" (170). However, the self-conscious manner in which Baker, and then Calder and other modern artists, capitalized on the Parisians' demand for the "authentic" raises a complex range of issues not delimited by such a definition of "primitivism."[7]

To view the images of Baker solely as referencing Africa and a return to a more "natural" state, indeed, to nature itself, is to oversimplify. As Clifford recognized,

"Archaic Africa . . . came to Paris by way of the future, i.e. America." He goes on to say that while "the standard poses adopted by 'La Baker' . . . evoked a recognizable 'Africanity'—the naked form emphasizing pelvis and buttocks," they also reveal "a segmented stylization suggesting a strangely mechanical vitality" (170). Such machinelike vitality characterizes Calder's wire sculpture, and it also informs the works of Calder's contemporaries, both American and French.

Fernand Léger, whose portrait in wire Calder executed in 1930, was a great admirer of American technology, and he shared Calder's fascination with Baker. According to Baker, it was Léger who encouraged Rolf de Maré, manager of the Théâtre des Champs-Élysées, to bring a black troupe from New York to Paris; interestingly, Léger made this recommendation after viewing the African pavilion at the International Exposition of Decorative Arts held in Paris in 1925. Léger was in the audience at Baker's premiere at La Revue Nègre—along with Gerald and Sara Murphy, Jean Cocteau, Colette, Darius Milhaud, and Janet Flanner, among other luminaries—and he was apparently thrilled by her performance (Rose 8). Several years earlier, Léger had designed costumes and sets for the Swedish Ballet's 1923 production of La Création du monde (The creation of the world), also produced by Rolf de Maré. What is so striking about his designs for this production is precisely the "mechanical vitality" that Clifford perceived in tribal artifacts—and in Baker's poses (ill. 49). In designing his sets and costumes Léger extracted a sleek mechanical quality from his own numerous drawings of African sculpture; such a fusion complemented the scenario and the music of La Création du monde, which likewise encapsulated both the primitive and the modern, as we will see in the final chapter. Léger's involvement in such a production based on the convergence of two cultures—the African and the black American, the primitive and the technological—fully prepared Léger for Baker's dramatic entrance on the Parisian stage.

A similar impulse to exploit this mechanical/primitive nexus is at work in the art of one of Calder's fellow expatriates, Man Ray, who also represented Baker in his art, specifically in his photographic commissions. Shortly after La Revue Nègre arrived in Paris, Man Ray was called in to photograph the cast at one of its rehearsals. It has been reported, though not confirmed, that Man Ray then singled out Baker and photographed her on the roof with the Eiffel Tower in the distance (Haney 163–164).[8] In the same year, Man Ray created Rebus (ill. 40), representing the mechanical housing of a rifle, which exhibits a remarkable similarity to African carvings and to Léger's geometricized costume designs—and by extension to a typical Baker stance. While Léger's point of departure was an African artifact that he mechanized, Man Ray's initial inspiration was an industrial component, which through careful placement he Africanized, transforming the object into a modern fetish by means of a visual pun. Though coming from opposite directions, both artists subsumed the primitive into the technological language of modernism. Once again, such an embrace of the primitive by the technological suggests an attempt to humanize—and thereby redeem—the technological by associating it with a preindustrial culture.

Alexander Calder also lends a technological note to his representations of Baker; indeed, he combined an interest in tinkering with industrial materials with a

49. Fernand Léger, Sketch for *La Création du monde*, 1923. Published in *L'Esprit nouveau* no. 18 (1924). Copyright © 2003 Artists Rights Society (ARS), New York/ADAGP, Paris.

newfound fascination with the primitive vitality of Baker. Calder saw his wire sculpture as a kind of spontaneous drawing in space—or "three-dimensional line drawing"—and also as a way of engaging the intellect. As he put it, "I think best in wire" (qtd. in Lipman 238). Calder's delineation of Baker in iron wire encoded something of the spontaneity of her dancing while at the same time linking such energy to the realm of the intellect, his own as well as Baker's. Baker herself claimed that she made use of "the intelligence of the body" (qtd. in Sharpley-Whiting 105).

There is another sense in which the wire medium points in two different directions. While in the "civilized" world the production and uses of wire are largely industrial, in Africa it was used extensively for decorative purposes, for jewelry and body adornment. The Maasai, Toposa, and Turkana of East Africa, among other African peoples, traded for European materials such as wire during the colonial period, and they also salvaged metals from such objects as cartridge cases, which they then reshaped into wire. These tribesmen and women then put these materials to use in radically different ways—adapting them to traditional, decorative uses, such as "coiled torques of iron wire" for neck, arm, and wrist ornaments (A. Fisher 33, 45).

Again we see a conflation of the technological and the primitive in Calder's use of a material common both to modern industrial and traditional African culture.

What separates Calder's art from that of his contemporaries Fernand Léger and Man Ray, however, is his injection of whimsy and humor into his works. Anyone who has seen film footage of Calder operating his *Circus* or dancing with one of his wire renditions of Baker (included in the American Masters video production *Alexander Calder)* cannot help appreciating the primacy of humor for Calder. The wire sculptures themselves are humorous; as Calder told a *New York Times* reporter in 1929, he wanted a wire line that "moves of its own volition . . . jokes and teases . . . [is] deliberately tantalizing [and] goes off into wild scrolls and tight tendrils" (qtd. in Sperling, "Calder" (23).[9] As it defines the body and features of Baker, the iron wire—with its trajectories that loop, bend, buckle, and spiral—seems to have a quirky and comic life of its own.

From the very beginning, humor was also key to Baker's success; in fact, she was known for hamming it up in her performances. In the Broadway show *Shuffle Along*, for instance, she was billed as "That Comedy Chorus Girl" for her antics at the end of the chorus line: "she rolled her eyes, contorted her face and swiveled her body" in an exaggerated mimicking of the rest of the chorus. As Wendy Martin noted, her act became "a deliberate parody of the blackface vaudeville routines and the conventions of the Negro minstrel show" (311). Such humor served, then, not as a perpetuation of stereotypes of vaudeville but as a send-up of those stereotypes.

In Paris, too, reviews of Baker's performances often noted her talent for injecting comedy into her routines. As critic Anita Loos wrote of her premiere performance, Baker had triumphed with her "witty rear end," an observation suggesting Baker's control over her body for the particular purpose of eliciting laughter. And, in her most notorious role as Fatou of 1926 (ill. 50), "she romped on stage at the Folies Bergère in Paris wearing a girdle of bananas and nothing else" (qtd. in Emery 230). Here she both plays into and playfully mocks the colonialist fantasy of a French explorer who lies asleep in the jungle. To the accompaniment of drums, Baker made her entrance climbing backward down the trunk of a tree; she then began to dance, moving her hips so that the bananas bounced and swung in arcs while she simply laughed. In recognition of the hilarity of her performance, a critic for the *Mercure de France* wrote, "This girl has the genius to let the body make fun of *itself*. . . . [H]er body shakes as if in a trance, but with such remarkable humor" (qtd. in Hammond and O'Connor 42). Some of the comic spirit of her performance is, of course, generated by reference to vaudevillian conventions; as Nancy Nenno has observed, Baker "actively replicated stereotypes of the American black as comic entertainer" (147). However, she knew how to use humor as a powerful antidote to those deeply entrenched stereotypes. And while it exposes the absurdity of those stereotypes, it suggests Baker's own sense of creative autonomy.

Such reenactments of negative stereotypes look forward to the postmodern practice of quoting in order to undermine or sabotage past stereotypes. Take, for instance, Kara Walker's humorous yet extremely disconcerting paper cutout murals

50. *Josephine Baker*, Photograph from program for the Folies-Bergère, 1926-27. Courtesy of Maureen McCabe, Quaker Hill, CT.

representing a familiar cast of racial stereotypes: nineteenth-century silhouettes of mammies, pickaninnies, old slaves, Uncle Toms—and even a more modern image of Baker in her famous banana skirt. As Jo Anna Isaak has suggested, by affixing black silhouettes of such stereotypes to white gallery walls, the artist makes the viewer aware of the interdependency between relationships the of figure/ground, master/ slave, and white/black. Walker herself remarked, "I realized . . . that the shadows . . . of the past . . . are continually informing, no, more like de-forming and re-forming, who we think we are" (qtd. in Isaak 6).[10] Although less self-consciously than Walker (and with greater levity), Baker, too, enlisted stereotypic perceptions of blacks in order to deconstruct and reconstruct the notion of what it meant to be a black person in postwar Paris.

Humor constituted only one facet of Baker's performance strategy. She typically alternated her playfully parodic presentation of self with a more controlled, even elegant persona, oscillating between accommodating and challenging the Parisian audience's expectations as to the identity and sexuality of the black woman. As Rose has

written, "the next moment she dropped the contortions, the mugging, and reverted to beauty" (25). Baker set up a tension between two impulses, a tension characterized by Dalton and Gates as that between "the energy of *le jazz hot* and elegance of the Black Venus." She is "at once erotic and comic, suggestive and playful, intense and insouciant, primitive and civilized" (918).

Calder achieved a similar effect and an equally potent tension between opposite impulses. The artist's vibrating wire portraits of Baker have an awkward funkiness that plays on the stereotype of a goofy, big-mouthed vaudevillian performing for laughs, while at the same time these works have a sleekness that produces a sense of grace and beauty. Both Calder and Baker thereby set up an effective dichotomy in their art—presenting an object both of laughter (the vaudeville comedienne) and of awesome physical beauty (the queen of Paris nightlife). This adoption of seemingly conflicting personae was meant not simply to parody stereotypes but also to hold up an alternative, more admirable image of the black performer. Given that the cultural climate of Paris was one that encouraged a more positive self-image on the part of African American expatriates, this goal was more easily achieved in France than in postwar America.

The French adored Baker, and this infatuation—and Baker's exploitation of that infatuation—must be understood against the backdrop of the very different race relations of her native as opposed to her adopted country. As Dalton and Gates have underscored, while the French were by no means innocent of racial bias, "compared to America, France was color-blind" (904). In France, there was a very different model for black/white relationships, and, as Martin noted, this was largely because the French context had less to do with a history of slavery than it did with a colonial empire. For the most part, those colonized by the French resided not in Paris itself but rather on a far away "dark continent." However, in the United States, enslavement of blacks had taken place at home and was not yet a distant memory, so "the subordination of blacks left over from slavery remained intact" (317). By relocating to Paris, Baker freed herself from American prejudice—and from the expectations of that audience. Rather than serving as a sign of slavery, she was free to exploit the French desire to see in the African American woman both an exoticism linked to Africa and a symbol of liberation. Baker capitalized on this identity in order to engage French dual fascination with Africa and America—and to become fabulously wealthy.

Calder, too, was inspired not only by *américanisme* in general but also by the French embrace of Baker and all that she stood for. (This inspiration did not, however, result in great success for Calder, who did not attain the star status—or the wealth— that Baker did until well after the 1920s.) Baker served to validate Calder's own embrace of popular culture, hardly widely sanctioned source material for artists at the time. As one reviewer of Calder's 1928 New York show of wire works wrote, "Convoluting spirals and concentric entrails: the kid is clever but what does papa think?" (qtd. in Calder 86). Especially in contrast to the French, Americans generally were quite ambivalent toward their own popular culture—toward the things that Calder was increasingly drawn to in his art, which included the circus with its

associations of the demimonde and dance hall, as well as jazz culture with its associations of degenerate abandon and of the African "sub"continent.[11] Distanced from the strictures of American society and inspired by the *américanisme* of the French, both Calder and Baker were free to explore the new cultural terrain of postwar France and in the process to generate new forms of identity.

The prime personification of *américanisme* for the French avant-garde was, of course, the *jeune fille américaine*. With her youthfulness, her adventurous spirit and unconventional ways, the young American girl embodied all that was most admired in America. Francis Picabia created the most compelling image of this mythic personage in the form of a sparkplug in 1915 (ill. 35). A few years later in 1917, Picabia conceived of another American girl, simply titled *Américaine*, this time in the guise of a lightbulb but with much the same connotations as the earlier work; she serves as a source of light, a jolt of energy. However, Picabia perplexingly fails to give a face to either rendition of the young American girl.

What do we make of the facelessness of these embodiments of the American girl? Given the contemporary cynicism about the depersonalizing effects of technology, it is tempting to view such facelessness as a representation of alienation. However, a viewer of the 1920s may have perceived more positive meanings. At least this is Maud Lavin's view of a work by German Dadaist Hannah Höch. Lavin's reading of Höch's *The Beautiful Girl*, of 1919–1920, a photomontage featuring the image of a young girl with a lightbulb as a head, may provide clues to the significance of the facelessness of Picabia's representations. *The Beautiful Girl* was executed by a female artist very cognizant of the complex ramifications of the emergence of the New Women in the culture of Weimar Germany. Though the American context of Picabia's work is necessarily different from Höch's, the emergence of the New Woman challenged dominant male culture throughout the Western world and everywhere raised compelling questions as to her identity. Who was this "beautiful girl," this New Woman? Or, more pertinent, who was she in the process of becoming? One implication of such questions is that these faceless images may well have suggested not alienation but rather a kind of tabula rasa, a blank slate that expressed Hannah Höch's high hopes—and Picabia's praise combined with apprehension—for the New Women (Lavin 46). Viewed in this light, these works comment on the potential of building a new identity for a new era.

Perhaps in tribute to Picabia, Calder substituted a lightbulb for a woman's head in *Umbrella Light* of about 1929 (ill. 51), a sculpture that also functions as an electric lamp. With a backbone of stiffened electrical cord and limbs of wire, Calder's New Woman strides forcefully into the future. Like both of Picabia's highly charged *jeunes filles*, this one is a turn-on, not just metaphorically but literally. Calder has extended Picabia's metaphor by wiring the sculpture electrically so that the lightbulb actually functions. Yet for all of her wired strength, this New Woman is nonetheless still without a face, without a human identity.

Perhaps it is Baker who finally gave the *jeune fille américaine* a distinct identity when she forged a new persona for herself in Paris. In recognition of this feat, Calder seized on Baker as the embodiment of the *jeune fille américaine*. The artist not only

51. Alexander Calder, *Umbrella Light*, ca. 1929. Copyright © 2003 Estate of Alexander Calder/Artists Rights Society (ARS), New York.

captured the essential qualities of this paradigm of American culture but also gave her a face and a specific identity. That Calder gave the *jeune fille américaine* a black identity is a tacit acknowledgment of modernism's huge debt to black culture, indeed, an affirmation that modernism was as much determined by black cultural forms as it was by machine-age forms. As Lemke has argued, "black, or African-inspired, expressions have played a seminal role in the shaping of modernism"; in fact, she maintains that modernism assumed the shape it did only through the "injection of blackness" (4). It is this often subordinated "black face" of modernism that surfaces in Calder's representations of Baker as *jeune fille américaine*. As a product of both black culture and the machine age, Baker was able to negotiate the passage from the blackface of vaudeville (or minstrel shows) to the black face of modernism. And Calder's portraits, too, are an affirmation of modernism as an aesthetic collaboration between black and machine-age cultural forms.

Also germane to the mythic makeup of the *jeune fille américaine* is a blurring of the distinctions between the masculine and the feminine. This New Woman of the

postwar years was not afraid to assume roles previously occupied only by men, nor was she averse to adopting the look and fashion of men. The androgyny of some of the images of Baker is certainly part of this play of opposites. The representations of Baker by artists, commercial photographers, and graphic designers exploit an eroticism that is somehow both female and male. In publicity photos, as well as in one of Paul Colin's, prints for *Le Tumulte Noir*, for instance, she is represented dressed in a man's suit, cutting a striking image as a black Marlene Dietrich. In her performances, too, Baker often exploited a dual sexuality, and her departure from norms of female self-presentation caused early audiences some confusion. Her short hair, "highly brilliantined and pasted down," and her unconventional demeanor led some to wonder about her gender, as did critic Pierre de Régnier in 1925: "Is it a man? . . . Is it a Woman?" (qtd. in Lemke 99). Her voice, too, could be sweet and feminine one moment, and then would drop to a low register with rather gravelly undertones the next, or as e. e. cummings described it, "Her voice [was] simultaneously uncouth and exquisite" (qtd. in Rose 162). Baker clearly embodied ambiguity; however, her gender was never really in question. It was always clear that she merely toyed with androgyny; for this reason Marjorie Garber has aptly labeled Baker a "female female impersonator" (Garber 280).

Baker's sometimes outrageous costuming also capitalized on such ambiguity. In her role as Fatou at the Folies-Bergère (ill. 50), the banana-skirted Baker combined the phallic and the feminine in one body, playing up provocative oppositions in order both to enhance and undermine the "savage" allusions of her performance. A photograph from another performance features Baker reclining catlike on the stage, her fingers taking on the semblance of tiger claws. On the one hand, the stage sets surround this female/animal with attributes of the jungle, while on the other, her body and hair are defined by a streamlined, machinelike perfection, a sleekness that had by the mid-1920s become linked with a machine aesthetic usually identified with masculinity.[12] Rather than posing as the submissive native, essentialized as one with her jungle habitat, Baker becomes the master of that jungle.

This concept of mastery foregrounds Baker's own agency in the construction of identity. In the late 1920s, Baker acquired a leopard named Chiquita who became her constant companion on the streets of Paris—that is, until the leopard escaped and authorities determined that the animal was too dangerous to remain uncaged. Baker's proud display—and naming—of Chiquita, can be read as a reversal of colonial subordination; as Martin has written, "in her own process of becoming tamed and civilized, she had gained the authority to tame the panther" (322). Now Baker has assumed the role of subordinator. Likewise, the pose Baker assumed for a publicity shot atop the skin of a dead tiger, though still implying an identification with the animal world, also signals an assertion of mastery over it. Baker's clever maneuverings through the cultural politics of Paris can be seen as the remnants of colonialist exploitation; however, the ironical manner in which she pulled off her outrageous feats marks her as a harbinger of postcolonialism. She effected this transition by calling into question historical relations of power enacted through human/animal, and by

extension male/female, and white/black interactions; by such a destabilization of colonialist expectations, the "Black Venus" maintained her autonomy—and her sway over her Parisian audience.

Such disruption of norms of French colonialism anticipates the postmodern performance art of Grace Jones, the Jamaican American fashion model, singer, and actor.[13] For one thing, Jones takes the machined sleekness implied by Baker's posturings to unparalleled extremes. On her 1985 album cover for *Island Life,* produced by Parisian illustrator Jean-Paul Goude, for instance, Jones appears oiled and seminude, with breasts and one ankle tightly bound with cloth strips. Here the conflation of jungle allusions and sleek, streamlined body suggests a significantly more explicit androgyny than does Baker's performance. Jones's collapsing of gender distinctions is an exaggerated version updated for the 1980s. Just as Baker perplexed Parisian audiences with her startling gender reversals in modernist Paris, Grace Jones, in the words of Richard Powell, "confounded mainstream expectations" in postmodern New York (221–222). And while Baker's manipulations of racist and sexist stereotypes were quite playful, Jones raised the ante and, as Miriam Kershaw observed, "paraded potent signifiers of race and gender—boxing gloves, gorilla suits, stiletto heels, blackface, and raffia skirts," with a much more satiric (and, one might add, humorless) effect (24). In comparison to Baker's frolicsome performances, Jones's quite imperious simulations engage the more self-conscious culture of the 1980s—a time when commentary on race and gender was considerably more charged than it was in the 1920s.

The connection between Jones and Baker is by no means fortuitous; in a 1985 issue of *Interview*, Jones acknowledged her identification with Baker, and her performances contain exceedingly self-conscious references to Baker's performative strategies (Kershaw 21). This debt to the "Black Venus" of 1920s Paris is made especially clear in Jones's collaboration with Keith Haring on two performances at the Paradise Garage in 1985. Instead of drawing a body with wire as did Calder a half century earlier, Haring drew his characteristic graffiti lines directly on Jones's body; he also created a girdle of neon yellow spikes, a stylized allusion to Baker's banana skirt.[14] Jones's and Haring's tribute is not only to Baker but also to Calder, as manifested in Jones's body adornments. Working with jewelry designer David Spada, Haring designed sculptural embellishments in the form of metallic conical coils for her breasts and bangles for her arms and legs. Animated by the actual body of Grace Jones, Calder's wire sculptures are brought to life. Perhaps Kershaw best described the effects of this compelling mélange of symbolic forms:

> **She strides across a stage of pillars and chains. Her tall, muscular frame**
> **pulses with graffiti. White striations and chevrons contrast with her skin.**
> **She beats a drum, the neon red and yellow spikes of her skirt, anklets, and**
> **bracelets dancing with her body's undulations. On her breasts spiral metal**
> **coils. A dance of signs ricochets through centuries and across cultures:**
> **a masked African ancestor on the Ivory Coast dancing in a raffia sheath**
> **and anklets; Josephine Baker dancing in her famous banana skirt at the**

**Folies-Bergère; a Calder mobile figure swinging through the world of modernism; to the techno-pop present of dance club, flashing lights, and amplified sound in SoHo. (19)**

As Kershaw noted, Jones's updating of Baker involved a commentary on an "iconography of power and subordination" that was considerably more ironic than we find in Baker (21). Indeed, Baker's sabotage of negative stereotypes seems rather tentative in comparison to that of Jones, who adapted Baker's performative strategies for the more racially savvy audience of the 1980s.

Calder also charts a course toward the unsettling of colonialist norms, particularly in his definition of Baker's body as lean and rather angular (one might say masculine, especially given the delineation of her hair as tightly looped wire hugging the skull)—and, most significantly, as active. This is especially apparent when Calder's portraits of Baker are viewed in relation to another portrait, *La Negresse*, which has also been titled *Josephine Baker's Mother*, of 1929 (ill. 52). For this work, Calder placed the nude figure in a reclining rather than upright position. As such, she is closer to the earth—and seems, in fact, to be working or cultivating that earth—and thus closer to tropes linking women to instinct and ultimately to nature. However, the work evokes not just "Mother Earth" but also "Mother Africa." Furthermore, the iron wire lines of this work map out rather fleshy volumes in stasis rather than lean limbs in movement. Indeed, her massive buttocks call to mind the Hottentot Venus, that nineteenth-century image of the black female as object of racist curiosity. Baker herself—and Calder's renditions of her—managed to transform such negative images of black women into more positive images inspiring admiration. While *Josephine Baker's Mother* perpetuates negative stereotypes of the past century, the daughter represents the New (black) Woman of the present; the Hottentot Venus of the past has been replaced by the "Black Venus" of contemporary Paris. The way that Calder defines Baker thus lends a modern (one might say "male") aesthetic to the primitivist ("female") content. Calder's powerful presentation of Baker as active rather than passive, potent rather than fertile, also works against traditional expectations. Such an animated conception defines Baker as an active person of the world rather than a passive fertility figure. Understood in terms of these oppositions—female/male, fertility/potency, past/present, primitive/technological—and of the destabilized relations of power that they imply, Calder's renditions of Baker bring a new level of complexity to this notion of technological primitivism.

In his Baker series, Calder establishes a charged tension between opposing forces. There is one exception, however, and that is the final image Calder made of Baker, in which this tension seems greatly diffused. In *Aztec Josephine Baker* of about 1929 (ill. 53) (at fifty-three inches, also the tallest in the series), Calder gives us a subdued Baker. She now stands with her arms hanging limply at her side, her mouth closed as if in silent protest, and her eyes without the sparkle of earlier versions. While the four earlier sculptures of Baker feature arms reaching out to activate space, *Aztec Josephine Baker* is more contained, defined with a greater sense of planarity. Perhaps the most

52. Alexander Calder *La Negresse* or *Josephine Baker's Mother*, 1929. Wire. Copyright © 2003 Estate of Alexander Calder/Artists Rights Society (ARS), New York.

telling departure from earlier versions is Calder's representation of the breasts. While in earlier versions the coiled breasts project upward, echoing the equally outward moving spiral of a belly, the breasts of *Aztec Josephine Baker* are simply hung from her shoulder blades and assume a more static arrangement. Furthermore, her belly is reduced to a minimal buttonhole squiggle. This is a radical departure from the life-affirming, outward-moving, space-activating anatomy of her predecessors. Though not without a touch of humor, it is no longer as infectious as in earlier versions; indeed, the dominant spirit of the piece is one of deflation. Could this be Calder's recognition of the changing perceptions of Baker among Parisians toward the end of the decade? Could it also encode something of Baker's own response to this shift of attitude?

By 1928, Baker had begun to fashion a new persona for herself, assuming an increasingly sophisticated, or "civilized," guise. Rather than banana skirts and minimal costumes of feathers and beads, she began to wear elegant evening dresses offering considerably more coverage and conveying greater refinement. Though this process of redefinition had already begun by 1928, the reception Baker encountered during her two-year international tour which she embarked on that year, no doubt accelerated the transformation. With performances in twenty-five countries in western Europe and South America, Baker clearly intended this to be a triumphal tour, but instead it turned into a swan song for her former self. Especially in the increasingly conservative political climate of Austria and Germany, the media turned against this "Congo savage," demonizing her as "Satan's Handmaiden" (Wiser 297). Even though she downplayed her role as "the sexually uninhibited primitive" during her

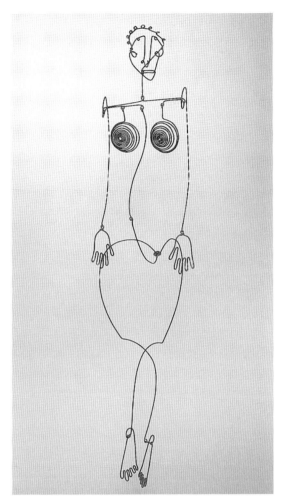

53. Alexander Calder, *Aztec Josephine Baker*, ca. 1929.
Wire, 134.6 × 25.4 × 22.9 cm. Private Collection.
Copyright © Art Resource, NY Copyright © 2003
Estate of Alexander Calder/Artists Rights Society (ARS),
New York.

second swing through Germany in 1929, Baker was prohibited from performing by the Munich police because she was thought to pose a threat to decency (Nenno 157–158). Parisians, too, used Baker as a scapegoat in their growing resentment against Americans for their "corruption" of French culture. As Wiser has written, "the French romance with negritude had shifted to a protective chauvinism," and the black community particularly felt the animosity as new ordinances were passed to counteract the monopoly of all-black American jazz bands in Paris nightclubs (296).[15]

While many French critics lauded this "new" Baker, American critics largely lamented the transformation both in the media's perceptions and its effect on Baker. Reviewing her show during the 1930 Colonial Exposition in which Baker made a strikingly dignified entrance, Janet Flanner wrote in one of her "Letters from Paris" in the *New Yorker*: "Her caramel-colored body, which overnight became a legend in Europe, is still magnificent, but it has become thinned, trained, almost civilized. . . . On that lovely animal visage lies now a sad look, not of captivity, but of dawning intelligence. . . . She is far from the banana-belt costume that made her the idol of Berlin, Barcelona, Budapest" (72–73). It is this sadness that Calder captures in his *Aztec Josephine Baker*, her vitality stifled by a public that no longer appreciated her talent

for playing the modern against the primitive—nor her comic subversions of the audience's expectations. A few years later, Nancy Cunard, the British/American heiress, edited the anthology *Negro*, in which she also expressed her regret for Baker's capitulation to the French. In her contribution, she extracted a series of comments made by French critics about Baker:

> **The Ebony Venus—the banana dancer—Seems to whiten as we gaze at her—By far the best possible example of the perfecting of the black race by its intellectual contact with European civilization—What a difference between the little savage of the early days with her delirious, grotesque dances and the toned-down, refined *artiste* transformed by Paris. . . . Civilization has done its work—Josephine is from now on assimilated by the western world. . . . Josephine est blanche . . . (Josephine is white)! (329)**

That the French viewed Baker's "progress" from savage to sophisticate in a positive light may not be so surprising; after all, such an aspiration to make Baker into "a whitened, gallicized actress" was part and parcel of what the French called *mission civilisatrice*, the notion that they could civilize anyone by teaching them French ways. For Cunard, however, Baker's transformation represented a surrender to French objectives, a submission that revealed the nationalism and prejudice of the French (Lemke 107). How much of Baker's new identity was a capitulation to such pressures, and how much a calculated marketing decision on Baker's part, is open to debate. However, it is clearly this sense of surrender and deflation of spirit that Calder chose to render.

Alexander Calder's portraits of Josephine Baker are a powerful testament to the cultural climate of postwar Paris and to modernism itself. The definition in wire of so ideologically loaded a form as the body of Baker became a means for Calder to address key issues regarding both the redeeming force of technology in elevating "primitive" impulses and the rejuvenating power of the primitive in recovering human agency and humor in a world increasingly governed by technology. What we also find in these works is an inscription of Baker's own motivations. As an American in Paris, Baker was able to distance herself not only from the context of American vaudeville and the history of slavery but also from that of French imperialism and the display of colonial subjects. Unconstrained by either, she maintained a liminal status with regard to the cultural prejudices, both American and French, that threatened to confine her energies as a black woman. Both Baker's forging of a unique identity as a Jazz Age icon and Alexander Calder's construction of his machine-age portraits thus engage the crucial ideological issue of the expatriate experience: the interchange between the French and the American, as well as the black and the white, in the construction of a new identity for the modern era. Furthermore, both show how the meshing of content and method—the conflation of a specifically American content and an aesthetic based on both popular culture and technological principles—is crucial to understanding the complex mediation of the technological and the primitive in modernist culture. As well, both move us toward a comprehension of the complexities of identity construction in the postcolonial present.

.

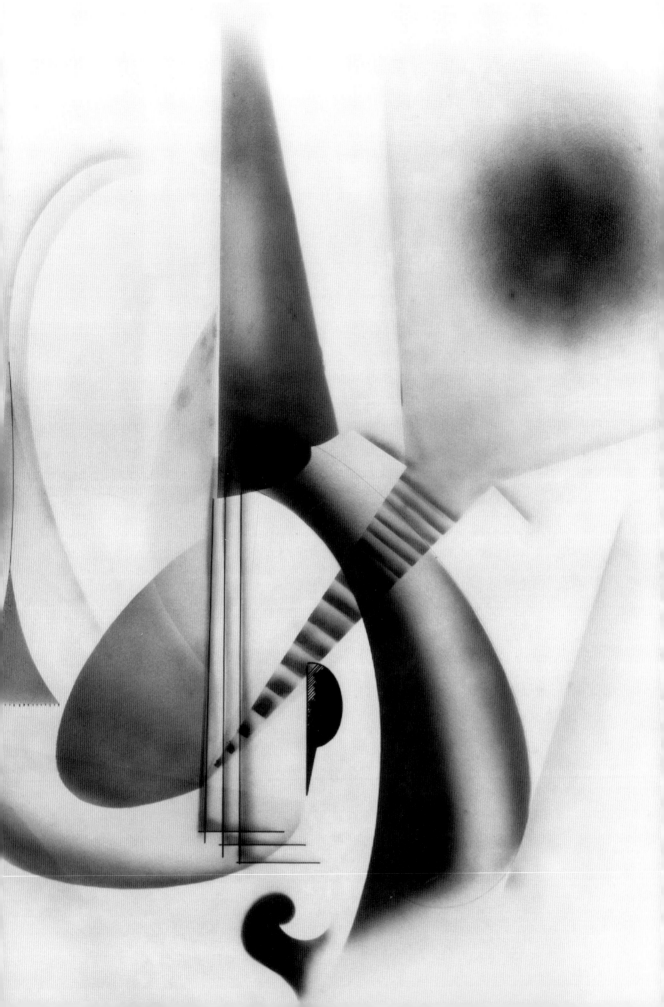

# JAZZ

# 7

# The "Jazzing" of the American Avant-Garde

Jazz is generally considered the quintessential expression of America in the machine age. Evolving in the 1910s and flourishing in the 1920s, jazz came to exemplify the youthful spirit and dynamic energy of America itself. As a new and vital musical force, jazz was viewed as encoding certain key aspects of the machine environment. The urgent rhythmic base of jazz, for instance, was associated with reverberations of the machine itself. Perhaps Waldo Frank best expressed the common perception of this conjunction of jazz and the machine: "Jazz syncopates the lathe-lunge, jazz shatters the piston-thrust, jazz shreds the hum of wheels, jazz is the spark and sudden lilt centrifugal to their incessant pulse. . . . This song is not an escape from the Machine to limpid depths of the soul. It is the Machine itself!" (118–119). In part because jazz so thoroughly engaged this paradigm of postwar American culture, it came to be, in Donna Cassidy's words, "a metaphor for the nation" (70). Avant-garde artists appropriated these two paradigms of American culture, coupling jazz and the machine in innovative ways and in the process creating an indigenous art.

Jazz was also, in a broad cultural sense, an integral part of the widespread reaction against tradition in the early years of this century. Unchecked by conventional rules of music, jazz was perceived as spontaneous, expressive, and free; as such, it provided a model for the rebellion of avant-garde artists who were searching for ways to subvert established definitions of art.[1] As the avant-garde began to acknowledge jazz as a valid inspiration for their burgeoning modernism, the syncopated rhythm of jazz increasingly informed their works. Key to this rebellion against tradition were the "unsanctioned" sources of jazz, that is, its sources in African and African American cultures.

Implicit in the avant-garde's rebellious embrace of jazz is a recognition of these sources and a consequent validation of black culture. Such a gesture points to the acknowledgment of the role of African American popular culture in the creation of American modernism and American identity. The conjunction of jazz and the machine thus implicated black culture in a tripartite alliance. The establishment of a jazz-based modernism raises critical issues having to with the disintegration of the boundaries

133

between "high" and "low" culture as well as with the interchange between the technological and the "primitive," the white and the black.

The tacit embrace of both machine and African American culture also characterized much contemporary cultural commentary. Robert Coady, who launched the avant-garde journal *Soil* in 1916, enlisted technology as well as black cultural traditions in his campaign to rejuvenate American art. He declared that "our art is, as yet, outside of our art world." According to Coady's new definition, the "Sky-scraper . . . Steam-shovel . . . and Gertrude Stein," along with phenomena such as "Rag-time, Syncopation . . . Minstrels . . . and Bert Williams," qualified as significant forms of American art" ("American Art" [1917] 55, "American Art" [1916] 3). Cultural commentator Gilbert Seldes also exalted the role of African Americans in determining national culture, writing in "Toujours Jazz": "In words and music the Negro side expresses something which underlies a great deal of America—our independence, our carelessness, our frankness, and gaiety." And he went on to embrace jazz as "the symbol, or the byword, for a great many elements in the spirit of the time—as far as America is concerned it is actually our characteristic expression" (69–70, 83). For Coady and Seldes, among others, jazz expressed a distinct American spirit, a spirit that was an amalgam of "Sky-scraper" and "Syncopation," "frankness and gaiety," white and black. In their search for a distinctively American idiom, writers and artists alike increasingly turned to this popular indigenous music for inspiration.

Of all the American modernists, perhaps Stuart Davis most thoroughly exploited the dichotomous associations of jazz. In his words, jazz was "a continuous source of inspiration in my work from the beginning." As a young artist in the 1910s, Davis frequently represented jazz or ragtime musicians and singers playing in various clubs, or "jooks," as they were called. Several early works, including *Barrel House—Newark* and *The Back Room*, both of 1913, feature black piano players, drum sets, and "low-life" types milling around in front of barrels of whiskey stacked against the wall. The artist's openness to such content was no doubt conditioned by his early contact with the circle of artists around Robert Henri; Davis studied at Henri's School of Art in New York from 1909 until 1912. Echoing Henri's zeal for firsthand experience of New York street life, Davis wrote in his autobiography: "Enthusiasm for running around and drawing things in the raw ran high." To satisfy what he termed "this compulsion," Davis haunted "the burlesque shows . . . the Music Halls of Hoboken; the Negro Saloons." According to Davis, he and fellow artist Glenn O. Coleman "were particularly hep to the jive, for that period, and spent much time listening to the Negro piano players in Newark dives" (*Stuart Davis* 21).[2] Here Davis is recollecting the prewar years, a time when ragtime dominated the "Negro Saloons" of Newark, Hoboken, and Manhattan's tenderloin district.

Davis referred to ragtime, or "ragtime jazz" as he called it, as a "great American art expression, the dominant force in music in the world today without question," adding that he appreciated it "more than most" ("Journal" 39). A 1918 drawing of Scott Joplin at his piano records Davis's admiration for this black composer widely recognized as the "King of Ragtime." Although Davis acknowledged the preeminent

role of African Americans in creating a specifically American music, these pictorial or illustrational interpretations remain superficial manifestations of modern art's relation to jazz; indeed, they are representations of artistic "slumming" in black culture. Although the artists went directly to the source to soak up the atmosphere of "jooks" and appreciated the music being produced there, their perspective remained spectatorial. The depictions of "low life" entertainments resulting from such immersion in black culture inevitably contain a note of condescension. As Cassidy has suggested, both the artist and the viewer "encounter this music and its social spaces at one remove. Ultimately, we are tourists and outsiders in the world of jazz and other working-class entertainments" (106).

Not until the postwar years did jazz become an important reference point for a new language of art-making as distinct from a subject for paintings. As the avant-garde attempted a translation of the inventive genius of this new music into a visual language that was consonant with the music itself, jazz began to inform painting in more radical ways. Implicit in this meshing of radical style and unorthodox content was precisely that duality spelled out above: that is, a dual acknowledgment of the industrial overtones of jazz and of its African and African American sources.

Once artists began to appreciate the implications of jazz for developing a new modernist language, mimetic representation of the sites of jazz entertainment gave way to the visual embodiment of structural principles inspired by the music itself. The collage aesthetic provided a key to this translation of jazz into visual terms. For *Jazz*, an aerograph of 1919 (ill. 54), for instance, Man Ray used a technique derived from collage: he carefully placed cut-out stencils and then airbrushed them so as to establish a staccato rhythm, a repetition of geometric and raylike forms that synesthetically replicate the sounds of jazz. While the presence of jazz instruments (the flaring cone of trumpets or saxophones and the curved neck of a bass) is implied here, the artist's primary aim is to transfer something of the sound sensations and excitement of jazz into the language of art. In moving from the documentation of sites where jazz was performed to a more abstract language informed by jazz, Man Ray may have erased specific images of blackness; however, in doing so he managed to complicate and thereby enrich the vibrant dialogue between the black and the white, the "primitive" and the technological.

By 1917, the first phonographic recordings of jazz had become available, and Stuart Davis, along with other artists, became avid collectors of these recordings. As jazz became more accessible, it became an integral part of the avant-garde's daily environment. Instead of trekking to jazz clubs, artists could for the first time play their favorite music in their own studios while they painted. Davis later commented on the effect of this intimate proximity of jazz: "I never realized that it was influencing my work until one day I put on a favorite record and listened to it while I was looking at a painting I had just finished. Then I got a funny feeling. If I looked, or if I listened, there was no shifting of attention. It seemed to amount to the same thing—like twins, a kinship. After that, for a long time, I played records while I painted" (qtd. in Lucas 33).

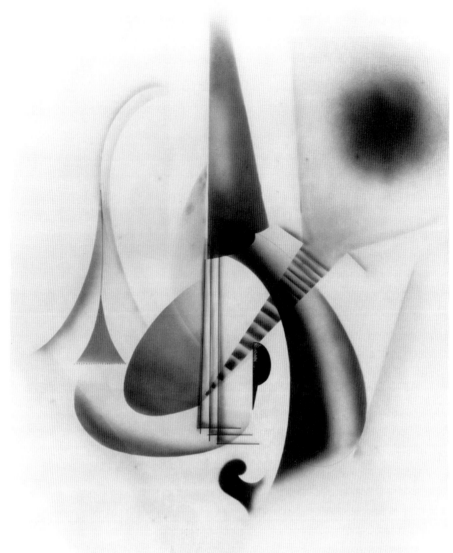

54. Man Ray, *Jazz*, 1919. Tempera and ink (aerograph) on paper, 28 × 22 in. Columbus Museum of Art, Ohio. Gift of Ferdinand Howald. Copyright © 2003 Man Ray Trust/ Artists Rights Society (ARS), New York/ADAGP, Paris.

This new mode of jazz listening removed the artist from the source of entertainment and from the black musicians who created it; however, it meant that jazz became a more integral part of the artist's studio and engendered a "kinship" between painting and music. For Davis, jazz became as much part of his milieu as did the technological environment outside the studio; indeed, through the new media of electronic reproduction of sound, jazz introduced a technological element into the studio. While listening to jazz, Davis thus found visual equivalents for the aural rhythms of the music combined with the cacophony of urban commotion.

Just as Man Ray's visual translation of jazz was dependent on the collage aesthetic, so, too, Davis discovered structural principles in jazz that corroborated his conception of art as a construction, as an expression analogous to the technological environment. In interviews and journal entries, Davis referred to jazz as a kind of collage or montage of sounds: "The power that jazz music has comes of course from its

positive rhythm and the distinct quality of its separate instruments" ("Journal" 76). Davis went on to refer to his own art-making as "the same thing as when a musician takes a sequence of notes and makes many variations on them" (qtd. in Seckler 30). In place of aural rhythms, the artist created pictorial rhythms based on analogous creative processes—sequences of images that were repetitive yet lively, carefully planned yet seemingly spontaneous.

It has become a commonplace in discussions of jazz that the spaces between the notes are as potent as the notes themselves. As Davis noted, "The negroes [sic] are masters of fractions. They know what lies between a third and 1/4" ("Journal" 33). In his painting, Davis, too, relies on a fairly precise rhythmic sense. Instead of providing smooth transitions or modulations between shapes, he juxtaposed form against form, resulting in abrupt transitions, or syncopated rhythms. While *Lucky Strike* of 1921 (ill. 5) represents a package of tobacco and engages the visual language of advertising, the painting also alludes to smoking and by extension to the smoky jazz joints where Davis hung out. Furthermore, the painting's brightly colored geometric shapes set up a kind of cadence across the surface—thin strips of red, silver, and blue providing a counterpoint to the dominant patches of green, with stenciled lettering providing additional rhythmic emphasis. While it is impossible to establish a one-to-one correlation between painting and jazz, Davis imbued his works with a rhythmic structure that played off—or harmonized with—the jazz he was listening to.

All this talk of structure calls into question accepted notions regarding the interrelationship between jazz and the visual arts. In relating the two, most writers have focused on the spontaneity of jazz, stressing the importance of improvisation. This is especially evident in literature since the 1950s, when musicians like Ornette Coleman set a standard for jazz based more than ever before on improvisation and when Abstract Expressionist artists, following hot on the heels of Surrealism, exploited a seemingly spontaneous process that had a parallel in contemporary jazz performance. Not surprisingly, in Stuart Davis criticism beginning in the 1950s, the importance of improvisation has assumed mythic proportions. Writing in 1957, John Lucas evaluated Davis's attempt to approximate the spirit of jazz in these terms, comparing the artist's "free arrangements of form or color [to] the improvisations of Hines or Armstrong." Lucas saw improvisation as "almost as much an end as a means—just as it is in the drumming of [George] Wettling" (34, 37). Though Lucas does cite jazz musicians who Davis greatly admired and who were his contemporaries, he tends to exaggerate the role of improvisation. More recently, Karen Wilkin reinforced this idea, writing, "To make a jazz analogy, which is always tempting given Davis's declared passion for hep music and hip talk, his approach is like that of a brilliant scat singer. Faithfully recorded details—the words of the song—are replaced by ecstatic improvisation" (*Stuart Davis* 165). And at the Metropolitan Museum of Art's retrospective of Davis's works of 1991, a wall label read, "Davis created a painterly analogy of the improvisational impulse of a jazz soloist."

However, in the jazz of the period under consideration here, improvisation was not the valued process it later became.[3] Throughout his career, Davis admired jazz not so much for its improvisatory inventiveness as for its exacting precision, even its

discipline. Recalling his exposure to works of modern art in the Armory Show in 1913, Davis wrote: "I also sensed an objective order in their works which I felt was lacking in my own. It gave me the same kind of excitement I got from the numerical precision of the Negro piano players in the Negro saloons" (*Stuart Davis* 23–24). This is not to say that Davis failed to recognize the new freedom of process, the freedom to elaborate or "embellish" on the basic structure that jazz offered. He stated that the primary element of a picture should be "strong enough to dominate and make seem orderly lack of order in the other elements, just as in a jazz band the powerful rhythm holds together the most unrelated excursions of the individual pieces" ("Notebooks" 35). Given the frequent focus in his journals on parallels between painting and jazz based on the internal logic and order of each, it appears that critics have tended to overstate, even to misrepresent, the improvisational element in Davis's works, even in his later seemingly less structured paintings.

Perhaps Davis best sums up the influence of jazz on his work in a frequently quoted remark of the 1940s. In listing "some of the things which have made me want to paint, outside of other paintings," Davis included "Earl Hines [*sic*] hot piano and Negro jazz music in general." "In one way or another," he continued, "the quality of these things plays a role in determining the character of my paintings. Not in the sense of describing them in graphic images, but by predetermining an analogous dynamics in the design, which becomes a new part of the American environment. Paris School, Abstraction, Escapism? Nope, just Color-Space Compositions celebrating the resolution in art of stresses set up by some aspects of the American scene" ("Cube Root" 33–34). Instead of exploiting the notion of improvisation in jazz, Davis capitalized on the machinelike rhythm of jazz in creating "an analogous dynamics in the design" of his own works. And this rhythmic precision informs his early collages of the 1920s as well as his later compositions characterized more conspicuously by syncopated cadences. What jazz offered Davis, then, was a model for his own belief in the progressivism of modern technology, a rhythmic structure that suggested the pictorial principles of a new collage aesthetic, and a subject that allowed the artist to give expression to his appreciation for popular culture and black entertainment.

A further examination of the art of Man Ray may serve to clarify this jazz/collage analogy. The first of his works to broach this issue may well be *Dance* of 1915 (ill. 11), a work featuring several overlapping automaton-like figures that gesture as if in the midst of a spirited dance. A jagged black-edged aura around the figures suggests shadows produced by the spotlighted illumination of a nightclub as well as the staccato rhythm of dance music. The previous year, Man Ray had executed *War (A.D.MCMXIV)*, a painting that likewise featured automaton figures; indeed, it was Man Ray's first painting to do so. But while the effect of *War* is of a regimented, unidirectional march of soldiers and horses under military command, the spirit of *Dance* is one of exalted liberation. The dancers may still be faceless automatons, but they are emancipated. Instead of military seriousness and the precision of the soldiers' orderly progression toward a goal (presumably the front), the figures in *Dance* evoke spontaneity as each responds exuberantly—and individually—to the infectious beat. Referring to works of

this period, Man Ray described his human figures as reduced to "flat-patterned disarticulated forms" (*Self Portrait* 52). By "disarticulating" planar forms, in effect "hinging" the joints, the artist simulates not only collage but also the frenetic motion of the new dances inspired by jazz music. The abrupt juxtaposition of forms can be seen as akin to jazz rhythm—and to jazz dance. It is worth noting, too, that *War* is the artist's only major treatise on World War I; once the war began, Man Ray, like the Europeans who sought refuge in New York, all but ignored that event in their art. The shift in context here from regimentation to liberation, from exterior battleground to interior jazz joint, signifies a powerful desire for escape among Dadaists in New York. The artists sought to avoid not only participation the war but also any reference to it in their art. Instead, they sought a kind of release in the liberated sounds of jazz and a safe haven in jazz clubs.[4]

The ecstatic dance gesture of the central figure partakes not only of escape from realities of the war but also of newly devised dance forms. Rather than the reserved tenor of Victorian dances, reels, and set or "square" dances popular in the early years of the century, the new rage for ragtime and jazz generated more raucous dances like the fox-trot, Scratchin' the Gravel, and the Black Bottom. A dance craze swept the country; in the words of Irene Castle of the popular Castle dance team, "By the fall of 1913, America had gone absolutely dance-mad" (qtd. in Collier, *Jazz* 20).[5] Jazz and the dances it spawned seemed to celebrate a radically new spirit that embraced the energy of black culture and of the vitality of the American metropolis. Artists like Man Ray appropriated jazz as a way of identifying with such vital energy sources.

Two events in Man Ray's life in 1915 conspired to "jazz up" his art, preparing the artist for immersion into new concepts in art and music. The first was his move from rural New Jersey to midtown Manhattan. "They were building the Lexington Avenue subway," wrote Man Ray, "and the racket of concrete mixers and steam drills was constant. It was music to me and even a source of inspiration" (*Self Portrait* 59). Of more significance to Man Ray's early career, however, was the arrival in New York of Marcel Duchamp, who spurred on Man Ray's enthusiasm for his new environment and his acceptance both of the machine environment and popular culture. Like other Frenchmen visiting New York during the war years—Francis Picabia and Albert Gleizes, for instance—Duchamp was eager to experience things American. For Duchamp, this meant exploring the significance of American products such as shovels, typewriters, and bathroom fixtures for his ready-mades, as well as vaudeville and dance halls for his amusement. Photographer Berenice Abbott, who also arrived in New York in the teens, apparently joined Man Ray and Duchamp for excursions out on the town to drink and dance, in her words, to "toot around the Village together and have fun" (qtd. in Baldwin 68).

Abbott also claimed responsibility for introducing Man Ray to dancing, which became a lifelong passion (Hadler 94). Dance also became a recurrent theme in Man Ray's art, his early inspirations ranging from a rope dancer he had seen in a vaudeville performance, the subject of *The Rope Dancer Accompanies Herself with Her Shadows* of 1916; to a troupe of Spanish dancers he saw in New York, the source for *Seguidilla* of 1919; to, in Man Ray's words, "the gyrations of a Spanish dancer" of

*Danger/Dancer* (ill. 13) (*Self Portrait* 79). Although these and other dance-centered works may not refer explicitly to jazz, the artist's openness to sources in popular entertainment is part and parcel of his embrace of jazz, a pivotal principle for the artist's modernist evolution.

The centrality of jazz in the art of Man Ray is further amplified in *The Revolving Doors*, the series of ten collages he executed in 1916–1917, individually titled *Mime*, *Orchestra*, *The Meeting*, and *Jeune Fille* (to name only those illustrated here, all from a later replication of the collages). Constructing each work of brightly colored paper cutouts, Man Ray here made the switch from the simulated collage of *Dance* to actual collage. The artist has found a technique that takes on the machinelike precision and rhythm of jazz as well as something of the spirit of the urban environment. Endemic to this urban and industrial world was a new realm of sound—or "noise," as many insisted on calling the racket made both by machines and by jazz, the new music of urban America.

Man Ray also devised a way to exhibit *Revolving Doors* that indirectly reinforces the jazz analogy. He framed the ten works individually and attached them to a central rotatable pole, much like revolving doors. The artist thereby gave the viewer an active role in putting this contraption in motion. Especially since the images themselves suggest a jazz context, such a participatory role can be viewed as akin to early performance of jazz, wherein the black audience helped establish the beat by interjecting shouts of approval in a "call and response" interaction with the musicians (Ogren 8). Like the jazz aficionado, the viewer of *Revolving Doors* is no longer passive but is involved in bringing the art to life. In the technique, in the presentation, and, as we'll see, in the content of *Revolving Doors*, then, Man Ray has evoked an entertainment well suited for the dominant machine culture of the early twentieth century. Indeed, his work demonstrates how machine and black culture came together to spawn a revolution in language—visual as well as aural: the language of art and the language of jazz.

In creating one of the first participatory works of art, Man Ray follows the precedent of Marcel Duchamp's *Bicycle Wheel* of 1913. But while the viewer's initiation of movement in Duchamp's ready-made causes a blurring of spokes and a sense of abstract movement, the rotation of the panels of *Revolving Doors* puts into motion a rhythmic sequence of forms that is associative on a very different level. When the "pages" are turned and the images decoded, a kind of narrative unfolds, a story that touches on different aspects of American popular culture—technology, music, and dance. As well, this mode of presentation might be thought of as a kind of protocinema.

The narrative of *Revolving Doors* begins with *Mime* (ill. 12), whose figure with outstretched arms echoes the joyous spirit of the artist's *Dance* and affirms his dual discovery of the collage medium and the content of popular culture. Man Ray has instilled in this automaton-like figure a lightheartedness, in his words, a "laughing" mood, which he had come to appreciate in the popular entertainments such as vaudeville ("Revolving Doors" 152). The second in the series, *Long Distance*, features the shape of a dirigible set against geometric rays of color. Through the simplest of means, Man Ray has suggested the irrepressible energy of the technological world

III

55. Man Ray, *Orchestra*, from the portfolio *The Revolving Doors*, 1926 (original collages, 1916-17). Pochoir on paper, 22 × 14 7/8 in. Smithsonian American Art Museum. Copyright © 2003 Man Ray Trust/Artists Rights Society (ARS), New York/ADAGP, Paris.

into which modern art and jazz were born. Furthermore, in sandwiching *Long Distance* between *Mime* and the third in the sequence, *Orchestra* (ill. 55), the artist emphasized the connection between the technological and the world of dance and jazz. *Orchestra* features brightly colored cutouts that suggest musical instruments: the red silhouette of a bass and the flared shapes of woodwind and brass instruments. The tight grouping of these instruments accurately reflects the production of jazz by small combos at this time. Prior to the arrival of symphonic jazz in the years after 1921, jazz was played in smaller clubs, honky-tonks, or "jooks," by combos consisting of only five or six instruments—typically a bass, drums, a few horns, and sometimes a piano (Collier, *Jazz* 19). The compact collaging of abstracted forms in *Orchestra* is, however, not so much mimetic of the visual site of jazz performance as expressive of something of the nature of the sound and the interplay of the players.

The fourth in the series, *The Meeting* (ill. 56), features a centralized drill-like image—perhaps inspired by the "music" of steam drills outside his studio—and two

56. Man Ray, *The Meeting*, from the portfolio *The Revolving Doors*, 1926 (original collages, 1916–17). Pochoir on paper, 22 × 14 7/8 in. Smithsonian American Art Museum. Copyright © 2003 Man Ray Trust/Artists Rights Society (ARS), New York/ADAGP, Paris.

other figures that seem to weave and merge as if to an implied beat. As Roger Shattuck observed, "caricatured male and female cutouts turn and maneuver as on a carousel" (330). Where Shattuck characterized the work as a "geometric-anthropomorphic fantasy" (314), Man Ray described the figures as "pseudo-mechanistic," as "[t]hree beings meeting in one plane . . . a yellow concave, a red convex, and a spiral blue" (*Self Portrait* 59; "Revolving Doors" 152). Both descriptions—and the work itself—imply a collapsing of the distinctions between the human and the mechanical, a biomechanical merger that emphasizes the connection between, even fusion of, the driving machinelike rhythm of jazz and the participatory involvement of the audience/dancers, as well as something of the sexual connotations of jazz common at the time.

This Jazz Age drama is further embellished in the fifth work in the series, *Jeune Fille* (ill. 57). As we've seen, French artists, including Picabia, were fascinated with the *jeune fille américaine*, who signified rather romantic, if naive, notions regarding American women and America itself. Given this cultural context, the *jeune fille* of Man Ray's title can be understood as a distinctively American type. The collage can

VII

57. Man Ray, *Jeune Fille*, from the portfolio *The Revolving Doors*, 1926 (original collages, 1916–17). Pochoir on paper, 22 × 14 7/8 in. Smithsonian American Art Museum. Copyright © 2003 Man Ray Trust/ Artists Rights Society (ARS), New York/ADAGP, Paris.

thus be decoded as a multilayered commentary regarding the youthful culture of America. Constructed of colorful strips of construction paper, Man Ray's *Jeune Fille* is highly geometricized, as is Picabia's *Portrait d'une jeune fille américaine* (ill. 35). But while Picabia's sparkplug seems absolutely static, Man Ray has given his *jeune fille* a slight forward tilt to suggest forward movement. Furthermore, below the collaged torso the artist has positioned a hemispheric belly (an indicator of female gender), which seems to enable her implied movement. And the free-form strings attached below suggest the free movement of a dancer's fringed flapper dress. With great wit and economy, Man Ray has fashioned a *jeune fille* who dances to the rhythms of the jazz-combo of her neighboring collage, *Orchestra*.

Both Picabia's and Man Ray's *jeunes filles* are also remarkably androgynous, as were the dress fashions of the time. (Picabia's sparkplug is altogether lacking in "feminine" characteristics, while Man Ray only hints at female anatomy.) Both works foreground the rebellious and erotic dimension of the New Woman of the postwar years. In defiance of traditional feminine attire and behavior, these youthful machine-women

assert a manly appearance while at the same time taking on an active role, sparking passion in Picabia's version and dancing with abandon in Man Ray's. With their androgynous, indeed phallic, forms, these machine-women acknowledge a new machine aesthetic as well as the blurring of gender distinctions in this era of the New Woman.

Such a reading of Man Ray's *Jeune Fille* as a Jazz Age flapper is reinforced by comparison with a drawing, also entitled *Jeune Fille*, executed by Man Ray in 1917 (ill. 58). By reverting to a more realistic style, the artist gives us clues to the collage version. With bobbed hair and a straight-lined pleated shift, this *jeune fille* is the embodiment of the New Woman. The gesture of this figure—one arm flung forward counterpoised with a backward kicking leg—can signify but one thing: the Charleston, a dance that became synonymous with the Jazz Age. In these works, Man Ray has captured the exuberance of the Charleston's characteristic gestures as a way of celebrating not only jazz itself but also Jazz Age women and American culture.

A decade later Man Ray would fashion his mistress, Kiki, into a French version of the *jeune fille américaine*. According to Neil Baldwin, Man Ray styled Kiki's hair, "designed" her face, and even determined her wardrobe, on occasion ordering clothing for her from America (107, 132). In the process, the artist reconfigured Kiki into his own image of a *jeune fille américaine*. Kiki's transformation can be seen by comparing early photographs, in which she sports longish hair and appears rather soft and feminine, to later images such as those in the final sequences of Man Ray's first film, *Emak Bakia* of 1926, in which her hair is bobbed and slicked down close to her head, much like Josephine Baker's. Her appearance now conforms to the *jeune fille* as New Woman.

*Emak Bakia* also features footage of Kiki in the midst of a lively Charleston; the film thus actualizes the movement implied in his earlier drawing, *Jeune Fille*, placing it in a sequential context informed by jazz culture. The artist called his film a "cinepoème," which nicely describes its unfolding of poetic images; the film interweaves footage of dance and musical performance, an automobile in motion, lighting effects produced by the revolving of reflective objects, among other unrelated phenomena, including the Charleston dance sequence featuring Kiki's legs and feet. To suggest jazz accompaniment, the artist alternated the Charleston footage with shots of a banjo strummed by a black musician. Through his precise editing of the banjo strumming and dance sequences, Man Ray proposed a new kind of filmic structure, one simulating the rhythmic cadences of jazz itself. Not surprisingly, the artist specified that the film be accompanied by "old jazz" (*Self Portrait* 272).[6] The jazz accompaniment and the banjo player also foreground the black presence in the production of music, jazz dance, and even film.

By embracing a filmic structure informed by jazz for *Emak Bakia*, Man Ray has refused traditional narrative; instead of a scenario, the artist presents various motifs simply as repetitive sequences: the exit of women from the automobile, the kicking legs of the Charleston, and the strumming of the banjo. The narrative remains open-ended and ultimately unresolved. Like jazz itself, the film has structure but lacks any kind of definitive resolution. Man Ray subverted expected narrative structure not only through images but also through subtitles. Toward the end of the film, he inserted the

58. Man Ray, *Jeune Fille*, 1917.
Drawing. Copyright © 2003 Man Ray
Trust/Artists Rights Society (ARS),
New York/ADAGP, Paris.

line: "La raison de cette extravagance"; however, nothing in the footage that follows explicates the reason for "this extravagance." Rather than a sense of narrative resolution, the audience is left with a lively and resonant montage of poetic images evocative of jazz, modern machines (the automobile and movie camera), and black culture. Perhaps we can also see Man Ray's filmmaking as exposing a doubly technological mediation, since a machine is necessary to shoot film as well as to project it.

While Kiki may have taken on certain aspects of the *jeune fille* as flapper, the transformation seems to have owed more to Man Ray's agency than to her own. As discussed in the preceding chapter, it was Josephine Baker who personified the ultimate flapper, what Noel Coward called the "syncopated child" of the Jazz Age (qtd. in Chinitz 319). Baker revolutionized jazz dance, infusing it with complex cadences. As dance critic Mindy Aloff put it, Baker had the rare ability to move different parts of

her body to different rhythms, "all of them in delicious syncopation" (32). And, of course, it is Alexander Calder's wire renditions of Baker that best evoke the liberated movement of jazz dance. His portraits suggest the exuberance and audaciousness that encapsulate this mythic "syncopated child" of Jazz Age culture and that characterized Baker herself; indeed, it is her sense of agency in determining new models of conduct in the postwar years that is most striking. Baker's identity as an African American adds a new dimension to this concept of the *jeune fille américaine*. By injecting blackness into this new paradigm, Calder implicitly recognized the role of African American culture in determining new cultural paradigms. By focusing on Josephine Baker, Calder also suggests that this nexus between black and white was by no means simple appropriation but rather an "aesthetic collaboration" (Lemke 3).

Paradoxically, this sense of creative collaboration is both challenged and enhanced by the fact that Calder's sculptures have no color; the artist simply outlined the figure in wire, leaving the interior blank. Blackness is implicit, of course, because we know this is Josephine Baker, but it is up to the viewer to fill in the contours. However, the literal openness of the sculpture elicits audience participation not only in supplying the color of her skin but also in perpetuating or countering stereotypes. In this context, an essay by Zora Neale Hurston is most apt. In "What White Publishers Won't Print," which appeared in the *Negro Digest* in 1950, Hurston disparaged "the Anglo-Saxon's lack of curiosity about the internal lives and emotions of the Negroes" and challenged the claims of anthropological objectivity of such institutions as the American Museum of Natural History (169):

> **The question naturally arises as to the why of this indifference, not to say skepticism, to the internal life of educated minorities. The answer lies in what we may call THE AMERICAN MUSEUM OF UNNATURAL HISTORY. This is an intangible built on folk belief. It is assumed that all non-Anglo-Saxons are uncomplicated stereotypes. Everybody knows all about them. They are lay figures mounted in the museum where all may take them at a glance. They are made of bent wires without insides at all. (qtd. in Rony 210–211)[7]**

Hurston's chilling passage seems a perfect description of Calder's portrait of Josephine Baker. She consists of "bent wires without insides" onto which any old stereotype could be imposed. However, Baker's own shrewdness in adapting to her Parisian audience is also relevant here. Referring to the stereotypes and primitivist tropes that her audience wanted to see in her, Chinitz wrote, "she appropriated them, performed them, made them her own" (331). Calder's *Josephine Baker* thus allows viewers either to give free rein to their own stereotypical perceptions of Josephine Baker as erotic jazz dancer or to reevaluate those stereotypes in terms of a more enlightened cross-cultural encounter, one that honors Baker's agency in acting out those stereotypes.

Just as we implicitly read Calder's wire figures of Baker as black, we understand their musical context as jazz; they are after all not passive static constructions but made to be active. The lines of the sculpture define a body in movement, but here,

too, it is the spectator who fills in the gaps (or silence), intuiting the syncopated beat to which she moves. This meshing of black and white (assuming a largely white art viewing audience) in Calder's work mirrors the wider collaboration of the two—in the world of entertainment and of modernism; indeed, it comprises a recognition of both the challenges confronted by blacks in modern culture and the contributions of black culture to postwar American modernism.

The notion of jazz as a model for artistic collaboration between black and white in machine-age America was not, of course, universally sanctioned. In appropriating jazz, Davis invoked a domain of popular culture that was still suspect as source material for "fine" art. In fact, his elevation of jazz was thought to degrade his work; as one reviewer wrote, Davis was "O.K. if you like Jazz, but don't confuse Jazz with Music" (Boswell 3). For Davis and others of the avant-garde, jazz may have had progressive connotations; however, for many others it conjured up distinctively unwholesome associations.[8] Originating as it did in Africa, developing in the brothels of the Storyville section of New Orleans, and thriving thereafter in the "vice" districts of major cities, jazz was considered decadent by many. Jazz musician Garvin Bushell recalled that in New York of the teens, "You could only hear the blues and real jazz in the gut-bucket cabarets where the lower class went" (qtd. in Schuller 67). And Davis remembered that since very little jazz was available on phonograph records "it was necessary to go to the source to dig it," to saloons that "catered to the poorest Negroes" (*Stuart Davis* 21). The implications of such slumming were particularly distressing to conservative critics of jazz who prophesied that "if we do not stop 'jazzing' we will go down, as a nation, into ruin" (Seldes 83).[9]

The distinctly unwholesome atmosphere of such jazz joints is explicitly rendered in Davis's early Ashcan works, such as *Barrel House—Newark*, a drawing reproduced in the *Masses* in 1914. Even the title reinforces the low-life connotations; as defined in the *New Grove Dictionary of Jazz*, the term "barrelhouse jazz" refers not only to a hybrid of American blues and New Orleans music but also to the slang for something rough or crude. The entertainment in such "dives" where Davis hung out is also suggested, if more subtly, in Davis's "automaton" collages of 1921, to be discussed below. Davis's embrace of low-life and black culture reveals the anti-elitist impulse that informed the art of many members of the American avant-garde.

Along with alcohol and tobacco, jazz was judged to be unfit for respectable society and a threat to the moral character of America and especially its youth. Interestingly, all three of these "base" diversions were faced with prohibition during this time of fervent reform. While only the movement to prohibit alcohol was successful, the three "evils" were often linked in the popular mind. Buoyed by the passage of the Eighteenth Amendment, prohibitionists turned their attention to banning both tobacco and jazz. In an essay entitled "Sudden Def" about the widespread denunciation of contemporary rap music today, Henry Louis Gates Jr. traces the lineage of such demonization to the Jazz Age: "Back in the twenties, citizens' groups took up arms against the licentious depravity of another emergent form of popular music." Gates

cites a 1922 article in the *Ladies' Home Journal* entitled "The Jazz Path of Degradation," which warned its readers, "Jazz is lewd to the physiological limit. In many cases it leads to worse things; and in others it cannot lead to worse things—being a sufficient evil end in itself." He also quotes a 1923 headline in *Musical Courier*: "REPRESENTATIVES OF 2,000,000 WOMEN MEET TO ANNIHILATE 'JAZZ' " (41).

"Jazzing" (or "jassing") was also a slang term both for sex and for dancing the sexy dances inspired by the new jazz. Not surprisingly, dances like the Black Bottom, the Mooche, Scratchin' the Gravel, and the Charleston were condemned along with jazz as corrupting influences on American youth, even as threats to the moral fiber of American society. Just as Man Ray's meshing of colors and merging of figures in *The Meeting* suggests sexuality, so, too, did the jazz dances of the time, which caused great controversy due to the physical contact of the dance partners combined with the intense beat of the music. Unlike established American dances of the turn of the century, in which dancers kept a discrete distance from one another, the new dances promoted a freedom of movement, an overt physicality, and a proximity that was thought to be scandalous by the more traditional observers of the time. In 1922, for instance, a newspaper article denounced the "cheek-pressers, hip-swingers, and lemon-rollers of the fierce jazz dance invaders," and, presaging the furor caused by rock and roll several decades later, advocated an "anti-vulgar dance ordinance" (qtd. in Stearns and Stearns 114). Perhaps Toni Morrison put it best in *Jazz*, her novel set in the 1920s: "They suspected that the dances were beyond nasty because the music . . . begged and challenged each and every day. 'Come,' it said. 'Come and do wrong' " (56, 67). As Morrison makes clear, jazz faced condemnation and censure not just from the white but also from the black establishment.

Especially among the black cultural elite there was much hostility toward jazz. In one respect, their disapproval of jazz was similar to that of white conservatives; both groups saw jazz as a vulgar low-life activity. As David Levering Lewis has written, "upper-crust Afro-Americans still mostly recoiled in disgust from music as vulgarly explosive as the outlaw speakeasies and cathouses that spawned it" (173). African American critics of jazz viewed such negative associations of jazz as perpetuating stereotypical views of blacks as lascivious, undisciplined, and uncultured. The disapproval of many in the African American community was a way of countering prevalent stereotypes of blacks.

For critics of both races, the African origins of jazz further signified the debasement of this musical form. In their eyes, this kind of music came from a continent considered uncivilized and incapable of generating culture. But if jazz was perceived as originating in "primitive" societies, it was also seen very much as a product of urban and industrial America, thriving as it did in urban centers. In this context, it could be argued that the American avant-garde countered the primitiveness of jazz by associating it with something that was more highly valued in American culture, that is technology. For the avant-garde, the rhythmic base of jazz took on reverberations of the industrial environment and thus came to exemplify machine-age America. Europeans, in particular, fostered a view of jazz as embodying a distinctively

American—and industrial—tempo; with its hard-driving intensity, jazz was, according to Brecht, "the music of engineers" (qtd. in Tower 87). As we've seen, the American avant-garde's adoption of the collage technique can be seen as an attempt to legitimize their art in a culture that valued most the creations of engineers. By appropriating jazz into a collage aesthetic, then, the American avant-garde effectively industrialized the jazz reference.

This alliance of jazz and technology seems to imply a denial of the "negative" association of jazz with black culture. And in the early 1920s, many sensed that jazz was moving away from its "primitive" sources, that, as James Collier put it, "jungle music is undergoing a refining process under the fingers of sophisticated art" (*Reception* 17). This trend toward a "smoother, more polite, harmonic style" of jazz, sometimes called "sweet" or "symphonic" jazz, was initiated by Paul Whiteman, band leader of the most popular "symphonic jazz" orchestra in New York (Lemke 69). Whiteman attempted, in his words, to "make a lady of jazz" by presenting classical arrangements of jazz and, in the process, Europeanizing or "bleaching" jazz (qtd. in Lemke 70).[10]

To ascribe this impulse to "sanitize" jazz to the avant-garde, however, is problematic, at least in the immediate postwar years. As an analysis of their works shows, avant-garde artists did not deny the origins of jazz, nor was their intention to "whiten" it; instead, they affirmed both the technological and the primitive, creating a "technological primitivism" that reflects the duality—and vitality—of jazz itself. This duality was perhaps best described by Harry Kessler, chronicler of Weimar Germany, when he described Josephine Baker's show in Berlin in 1926 as "a mixture of jungle and skyscraper elements" and jazz itself as "ultramodern and ultraprimitive" (qtd. in Hadler 92).

Seen in terms of these oppositions, jazz encoded the dual fascination, among Europeans and Americans alike, with the American city, on the one hand, and with African American culture, on the other. The result is a new cultural hybrid of the white and the black, the "ultramodern and ultraprimitive." And it is the African component of jazz that catalyzed this cross-cultural hybrid. It could be argued that this fusion privileges the technological over the primitive and sanitizes black culture for white consumption, and to some extent such ethnocentric assumptions persist. However, such appropriation may also propose a model in which usually fixed binary oppositions begin, in Lemke's words, "to drift into one another" (148). For the American avant-garde, this meshing of opposites assumes complex and shifting meanings. Several works discussed earlier as "avant-garde automatons" could use further attention in this context.

Stuart Davis's take on this "technological primitivism" is perhaps best stated in *ITLKSEZ* (ill. 8), whose imagery and collaged title—shorthand for "it looks easy"—merit reexamination at this point. While the stylized black face of the figure suggests vaudeville, ragtime, and jazz performance, as well as African sculpture, the enigmatic title implies a commentary on the embrace of such phenomena by the white establishment of modern art. The implicit irony here is that, while the amalgam of black and white that Davis suggests may look "EZ," it is in fact not something to be taken for granted—either in art or in the larger culture. Instead of a sanitization of black

culture, Davis's particular use of collage can be seen as a way to open up a space for a dialogue between black and white; most important, it is an acknowledgement of black culture's role in configuring modernism.

The play between the technological and the primitive is further complicated in another of Davis's figurative collages, *Untitled (Figure)* (ill. 9), which also sheds light on jazz discourse. As mentioned earlier, the Gold Seal Congoleum advertising logo, strategically glued to the hip, suggests mobility. The figure seems to be performing a ritual tribal dance or perhaps a jazz dance. In fact, with its forward-reaching hands, the figure not only resembles an African artifact but also looks very much as if it is doing the conga, a Cuban line dance of African origin.[11] And the Congoleum logo alludes not just to a mass-produced flooring but also to a "primitive" place—to the Congo as the source for "raw" materials, in this case rubber, and as the source for the "raw" forms of the new jazz dances. In such works, Davis establishes a dialogue between the technological (or sophisticated) and the primitive (or folk). Davis once insisted that "jazz isn't folk art. It's an art of the city and therefore sophisticated" (qtd. in O'Doherty 27). While such a statement may seem to downplay the African sources of jazz and to privilege the white over the black, what Davis advocates is not so much a "whitening" of jazz as an openness to its sophistication, a creative nexus between "folk" and "high art," between black and white. Cassidy has made the case that the overall development of Davis's work suggests the "whitening" of the jazz context and that such an erasure of black references paralleled "a similar whitening process in jazz itself" (112). An analysis of Davis's later works of the 1930s and 1940s may well support such a conclusion; however, the focus here is on the early 1920s, a time when jazz had not yet been thoroughly whitened. Jazz was then a hot commodity and a charged terrain for modernists like Davis who were interested in challenging conventions.

Man Ray also grappled with the issue of technological primitivism, perhaps most definitively in *Danger/Dancer*, an aerograph of 1920. As we've seen, given Man Ray's inspiration for this work in the movements of a dancer, the arrangement of gears can be read as a tripartite segmentation of a body—an abstract rendition of head, torso, and legs analogous to the stylizations of African artifacts. As well, the implied repetitive movement of the gears suggests a rhythmic dance beat. However, Man Ray's introduction of a third gear locks the configuration in a mechanistic embrace. Instead of the easy rhythmic movement suggested in his earlier works on the dance theme, here the dancer is immobilized, the music silenced. Man Ray thereby problematized the technological/primitivist nexus. While the locked gears may signal a need to control the unbridled abandon signified by the primitive—and by jazz itself—they may also suggest an indictment of technology. After all, it is the machine that has stilled the dancer. In acknowledging machine control over human behavior, the artist warned of the dangers not of "primitive" but of technological abandon. In foregrounding the beauty of these gleaming gears, Man Ray seemed not so much to diminish that threat as to point to the seductive power of technology.

There is another way in which the aerographic technique used in *Danger/Dancer* and in *Jazz* enhances the technological alignment of these works. In this rapid-fire

application of paint from a pressurized air-gun, Man Ray discovered an efficient means of getting paint to canvas, and the residue of that speed is evident in the final product. The aerographs are thus doubly technological, evoking a slick surface associated with machine design as well as a sense of speed in execution. Every aspect of twentieth-century life seemed to be speeded up—from new modes of transportation and communication to Taylorized methods of factory production, creating what French writer Paul Adam called a "cult of speed" (qtd. in Kern 111).[12] Duchamp commented that "the whole idea of movement, of speed, was in the air," and the Italian Futurists announced a new aesthetic of speed (qtd. in Kuh 48). European and American artists' adoptions of new techniques like collage and aerography can be seen as an engagement with this quickened pace of a fast-changing world.

This concept of speed is also fundamental to popular notions of ragtime and jazz. The term ragtime, according to Kern, refers to "the irregular movement of syncopated rhythm and its effect on traditional time—literally, time in tatters." And "jazz" has been used as a slang term for speed (23–24). French writer Blaise Cendrars claimed that his typewriter was "as fast as jazz" (qtd. in Hadler 91). The fast execution that such artists as Calder, Man Ray, and Davis suggest—through the rhythmic looping of wire, the quick and sure placement of stencils and other extraneous materials—underscores this link between jazz rhythm and modes of art-making. Furthermore, this metaphoric injection of speed and liveliness into avant-garde art practices would seem to satisfy the desire for revivification invoked by critics of the day. As critic Joel A. Rogers wrote in 1925, "Jazz is rejuvenation, a recharging of the batteries of civilization with primitive vigor" (223–224).

For the avant-garde, then, the rhythmic base of jazz evoked both drums in a jungle and machines in a factory. American artists' coupling of jazz and constructive modes of art-making served both to acknowledge the African origins of jazz and to valorize black culture in machine-age America. Artists including Man Ray and Stuart Davis came to jazz before it had been "whitened." Rather than a sanitizing gesture, then, the artists' appropriation of jazz provided a counterpoint to the oppressive seriousness of technology. At the same time, however, such a pairing pointed to technology as potentially wild and uncontrollable. Rather than an attempt to make jazz more palatable and dignified by associating it with more mainstream culture of the 1920s, the American avant-garde's embrace of this popular music validated it as an appropriate subject and inspiration for avant-garde art and acknowledged the seminal role of black culture—both African and African American—in formulating a new visual language. Again, it is the duality, irony, and juxtaposition of diverse elements inherent in the avant-garde's engagement with jazz culture that makes this such fertile territory for coming to terms with American modernism.

# 8

# Expatriates of the Jazz Age

*Gerald Murphy, Cole Porter,
and the Ballets Suédois*

Further examination of the expatriate experience serves to bring into sharper focus key issues of jazz culture. One project in particular sheds light on perceptions of American jazz from abroad: *Within the Quota*, the avant-garde ballet collaboratively created by Gerald Murphy and his long-time friend Cole Porter. Produced by the Ballets Suédois, *Within the Quota* premiered on October 25, 1923, at the Théâtre des Champs-Élysées, with choreography by dancer Jean Börlin; direction by fellow Swede Rolf de Maré; scenario, set, and costume design by Gerald Murphy; and music by Cole Porter. Though the production involved international collaboration, the thematic focus and musical score of *Within the Quota* were strictly American. The impresario of the Ballets Suédois, Rolf de Maré, had commissioned Murphy to create a specifically "American" ballet, and so Murphy wrote a scenario based on the adventures of an innocent Swedish immigrant fresh off the boat in New York City. This was a timely theme since Sweden was then very poor, unemployment was high, and young Swedes were "emigrating *en masse* to America" (Häger 44).

*Within the Quota* was on the same program with another *gesamtkunstwerk*, or total work of art, the more famous *La Création du monde*, created by a French team of artists: Fernand Léger designed the costumes and sets, Darius Milhaud composed the jazz-inspired music, and poet Blaise Cendrars wrote the scenario. Based as it was on African creation myths, *La Création du monde* was radically different from *Within the Quota*; however, this seemingly odd pairing of the primitive and the contemporary offers insights into a wide array of issues pertaining to the appropriation of jazz by the American as opposed to the French avant-garde.

The action of *Within the Quota* begins with a simulation of the great whistles of an ocean liner entering the New York harbor. A naive immigrant disembarks and is immediately enmeshed in a scenario that takes him through a series of encounters with American personalities (ills. 59, 60), most of them stereotypes appropriated from silent film. As one writer described the scenario.

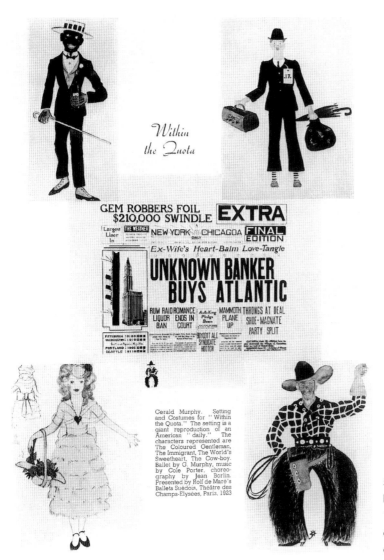

Within the Quota

Gerald Murphy. Setting and Costumes for "Within the Quota." The setting is a giant reproduction of an American "daily." The characters represented are The Coloured Gentleman, The Immigrant, The World's Sweetheart, The Cow-boy. Ballet by G. Murphy, music by Cole Porter, choreography by Jean Borlin. Presented by Rolf de Maré's Ballets Suédois, Théâtre des Champs-Elysées, Paris, 1923.

59. Gerald Murphy (with Sara Murphy), *Costume Studies for 'Within the Quota'*, 1923. Gouache on paper. Copyright © 2003 Estate of Honoria Murphy Donnelly.

A Millionairess, bedecked with immense strings of pearls, ensnares him; but a "Reformer" frightens her away. Then a Colored Gentleman appears and does a vaudeville dance. He is driven away by a "dry agent" who immediately thereupon takes a nip from his private flask and disappears, to the immigrant's increasing astonishment. The Jazz Baby, who dances a shimmy in an enticing manner, is also quickly torn from him. A magnificent cowboy and a sheriff appear, bringing in the element of Western melodrama. At last the European is greeted and kissed by "America's Sweetheart"; and while this scene is being immortalized by a movie camera, the dancing of the couples present sweeps all troubles away. (Michel 38)

As the plot summary shows, Murphy set up provocative oppositions between the principal characters and a "Puritan," who appears in the guise of different kinds of reformers, each one determined to save the ill-fated Immigrant from various American

60. Gerald Murphy (with Sara
Murphy), *Costume Study for 'Jazz
Baby'*, 1923. Gouache on paper.
Copyright © 2003 Estate of
Honoria Murphy Donnelly.

corruptions: the Millionairess with her oversized pearls is confronted by a Social
Reformer; the Colored Gentleman with his champagne bottle by a Revenue Agent; Jazz
Baby with lit cigarette by another Social Reformer (or "uplifter"); and the Cowboy with
his six shooters by a Sheriff. The culmination of the action brings the only successful
rendezvous—that of the Swedish Immigrant and America's Sweetheart, who comes to
his rescue, transporting him to Hollywood where his dreams come true.[1]

  Such a narrative clearly played into the *américanisme* of the postwar era.
American society, and particularly New York, was seen by the French as one great
collage—much like Murphy's cover design for the souvenir program for *Within the
Quota* (ill. 61).[2] The cover features a cut-out figure of a wide-eyed Swedish immigrant
superimposed on an assemblage of images, including the Flatiron Building, ocean-
liner smokestacks, bridge scaffolding, subway cars, and a seaplane just landed in the
Hudson River—all rather chaotically juxtaposed to suggest the cacophony of the city
and the excitement of the European's first impressions.

  Like Murphy's cover design, Cole Porter's musical score for *Within the Quota*
was informed by collage; Porter's score, described as a conflation of a Salvation Army

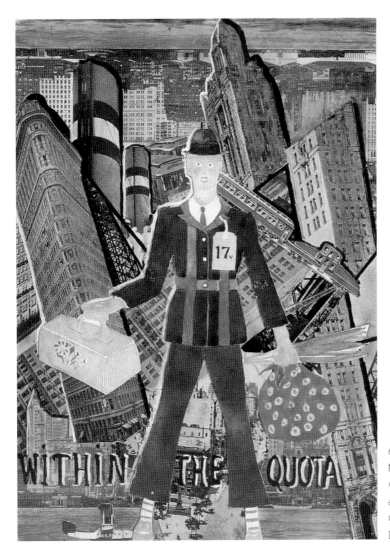

61. Gerald Murphy (with Sara Murphy), *Program for 'Within the Quota'*, 1923. Watercolor, gouache, and collage on paper. Copyright © 2003 Estate of Honoria Murphy Donnelly.

chorale, a fox-trot, and street noises simulating New York taxi horns, provided an aural collage analogous to Murphy's assemblage of images taken from popular culture (Rubin 28). However, just as Murphy unified his collage with a tight cubist construction, Porter, too, provided a substructure for these diverse sounds. And that substructure was jazz, which was, of course, all the rage in postwar Paris. Fed by the prevailing *américanisme* of the day, this explosion of interest fueled the notion of jazz as quintessentially American—even as the overriding metaphor for American urban and industrial dynamism. Embodying what was felt to be a uniquely "American tempo," the jazz-based score provided the perfect accompaniment to the action of *Within the Quota*.

Prior to his involvement in this project, Cole Porter had written popular songs for student productions at Yale University (1909–1913) and then for Broadway musicals; however, he had not yet achieved great fame.[3] Porter arrived in Europe in 1917 to work on the war relief effort, and by the early 1920s he was in contact with European composers, including Darius Milhaud and other members of *Les Six*, the group of composers around Erik Satie. These composers generally held jazz in high

esteem; they certainly did not considered it "trash" as was often the case among "highbrow" practitioners of culture in America. Encouraged by the high regard for jazz among French avant-garde circles, Cole Porter tried his hand at this musical genre. In 1923, Porter told a *New York Herald* interviewer, "It's easier to write jazz over here than in New York . . . because you are too much under the influence of popular song in America, and jazz is better than that" (qtd. in Vaill 130). For Porter, jazz seemed a more serious musical genre than the songs for Broadway that he had been writing. *Within the Quota* was, however, Porter's only foray into jazz, in his words, "my one effort to be respectable" (qtd. in McBrien 91).

The action of the ballet itself took place in front of Gerald Murphy's backdrop, which was a parody of the front page of a Hearstian tabloid blown up to gigantic proportions (ill. 62). The transatlantic context of this backdrop will be discussed in the final chapter, but a short description is in order here. The backdrop featured fantastically inventive headlines that proclaimed the extravagance of American life: "Ex-Wife's Heart-Balm Love-Tangle"; "UNKNOWN BANKER BUYS ATLANTIC"; "Rum Raid Liquor Ban"; "Romance Ends in Court"; and "Boycott All Syndicate Hooch." Murphy announced to French reporters that it was "a composite of 250 American newspapers I have studied. . . . The object is to get the quintessence of Americanism out of its newspapers" (qtd. in Rubin 29). Murphy's take on Americanism is, of course, ironical; embedded in the backdrop and scenario of *Within the Quota* is an incisive critique of American culture. Its special targets were American stereotypes, yellow journalism, immigration quotas (hotly debated at the time), and the recent passage of the Eighteenth Amendment inaugurating Prohibition. The reception of *Within the Quota* was "triumphal" according to *Le Figaro* (qtd. in Kimball 28). It was touted by American critic Gilbert Seldes as "an American ballet, the first to be staged by a foreign company and the first in which popular American music has been used to illustrate an American theme" (qtd. in Vaill 132–133).

The premiere of *Within the Quota* marked the three-year anniversary of Ballets Suédois; the company had debuted in October 1920 in Paris, where it remained for its five-year existence. Founded by wealthy Swedish landowner Rolf de Maré, Ballets Suédois was modeled on the more famous and longer-lived Ballets Russes (1909–1929) founded by Serge Diaghilev. Early on, Ballets Suédois exhibited key connections with that well-established company; most significantly, its principal dancer and choreographer, Jean Börlin, had studied with Russian choreographer Michel Fokine, who had left Diaghilev's company to become a guest choreographer at the Swedish Royal Opera in 1913. Furthermore, quite a few composers, writers, and artists who had worked with Ballets Russes also accepted commissions from Ballets Suédois, including Debussy, Ravel, and Bonnard (Garofala 68). Gerald Murphy, too, got his first taste of avant-garde ballet through the Russians. Shortly after his arrival in Paris in 1921, Murphy began a six-month apprenticeship with Natalia Goncharova, the Russian avant-garde painter who was heavily involved in Diagilev's productions. In fact, Goncharova invited Murphy and his wife, Sara Wiborg Murphy, to help create and repair set designs for Ballets Russes's production of Stravinsky's *Les Noces*, which premiered in June 1923.

62. Gerald Murphy, *Backdrop for 'Within the Quota'*, 1923. Approx. 30 × 40 ft. Copyright © 2003 Estate of Honoria Murphy Donnelly.

Ballets Suédois soon established a reputation as the more experimental of the two companies, more innovative in its dance and music, its visual presentation, and its emphasis on the integration of all the arts, as well as in its contemporaneity—that is, its more sustained emphasis on modern urban themes and vernacular references (Baer 10). A publicity brochure of November 1921, marking the successful completion of the company's first year of operation, announced the new direction away from what it felt were the academic conventions of Ballets Russes:

> **Only the Ballets Suédois "DARES."**
> **Only the Ballets Suédois represents contemporary life.**
> **Only the Ballets Suédois is truly against academicism.**
> **. . . it propagates REVOLUTION by a movement that every day destroys convention by replacing it with invention. LONG LIVE LIFE. (qtd. in Garofala 69)**

This Dada-like proclamation established the tone for Ballets Suédois's future productions, and especially *Within the Quota* and Francis Picabia's *Relâche* of 1924. Likewise, it set the tone for the revolutionary jazz-inflected musical accompaniment of these productions.

*La Création du monde*, written by Blaise Cendrars, preceded *Within the Quota* on the program, the French writer's tales of creation thus preparing the way for

Murphy's tales of contemporary immigration. Cendrars based his scenario on *L'Anthologie nègre* (1921), his collection of African oral traditions, folk beliefs, and creation stories, adapted from tales collected by Father H. Trilles, a nineteenth-century missionary (Mawer 146). As his scenario makes clear, Cendrars attempted to present the process of creation from precreation chaos to the emergence of plants and animals and finally of human life:

1. **The curtain rises slowly on a dark stage. In the middle of the stage we see a confused mass of intertwined bodies: chaos prior to creation. Three giant deities move slowly around the periphery. These are Nzame, Medere, and N'kva, the masters of creation. They hold counsel together, circle round the formless mass, and utter magic incantations.**
2. **There is movement in the central mass, a series of convulsions. A tree gradually begins to grow, gets taller and taller, rising up straight, and when one of its seeds falls to the ground, a new tree sprouts. When one of the tree's leaves touches the ground, it lengthens, and swells, rocks back and forth, begins to walk, becomes an animal. An elephant hanging in mid-air, a creeping tortoise, a crab, monkeys sliding down from the ceiling. (qtd. in Häger 190).**

Next in this evolution of life forms is the appearance of man and woman: "They recognize one another; they come face to face." A dance of desire follows, and the conclusion brings calm, the kiss, and, in the final words of the scenario, "Spring has arrived" (qtd. in Häger 190).

Although Fernand Léger collaborated with Cendrars on the scenario, his main contribution was the design of the stage sets and costumes (ills. 63, 64). Consisting of two-dimensional constructions, the dancers' costumes were particularly striking. The grandest, representing the three gods of creation, were about twenty-six feet tall; smaller constructions represented various creatures of the primordial jungle—monkeys and crocodiles, insects and birds. The performers propelled these constructions around the stage by walking on stilts to enact the three gods, crawling on hands and knees to portray animals and reptiles, and dancing *en pointe* to mimic flying birds (Baer 28). Toward the end of the ballet, the first human couple emerges from the amorphous mass. Wearing masks and black leotards painted to simulate scarification and the stylization of African artifacts, the two dancers disentangle themselves from the chaos of "lower" life forms to dance a pas de deux.

While the theme of *La Création du monde* advanced a spectacle of primitivism, that of *Within the Quota* fostered cosmopolitan and urban associations. In both scenarios, however, these images are so exaggerated that they become caricatures of the primitive and the civilized, respectively—a facet of the scenario that was likely unintentional in Léger's case but very deliberate in Murphy's. Ultimately, however, *La Création du monde* affirms civilization and *Within the Quota* gestures toward the primitive,

63. Fernand Léger, *Set Design for 'La Création du monde'*, 1923. Copyright © 2003 Artists Rights Society (ARS), New York/ADAGP, Paris.

once again illustrating the fluid dialogue of the primitive and the technological in the post-war years.

Léger, for instance, viewed the primitive through the lens of a machine aesthetic, so that his stylized costume designs partake of both the primitive and the mechanical (see ill. 49). As Watkins notes, Léger's "totemic deities loom as ancient versions of urban skyscrapers" (122). Furthermore, Léger stipulated that both costumes and stage sets were to have moving parts like primitive machines: "The three deities—statues in high-relief and relief fragment"—would have "mobile sections." As well, there would be a "continuous mobility of stage via displacement of mobile sets" (qtd. in Häger 190). Through a coordination of movement, Léger established a dynamic correspondence between stage set and dancers, a symbiosis that suggests a unity not only of all living things but also of the biological and the mechanical—a biomechanical synchronization. Concurrently, Russian Constructivist theater, which flourished after the Bolshevik Revolution, embraced "biomechanics," a similar interrelationship between human actors and stage sets. Conceived by Vsevolod Meyerhold, this theatrical innovation was meant to bolster political commitment, specifically the Russian avant-garde's conviction that "nothing could better resolve the crises . . . and rebuild the state than machinery, industry, and a healthy human race" (Lozowick 3). Léger adopted this concept of biomechanics for a very different narrative, one that proposes a similar meshing of the biological and the mechanical but without the revolutionary or utopian zeal of the Russians.

While *La Création du monde* incorporates certain aspects of the mechanical into its jungle setting, *Within the Quota* interjects "primitivist" elements into a more urban realm. Murphy's inclusion of the "Colored Gentleman," a vaudeville entertainer,

64. Fernand Léger, *Bird Costume for
'La Création du monde'*, 1923.
Copyright © 2003 Artists Rights
Society (ARS), New York/ADAGP,
Paris.

suggests a throwback to nineteenth-century stereotypes of blacks. Furthermore,
Murphy incorporated the shimmy and the fox-trot, dances that flourished in the urban
dance halls of Harlem but which were imported from the South and were understood
as having African sources. However, in spite of the gestures toward the opposing
impulses of the mechanical and the tribal, *La Création du monde* encodes a perspec-
tive that remains largely colonialist, while reverberations of *Within the quota* remain
predominantly urban.

Such differences are also implicit in the scores of Cole Porter and Darius Milhaud,
which complement the two scenarios in important ways. Perhaps Milhaud's score is best
described by Léger: "The general rhythm grave and slow; accentuated at moments, but
remaining rather solemn and ceremonial" (qtd. in Häger 190). Milhaud's score opens

with a saxophone, which immediately suggests a "jazz-tinged atmosphere." As music critic Allan Kozinn described it, "The saxophone plays a rather gentle, almost Bachian melody over a soft, undulating piano, violin and cello accompaniment." While the sections that follow are more overtly jazzy—"the wind and brass lines are sassy, the percussion insistent"—the overall tenor of the ballet is solemn and ceremonial, following Cendrars's story of creation (n. pag.).[4] Although Milhaud scored his work for a chamber ensemble, his selection of instruments was not typically symphonic; in fact, it was quite unconventional: two flutes, oboe, two clarinets, saxophone, bassoon, horn, two trumpets, trombone, piano, two violins, cello, bass, and a battery of percussion instruments. Such an emphasis on brass, woodwind, and percussion instruments made for a more cacophonous, jazz-based sound than was the usual fare of chamber music. Unlike Stravinsky's more tumultuous "Le Sacre du printemp" of a decade earlier, however, *La Création du monde* exhibits a greater regard for order.

Underlying the sometimes strident surface of Milhaud's score is the utmost in structural refinement. As in the case of Stuart Davis, what mattered most to Milhaud was not so much the improvisatory feeling of jazz but its underlying structure and discipline. As he wrote, "syncopated music calls for a rhythm as inexorably regular as that of Bach himself, which has the same basis" (*Autobiography* 120, 119). In his score, Milhaud suggests a fusion of seemingly opposed musical discourses of jazz and neoclassicism or, in Milhaud's words, a "wholesale use of the jazz style to convey a purely classical feeling" (*My Happy Life* 118). What this meshing does, of course, is to complement the theme of the ballet—the inevitable and "inexorably regular" march toward civilization, chaos succumbing to order.

Cole Porter's score for *Within the Quota* matched the ballet's narrative more closely than did Milhaud's. Porter opens *Within the Quota* with a quiet passage, not unlike Milhaud's, and then builds to jazzier heights. Porter's score, originally written for four pianos, was orchestrated by French composer Charles Koechlin.[5] Like Milhaud's, Koechlin's orchestration was weighted heavily with brass and percussion instruments, but it featured more pronounced contrapuntal and polyrhythmic structures than are found in Milhaud. The score for *Within the Quote* is also far wittier— "jazz in a lighter vein," as Baer aptly called it (73).

Comprised of ten movements, *Within the Quota* begins with a movement introducing the major themes and builds gradually to the loud syncopation of brass instruments that announces the arrival of the Immigrant. Each subsequent movement is titled after the characters whom the Immigrant encounters. In the next two movements, Millionairess and the Millionairess Reformer (#2 and #3), rather refined piano and string episodes give way to a cacophony meant to mimic the confusion of the Immigrant himself as the Reformer intervenes. In the movements "Colored Gentleman" and the "Colored Gentleman Reformer" (#4 and #5), witty and jaunty syncopation is followed by wild drums and chaotic strings and woodwinds as the Revenue Agent enters to confiscate the scofflaw's liquor. And for "Jazz-Baby" and "Jazz-Baby Reformer" (#6 and #7), Porter creates a sexy musical aura to accompany Jazz Baby's Shimmy and her sultry walk. Adding a note of melodrama (#8), the Cowboy enters to the beat of insistent

drums heralding his macho persona, this movement ending with horns, much percussion, and a huge blast simulating the firing of the Cowboy's six-shooters as the Sheriff arrives. A sweet, melodic violin passage follows, a kind of "burlesque on pop tunes" heralding "America's Sweetheart" (#9), who in the Finale (#10), rescues the Immigrant, providing a suitably triumphant Hollywood conclusion (Kimball 5). Throughout the ballet, the influences of Stravinsky, Milhaud, and American jazz are apparent, as are Porter's wit and his penchant for parody. Recognizing Porter's humor, contemporary reviewer Deems Taylor wrote that his score "comprised some very good jazz and some polytonal dissonances that were evidently meant to be as funny as they sounded" (qtd. in Kimball 6). And American critic Paul Rosenfeld wrote that "*Within the Quota* is very good burlesque indeed. Cole Porter's music brings a talented and original humorist to light" (qtd. in C. Schwartz 82).

*La Création du monde* and *Within the Quota* presented equally fantastical representations of folk cultures of Africa and of the United States, respectively. But while these productions played into the European desire for a mythic view of each country, they were also informed by an attempt at authenticity. De Maré was especially keen on integrating his knowledge of African culture into *La Création du monde*; he had spent time in Africa collecting artifacts and stories and even made documentary films of African dance. He shared his films and insights with his chief choreographer, Jean Börlin, who was apparently also eager to exploit ethnographical research in the interest of authenticity (Garofalo 73). Furthermore, Léger derived his set and costume designs from drawings and actual tracings of African artifacts taken from books on African art, including Carl Einstein's *Negerplastik* of 1915 (Watkins 119). Cendrars, too, having just published his anthology of African folk beliefs, sought to carve out a narrative based on a genuine understanding of African culture. As recounted in the official history of the troupe, he based the theme of *La Création du monde* on a particular Fang legend (Brender 120).

The trajectory of the ballet's narrative, however, ultimately suggests less an affirmation of authenticity than a message more in keeping with the French colonialist notion of *mission civilisatrice*, the persistent drive to civilize the Other. In the course of the ballet, choreography based on African dance gives way to a more thoroughly European mode of dance, and the ballet ends with the first human couple engaged in a distinctively balletic pas de deux. As the dance medium becomes Europeanized, its African elements are increasingly subordinated. While *Within the Quota* manages a fusion of the "primitive" into the urban, *La Création du monde* remains an enactment of colonialist myth.

The differences between the two scenarios have their equivalent in the scores. Like Cendrars's scenario, Milhaud's score can be seen as an attempt at authenticity. In 1922 Milhaud had gone to the source, to the nightclubs of Harlem to hear jazz firsthand. According to Madeleine Milhaud, he spent every evening in Harlem listening to New Orleans jazz (Milhaud and Nichols 51). Milhaud's description of the music he heard there imparts great excitement: "The music was . . . a revelation to me. Against the beat of the drums, the melodic lines criss-crossed in a breathless pattern of broken

and twisted rhythms." The ultimate result of this encounter was *La Création du monde*. As Milhaud wrote, "At last . . . I had the opportunity I had been waiting for to use those elements of jazz to which I had given so much study. I adopted the same orchestra as used in Harlem, seventeen solo instruments" (*My Happy Life* 110, 118).

Milhaud's assimilation of jazz had, of course, important precedents in avant-garde music. Somewhat earlier, other composers in Paris had referenced jazz and ragtime in their compositions, including Erik Satie, who wrote *Ragtime du paquebot* for Ballet Russes's *Parade* of 1917, and Igor Stravinsky, who wrote *Ragtime* for his *L'Histoire du soldat* of 1919. As suggested in such titles, while composers at this time were familiar with ragtime, they were generally unfamiliar with genuine jazz. Stravinsky was especially interested in old-fashioned ragtime, which he studied not from listening to live performances but from scores and recordings (Mawer 117, 3). Milhaud, on the other hand, wanted to understand early jazz firsthand. As Mawer notes, Milhaud was "not interesting in mere pastiche, but in rethinking, reworking and intensifying what he finds" (123).

Milhaud also, of course, relied on recordings, which were valuable in keeping alive his firsthand impressions after he returned to Paris. As he later wrote, "I never wearied of playing over and over, on a little portable gramophone shaped like a camera, 'Black Swan' records I had purchased in a little shop in Harlem" (*My Happy Life* 110). The Black Swan recordings he referred to were issued by Pace Phonograph Company, established in 1921 in New York as the only company to sponsor black artists that was run by African Americans. The production of "race records," as they were called, functioned as the black jazz community's way of retaining control over their music in the face of the rising popularity of the symphonic jazz endorsed by Paul Whiteman (Lemke 77–81). As noted in the preceding chapter, Whiteman, the leader of the best-known symphonic jazz orchestra in New York, attempted to distance jazz from its origins in black culture by presenting classical arrangements of jazz. The fact that Milhaud purchased Black Swan recordings rather than the more accessible symphonic jazz recordings is indicative of Milhaud's regard for authenticity.

When it came to composing music, however, Milhaud's assimilation of jazz seems anything but authentic; indeed, in some ways it parallels symphonic jazz in that, to quote Milhaud, he used "the jazz style to convey a purely classical feeling" (*My Happy Life* 118). Critics, too, have viewed his music as an attempt to "elevate" jazz by disengaging it from its sources. For instance, Paul Collaer described Milhaud's syncopated style as "directly inspired by African rhythms; but Milhaud, by a stroke of genius has transported jazz to an entirely different level of expressiveness" (70). Such criticism would seem to link Milhaud with Paul Whiteman, who believed he could "civilize" jazz by deemphasizing, even erasing, its African elements. However, Milhaud is coming from the opposite direction. He sought not to rehabilitate jazz itself but to infuse classical music with new life. This was Milhaud's radical contribution. Unlike Whiteman, who attempted to make jazz more palatable to a white audience by editing and censoring it, Milhaud's infusion of jazz into his compositions was meant to shake up the classical tradition. That Milhaud saw his derivations as distinct from Whiteman's is clear from his description of Whiteman's orchestra as having "the

precision of an elegant, well-oiled machine, a sort of Rolls Royce of dance music, but whose atmosphere remained entirely of this world and without inspiration" (*My Happy Life* 109). Interestingly, Edmund Wilson, who worked as a press agent for Ballet Suédois in New York for a brief period, seems to have shared Milhaud's view of Whiteman's symphonic jazz, calling it "a little dry, a little deliberate, a little lacking in lyric ecstasy" (238). Whereas Whiteman's was a conservative impulse to sanitize jazz for popular consumption, Milhaud's was a subversive recognition of the African source of jazz as a way of reinvigorating the classical tradition. The composers are thus mirror images of one another, and the motivations of the two are diametrically opposed. Where Whiteman attempts to take jazz out of the jungle so as to "whiten" it, Milhaud could be said to "darken" jazz by valuating its African source.[6] Granted, both approaches still represent a colonialization of jazz; however, in its affirmation of jazz's sources, Milhaud's perspective is ultimately less condescending.

There is another sense in which Milhaud's assimilation of jazz can be seen as an attempt at authenticity. Milhaud's initial introduction to African-derived music was not only through American jazz bands in wartime Paris but also through indigenous Brazilian music. As attaché of poet and statesman Paul Claudel, Milhaud had gone to Brazil in 1917, where he stayed for nearly two years and where he was drawn to the country's heavily Africanized popular music and dance forms. When Milhaud encountered jazz in Harlem a few years later, instead of viewing jazz as a phenomenon born in urban America as the American avant- garde tended to do, Milhaud viewed jazz from a perspective conditioned by Brazilian popular culture. Milhaud described the music of a blues-jazz singer in Harlem, "A Negress whose grating voice seemed to come from the depths of the centuries," as an "authentic music [that] had its roots in the darkest corners of the Negro soul, the vestigial traces of Africa, no doubt" (*My Happy Life* 118). For Milhaud, this linking of jazz with Africa was a way of validating the emotional intensity he appreciated in jazz.

Milhaud's music for *La Création du monde* was seen by some, however, not as a positive valuation of jazz but as crude and barbaric. "The feeling one gets listening to Darius Milhaud's latest production is rage," wrote one critic shortly after its premiere. "Going back to tom-toms . . . xylophones, bellowing brass and noise is not progress!" (qtd. in Mawer 149). However, Milhaud countered such attacks by affirming the "primitivist" impulses of jazz: "Black jazz is far removed from the slick sophistication of so much contemporary American dance music. It never loses its primitive African character; the intensity and repetitiousness of the rhythms and melodies produce a tragic, desperate effect. And it is this capacity to arouse deep emotions in its listeners that puts it in the same category as the greatest works of art" (qtd. in Collaer 69).

Milhaud's positive valuation of the "primitive soul" of Africa was, of course, part of the general call for a return to instinct and feeling that characterized postwar sensibility. By using African creation myths and jazz-inflected music to suggest chaos giving way to a new order, *La Création du monde* proposed a spiritual rather than cerebral (or technological) model for the rebirth of Western culture after the cataclysm of world war. Even though such a strategy may hint at Whiteman's "cleansing"

of the source, Milhaud's music embraces the more radical ambition of reviving traditional symphonic music by infusing it with the essential blackness of jazz.

Porter and Murphy come to this postwar dilemma, this desire for renewal, from a perspective diametrically opposed to that of Milhaud. When the two friends met in Venice during the summer of 1923 to work out the scenario for *Within the Quota*, they generated a script more in tune with the streets of New York than the jungles of Africa. However, Porter's appropriation of jazz is not unrelated to that of Milhaud. Both used jazz as subversions of established modes—conventional symphonic musical traditions in Milhaud's case and conventional optimism toward America's technological prowess in Porter's. *Within the Quota* undercuts the more extreme impulses of modern civilization, and it does so by poking fun at a culture in thrall to materialism and commercialization. With its simulation of real-world sounds, such as ocean-liner whistles and taxi horns, Porter's score wittily mimics urban realities. And Murphy's backdrop parodies media representations of such phenomena. Instead of the earth tones dominant in Léger's sets, Murphy appropriates bold black-and-white lettering for his sensational headlines, adding red to highlight their hyperbole. Murphy and Cole infuse irony and wit into the urban domain, thereby preventing the viewer from taking that world—or the narrative—too seriously. Perhaps, then, at their roots these two productions display the same desire for rebirth, for a search for a balance between the two extremes of intuitional motivation, on the one hand, and a more cerebral materialist drive, on the other.

Like Milhaud's score, Porter's music has a certain resemblance to the symphonic jazz emerging at this time. Porter's score has been compared to George Gershwin's *Rhapsody in Blue*, undoubtedly the most famous composition of symphonic jazz, which had its premiere in February 1924, four months after that of *Within the Quota*. Paul Whiteman performed Gershwin's piece in a concert at New York's Aeolian Hall in what has been acclaimed as the "First American Jazz Concert" and credited as inaugurating symphonic jazz. It should be emphasized, however, that Porter's score for *Within the Quota* was informed by the high respect for presymphonic jazz among the composers of *Les Six*. Furthermore, Porter's music acknowledges jazz's origins in African American culture by providing the beat for the shimmy and the fox-trot, dances that were written into the scenario of *Within the Quota*. In the early 1920s, these dances were still considered largely black cultural practices, largely unknown beyond the confines of Harlem (Emery 221). However, the wit and humor of his score definitively separate Porter's score from symphonic jazz. Porter instills his music with jazz's more outrageous wit—with a jaunty and rollicking cacophony that embraced absurdity and humor. Rather than something requiring "elevation," jazz was a liberating force that allowed Porter to give full expression to a parodistic view of American culture from abroad.

*Within the Quota* and *La Création du monde* share a more comprehensive goal, that of establishing more communal means of expression, of creating art that would communicate to the largest possible audience. A general perception of the time, expressed in such avant-garde journals as *L'Esprit Nouveau*, was that the power of African art lay in its accessibility, that there was less of a dichotomy between high art

and everyday life in Africa than in the West (Brender 135). Rolf de Maré shared this view, insisting that folkloric ballets were "understandable to everyone because of the most general spirit of that folklore—universal appeal." And he felt that African art, in particular, exhibited a "primary form" that could reveal "a prodigious, universal plastic language that can communicate everything through the senses, which impose on everyone a common experience" (qtd. in Brender 135).

As a popular musical form, jazz is by definition a music of great accessibility. Especially in early jazz performances the audience typically had an active role; in fact, a defining feature of such entertainment was the rich dialogue between performers and audience. Those in the audience typically helped establish the beat and interjected shouts of approval in a "call and response" interaction with the musicians. A distinctive "language" emerged that encouraged spontaneity and enhanced the communicative power of jazz (Ogren 12). Because the two productions under consideration here conformed to the conventions of ballet, which dictated presentation on a stage, the participatory involvement of the audience was necessarily diminished; however, both ballets can be seen as fostering the idea of accessibility by virtue of adopting popular art forms of jazz and jazz dance.

Murphy, too, sought a universal language and, like Porter, found it in popular culture, most notably in cinema. Since its own birth coincided with the emergence of jazz, cinema was quite naturally perceived as part and parcel of Jazz Age culture; indeed, along with other manifestations of mass culture, cinema was routinely linked with jazz (Chinitz 320–321). For example, expatriate writer Matthew Josephson extolled America's popular culture as "that effervescent revolving cacophonous milieu . . . where the Billposters enunciate their wisdom, the Cinemas transport us, the newspapers intone their gaudy jargon . . . and skyscrapers rise lyrically to the exotic rhythm of jazz bands" (305). Murphy's scenario revolves around characters appropriated from Hollywood stereotypes, and such a derivation implicitly acknowledges cinema as the medium in which key narratives of American culture were to be enacted. This was a sentiment gaining much credence at the time; that is, the recognition of cinema as a sign of America's inventive spirit. Waldo Frank, for one, believed that "the true popular theater of the American masses is . . . the Movie" (qtd. in Levin 119). Once again, culture critics express a conviction that a new art generated from popular culture, here cinema, would rekindle American art.

Cinema was, of course, in its infancy at this time, existing only as silent entertainment often with live piano accompaniment. Especially with the initiation of the star system, this new medium began to generate a great deal of excitement. Mary Pickford was one of the first actresses to be actively promoted as a star, and, along with such stars as Lillian Gish and Charlie Chaplin, captivated audiences at home and abroad. Responding to this dramatic rise in popularity of cinema, artists in the postwar years increasingly referred to cinema in their art or turned to film as a medium, as in the case of Charles Sheeler and Paul Strand, who produced *Manhatta* in 1921; Léger and George Antheil, who made *Ballet Mécanique* in 1924; and Man Ray, whose *Emak Bakia* appeared in 1926.

Murphy also advanced the idea of this new medium as a principal purveyor of American culture, underscoring the pivotal role of cinema through various filmic conventions. While Murphy's backdrop features the front page of a newspaper, it is blown up large as if "projected on a cinema screen" (Baer 28). Most pertinent, however, is Murphy's adoption of Hollywood stereotypes as major protagonists: a Tom Mix cowboy with his "20-gallon hat" and his fancy animal-skin chaps; a Sheriff with his oversized badge; Jazz Baby with her cropped hair and fringed flapper dress; and America's Sweetheart with her Pickfordesque golden curls. At the end of the ballet, a cameraman enters the stage to record the finale, and the movie camera itself becomes a protagonist, inspiring the dancers to "play to the camera." As one reviewer described the frenetic finale: "the characters 'revolve' jerkily, as in an old movie" (qtd. in Häger 44). Just as the actors' jerky movements mimicked early cinema, the unfolding of the narrative in short sequences rapidly succeeding one another "with linked cuts or dissolves" resembled film montage (Häger 44). The characters also moved to the beat of Porter's score, which included witty allusions to the musical accompaniment of silent film. The happy ending in Hollywood was, of course, the ultimate tribute to the apotheosis of cinema in Jazz Age America.

Perhaps Murphy's characterization of the *jeune fille américaine* in this ballet best encodes basic jazz symbology as well as his cinematic portrayal of American culture. Murphy's American Sweetheart, modeled as she was on Mary Pickford (who was universally known as "America's Sweetheart") seems an embodiment of the *jeune fille américaine* and of jazz itself. Jazz was often linked with the image of a frenetic young American woman as well as to notions of the New Woman. Murphy's Sweetheart certainly fit the European fantasy of the American girl as the epitome of a youthful Jazz Age America. She also shares the schoolgirl charm and energetic enthusiasm of the "Little American Girl" in Jean Cocteau's *Parade*, an important precedent for Murphy. But more important, America's Sweetheart signifies the myth of the transformative power of American culture. In the hands of this *jeune fille américaine*, the Immigrant is converted from a naive yokel into a Hollywood movie star. Yet America's Sweetheart remains a somewhat conflicted embodiment of this archetype, certainly not the definitive one. While her appearance suggests the "goodie-goodie" side of the *jeune fille américaine*, her actions suggest a greater degree of liberated self-determination. She is empowered by the postwar ambiance of freedom to take charge of the Immigrant; however, she does so in terms of traditional feminine demeanor. Mary Pickford's film characters exhibited similar dichotomous behavior. As described by Turner, "Though her angelic face and ringlet curls looked the very image of Victorian innocence, Pickford's screen persona was more like that of a little hellion . . . something entirely modern to European audiences" ("*La Jeune fille américaine*" 5). In the film *Amarilly of Clothes-line Alley* of 1918, for instance, Pickford played a young woman from a poor Irish family in a New York slum who flaunted a girlish flirtatiousness but also a more liberated spunkiness as she donned a leather helmet and goggles and jumped on a motorcycle. As does Pickford's character, Murphy's Sweetheart enacts certain behavior traits of the New Woman but with the conventional underpinnings of Victorian charm.

America's Sweetheart was not the only, and certainly not the most engaging, *jeune fille américaine* in the ballet's cast. The more sultry seductress, Jazz Baby, embodies the more flamboyant, full-blown traits of this mythic *jeune fille* (ill. 60). Unlike America's Sweetheart with her frilly dress and curly blond locks modeled on Mary Pickford, Jazz Baby's cigarette, revealing dress, and bobbed hair are more in keeping with the "flapper" roles played by Clara Bow, Colleen Moore, and, later in the 1920s, Joan Crawford.[7] Jazz Baby thereby announces a more thoroughgoing identification with the *jeune fille américaine* as New Woman; as Chinitz wrote, the emancipated woman of the postwar era "found her archetypal expression in the flapper" (320). Murphy's scenario accorded Jazz Baby a much more complex and engaging role than the lovable Sweetheart, and Porter's musical accompaniment follows suit. When Jazz Baby enters the stage, Porter's score picks up its tempo and its complexity; the drums set a regular beat while violins establish a sprightly yet seductive syncopation, setting the stage for the shimmy, which one can imagine Jazz Baby performing with great abandon and seductive charm. While such uninhibited freedom and liberated sexuality were viewed by traditionalists as signs of moral degeneration, many women of the time viewed them as freedom (Chinitz 320). For Murphy, too, such behavior is not reprehensible but liberating.

For Murphy, then, Jazz Baby is clearly the jazz archetype. And perhaps it is her cigarette, held stylishly in a long holder, that defines her character most definitively. When smoked by women of the postwar years, cigarettes suggested naughtiness and sexual availability, as well as intrusion into male spheres of activity; the cigarette thus links Jazz Baby with "a particularly provocative kind of freedom" (Schudson 196). Like the movie camera, the cigarette is not merely a prop but a principal actor in Murphy's production; it announces and defines Jazz Baby's character, thus advancing the plot of *Within the Quota*. Jazz Baby's seduction of the flustered Immigrant is ultimately thwarted by one of the ever-present puritanical Reformers who viewed Jazz Baby as the embodiment of moral degeneration. It is the more conventional Sweetheart who ultimately wins the heart of the Immigrant with her flirtatious charm and triumphs in the end. However, given his ironical perspective, Murphy is likely parodying the tendency of Jazz Age film dramas to flirt with new fashions and moral standards while falling back on sentimental endings. For Murphy, Jazz Baby, like jazz itself, was an embodiment of freedom from the constraints of convention as represented by the various reformers in the ballet; he saw social reformers as infiltrating American life, constricting its liberties, and diminishing its pleasures. Rather than representing the dangerous allure of the New Woman, Murphy's Jazz Baby is a positive emblem of jazz and a condemnation of the judgmental prudery of American postwar culture.

Murphy based his production not on established or highbrow notions of American culture but on filmic characters and conventions. In an interview that appeared in the Paris edition of the *New York Herald* on the day the ballet premiered, Murphy claimed that the ballet was "nothing but a translation on the stage of the way America looks to me from over here" (qtd. in Vaill 130). However, like most of his comments to the press, Murphy's comment is tongue in cheek. Rather than an honest

view of America itself, Murphy's was a view of how America was pictured in the media, in newspapers, and in the cinema. Perhaps this was Murphy's way of distancing himself from a culture that he both loved and loathed. While he presented America as an exemplary model of modern life, he also denounced it as hopelessly puritanical and crassly commercial. Murphy's representation of jazz also has reverberations for modernism itself, touching on key issues of race and gender in postwar American culture.

The focus of this chapter has been on the years immediately following World War I through 1923, a period when jazz was still associated more with "jooks" in Harlem than with the symphonic version of Paul Whiteman; symphonic jazz had not yet defined jazz as completely as it would later in the decade. In 1926, Milhaud made another trip to New York and was taken aback by the transformed jazz scene. No longer an exciting underground phenomenon, jazz had become wildly popular. In his words, "Even in Harlem, the charm was broken for me! Snobs, Whites, amateurs of exoticism, tourists of negro music had penetrated even its most intimate nooks. That's why I gave it up" (*My Happy Life* 158). Jazz, it seems, was only interesting to him when it represented a kind of subversion of established norms. Porter, too, lost interest in jazz and returned to writing popular songs for Broadway, making his mark by 1928 in the musical *Paris*. The two composers converged on stage at the Théâtre des Champs Élysées and then went in opposite directions—Milhaud to more "serious" classical music, and Porter to more melodic tunes suitable for Broadway musicals. Gerald Murphy never attempted such a collaboration again and remained a painter only until the late 1920s, when he returned to New York to help with the family business after the devastating crash of the stock market and the tragic death of one of his sons. For a brief moment in the early 1920s, however, these members of the Parisian and American avant-garde came together in an exciting collaborative effort to produce jazz-inflected music and art, resulting in two ballets in which jazz serves as the catalyst for multidimensional reflections on cultural dynamics of the machine age.

# Epilogue

## *Transatlantic Exchange*

Much of the discourse of machine-age art revolves around the transatlantic dialogue established between American and French artists after World War I. The richness of this exchange derives from the fact that the cultural interchange between the Old World and the new America was no longer as unidirectional as it had been prior to the war. For the first time European artists were as eager to learn about things American as their American counterparts were to experience European culture. Jazz, of course, was a pivotal force in equalizing this exchange, as was the European perception of America as the most technologically advanced country in the world.[1] Many American artists and writers, as we've seen, generated a modernism informed as much by the perceptions of America from across the Atlantic as by their own experiences in the United States. Their expatriation tended to encourage a fresh view of American culture, one certainly tinged with an irony fostered by the artists' distance from their native country as well as by their ambivalence toward certain American values.

Gerald Murphy's backdrop for the ballet *Within the Quota* (ill. 62), introduced in the previous chapter, gives powerful testament to the extraordinary consequences of this transatlantic exchange for American modernism and merits closer analysis. With dimensions of thirty by forty feet and wildly exaggerated headlines, such as "UNKNOWN BANKER BUYS ATLANTIC," Murphy's backdrop was a colossal parody of tabloid papers. However, scrutiny of contemporary papers has revealed that Murphy appropriated and then altered actual headlines pertaining to current topics. The newspaper closest at hand for Murphy was not a tabloid, however, but the Paris edition of the *New York Herald* (Murdock 112). Murphy embellished the headlines he found to achieve the effect of tabloids and the parody he intended. As an expatriate newly arrived in Europe, Murphy scrutinized his native country with fresh eyes. As he said, "I put into the play all the things that come out of America to me, you see, as I get things into perspective and distance" (qtd. in Vaill 130).

Murphy's extraction and collation of headlines from the media clearly references the collage practice of Braque and Picasso, who also used newspaper clippings that commented on events of the day. For example, Picasso's early collages, such as *Bottle of Suze* of 1913, include fragments of newspaper stories describing anarchist uprisings as well as the Balkan Wars. However, Murphy freely manipulates the headlines and blows them up to enormous proportions. And while Picasso's references are subsumed into a cubist still life so that their messages tend to be obscured, Murphy's

cultural references are the principal and overt content of the work. The result is a parody not just of American journalistic sensationalism but also of the European notion of *américanisme*—everything American as bigger, better, and more brazen. The headlines' content mixes both playful admiration and critical perception of America's foibles from across the Atlantic. In the context of ballet's narrative, the backdrop becomes an incisive commentary on postwar transatlantic discourse—on the differences in cultural values, gender identities, and stereotypical perceptions of another culture.

Take, for example, Murphy's juxtaposition of an ocean liner and a skyscraper prominently displayed on the upper left of the backdrop. The artist's choice of these two monuments is most telling. Murphy represents not just any skyscraper: this is the Woolworth Building, Cass Gilbert's masterpiece, begun in 1913 and completed in 1918. At 792 feet, the Woolworth Building was the world's tallest skyscraper and embodied American technological and commercial prowess. French dadaist Marcel Duchamp had acknowledged the symbolic status of the Woolworth Building when he designated the entire building as a ready-made shortly after he arrived in New York in 1915. Like his appropriation of a urinal for the more modest (in scale, at least) *Fountain* of 1917, this gesture was for Duchamp a way of examining certain American values. While the urinal highlighted the importance of the modern bathroom for Americans, particularly in comparison to Europeans, Duchamp's selection of the Woolworth Building foregrounded the disproportionate importance of big business, money, and consumption in American culture.

Through such ready-mades Duchamp explored what happens when ordinary objects—like snow shovels, urinals, or even entire buildings—are displaced from their intended settings and moved into the realm of art and how such re-placements transform meaning (Adcock 54). Murphy effected a similar transformation in his backdrop, that is, in his displacement of the Woolworth Building from its context in Lower Manhattan to its re-placement on a stage in Paris. On that stage, this American icon is paired with the image of an ocean liner. While his selection of the skyscraper is very specific, Murphy's choice of ocean liner remains ambiguous, since he never identified the liner he had in mind. However, in the context of the ballet with its transatlantic dialogue, it is tempting to identify this as a European ship; the artist may well have had the French Line's *Paris* in mind, which carried many American artists from New York to France in the 1920s. Charles Demuth, for instance, embarked on the *Paris* during its first year of operation in 1921. And though Murphy and his family had crossed initially on the S. S. *Cedric* to England, he made a visit back home to New York on the *Paris*. During that trip Murphy took dozens of photographs of the ship's deck; furthermore, a large model of the *Paris* had been exhibited at the Salon d'Automne in the fall of 1921 (Vaill 122). Both Demuth and Murphy gave tribute to this celebrated ship in paintings: Demuth in his *Paquebot Paris* of the same year and Murphy in *Boat Deck* of 1923. Given the general fascination with the *Paris* at the time, it is likely that this ocean liner was at least one of the ships on his mind when Murphy conceived of the pairing of skyscraper and ocean liner in his theatrical backdrop.

The ocean liner *Paris* was commissioned after World War I as one of the most elegant ships afloat. Ocean liners have always been associated with the female gender, and descriptions of the *Paris* and of other French liners tend to emphasize this. One writer described the *Paris* as "a 34,550-ton confection of shimmering Lalique glass and languid iron tracery." And Ludwig Bemelmans described the *Normandie*, another French Line ship, as "more female than all other ships I have known" (qtd. in Maddocks 99, 6).[2] Murphy's representation of this face-off between a French ocean liner and the Woolworth Building, "The Queen of the Seas Versus the Cathedral of Commerce" (as the caption reads), is thus loaded with gendered meanings.[3] Essentially, this is a competition between feminine and masculine values as exemplified by the city of Paris and the metropolis of New York: Paris, with its historical associations with refinement and culture, and New York, symbol of commercialism, invention, and bold entrepreneurialism.

The outcome of this competition is implicit in the image itself. Contemporary promotional advertisements for shipping lines often compared the newest and grandest ships to the latest skyscrapers; however, the ships in such ads were always upended (with prows pointed upward) and therefore implied an expanding preeminence. Murphy, however, has pointed the prow of the ocean liner downward, a reversal that seems to project a rather dire fate for this ship—and its embodiment of Parisian elegance and culture. Another writer who noticed this reversal sees it as an allusion to the sinking of the *Titanic* eleven years earlier (Murdock 113). Ocean liners were, in fact, doomed to extinction; in the next decade many were destroyed by fire or other disasters, and many others were mothballed and eventually scrapped. Such a fate was in sharp contrast to that of the skyscraper, which increasingly ruled the skies and exerted an ever-expanding power over the economy, especially in America.

These two paradigms—the French and the American, the feminine and the masculine, initially set in motion in Murphy's backdrop—are confirmed and further amplified in his paintings. Murphy continues the hyperbolic scale of his backdrop in *Boat Deck*, a lost work of 1923 (ill. 65), which measures eighteen by twelve feet. This is by far the largest of his easel paintings, and Murphy may have initially intended it as a visual prop for the first movement of *Within the Quota*, which announced the arrival of the ship transporting the Immigrant to New York (Rubin 20). However, the painting was not used in the performance, and at some point Murphy redesignated it as an easel painting. In 1924, he submitted it to the Salon des Independants at the Grand Palais, and in that venue the work raised quite a stir. Particularly in comparison to the other, more modestly scaled paintings in the show, *Boat Deck* seemed rather out of place but also oddly unapologetic, if not arrogant—an attitude Murphy himself seems to have adopted for the occasion. When told by a critic from the *New York Herald* that his painting was too big, he responded, "Well I think the other paintings are too small. After all, it is the Grand Palais." In another interview, Murphy proclaimed that the painting was really quite small in comparison to the real ocean liner that would be carrying it back to the United States (qtd. in Turner, *Americans in Paris* 25). Artist and painting alike seem to emanate what was felt to be characteristically American audacity.

65. Gerald Murphy, *Boat Deck*, 1923. Oil on canvas, ca. 18 × 12 ft. Location unknown. Copyright © 2003 Estate of Honoria Murphy Donnelly.

It was not, however, just scale that set his work apart; Murphy's painting seems significantly more technological and industrial than its competition. Murphy zeroes in on the ship's technological systems: the smokestacks refer to the mechanical systems that propel the ship, the wires above to systems of electrical communications, and the circular openings to the ship's ventilation system. Furthermore, Murphy juxtaposed the component parts in a very condensed, overlapping fashion. Rather than depicting the entire ship, Murphy blocks out a very small part of the liner, presenting a great collage of its mechanical systems. Murphy's verbal description, too, presents a matter-of-fact rundown of parts. He wrote that he had been "struck by the look (especially with the floodlights at night) of the huge almost vertical red-lead-colored smoke-stacks against the sky and the wires of the radio-telegraph, at their base the squat conglomeration of

rectangular, ships-white-with-black-trim officer's cabins, dead-white mushrooming ventilators with black, gaping pure-circle mouths cut across with white rods spaced into six geometrical segments. Gray, white, black & red-lead: the whole" (qtd. in Vaill 135–136). Furthermore, not only did Murphy simulate shiny metallic surfaces, he also framed the painting with a simple steel casing, which serves to accentuate the technological feel. In drawing analogies between painting and engineering, Murphy gave the painting an unmistakably masculine inflection. Instead of the sleek, one might say feminine, grace of the entire ocean liner, Murphy represents the great phallic funnels. In this work, then, Murphy has subsumed the essential femaleness of the ocean liner into the realm of masculine control and engineered perfection.

Although often identified as the *Paris*, Murphy claimed that *Boat Deck* was not a simple representation of a particular ship but a composite: "My painting is . . . based on 100 photographs of the *Olympic* and the *Paris* which I took on recent sea voyages" (qtd. in Rubin 46).[4] Of significance here is the fact that the controlling interest of the White Star Line, the British fleet to which the *Olympic* belonged, had been purchased by American financier J. P. Morgan in 1902. The composite, then, would seem to suggest French/American hybrid. According to one of Morgan's associates, the ultimate goal of this infamous banker was to stretch "our railroad terminals across the Atlantic" by absorbing the world's major shipping lines and then linking the ships with his rail networks (qtd. in Maddocks 98). Morgan's megalomania is revealed, too, in cartoons and advertisements of the time. For instance, one cartoon features Morgan announcing to Neptune, Roman god of the sea, "You may as well slide off into the water, old chap, I'll boss the ocean from [now] on." And an advertisement for Morgan's International Mercantile Marine Company of 1919 reads, "Arrayed like a massive invasion fleet, J. P. Morgan's ships appear to be smothering the ocean." Indeed, his aspirations extended beyond the Atlantic, as another ad for the White Star Line makes clear: "The Services and Connections of the White Star Line encircle the Globe" (ills. in Maddocks 98–99, and *White Star* n. pag.).

"UNKNOWN BANKER BUYS ATLANTIC" thus becomes a none too oblique headline announcing J. P. Morgan's expanding control of intercontinental shipping. Just as Morgan absorbed the world's shipping lines into his own financial empire, Murphy seems to have absorbed British and French ships into his "composite" painting. Seen in this light, Murphy's appropriation of the feminine associations of French art and culture (not to mention its ocean liners) into a masculinized engineered or machine aesthetic takes on rather chauvinistic reverberations. When an interviewer questioned him about the Americanness of *Within the Quota*, Murphy gave this response: "Paris is bound to make a man either more or less American" (qtd. in Vaill 133–134). The implication here, as well as in Murphy's works, is that the Parisian experience has made the artist more, rather than less, American, or at least more self-conscious about his Americanness.

Calder's wire sculptures are also revealing testaments to this transatlantic exchange. As we've seen, soon after arriving in Paris in 1926 Calder began to fashion portraits of *fil de fer*, or threads of iron, as one critic described it (Lipman 234). Significantly, Calder's first wire portraits were of black American expatriates of the entertainment and sports world: *Josephine Baker* and *Boxing Negro* (ills. 46 and 66).

66. Alexander Calder, *Wire Figure (Struttin' His Stuff)* or *Boxing Negro*, 1926. Location unknown. Photograph, Peter A. Juley & Son Collection, Smithsonian American Art Museum. Copyright © 2003 Estate of Alexander Calder/Artists Rights Society (ARS), New York.

Through his wire portraits Calder engaged aspects of American culture that were particularly intriguing to Europeans; these included race relations and notions of "primitivism," which, as we've seen in the case of Josephine Baker, take on radically different meanings when viewed from France. His wire portraits also encompassed sports such as boxing, which were perceived abroad as particularly American.

Calder's *Boxing Negro* (ill. 66) refers to a decidedly meritocratic sport, one open to all classes and races.[5] Like Thomas Eakins before him, Calder implicitly recognized boxing as an avenue to success and a means of gaining social acceptance especially for disenfranchised groups such as blacks and immigrants. By the 1920s, boxing had gained legitimacy and had become "big business" in America; however, prejudice against black boxers remained intense (Sammons 66). In the postwar years, racial conditions for blacks had not markedly changed from earlier in the century when Jack Johnson, who became the first black heavyweight champion in 1908, fled to Europe because of intense opposition in the United States to a black's holding the title. By the 1920s, Paris had become a mecca for many African Americans who were underappreciated in America. Black jazz musicians and performers were, of course, the core of this movement, but the community of expatriate blacks included artists and writers of the

Harlem Renaissance as well as figures from the world of black sports. As Tyler Stovall pointed out, "Paris offered them a life free from the debilitating limitations imposed by American racism. In France a black man or woman could live among whites as an equal, fully accepted human being" (26).

In pairing *Josephine Baker* and *Boxing Negro* as his first works in wire, Calder raises intriguing questions. Could the latter work be a reference to a particular boxer? If so, perhaps the boxer Calder had in mind was "Panama" Al Brown, a young boxer who immigrated to the United States from Panama and who has been referred to as "a male Josephine Baker" (Stovall 67–68). Brown settled in Harlem in the early 1920s and established a reputation as a talented welterweight; however, like Jack Johnson before him, Brown confronted insurmountable racial barriers. White boxers simply refused to fight blacks. Frustrated by the situation in America, he left for France, arriving in Paris in 1926, the same year Josephine Baker and Alexander Calder had arrived. Like his female counterpart, Brown thrived in Paris, later remarking, "Everywhere I encountered the same warm, smiling welcome, the same excellent champagne . . . everywhere my checkered cap, my light beige suite, and my suede shoes made a sensation" (qtd. in Stovall 67). Brown found himself the focus of much attention as the new hero of the Paris boxing world, attracting large audiences and earning record purses (Stovall 67).

Calder's wire figure seems not to be participating in an actual boxing match but engaged instead in what looks more like a song-and-dance routine. He is elegantly outfitted in a tuxedo complete with tails and top hat, his mouth wide open as if in song and his arms raised not in defense but to entertain an audience. Calder presents the boxer not in the ring but as an entertainer in a more general sense. Having boxed his way up the social ladder, this anonymous athlete seems to have currency beyond the ring; he has become a star, here pictured out on the town enjoying himself. To underscore his celebrity status, Calder attached a shiny wire star to the boxer's lapel. Calder suggests the radical transformation in race relations effected by the displacement of the black boxer from New York to Paris.

While Calder does not identify the boxer as Al Brown, the boxer's story fits the ebullient spirit of this wire sculpture. Furthermore, Calder suggests a sympathetic identification with the experiences of such African Americans. As an expatriate artist, Calder was also an object of curiosity, and like the boxer, he, too, gets revalued in Paris. Riding about the city on his bicycle dressed in his trademark red flannel shirt, Calder was perceived by the French as a big American kid. He had begun to perform his *Circus* for various groups in Paris and did so with a childlike sense of glee. Much like the black entertainers who descended on Paris in the 1920s, Calder was viewed as a kind of American primitive, embodying American innocence and mobility. The vogue for primitivism in 1920s Paris conditioned French response both to American blacks and to artists like Calder. Whether focused on white artists or black entertainers, this attention—albeit somewhat patronizing—brought acceptance into the community of artists and entertainers of Paris. Granted, Calder never faced the prejudice that African Americans had experienced in America; however, after relocating to Paris, Calder, like Al Brown and Josephine Baker, found an environment that was more welcoming than New York had been.

67. Stuart Davis, *New York-Paris No. 1*, 1931. Oil on canvas, 39 × 54 3/4 in. The University of Iowa Museum of Art, Iowa City. Copyright © Estate of Stuart Davis/Licensed by VAGA, New York, NY.

Calder's materials, his use of industrial wire for making art, also illustrate the way things get revalued when seen in a new context. Just as artists and entertainers experienced a revaluation in Paris, so, too, did industrial materials. Their use in describing black entertainment figures thus postulates a new relationship between the technological and the primitive. Several years later, American critic Henry McBride acknowledged the technological aspect of Calder's sculpture, writing that it "looks like machinery and moves like machinery." However, he added that "it is scarcely the sort of thing that we Americans would be likely to encourage" (qtd. in Turner, *Americans in Paris* 47). Though grounded in a thoroughly American sensibility, Calder's works came into being through European encouragement. Such divergent responses to his work, skepticism from America but encouragement from France, fostered a perspective on America that was largely positive, but with a critical and satiric edge. Implicit in Calder's wire works is an appreciation of the stardom accorded African American entertainers and American technological ingenuity as well as a send up of certain attributes and prejudices of American culture.

Murphy and Calder were not alone in pitting the American against the French to address cross-cultural issues. Stuart Davis, while not arriving in Paris until 1928 and only staying six months, also established a highly charged artistic coupling of Paris and New York. While in Paris, Davis executed numerous drawings and paintings of Paris street scenes. But soon after returning to New York, he began a series of paintings entitled *New York–Paris*, which featured monuments and mementos of his native city juxtaposed with those he remembered from Paris. *New York–Paris No. 1* (ill. 67), for instance, features a package of Stud chewing tobacco floating next to a black-stockinged leg

(high-heeled and presumably French) striding aggressively to the left; to the right, a Parisian sidewalk café is surmounted by a horizontal image of the Chrysler Building, its pointed spire scraping the clouds. In another in the series, *New York–Paris No. 3*, an airplane circles the Woolworth Building, which projects high above Washington Market, both of which dwarf a Parisian hotel and café below, remnants from Davis's paintings of Paris street scenes executed in 1928.

Such a dialogue no doubt provided Davis with a way to keep his memories of Paris (largely positive) alive after returning home, where he was more than a little overwhelmed but also exhilarated by what he called "this frenetic commercial engine" (*Stuart Davis* 27). In his New York–Paris paintings, too, New York is the dominant force, its structures positioned above and more boldly defined than their Parisian counterparts. Furthermore, to judge from the highly embellished, somewhat fussy facades and pretty pastel colors in paintings the artist executed while in Paris, Davis viewed Paris more as a quaint picturesque village than as a major metropolis; indeed, Paris seems rather feminized in Davis's hands. Such a juxtaposition of New York and Paris might then be a way of putting all that femininity behind him, of getting back to the content of "frenetic" New York with which he ultimately felt more comfortable—gas pumps, skyscrapers, tobacco, and jazz, among other male-identified American phenomena. As he wrote after returning from his residency abroad, "It proved to me that one might go on working in New York without laboring under an impossible artistic handicap. It allowed me to observe the enormous vitality of the American atmosphere as compared to Europe and made me regard the necessity of working in New York as a positive advantage" (qtd. in Wilkin, *Stuart Davis* 124). The displacement in Davis's New York–Paris series is, then, one in which Paris is transported to the New York stage (or street) to fend for itself in an atmosphere of skyscraper gigantism and jazz cacophony. Unlike Murphy, who lived in France for nearly ten years, Davis preferred to depart sooner rather than later so as to reimmerse himself in the sensations of his native metropolis—and to native phenomena that he prioritizes in this intriguing series of paintings.

The transatlantic dialogue Murphy established is necessarily different from that of Davis in that Murphy's perspective is from the other side of the Atlantic. In this regard, Murphy's outlook is closer to that of Man Ray. Two works Man Ray executed shortly after his arrival in Paris in 1921, *Trans atlantique* and *Gift (Cadeau)*, also illuminate this dialogue. *Trans atlantique* includes a photograph of what looks like the contents of an ashtray just dumped into the gutter—matches, cigarette and cigar butts, ashes, crumpled and burned paper. The previous year Man Ray had entitled this same photograph *New York*, but here the photograph is spliced with other images, for instance, a segment of a map of Paris collaged on a checkerboard grid; the fluid boulevards of Paris appear to supersede the harsh grid of New York. It is as if one of the squares of that grid were blown up to reveal the city's less exalted contents—the trash of New York. The words *Trans atlantique* appear between the photo of New York and the map of Paris. In French, *transatlantique* refers to an ocean liner, and especially since the work was completed shortly after the artist's arrival (by ship, of course), no doubt this is one reference. However, by separating and thus underscoring both components of

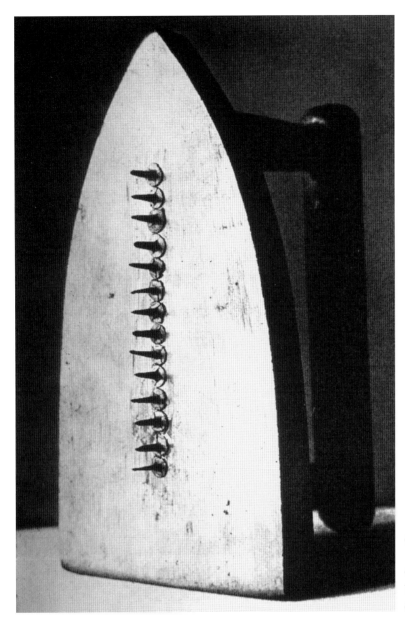

68. Man Ray, *Gift (Le Cadeau)*, 1921. Silver print, 11 × 9 in. Copyright © 2003 Man Ray Trust/Artists Rights Society (ARS), New York/ADAGP, Paris.

the title, Man Ray broadens the reference to emphasize the dialogue between countries. Like Murphy, Man Ray was exhilarated to be in Paris after rather difficult years in New York, and both artists shaped their art to reflect this transition.

Even more revealing of Man Ray's transatlantic dialogue is *Gift (Le Cadeau)* (ill. 68), a work done several months later. As the story goes, Man Ray found and assembled the components for this work during the opening of his first one-man show at the *Librairie Six* in December 1921. Wishing to escape the crowds, Man Ray and his new acquaintance, Erik Satie, took a break from the event and found themselves in a shop where Man Ray purchased a simple flatiron and some tacks. Man Ray glued a row of fourteen tacks to the iron's flat surface, and the two men walked this newly fabricated sculpture (or "assisted" ready-made) back to the exhibition, where it took its place

among Man Ray's other works. Man Ray intended the work as an "alarming gift"—a gift to Erik Satie and to Paris for the welcome he felt there (qtd. in Alexandrian 68). It is worth considering why the artist considered this object "alarming." Perhaps it was because the flatiron has been sabotaged; Man Ray's alteration has rendered it not only useless but also threatening in that the tacks—not to mention the scalding heat of the iron itself—are capable of inflicting great pain. Just as this object is charged with meaning, the transatlantic dialogue was a dynamic interchange.

In this transatlantic context, *Gift* also becomes a visual pun on the famous Flatiron Building in New York. By transposing this image to Paris in the form of a common flatiron, *Gift* takes on metaphoric meaning with transatlantic implications. It also becomes a sly commentary on America itself. Man Ray's act of sabotage implicitly extends to the Flatiron Building itself, especially given the adulation directed toward it earlier in the century. By its completion in 1902, this New York landmark had become a key image of modernity. Alfred Stieglitz photographed it as such and also wrote, "It appeared to be moving toward me like the bow of a monster ocean steamer—a picture of new America still in the making. . . . The Flat Iron is to the United States what the Parthenon was to Greece" (qtd. in Norman 45). Shortly after the building's completion, Sadakichi Hartmann composed an equally lofty poem, "To the Flat-Iron Building," to accompany Stieglitz's photograph, both of which appeared in *Camera Work*:

> *Iron structure of the time,*
> *Rich, in showing no pretence,*
> *Fair, in frugalness sublime,*
> *Emblem staunch of common sense . . .*
> *For future ages will proclaim*
> *Your beauty*
> *Boldly, without shame. (40)*

In Dada renditions such as *Gift*, however, the Flatiron takes a brutal beating. In the process, meaning is transformed, all sublime allusions eviscerated, and earlier adulatory representation turned on its head. No longer symbolic of a progressive America, this transformed image becomes a subversion of the very notion of progress. By so aggressively challenging deeply entrenched beliefs, Man Ray shares Duchamp's ironical view of progress as "an enormous pretension on our part" (qtd. in A. Jones 165).

Gerald Murphy, too, targets this icon of modernity. In his collaged program cover for *Within the Quota* (ill. 61), the Flatiron Building takes center stage as a key icon of New York. Great funnels of an ocean liner seem to emerge from the building itself, enhancing its resemblance to "the bow of a monster ocean steamer." However, Murphy gives the image a dada twist by tilting it to one side. Like a ship in high seas, Murphy's building seems unstable, and its precarious position renders the structure uninhabitable. As in *Gift*, the functionality of the structure has been sabotaged. Both images—that in Murphy's program cover and Man Ray's sculpture—exist as symbolic objects whose ironical message is unmistakable. In destabilizing the Flatiron Building,

each artist subtly undermines its prevailing status as symbol of a progressive America; as well, it becomes a visual manifestation of each artist's equivocal relationship with his native country and its core values.

Such unresolved sentiments seem to inform all four artists' relationships toward their native country and also to foreground the dilemma of the American artist in Paris. Murphy's flight from New York, for instance, was very much a defection—from America, as well as from family and societal expectations. After his graduation from Yale in 1912, Murphy worked for five years for Mark Cross, the family's men's clothing store on Fifth Avenue. Later Murphy stenciled the logo for Mark Cross onto the side of a building in his program for the ballet, designating it as a New York landmark for the Immigrant and as a personal landmark for himself. His decision to leave the firm—and America—was as much a retreat from American materialism as it was an advance toward a meaningful life of gentility and cultivation in France; or, to put it another way, as much a retreat from traditional male values as it was an advance toward female ones. However, this escape provided no simple solution for the expatriate artist.

Once in Europe, Americans found themselves valued for their embodiment of precisely those values they had fled. Furthermore, they found that their success among Europeans depended on their ability to capitalize on their American identity. As Man Ray said, "They crave America. So we are making a fair exchange" (qtd. in Turner, "Transatlantic" 139). And as John Dos Passos wrote in his memoir: "Americans were rather in style in Europe in the twenties. Dollars, skyscrapers, jazz and everything transatlantic had a romantic air" (153). Perhaps more than any expatriate artist, Gerald Murphy capitalized on his role of the American abroad. He named his property in Antibes "Villa America" and his schooner "Weatherbird" after a song recorded by Louis Armstrong and Earl Hines; he took great pleasure in making and serving American-style cocktails, which were popular among Europeans after the war; and for entertainment at Villa America, the Murphys played the latest American jazz recordings (Corn, "Identity" 152). For many observers, this unmitigated celebration of American culture informed Murphy's art as well. Dos Passos for one singled out Murphy's art as "the epitome of the transatlantic chic" ("Best Times" 153). Such statements, while certainly ego enhancing, tend to mask the ambiguity implicit in the artists' motivations and in the works themselves, indeed, to gloss over the irony and the critical edge of expatriate artists' critique of certain American values.

Such an interrogation of the American avant-garde in the contexts of transatlantic exchange, American popular culture, and traditional values, while it cannot fully answer, at least foregrounds the big question of what American culture became during the machine age. The development of postwar art was deeply embedded in the political and social issues of an American culture at once in thrall to the machine and wary of its power over people's lives. The historical forces discussed here, perhaps most significantly the pressures of gender and race, are mediated in the visual representations of the period; it is the works of art created both at home and abroad that acutely register the ambiguities, contradictions, and multiple impulses of the negotiations between art and the machine in the formation of modernism.

# Notes

## Introduction: The Mechanical Muse

1. For discussions of the various forces that ushered in the machine age, see Reyner Banham, Siegfried Giedion, David E. Nye, and Miles Orvell, to list only a few. In his seminal study, *Theory and Design in the First Machine Age*, Banham defined the machine age as spanning the years from around 1909 to about 1929, and I follow his example in this study. Other authors argue that the period encompassed both earlier and later developments, including Ostrander (1890–1940) and Wilson (1918–1941).

2. I appreciate Erika Doss's insights concerning the implications of such transformation of the labor force for American modernism.

3. For an elaboration on Wilson's argument, see my review in the *Archives of American Art Journal* (1986).

4. The following are a few books in this expanding sphere of scholarship: Cecelia Tichi, *Shifting Gears: Technology, Literature, Culture in Modernist America*; Lisa M. Steinman, *Made in America: Science, Technology, and American Modernist Poets*; O. B. Hardison Jr., *Disappearing Through the Skylight: Culture and Technology in the Twentieth Century*; Mark Seltzer, *Bodies and Machines*; Terry Smith, *Making the Modern: Industry, Art, and Design in America*; and Tim Armstrong, *Modernism, Technology, and the Body*.

5. Though she does not discuss collage per se, Tichi suggests this connection between the machine and the collage aesthetic. Throughout, I have broadly defined the collage aesthetic to include not only actual collage but also paintings and assemblage sculpture that encode the structural principles of collage.

6. The literature on European collage initiated this interest in the identity and associations embedded in collage; particularly smart readings of the iconographic implications include those by Robert Rosenblum, Jeffrey Weiss, Patricia Leighten, and Christine Poggi.

7. For her comments regarding this issue, I thank Erika Doss, who has written quite extensively on representations of labor in American art of a later period. See, for example, "Looking at Labor" and "Toward an Iconography of American Labor."

8. For a discussion of the distinctions between the technological and scientific model, see Steinman, chapters 1 and 2. Given what Steinman terms the "American regard for the practical, for that which was grounded in the real world," the technological model lends itself to this discussion of American modernism (9).

9. See, for instance, the photograph in Engelmann (n. pag.) that caught Wills in a particularly awkward moment during the semifinal match at Forest Hills in 1928, the year Calder depicted her in a similar pose.

## Chapter 1: The Avant-Garde Automaton

1. For instance, Caroline Jones writes that "Picabia's vision of machines as 'the very soul' of human life characterizes both the eighteenth-century search for a perfect automaton as well as the late-twentieth century tropism toward the utopian cyborg" (145); Poggi refers to Boccioni's *Unique Forms of Continuity in Space* of 1913 as "what might retrospectively be called a Futurist cyborg" (37).

2. For a discussion of the "American body-machine complex" in literature of the late nineteenth century, see Armstrong, *Modernism, Technology and the Body*; Rabinbach, *The Human Motor*; and Seltzer, *Bodies and Machines*.

3. That Eakins was able to give visual form to such human-as-machine metaphors was aptly demonstrated in an exhibition of his rowing paintings held at the Yale University Art Gallery,

which included all the extant works on this theme along with a rowing scull complete with oars and oarlock riggings. Thanks go to Martin Berger for bringing the exhibition project and its relevance for my own work to my attention (correspondence, October 1994).

4. The quoted passage is from Dos Passos's profile of Henry Ford in *U.S.A.* entitled "Tin Lizzie"; the author also wrote a profile of Frederick Winslow Taylor, "The American Plan," Part 3, *U.S.A.* (19–25).

5. For related readings of *ITLKSEZ*, see Wilkin, *Stuart Davis* (89), and Sims (153).

6. For a document featuring an advertisement for "Congoleum," see Walker Evans's photograph, *Billboard near Birmingham, Alabama*, 1936, which includes a billboard ad for a furniture company that would "furnish your home . . . [with] CONGOLEUM RUGS." Collection of the Canadian Centre for Architecture, Montreal, Canada.

7. For a comprehensive discussion of this issue, as well as for ads featuring the engineer-hero, see Tichi (97–170).

8. Interestingly, later in his career Davis denied any links to Dada; in a 1962 interview, for instance, he insisted, "Dadaism didn't appeal to me. I knew about it. . . . But these contradictory directions didn't bother me. I just stuck to the structural principles" (McCoy 9).

9. Henderson has discussed the *vagina dentata* theme in Duchamp's *The Bride* of 1912, noting that Duchamp "added what would seem to be the Bride's reproductive organs at the lower left, centered on a womb that bears the teeth of a gear wheel" ("X Rays" 334).

10. As Turner notes, the gala was in honor of Count Beaumont's performance series, Soirée de Paris at the Théâtre de la Cigale in Montmartre (*Americans in Paris* 49).

## Chapter 2: Man Ray's X-Ray(ted) Automata

1. While no extended analyses exist regarding the significance of the X-ray for the development of Man Ray's art, the connection was briefly noted by Henderson, "X Rays" (340), and most recently by Kevles (137).

2. In an issue of *Electrical Engineer* of 1896, one man claimed to have used X-rays to transform "a cheap piece of metal . . . to $153 worth of gold" (qtd. in Knight 21). See also Henderson's discussion of alchemy in "Ethereal Bride" (114).

3. For in-depth readings of this work, see Bohn, "Picabia's 'Mechanical Expression' "; Henderson, "Francis Picabia."

4. For an account of the improvements that made X-raying the brain possible, see Kevles (97–115).

## Chapter 3: The Gendering of Still Life in the Machine Age

1. Bryson's study was crucial in reviving interest in this genre, raising gender issues as well as acknowledging the importance of still life to modernism, particularly to the art of Cézanne. Especially relevant is "Still Life and 'Feminine' Space" (136–178). More recently, an exhibition at the Metropolitan Museum of Art and another at the Museum of Modern Art examined the implication of still life for modernism (Sims and Rewald; Rowell).

2. William Gerdts and Russell Burke have summed up the received wisdom regarding American still life: "By the early twentieth century, still-life painting as a genre and a discipline was on a decline in America." The writers attribute this largely to the fact that "thematic concern" had lost much of its meaning with the development of abstraction (227, 234).

3. For a further discussion of the pastel compositions, see Agee, *Morton Livingston Schamberg*. Agee notes that pastel experienced a revival of sorts in the late nineteenth century with Edgar Degas and the Impressionists and Odilon Redon and the Symbolists (n. pag.); even so, this genre was still not accorded a status equal to that of oil painting.

4. For an illuminating discussion of this work in the context of national identity, see also Corn, *The Great American Thing* (91–133).

5. See especially chapter 6: "The Perfectionist Project" (162–195), and Lears, "Some Versions of Fantasy" (390). For a discussion of the postwar shift from the projection of good health to the enhancement of personal attractiveness—and for a lively account of this obsession in American culture—see Hoy.

6. I am indebted to Karen Lucic for making available her unpublished essay on Davis's *Odol*, in which she illustrates such advertising sources.

7. Nancy Ring has given an insightful discussion of the gender implications of the reconfiguration of objects of domestic use by male artists in a chapter entitled "The Masculinization of American Culture: Man Ray and the New York Vanguard" (72–139).
8. For a thorough account of these controversies see Kanigel, especially "Judgment Day" (429–484).
9. As Corn has observed, the crossed razor and pen in *Razor* suggests the heraldic configuration of a skull and crossbones and so also touches on the memento mori theme, "reminding us of the vanity of worldly goods" ("Identity" 166).

## Chapter 4: Stuart Davis's "Tobacco Pictures"

1. For a discussion of Davis's formative years, see Hunter (31–44).
2. For a broad-based discussion of the postwar drive to assert an American identity, see Baigel, "American Art and National Identity"; for histories of advertising in the postwar years, see Marchand, Fox, and, for a more specialized study of cigarette advertising, Smith, *Smoke Signals*.
3. Wilkin, *Stuart Davis* (87–88), and Sweeney (13) have also made the connection with the American trompe l'oeil tradition, Wilkin noting that Davis's dealer, Edith Halpert, also exhibited William Harnett (226).
4. After World War I cigarette smoking was becoming, if not acceptable, at least more fashionable, among women as well (see Schudson (185–191)); however, it was the men who were doing the switching and who still dominated the market, thus my exclusion here of women.
5. For a photograph of the early designs of tin boxes of Lucky Strike "plug," see Jane Webb Smith (35).
6. Lucky Strike may have taken its cue from the French brand Gauloise, whose pack was colored "a patriotic blue—the color of the French foot soldier's uniform" (Klein 20); for a history of Lucky Strike packaging, see Mullen (54–55).
7. Cigarette smoking during wartime has always been endorsed; indeed, it was deemed a necessity for survival and a patriotic duty not only by Americans but also by soldiers of every other nationality. As Erich Maria Remarque wrote in his masterpiece of the First World War, *All Quiet on the Western Front*, "What would a soldier be without tobacco?" (qtd. in Klein 153).
8. See Lewis Kachur's discussion of *Sweet Caporal* and his illustration of the original packaging in Sims (97–98).
9. Other of Stella's collages with tobacco references include *Collage #17, Serenado* and *Royal Bengals*, named after a cigarette manufactured by Lorillard Company, and *Trumpeter*, which includes the segment of the brand's logo featuring a horseback rider blowing a trumpet; none of them were dated, but, according to Moser, they were executed between the late teens and the mid-1940s (75).
10. For cogent discussions of this series, see Moser (75–87) and Tashjian (175–177).
11. A photograph of an elderly Whitman appeared on a cigar box label—reproduced in Kaplan (ill. 60)—to give the particular brand a cachet of both the respectability of a famed writer and the allure of his daring and democratic perspective. Although he did not smoke, Whitman no doubt gladly lent his image to sanction such associations.
12. In the original newspaper, TAD's column appears alongside the cartoon, whose blurb reads in full: "I don't think I'll ever be right again—that ice cream last night poisoned me" (*New York Evening Journal* [February 16, 1924] photocopy, Stuart Davis Files, Hirshhorn Museum and Sculpture Garden, Smithsonian Institution, Washington, D.C.)
13. Sims draws a nice parallel between the sentiments expressed by Davis regarding *Men without Women* and those in Ernest Hemingway's collection of short stories published in 1927 with the same title, in which Hemingway "presents men in various situations where their sexual and social identities are challenged" (220–221).
14. As Iovine notes, Davis's mural, which had been rescued from the Music Hall by the Museum of Modern Art in 1974 and subsequently restored for the Metropolitan Museum retrospective of Davis in 1991, has been returned to its original home "free of cigarette smudges" (1).

## Chapter 5: The Constructed Self

1. The five portraits, *Ici, c'est ici Stieglitz foi et amour, Le Saint des Saints, De Zayas! De Zayas!, Voila Haviland*, and *Portrait d'une jeune fille américaine*, appeared in *291* 5/6

(July–August 1915). For a discussion of Picabia's machine portraits and their sources, see Rozaitis and Camfield, "The Machinist Style of Francis Picabia."

2. Nesbit also discusses the adoption of industrial models by Duchamp in "The Language of Industry."

3. See Bohn's "Visualizing Women in *291*" (240–261) for a further discussion of Picabia's sometimes scathing representations of women in *291*, a journal that was generally "sympathetic to women's causes and genuinely interested in women's contributions to art and literature" (247).

4. This link between Man Ray and Duchamp was observed by Nancy Ring in her more extensive discussion of the appropriation of "female" objects by male artists (29–30, 130–131).

5. My interpretation of this work was also informed by Gerald Silk, "Object Portraits" (17–18).

6. For a further discussion of how conventional tropes of the primitive become feminine tropes, see Torgovnick; for an illuminating discussion of Man Ray's construction of female sexuality as "primitive/irrational/other," see Chadwick.

7. Francis Naumann first identified this photograph/object as a self-portrait, "Cryptography and the Arensberg Circle" (128).

8. For an example of a bisexual carving from Mali, Dogon, see Vogel (8). I am indebted to Rebecca Leuchak for directing me to the creation myths of the Dogon peoples.

9. See also Camfield, *Marcel Duchamp*; for a discussion of "fantasies of masculine filiation," see Hopkins.

10. Tashjian suggested this analogy, extending it to include all of Duchamp's ready-mades ("New York Dada" 144).

11. Corn remarked on this duality in her discussion of how Duchamp deliberately selected a urinal as a means of suggesting what art should look like in such a technological culture, "An Icon Revisited."

12. For insights into the portraits by these and other women artists associated with Dada, see essays by Paul Franklin, Amelia Jones, Willard Bohn, Eleanor S. Apter, Clara Tice, Rudolf E. Kuenzli, Barbara J. Bloemink, Carolyn Burke and Marisa Januzzi, in Sawelson-Gorse, *Women in Dada*.

13. For more complete accounts of Elsa von Freytag-Loringhoven's life see Kuenzli, "Baroness Elsa von Freytag-Loringhoven"; Naumann, *New York Dada*, 168–175; Reiss; and, most recently, the biography by Gammel.

14. This observation is based on much appreciated critical feedback of my colleague Robert Baldwin.

15. For a discussion of *vagina dentata* imagery in Man Ray, particularly in *Gift* of 1921 (with its row of tacks) and even earlier in *Femme* of 1918 (with its lineup of clothespins), see Schrock (45–85). Schrock also sees *Object to Be Destroyed* as evoking fear of the *vagina dentata*; however, where she sees the pendulum itself as the instrument of destruction (likening it to a guillotine), I view the gears below as more convincing symbols of destruction.

## Chapter 6: Expatriate Portraiture

1. The first version is known only through a photograph by Peter A. Juley; one sculpture is in the collection of the Museum of Modern Art; another is in the collection of Musée National d'art moderne, Centre Georges Pompidou, Paris; and the other two, *Josephine Baker* and *Aztec Josephine Baker*, are in private collections (Prather 20).

2. For a rare photograph of this production, see Blake (94).

3. For further discussions of black culture as rejuvenating, see Coffman and Sharpley-Whiting (103–118).

4. In fact, the Baule mask in Man Ray's photograph has an impressive provenance; first featured in an important source book for artists, Carl Einstein's *Negerplastik* (1915), it later showed up in the collection of Helena Rubenstein. Thanks go to Christopher Steiner for pointing out the identity and different status of these two artifacts.

5. As Lulen Walker pointed out, Baker "adopted Florenz Ziegfeld's famous quote, 'It's getting darker and darker in old Broadway,' to relate similar developments in Paris" (n. pag.). Colin's portfolio was reprinted in 1998 with an introduction by Gates and Dalton. See also Dalton and Gates (903–934).

6. For a history of French display of colonialist peoples, see Greenhalgh and especially "Human Showcases" (82–111). Such an image also brings to mind the (unbuilt) house

that Adolf Loos designed for Josephine Baker in 1928; much like a fortress, it features bold horizontal striations that resemble cage or prison bars.

7. For further discussions of the primitivist/modernist nexus, see Torgovnick, Lemke, and North (especially chapter 3).

8. As Haney wrote, "After photographing the group, Man Ray plucked Josephine away from the others. He positioned her against a railing at the edge of the roof, the Eiffel Tower in the background. Josephine preened, puffed out her chest, grinned, strutted and struck a pose, parodying a cakewalk" (164). Chadwick repeats this account (8). However, only photographs of the entire troupe are in Man Ray's archives; according to Foresta, who has carefully searched the archive for photographs of Baker, the artist may have been reluctant to make photographs of Baker public due to the jealousy of his model and mistress, Kiki. According to Foresta, "If anyone was a threat to Kiki's singing and performing career . . . it was Baker" (E-mail correspondence, September 4, 1996).

9. Sperling elaborates on the role of humor and on the link Calder forges between play and technology in his *Circus* in "The Popular Sources of Calder's Circus."

10. Kara Walker's silhouetted image of Josephine Baker was included in a show at Wooster Gardens Gallery, New York, October 22–November 28, 1998.

11. For an excellent discussion of the conflicted response to the new age of American jazz among writers, see Chinitz.

12. Chadwick noted how fashion photography had transformed the female image by the mid-1920s into "that of the 'modern' body, a sleek, streamlined form of extreme artifice" (17).

13. My discussion of this linking of Grace Jones's postmodern performance to Josephine Baker's in 1920s Paris is informed by the essays of Wallace and Anderson.

14. For a 1936 performance at the Ziegfeld Follies, one of Baker's costumes featured a spiked rendition of the banana skirt, a stylization similar to the one adapted by Haring for Grace Jones.

15. For a discussion of the changing perception of Baker and the increasing xenophobia among the French, see Blake's fine book on Jazz Age Paris.

## Chapter 7: The "Jazzing" of the American Avant-Garde

1. For an informative discussion of jazz's appeal to those in search of "the new modern spirit," see Collier (*Jazz* 8–9).

2. For a more extensive treatment of the jazz theme in Davis's works prior to and after the 1920s, see Cassidy (69–114); the main focus of this study is on Davis's works of the 1920s, which Cassidy does not cover.

3. For a thorough treatment of the issue of improvisation during the early years of jazz, see Brown.

4. See Amelia Jones's insightful discussion, especially of Duchamp's and Picabia's escape from pressures and knowledge of the war through a rather dissipated life in New York (172–175).

5. Irene and Vernon Castle formed a white dance team in the teens, which, in association with black band leader James Reese Europe's orchestra, popularized such dances as the turkey trot, the fox-trot, and the Castle walk.

6. Unfortunately, the musical accompaniment featured in the compilation of Man Ray films being marketed today is classical music, which undermines the intended effect and meaning (*Man Ray Experimental Films*). For a further consideration of Man Ray's *Emak Bakia*, see Kovacs and Aiken.

7. I thank Christopher Steiner for bringing this passage to my attention.

8. In book titled *Voices from the Gutter*, jazz musician Art Hodes reminisces about the 1920s when, "if you played jazz, you were on the bottom of the social heap . . . consigned to the gutter" (Hodes and Hansen 232).

9. It should be noted that Gilbert Seldes was himself a jazz aficionado and is here condemning such criticism.

10. For a discussion of the symphonic jazz of Whiteman, see also Cassidy (95–103).

11. I am grateful to Todd Porterfield for this observation.

12. For discussion of how the technology of speed affected all aspects of twentieth-century life, see Kern (109–117). Also relevant is an updating of this concept for the electronic age in James Gleick's *Faster*.

## Chapter 8: Expatriates of the Jazz Age

1. Gerald Murphy is credited as costume designer in the ballet's program; however, the costumes, especially those of the women, are now thought to have been drawn by Sara Wiborg Murphy "to Gerald's specifications" (Vaill 131).
2. My discussion of Murphy in relation to *américanisme* is greatly indebted to Corn's incisive analysis in *The Great American Thing* (91–133).
3. Porter's first Broadway musical, *See America First* of 1916, apparently received very little notice; not until 1928 with the success of the musical *Paris*, featuring "Let's Do It, Let's Fall in Love," did Porter attain any real celebrity, as noted by Murdock (108). For a listing of Porter's early works, see C. Schwartz (271–276).
4. For my analysis, I have used the 1987 Arabesque recording, with liner notes by Kozinn.
5. In 1966 historian Robert Kimball discovered an incomplete version of Porter's piano score in the Cole Porter Papers at Yale University, but for years the original Koechlin orchestration was thought to have been lost. It was discovered in the late 1960s in the Dansmuseet in Stockholm but was not performed until 1991 when EMI Classics made a recording of the world premiere of the piece performed by the London Sinfonietta conducted by John McGlinn. I have based my discussion on this recording.
6. I take my lead here from Lemke, who characterizes a similar relationship between Whiteman's music and Picasso's painting (69).
7. See Basinger's discussion of Mary Pickford (15–64) and her chapter on flappers (411–449).

## Epilogue: Transatlantic Exchange

1. Lemke's discussion of this transatlantic dynamic is particularly insightful (93–94).
2. The *Oxford English Dictionary* traces the practice of referring to ships as feminine as far back as 1375, a tradition perhaps originating when ships were dedicated to the goddess carved on the bow. The world's leading shipping newspaper, the London-based *Lloyd's List*, recently featured a story entitled "Lloyd's List neuters ships," announcing that ships would henceforth be referred to as "it," not "she," a change of policy much criticized by scholars of maritime history (Errett).
3. Murdock identified the ship in the backdrop not as the *Paris* but as the *Leviathan*, built by Germany as the *Vaterland*, seized during World War I in New York and refurbished for the United States Lines after the war. Its initial voyage was in the summer of 1923, and so its image would have been readily accessible to Murphy (Murdock 113). However, with its German origin and its name, the *Leviathan* would hardly suit Murphy's caption, the "Queen of the Sea." Furthermore, since he had no experience on this liner, the image uppermost in his mind was more likely the *Paris*, an identification also supported by Rubin and Corn.
4. The three smokestacks decorated with two bands of color suggest an identification of the ship as the *Paris* rather the *Olympic*, which had four smokestacks.
5. As several titles have been used for this work, I have followed Marter and Turner in referring to this work as *Boxing Negro*. The work has also been called *Singer of Charm* (Marchesseau 126), *Struttin' His Stuff* (Prather 30), *Wire Figure* (Peter A. Juley and Son Collection), and *Wire Figure (Struttin' His Stuff)* (Estate of Alexander Calder).

# Bibliography

Adams, Henry. *The Education of Henry Adams*. 1907. Ed. Ernest Samuels. Boston: Houghton Mifflin, 1973.

Adcock, Craig. "Marcel Duchamp's Approach to New York: 'Find an Inscription for the Woolworth Building as a Ready-Made.' " *Dada/Surrealism* 14 (1985): 52–65.

Ades, Dawn. *Photomontage*. London: Thames and Hudson, 1986.

Agee, William C. "Morton Livingston Schamberg: Notes on the Sources of the Machine Images." *In New York Dada*, ed. Rudolf E. Kuenzli. 66–80.

———. *Morton Livingston Schamberg: The Machine Pastels*. New York: Salander-O'Reilly Galleries, 1986.

Aiken, Edward A. "Emak Bakia." *Art Journal* 46 (fall 1987): 178–184.

*Alexander Calder*. American Masters. Video. Dir. Roger Sherman. New York: WNET, 1998.

Alexandrian, Sarane. *Man Ray*. Chicago: J. Philip O'Hara, 1973.

Allen, Frederick Lewis. *Only Yesterday: An Informal History of the 1920's*. 1931. New York: Harper and Row, 1964.

Aloff, Mindy. "Josephine Baker's Jaunty Jiggle Makes a Comeback: Jazz Age Princess." *Dance Magazine* (July 1989): 32.

Anderson, Carolyn G. "En route to Transnational Postmodernism: Grace Jones, Josephine Baker and the African Diaspora." *Social Science Information* 32.3 (September 1993): 491–512.

Armstrong, Tim. *Modernism, Technology, and the Body*. Cambridge and New York: Cambridge University Press, 1998.

Baer, Nancy Van Norman. *Paris Modern: The Swedish Ballet 1920–1925*. San Francisco: Fine Arts Museums of San Francisco, 1995.

Baigell, Matthew. "American Art and National Identity: The 1920s." *Arts Magazine* 61 (February 1987): 48–55.

———. "Walt Whitman and Early Twentieth-Century American Art." In *Walt Whitman and the Visual Arts*, ed. Geoffrey M. Sill and Roberta K. Tarbell. New Brunswick, N.J.: Rutgers University Press, 1992. 121–141.

Baldwin, Neil. *Man Ray: American Artist*. New York: Clarkson N. Potter, 1988.

Banham, Reyner. *Theory and Design in the First Machine Age*. 2nd ed. New York: Praeger, 1967.

Banta, Martha. *Taylored Lives: Narrative Productions in the Age of Taylor, Veblen and Ford*. Chicago: University of Chicago Press, 1993.

Barton, Bruce. *The Man Nobody Knows*. Indianapolis: Bobbs-Merrill, 1925.

Basinger, Jeanine. *Silent Stars*. New York: Knopf, 1999.

Berger, Martin A. "Painting Victorian Manhood" In *Thomas Eakins: The Rowing Pictures*. New Haven, Conn.: Yale University Art Gallery, 1996. 102–123.

Blake, Jody. *Le Tumulte noir, Modernist Art and Popular Entertainment in Jazz-Age Paris, 1900–1930*. University Park: Pennsylvania State University Press, 1999.

Blesh, Rudi. *Stuart Davis*. New York: Grove Press, and London: Evergreen Books, 1960.

Bohn, Willard. "The Abstract Vision of Marius de Zayas." *Art Bulletin* 62.3 (September 1980): 434–452.

———. "Picabia's 'Mechanical Expression' and the Demise of the Object." *Art Bulletin* 67 (1985): 673–677.

———. "Visualizing Women in *291*." In *Women in Dada*, ed. Naomi Sawelson-Gorse. 240–261.

Boswell, Peyton. "Painted Jazz." *Art Digest* 17 (February 15, 1943): 3.

Braun, Marta. *Picturing Time: the Work of Étienne-Jules Marey (1830–1904)*. Chicago: University of Chicago Press, 1992.

Brender, Richard. "Reinventing Africa in Their Own Image: The Ballets Suédois' 'Ballet nègre,' *La Création du monde*." *Dance Chronicle* 9.1 (1986): 119–147.

Brilliant, Richard. *Portraiture*. Cambridge: Harvard University Press, 1991.

Brown, Lee B. "The Theory of Jazz Music, 'It Don't Mean a Thing . . .' " *Journal of Aesthetics and Art Criticism* 49.2 (spring 1991): 115–127.

Bryson, Norman. *Looking at the Overlooked: Four Essays on Still Life Painting*. Cambridge: Harvard University Press, 1990.

Buffet-Picabia, Gabrielle. "Some Memories of Pre-Dada: Picabia and Duchamp." 1949. *The Dada Painters and Poets: An Anthology*, 2d ed., ed. Robert Motherwell. Cambridge and London: Belknap Press of Harvard University Press, 1989. 255–267.

Burke, Carolyn. "Recollecting Dada: Juliette Roche." In *Women in Dada*, ed. Naomi Sawelson-Gorse. 546–577.

Burnham, Jack. "Sculpture and Automata." In *Beyond Modern Sculpture: The Effects of Science and Technology on the Sculpture of this Century*. New York: Braziller, 1968. 185–206.

Burr, Ty. "*Qatsi*, Part III: Technology Wins." *New York Times* March 19, 2000.

Byrnes, James B. *Tobacco and Smoking in Art*. Raleigh: North Carolina Museum of Art, 1960.

Calder, Alexander. *Calder: An Autobiography with Pictures*. New York: Pantheon, 1966.

Camfield, William A. "The Machinist Style of Francis Picabia." *Art Bulletin* 48 (September– December 1966): 309–322.

———. *Marcel Duchamp: Fountain*. Houston: Menil Collection, 1989.

———. "Marcel Duchamp's *Fountain*: Its History and Aesthetics in the Context of 1917." In *Marcel Duchamp: Artist of the Century*, ed. Rudolf E. Kuenzli and Francis M. Naumann. Cambridge and London: MIT Press, 1989. 64–94.

Carlin, John, and Sheena Wagstaff. *The Comic Art Show: Cartoons in Painting and Popular Culture*. New York: Whitney Museum of American Art, 1983.

Cartwright, Lisa. *Screening the Body: Tracing Medicine's Visual Culture*. Minneapolis and London: University of Minnesota Press, 1995.

Cassidy, Donna. *Painting the Musical City: Jazz and Cultural Identity in American Art, 1910–1940*. Washington and London: Smithsonian Institution Press, 1997.

Chadwick, Whitney. "Fetishizing Fashion/Fetishizing Culture: Man Ray's 'Noire et blanche.' " *Oxford Art Journal* 18.2 (1995): 3–17.

Chapius, Alfred, and Edmund Droz. *Automata: A Historical and Technological Study*. Neuchâtel, Switzerland: Editions du Griffon, 1958.

Chave, Anna C. "O'Keeffe and the Masculine Gaze." *Art in America* 78.1 (January 1990): 115–123.

Chinitz, David. " 'Dance, Little Lady': Poets, Flappers, and the Gendering of Jazz." In *Modernism, Gender, and Culture: A Cultural Studies Approach*, ed. Lisa Rado. New York and London: Garland, 1997. 319–336.

Clark, T. J. "The Look of Self-Portraiture." *Yale Journal of Criticism* 5.2 (1992): 109–118.

Clifford, James. "Histories of the Tribal and the Modern." *Art in America* 73.4 (April 1985): 164–177.

Coady, Robert. "American Art." *Soil* 1.1 (December 1916): 3–4.

———. "American Art." *Soil* 1.2 (January 1917): 54–56.

Coffman, Elizabeth. "Uncanny Performances in Colonial Narratives: Josephine Baker in *Princess Tam Tam*." *Paradoxa* 3.3–4 (1997): 379–394.

Colin, Paul. *Le Tumulte noir*. Portfolio of Lithographs. Paris, Editions d'Art Succès, 1927.

Collear, Paul. *Darius Milhaud*. San Francisco: San Francisco Press, and London: MacMillan Press, 1988.

Collier, James Lincoln. *Jazz: The American Theme Song*. New York and Oxford: Oxford University Press, 1993.

———. *The Reception of Jazz in America: A New View*. New York: Institute for Studies in American Music, 1988.

Cooper, Helen A. *Thomas Eakins: "The Rowing Pictures."* New Haven, Conn., and London: Yale University Art Gallery, 1996.

Corn, Wanda M. "Identity, Modernism, and the American Artist after World War I: Gerald Murphy and *Américanisme*." In *Nationalism in the Visual Arts*, ed. Richard Etlin. Studies in the History of Art 29. Washington, D.C.: National Gallery of Art, 1991. 149–169.

———. *The Great American Thing: Modern Art and National Identity, 1915–1935*. Berkeley, Los Angeles, and London: University of California Press, 1999.

———. "An Icon Revisited: Marcel Duchamp's 'Fountain.'" Paper presented at the meeting of the College Art Association, San Francisco, February 16, 1989.

cummings, e. e. "Vive la Folie!" *Vanity Fair* (September 1926). Rpt. *e. e. cummings: A Miscellany*. New York: October 1967. 159–163.

Cunard, Nancy, ed. *Negro: An Anthology*. 1934. New York: Negro Universities Press, 1969.

Dalton, Karen C. C., and Henry Louis Gates Jr. "Josephine Baker and Paul Colin: African American Dance Seen through Parisian Eyes." *Critical Inquiry* 24 (summer 1998): 903–934.

Davis, Stuart. "The Cube Root." *Artnews* 41.18 (February 1943): 22–23, 33–34.

———. "Excerpts from the Notebooks of Stuart Davis, with Diagrams and Sketches." In *Stuart Davis*, ed. Diane Kelder. 31–54.

———. "Journal." Microfilm Roll #3842. Washington, D.C.: Archives of American Art, Smithsonian Institution. (1920–1922): 1–187.

———. *Stuart Davis*. 1945. Rpt. as "Autobiography: Stuart Davis." In *Stuart Davis*, ed. Diane Kelder. 19–30.

De Kooning, Elaine. "Stuart Davis, True to Life." *Art News* 56 (April 1957): 40–42+.

Dos Passos, John. *The Best Times: An Informal Memoir*. New York: Atheneum, 1966.

———. *U.S.A.* New York: Random House, 1930.

Doss, Erika. "Looking at Labor: Images of Work in 1930s American Art." *Journal of Decorative and Propaganda Arts* 24 (spring 2002): 231–258.

———. "Toward an Iconography of American Labor: Work, Workers, and the Work Ethic in American Art, 1930–1945." *Design Issues* 13 (spring 1997): 53–66.

Douglas, Ann. *Terrible Honesty: Mongrel Manhattan in the 1920s*. New York: Farrar, Straus and Giroux, 1995.

Drucker, Peter. *The Practice of Management*. New York: Harper, 1954.

Emery, Lynne Fauley. *Black Dance from 1619 to Today*. 2nd ed. Princeton, N.J.: Princeton Book, 1988.

Engelmann, Larry. *The Goddess and the American Girl: The Story of Suzanne Lenglen and Helen Wills*. New York and Oxford: Oxford University Press, 1988.

Errett, Benjamin. "Lloyd's List Neuters Ships." *National Post Online* (March 21, 2002).

Fisher, Angela. *Africa Adorned*. New York: Abrams, 1984.

Fisher, Philip. *Making and Effacing Art: Modern American Art in a Culture of Museums*. New York: Oxford University Press, 1991.

———. "The Recovery of the Body." *Humanities in Society* 1 (spring 1978): 133–146.

Flanner, Janet. *Paris Was Yesterday: 1925–1939*. New York: Viking, 1972.

Foresta, Merry, ed. *Perpetual Motif: The Art of Man Ray*. New York: Abbeville, 1988.

Forgione, Nancy. "'The Shadow Only': Shadow and Silhouette in Late Nineteenth-Century Paris." *Art Bulletin* 81.3 (September 1999): 490–512.

Foster, Hal. "The 'Primitive' Consciousness of Modern Art." *October* 34 (fall 1985): 45–70.

Foster, Stephen C., and Rudolf E. Kuenzli, eds. *Dada Spectrum: The Dialectics of Revolt*. Madison, Wis., and Iowa City: Coda Press and the University of Iowa, 1979.

Fox, Stephen. *The Mirror Makers: A History of American Advertising and Its Creators*. New York: William Morrow, 1984.

Frank, Waldo. *In the American Jungle*. 1937. Freeport, N.Y.: Books for Libraries Press, 1968.

Freytag-Loringhoven, Elsa. "Love—Chemical Relationship." *The Little Review* 6.2 (June 1918): 58–59.

Gammel, Irene. *Baroness Elsa: Gender, Dada and Everyday Modernity*. Cambridge and London: MIT Press, 2002.

Garber, Marjorie. *Vested Interests: Cross-Dressing and Cultural Anxiety*. New York: Routledge, 1992.

Garofala, Lynn. "Rivals for the New: The Ballet Suédois and the Ballet Russes." In *Paris Modern: The Swedish Ballet 1920–1925*. San Francisco: Fine Arts Museums of San Francisco, 1995. 66–85.

Gates, Henry Louis, Jr. "Sudden Def." *New Yorker*, June 19, 1995. 34–42.

Gates, Henry Louis, Jr., and Karen C. C. Dalton, eds. *Josephine Baker and La Revue Nègre: Paul Colin's Lithographs of Le Tumulte Noir in Paris, 1927*. New York: Abrams, 1998.

Gerdts, William, and Russell Burke. *American Still-Life Painting*. New York: Praeger, 1971.

Giedion, Siegfried. *Mechanization Takes Command*. 1948. New York: Norton, 1969.

Gleick, James. *Faster: The Acceleration of Just About Everything*. New York: Pantheon Books, 1999.

Gopnik, Adam. "The Innocent." *New Yorker*, April 10, 1989. 109–113.

Greenhalgh, Paul. *Ephemeral Vistas: The Expositions Universelles, Great Exhibitions and World's Fairs, 1851–1939*. Manchester: Manchester University Press, 1988.

Haber, Samuel. *Efficiency and Uplift: Scientific Management in the Progressive Era, 1890–1920*. Chicago: University of Chicago Press, 1964.

Hadler, Mona. "Jazz and the Visual Arts." *Arts Magazine* 57 (June 1983): 91–101.

Häger, Bengt. *Ballets Suédois*. London: Thames and Hudson, and New York: Abrams, 1990.

Hammond, Bryan, and Patrick O'Connor. *Josephine Baker*. London: Cape, 1988.

Haney, Lynn. *Naked at the Feast: A Biography of Josephine Baker*. New York: Dodd, Mead, 1981.

Hardison, O. B., Jr. *Disappearing through the Skylight: Culture and Technology in the Twentieth Century*. New York: Viking, 1989.

Hartmann, Sadakichi. "To the Flat-Iron Building." *Camera Work* 4 (October 1903): 40.

Haskell, Douglas. "Design in Industry: Art as Toy." *Creative Art* 2 (February 1928): 56.

Haviland, Paul B. *291* 7–8 (September–October 1915): n. pag.

Heap, Jane. "Dada." *The Little Review* (spring 1922): 46.

———. "The Machine Age Exposition." *The Little Review* 12.1 (spring supplement, 1927): 36.

Henderson, Linda Dalrymple. *Duchamp in Context: Science and Technology in the "Large Glass" and Related Works*. Princeton, N.J.: Princeton University Press, 1998.

———. "Ethereal Bride and Mechanical Bachelors: Science and Allegory in Marcel Duchamp's *Large Glass*." *Configurations* 4.1 (1996): 91–120.

———. *The Fourth Dimension and Non-Euclidean Geometry in Modern Art*. Princeton, N.J.: Princeton University Press, 1983.

———. "Francis Picabia, Radiometers, and X-rays in 1913." *Art Bulletin* 71.1 (March 1989): 114–123.

———. "X Rays and the Quest for Invisible Reality in the Art of Kupka, Duchamp, and the Cubists." *Art Journal* 47.4 (winter 1988): 323–340.

Hodes, Art, and Chadwick Hansen, eds. *Selections from the Gutter: Jazz Portraits from "The Jazz Record."* Berkeley: University of California Press, 1977.

Hoffman, Katherine, ed. *Collage: Critical Views*. Ann Arbor, Mich., and London: UMI Research Press, 1989.

Homer, William I. "Picabia's *Jeune Fille Américaine dans l'état de nudité* and Her Friends." *Art Bulletin* 57.1 (March 1975): 110–115.

Hopkins, David. "Questioning Dada's Potency: Picabia's 'La Sainte Vierge' and the Dialogue with Duchamp." *Art History* 15 (September 1992): 317–333.

Hoy, Suellen. *Chasing Dirt*. New York and Oxford: Oxford University Press, 1995.

Hultén, K. G. Pontus. *The Machine As Seen at the End of the Mechanical Age*. New York: Museum of Modern Art, 1968.

Hunter, Robert. "The Rewards and Disappointments of the Ashcan School: The Early Career of Stuart Davis." In *Stuart Davis, American Painter*, ed. Lowery Stokes Sims. 31–44.

Hurston, Zora Neal. "What White Publishers Won't Print." In *I Love Myself When I Am Laughing . . . : A Zora Neal Hurston Reader*, ed. Alice Walker. Old Westbury, N.Y.: Feminist Press, 1979. 169–173.

Iovine, Julie V. "Piece by Piece, a Faded Icon Regains Its Art Deco Glow." *New York Times*, September 6, 1999.

Isaak, Jo Anna. *Looking Forward, Looking Black*. Geneva, N.Y.: Hobart and William Smith Colleges Press, 1999.

Jones, Amelia. "Equivocal Masculinity: New York Dada in the Context of World War I." *Art History* 25.2 (April 2002): 162–205.

Jones, Caroline A. "The Sex of the Machine: Mechanomorphic Art, New Women, and Francis Picabia's Neurasthenic Cure." In *Picturing Science, Producing Art*, ed. Caroline A. Jones and Peter Galison. New York and London: Routledge, 1998. 145–180.

Josephson, Matthew. "The Great American Billposter." *Broom* 3.4 (November 1922): 304–312.

Kachur, Lewis. "Stuart Davis and Bob Brown: 'The Masses' to 'The Paris Bit.' " *Arts Magazine* 57 (October 1982): 70–73.

———. "Stuart Davis's Word-Pictures." In *Stuart Davis, American Painter*, ed. Lowery Stokes Sims. 97–108.

Kanigel, Robert. *The One Best Way: Frederick Winslow Taylor and the Enigma of Efficiency*. New York: Viking, 1997.

Kaplan, Justin. *Walt Whitman: A Life*. New York: Simon and Schuster, 1980.

Kasson, John F. *Civilizing the Machine: Technology and Republican Values in America, 1776–1900*. New York: Viking, 1976.

Kelder, Diane, ed. *Stuart Davis*. Documentary Monographs in Modern Art. New York, Washington, D.C., and London: Praeger, 1971.

Kern, Stephen. *The Culture of Time and Space, 1880–1918*. Cambridge and London: Harvard University Press, 1983.

Kernfeld, Barry, ed. *New Grove Dictionary of Jazz*. New York: Macmillan, 1988.

Kershaw, Miriam. "Postcolonialism and Androgyny: The Performance Art of Grace Jones." *Art Journal* 56 (winter 1997): 19–25.

Kevles, Bettyann Holtzmann. *Naked to the Bone: Medical Imaging in the Twentieth Century*. New Brunswick, N.J.: Rutgers University Press, 1997.

Kimball, Robert. *Cole*. New York: Holt, Rinehart and Winston, 1971.

Klein, Richard. *Cigarettes Are Sublime*. Durham, N.C., and London: Duke University Press, 1993.

Knight, Nancy. " 'The New Light': X Rays and Medical Futurism." In *Imagining Tomorrow: History, Technology, and the American Future*, ed. Joseph J. Corn. Cambridge and London: MIT Press, 1986. 10–33.

Kovacs, Steven. "Man Ray as Film Maker." *Artforum* (May 1972): 79–82.

Kozinn, Allan. Liner notes, *La Création du monde and other works*. CD. New York: Arabesque, 1987.

Kuenzli, Rudolf E. "Baroness Elsa von Freytag-Loringhoven and New York Dada." In *Women in Dada*, ed. Naomi Sawelson-Gorse. 442–475.

———, ed. *New York Dada*. New York: Willis, Locker and Owens, 1986.

Kuenzli, Rudolf E., and Francis M. Naumann, eds. *Marcel Duchamp: Artist of the Century*. Cambridge and London: MIT Press, 1989.

Kuh, Katharine. *Break-up: The Core of Modern Art*. Greenwich, Conn.: New York Graphic Society, 1966.

Lakoff, George, and Mark Johnson. *Philosophy in the Flesh: The Embodied Mind and Its Challenge to Western Thought*. New York: Basic Books, 1999.

Lane, John R. *Stuart Davis: Art and Art Theory*. New York: Brooklyn Museum, 1978.

Lavin, Maud. *Cut with the Kitchen Knife: The Weimar Photomontages of Hannah Höch*. New Haven, Conn.: Yale University Press, 1993.

Lears, Jackson. *Fables of Abundance: A Cultural History of Advertising in America*. New York: HarperCollins, 1994.

———. "Some Versions of Fantasy: Towards a Cultural History of American Advertising, 1880–1930." *Prospects* 9 (1984): 394–405.

———. "Uneasy Courtship: Modern Art and Modern Advertising." *American Quarterly* 39 (spring 1987): 131–154.

Léger, Fernand. *Functions of Painting*. Ed. Edward F. Fry. New York: Viking, 1973.

Leighten, Patricia. "Picasso's Collages and the Threat of War, 1912–13." In *Collage: Critical Views*, ed. Katherine Hoffman. Ann Arbor, Mich., and London: UMI Research Press, 1989. 121–170.

Lemke, Sieglinde. *Primitivist Modernism: Black Culture and the Origins of Transatlantic Modernism*. Oxford and New York: Oxford University Press, 1998.

Levin, Gail. "The Ballets Suédois and American Culture." In *Paris Modern: The Swedish Ballet 1920–1925*. San Francisco: Fine Arts Museums of San Francisco, 1995. 118–127.

Lewis, David Levering. *When Harlem Was in Vogue*. New York: Oxford University Press, 1989.

Lipman, Jean. *Calder's Universe*. New York: Viking Press, 1976.

Lippard, Lucy R., ed. *Dadas on Art*. Englewood Cliffs, N.J.: Prentice-Hall, 1971.

Lozowick, Louis. "The Theatre of Meyerhold." *Theatre 1929* (1929): 3–4.

Lubin, David M. *Act of Portrayal: Eakins, Sargent, James*. New Haven, Conn., and London: Yale University Press, 1985.

Lucas, John. "The Fine Art Jive of Stuart Davis." *Arts Magazine* (September 1957): 32–37.

Lucic, Karen. Stuart Davis and *Odol*: Modernist and Marketplace Identities. Unpublished essay, 1995.

Lynes, Barbara Buhler. *O'Keeffe, Stieglitz and the Critics, 1916–1929*. Chicago: University of Chicago Press, 1991.

MacAgy, Douglas. "Gerald Murphy 'New Realist' of the Twenties." *Art in America* 51:2 (1963): 49–57.

Maddocks, Melvin. *The Great Liners*. Alexandria, Va.: Time-Life Books, 1978.

Man Ray. *Man Ray Experimental Films*. Videos. Los Angeles: 1/2-inch Heaven.

———. "Revolving Doors." *TNT* (March 1919). Rpt. in *New York Dada*, ed. Rudolf E. Kuenzli. 152.

———. *Self Portrait*. 1963. Boston: Little, Brown, 1988.

Marchand, Roland. *Advertising the American Dream: Making Way for Modernity, 1920–1940*. Berkeley: University of California Press, 1985.

Marchesseau, Daniel. *The Intimate World of Alexander Calder*. New York: Abrams, 1989.

Marinetti, Filippo Tommaso. "The Founding and Manifesto of Futurism." 1909. In *Marinetti: Selected Works*, ed. R. W. Flint, trans. R. W. Flint and Arthur A. Coppotelli. New York: Farrar, Straus and Giroux, 1972. 39–44.

Marter, Joan. *Alexander Calder*. Cambridge and New York: Cambridge University Press, 1991.

Martin, Wendy. "Remembering the Jungle: Josephine Baker and Modernist Parody." In *Prehistories of the Future: the Primitivist Project and the Culture of Modernism*, ed. Elazar Barkin and Ronald Bush. Stanford, Calif.: Stanford University Press, 1995. 310–325.

Mawer, Deborah. *Darius Milhaud: Modality and Structure in Music of the 1920s*. Aldershot, England: Scholar Press, and Brookfield, Vt.: Ashgate, 1997.

McBrien, William. *Cole Porter: A Biography*. New York: Alfred A. Knopf, 1999.

McCoy, Garnett, ed. "An Interview with Stuart Davis." *Archives of American Art Journal* 31 (1991): 9.

Michel, Arthur. "Swedish Ballet Celebrated Folk Form." *Dance Magazine* 17 (April 1943): 10, 36–40.

Milhaud, Darius. *Création du monde and Other Works*. CD. New York: Arabesque, 1987.

———. *My Happy Life*. London and New York: Marion Boyars, 1995.

———. *Notes without Music: An Autobiography*. New York: Knopf, 1953.

Milhaud, Madeleine, and Roger Nichols. *Conversations with Madeleine Milhaud*. London: Faber and Faber, 1996.

Mitchell, Dolores. "The Iconology of Smoking in Turn-of-the-Century Art." *Source* 6.3 (1987): 27–33.

Morgan, Margaret A. "A Box, a Pipe, and a Piece of Plumbing." In *Women in Dada*, ed. Naomi Sawelson-Gorse. 48–79.

Morrison, Toni. *Jazz*. New York: Alfred A. Knopf, 1992.

Moser, Joann. *Visual Poetry: The Drawings of Joseph Stella*. Washington, D.C., and London: Smithsonian Press, 1990.

Mullen, Chris. *Cigarette Pack Art*. New York: St. Martin's, 1979.

Murdock, Robert M. "Gerald Murphy, Cole Porter, and the Ballets Suédois Production of 'Within the Quota.'" In *Paris Modern: The Swedish Ballet 1920–1925*. San Francisco: Fine Arts Museums of San Francisco, 1995. 108–117.

Nanry, Charles. "Jazz and Modernism: Twin-Born Children of the Age of Invention." *Annual Review of Jazz Studies* 1 (1982): 146–154.

Naumann, Francis. "Cryptography and the Arensberg Circle." *Arts Magazine* 51.9 (May 1977): 127–133.

———. *New York Dada: 1915–23*. New York: Abrams, 1994.

———, ed. *Making Mischief: Dada Invades New York*. New York: Whitney Museum of American Art, 1996.

Nenno, Nancy. "Femininity, the Primitive, and Modern Urban Space: Josephine Baker in Berlin." In *Women in the Metropolis, Gender and Modernity in Weimar Culture*, ed. Katharina von Ankum. Berkeley: University of California Press, 1997. 145–161.

Nesbit, Molly. "The Language of Industry." In *The Definitively Unfinished Marcel Duchamp*, ed. Thierry du Duve. Cambridge and London: MIT Press, 1991. 351–384.

———. "Ready-Made Originals: The Duchamp Model." *October* 37 (summer 1986): 53–64.

Nicholls, Peter. "Machine and Collages." *Journal of American Studies* 22 (1988): 275–280.

Nochlin, Linda. Response to T. J. Clark, "The Look of Self-Portraiture," *Yale Journal of Criticism* 5.2 (1992): 119–121.

Norman, Dorothy. *Alfred Stieglitz: An American Seer*. New York: Random House, 1973.

North, Michael. *The Dialect of Modernism: Race, Language, and Twentieth-Century Literature*. London and New York: Oxford University Press, 1994.

Norton, Louise. "The Buddha of the Bathroom." *The Blind Man* 2 (May 1917): n. pag.

Nye, David E. *Electrifying America: The Social Meanings of a New Technology*. Cambridge and London: MIT Press, 1990.

O'Brien, Richard. *The Story of American Toys*. New York: Abbeville, 1990.

O'Doherty, Brian. "Stuart Davis, a Memoir." *Evergreen Review* 10.39 (February 1966): 22–27.

Ogren, Kathy J. *The Jazz Revolution: Twenties America and the Meaning of Jazz*. New York and Oxford: Oxford University Press, 1989.

Orvell, Miles. "The Artist Looks at the Machine: Whitman, Sheeler and American Modernism." In *After the Machine: Visual Arts and the Erasing of Cultural Boundaries*. Jackson: University Press of Mississippi, 1995. 3–27.

Ostrander, Gilman M. *American Civilization in the First Machine Age, 1890–1940*. New York: Harper and Row, 1970.

Pach, Walter. *Queer Thing, Painting*. New York: Harper, 1938.

Phillips, Sandra S. "Themes and Variations: Man Ray's Photography in the Twenties and Thirties." In *Perpetual Motif*, ed. Merry Foresta. 175–231.

Picabia, Francis. "French Artists Spur on an American Art." *New York Tribune*, October 24, 1915. Rpt. *New York Dada*, ed. Rudolf E. Kuenzli. 128–135.

Plottel, Jeanine Parisier, ed. *Collage*. New York: New York Literary Forum, 1983.

Poggi, Christine. *In Defiance of Painting: Cubism, Futurism, and the Invention of Collage*. New Haven, Conn., and London: Yale University Press, 1992.

———. "Metallized Flesh: Futurism and the Masculine Body." *Modernism/Modernity* 4.3 (1997): 19–43.

Porter, Cole. *Cole Porter: Overtures and Ballet Music*. CD. London Sinfonietta. Cond. John McGlinn. EMI, 1991.

Powell, Richard. *Black Art and Culture in the 20th Century*. London and New York: Thames and Hudson, 1997.

Prather, Marla. *Alexander Calder, 1898–1976*. Washington, D.C.: National Gallery of Art, and New Haven, Conn., and London: Yale University Press, 1998.

Rabinbach, Anson. *The Human Motor: Energy, Fatigue, and the Origins of Modernity*. New York: HarperCollins, 1990.

Raynal, Maurice. "What is Cubism?" 1913. Rpt. in *Cubism*, Edward Fry. New York and Toronto: McGraw-Hill, 1966. 128–130.

Reiss, Robert. " 'My Baroness': Elsa von Freytag-Loringhoven." In *New York Dada*, ed. Rudolf E. Kuenzli. 81–101.

Richter, Hans. *Dada: Art and Anti-Art*. New York: Abrams, 1970.

Ring, Nancy N. "New York Dada and the Crisis of Masculinity: Man Ray, Francis Picabia, and Marcel Duchamp in the United States, 1913–1921." Ph.D. diss., Northwestern University, 1991.

Rogers, Joel A. "Jazz at Home." In *The New Negro*, ed. Alain Locke. 1925. New York: Atheneum, 1992. 223–224.

Rony, Fatimah Tobing. *The Third Eye: Race, Cinema, and Ethnographic Spectacle*. Durham, N.C., and London: Duke University Press, 1996.

Rosaldo, Michelle Zimbalist, and Louise Lamphere, eds. *Woman, Culture, and Society*. Stanford, Calif.: Stanford University Press, 1974.

Rose, Phyllis. *Jazz Cleopatra: Josephine Baker in Her Time*. New York: Doubleday, 1989.

Rosenblum, Robert. "Picasso and the Typography of Cubism." In *Picasso in Retrospect*, ed. Roland Penrose and John Golding. New York: Harper and Row, 1973. 33–47.

Rosenstock, Laura. "Léger: 'The Creation of the World.' " In *Primitivism in 20th Century Art: Affinity of the Tribal and the Modern*, ed. William Rubin. Vol. 2. New York: Museum of Modern Art, 1984. 475–486.

Roskill, Mark. *The Interpretation of Pictures*. Amherst: University of Massachusetts Press, 1989.

Rothstein, Edward. "Giving the Truth a Hand." Rev. of *Philosophy in the Flesh: The Embodied Mind and Its Challenge to Western Thought*, by George Lakoff and Mark Johnson. *New York Times Book Review*, February 21, 1999, 25.

Rowell, Margit. *Objects of Desire: The Modern Still Life*. New York: Museum of Modern Art, 1997.

Rozaitis, William. "The Joke at the Heart of Things, Francis Picabia's Machine Drawings and the Little Magazine *291*." *American Art* (summer/fall 1994): 43–59.

Rubin, William. *The Paintings of Gerald Murphy*. New York: Museum of Modern Art, 1974.

Sammons, Jeffrey T. *Beyond the Ring: The Role of Boxing in American Society*. Urbana: University of Illinois Press, 1988.

Sanouillet, Michel, and Elmer Peterson, eds. and trans. *The Writings of Marcel Duchamp*. New York: De Capo, 1989.

Sawelson-Gorse, Naomi, ed. *Women in Dada: Essays on Sex, Gender and Identity*. Cambridge and London: MIT Press, 1998.

Schapiro, Meyer. "The Apples of Cézanne: An Essay on the Meaning of Still-life." In *Modern Art: 19th and 20th Centuries*. New York: Braziller, 1978. 1–38.

———. *Cézanne*. 3rd ed. New York: Abrams, 1965.

Schrock, Peggy Elaine. "With 'homage and outrage': Man Ray and the Dangerous Woman." Ph.D. diss., University of Illinois at Urbana-Champaign, 1992.

Schudson, Michael. *Advertising, the Uneasy Persuasion: Its Dubious Impact on American Society*. New York: Basic Books, 1984.

Schuller, Gunther. *Early Jazz: Its Roots and Musical Development*. New York: Oxford University Press, 1968.

Schwarz, Arturo. "An Interview with Man Ray, 'This Is Not for America.' " *Arts Magazine* 51 (May 1977): 116–121.

———. *Man Ray: The Rigour of Imagination*. New York: Rizzoli, 1977.

Schwartz, Charles. *Cole Porter: A Biography*. New York: Dial, 1977.

Seckler, Dorothy. "Stuart Davis Paints a Picture." *Art News* 52.4 (summer 1953): 30–33+.

Seldes, Gilbert. *The Seven Lively Arts*. New York and London: Harper, 1924.

Seltzer, Mark. *Bodies and Machines*. New York: Routledge, 1992.

Sharpley-Whiting, T. Denean. *Black Venus: Sexualized Savages, Primal Fears, and Primitive Narratives in French*. Durham, N.C.: Duke University Press, 1999.

Shattuck, Roger. "Candor and Perversion in No-man's Land." In *Perpetual Motif*, ed. Merry Foresta. 311–333.

Sherman, Dominique Hara, and Katherine Lister. "Postmodern Transgressions: Artists Working Beyond the Frame." Exhibition brochure. New Haven, Conn.: Yale University Art Gallery, 1999.

Silk, Gerald. *Automobile and Culture*. Los Angeles and New York: Museum of Contemporary Art and Abrams, 1984.

———. Object Portraits: Identity, Likeness, Style. Unpublished essay, 1985.

Simpson, Marc. *Winslow Homer: Paintings of the Civil War*. San Francisco: Fine Arts Museums of San Francisco, 1988.

Sims, Lowery Stokes, ed. *Stuart Davis, American Painter*. New York: Metropolitan Museum of Art, 1991.

Sims, Lowery Stokes, and Sabine Rewald. *Still Life: The Object in American Art, 1915–1955*. New York: Metropolitan Museum of Art, 1997.

Smith, J. Thorne. "Advertising." In *Civilization in the United States: An Inquiry by Thirty Americans*, ed. Harold E. Stearns. New York: Harcourt, Brace, 1922. 381–395.

Smith, Jane Webb. *Smoke Signals: Cigarettes, Advertising and the American Way of Life*. Richmond, Va.: The Valentine Museum, 1990.

Smith, Terry. *Making the Modern: Industry, Art, and Design in America*. Chicago, University of Chicago Press, 1993.

*"Sold America!"—The First Fifty Years*. New York: American Tobacco Company, 1954.

Sperling, L. Joy. "Calder in Paris: The Circus and Surrealism." *Archives of American Art Journal* 28 (1988): 16–29.

———. "The Popular Sources of Calder's Circus: The Humpty Dumpty Circus, Ringling Bros and Barnum and Bailey, and the Cirque Medrano. *Journal of American Culture* 17 (winter 1994): 1–14.

Stearns, Marshall, and Jean Stearns. *Jazz Dance: The Story of American Vernacular Dance*. New York: Macmillan, 1968.

Steinman, Lisa M. *Made in America: Science, Technology, and American Modernist Poets*. New Haven, Conn., and London: Yale University Press, 1987.

Stella, Joseph. "The Brooklyn Bridge; A Page of My Life." *Transition* 16–17 (June 1929): 87.

Stevenson, Lesley. "Fruits of Illusion." Rev. of *Looking at the Overlooked*, by Norman Bryson. *Oxford Art Journal* 61.2 (1993): 81–85.

Stewart, Rick. *An American in Paris: Gerald Murphy*. Dallas: Dallas Museum of Art, 1986.

Stovall, Tyler. *Paris Noir: African Americans in the City of Light*. New York: Houghton Mifflin: 1996.

Sweeney, James Johnson. "Interview." *Museum of Modern Art Bulletin* 13.4–5 (1946): 19–21.

———. *Stuart Davis*. New York: Museum of Modern Art, 1945.

Tashjian, Dickran. "New York Dada and Primitivism." In *Dada Spectrum: The Dialectics of Revolt*, ed. Stephen C. Foster and Rudolf E. Kuenzli. 115–144.

———. *Skyscraper Primitives: Dada and the American Avant-Garde, 1910–1925*. Middletown, Conn.: Wesleyan University Press, 1975.

Taylor, Joshua C. "Appendix A: Four Futurist Manifestoes." In *Futurism*. New York: Museum of Modern Art, 1961. 124–133.

Thomas, Ann, ed. *Beauty of Another Order: Photography in Science*. New Haven, Conn., and London: Yale University Press, 1997.

Tichi, Cecelia. *Shifting Gears: Technology, Literature, Culture in Modernist America*. Chapel Hill: University of North Carolina Press, 1987.

Tomkins, Calvin. "Found Generation." *New Yorker*, July 22, 1996, 71–73.

———. *Living Well Is the Best Revenge*. New York: Viking, 1971.

Torgovnick, Marianna. *Gone Primitive: Savage Intellects, Modern Lives*. Chicago and London: University of Chicago Press, 1990.

Tower, Beeke Sell. "Jungle Music and Song of Machines: Jazz and American Dance in Weimar Culture." In *Envisioning America: Prints, Drawings, and Photographs by George Grosz and His Contemporaries, 1915–1933*. Cambridge: Busch-Reisinger Museum, Harvard University, 1990. 87–105.

Turner, Elizabeth Hutton. *American Artists in Paris, 1919–1929*. Ann Arbor, Mich., and London: UMI Research Press, 1988.

———. *Americans in Paris (1921–1931)*. Washington, D.C.: Phillips Collection, 1996.

———. "*La jeune fille américaine* and the Dadaist Impulse." In *Women in Dada*, ed. Naomi Sawelson-Gorse. 4–21.

———. "Transatlantic." In *Perpetual Motif*, ed. Merry Foresta. 137–173.

Vaill, Amanda. *Everybody Was So Young: Gerald and Sara Murphy*. London: Little, Brown, 1998.

Vanderlip, Dianne Perry. "Smoking and Smokers in Art: 'Party Time' in Context." Exhibition brochure. Denver: Denver Art Museum, 1998.

Varnedoe, Kirk, and Adam Gopnik. *High and Low: Modern Art and Popular Culture*. New York: Museum of Modern Art, 1990.

Vogel, Susan. *African Aesthetics: The Carlo Monzino Collection*. New York: Center for African Art, 1986.

Wagner, Susan. *Cigarette Country: Tobacco in American History and Politics*. New York: Praeger, 1971.

Walker, Lulen. "*Le Tumulte Noir*: Paul Colin's Jazz Age Portfolio." Washington, D.C.: National Portrait Gallery, 1997.

Wallace, Michele. "Modernism, Postmodernism and the Problem of the Visual in Afro-American Culture." In *Out There: Marginalization and Contemporary Cultures*, ed. Russell Ferguson. Cambridge and London: MIT Press, 1991. 39–49.

Watkins, Glenn. *Pyramids at the Louvre: Music, Culture, and Collage from Stravinsky to the Postmodernists*. Cambridge and London: Harvard University Press, 1994.

Watson, Steven. "Group Portrait: The First American Avant-Garde." Exhibition brochure. Washington, D.C.: Smithsonian Institution, National Portrait Gallery, 1991.

Weiss, Jeffrey S. "Picasso, Collage, and the Music Hall." In *High and Low: Modern Art and Popular Culture*, ed. Kirk Varnedoe and Adam Gopnik. 82–115.

*White Star Triple Screw Atlantic Liners, Olympic and Titanic*. Rpt. 1 from *The Shipbuilder*. New York: Arco, 1970.

Whitman, Walt. *Leaves of Grass*. Ed. Harold W. Blodgett and Sculley Bradley. New York: Norton, 1968.

Wilkin, Karen. " 'Becoming a Modern Artist': The 1920s." In *Stuart Davis, American Painter*, ed. Lowery Stokes Sims. 45–55.

———. *Stuart Davis*. New York: Abbeville Press, 1987.

Will, George F. "A Faster Mousetrap." Rev. of *The One Best Way: Frederick Winslow Taylor and the Enigma of Efficiency*, by Robert Kanigel. *New York Times Book Review*, June 15, 1997, 8.

Williams, William Carlos. *Selected Essays*. New York: New Directions, 1969.

Wilson, Edmund. "The Problem of the Higher Jazz." 1926. Rpt. in *The Higher Jazz*, ed. Neale Reinitz. Iowa City: University of Iowa Press, 1998. 235–239.

Wilson, Richard Guy. *The Machine Age in America, 1918–1941*. New York: Brooklyn Museum, 1986.

Wiser, William. *The Great Good Place: American Expatriate Women in Paris*. New York and London: Norton, 1991.

Wolf, Ben. *Morton Livingston Schamberg*. Philadelphia: University of Pennsylvania Press, 1963.

Wood, Beatrice. *I Shock Myself: The Autobiography of Beatrice Wood*. Ed. Lindsay Smith. San Francisco: Chronicle Books, 1988.

Wosk, Julie. *Breaking Frame: Technology and the Visual Arts in the Nineteenth Century*. New Brunswick, N.J.: Rutgers University Press, 1992.

Zabel, Barbara. "The Avant-Garde Automaton: Two Collages by Stuart Davis." *Archives of American Art Journal* 32 (1992): 11–15.

———. "The Constructed Self: Gender and Portraiture in Machine-Age America." In *Women in Dada*, ed. Naomi Sawelson-Gorse. 22–47.

———. "Gendered Still Life: Paintings of Still Life in the Machine Age." In *Modernism, Gender, and Culture*, ed. Lisa Rado. New York and London: Garland, Wellesley Series in Critical Theory, Literary History, and Culture, 1997. 229–246.

———. "The Machine and New York Dada." In *Making Mischief: Dada Invades New York*, ed. Francis Naumann. 280–286.

———. "Man Ray and the Machine." *Smithsonian Studies in American Art* 3.4 (1989): 66–83.

———. Rev. of *Perpetual Motif: The Art of Man Ray*, by Merry Foresta. *Archives of American Art Journal* 28 (1988): 29–33.

———. Rev. of *The Machine Age in America, 1918–1941*, by Richard Guy Wilson, Dianne H. Pilgrim, and Dickran Tashjian. *Archives of American Art Journal* 26 (1986): 32–36.

———. "Stuart Davis's Appropriation of Advertising: The 'Tobacco' Series, 1921–1924." *American Art* 5.4 (1991): 57–67.

# Index

Page references to illustrations appear in *italics*.

Roche, Juliette, 91
Rockefeller, John D., 10
Röntgen, Wilhelm Conrad, 25–27
Rose, Phyllis, 115, 119–20

Satie, Erik, 178–79; *Ragtime du paquebot*, 90
Schamberg, Morton, 51–53; and Elsa Freytag-Loringhoven, *God*, 104–06, *106*; *Painting (formerly Machine)*, *53*
Schapiro, Meyer, 48
Schwitters, Kurt, *Merzz 19*, 66–67, *66*
Seldes, Gilbert, 79, 134, 156, 186 n 9
Silk, Gerald D., 88–89
*Soil* (magazine), 134
Steinman, Lisa, xv, 48, 182 n 8
Stella, Joseph, *Macchine Naturali*, xiii, 76–77
stereotype(s): of African Americans, 118–19, 146–48, 160; of Africans, 112–15; of Americans, 98, 153–54; of French colonialists, 118; of Hollywood, 160–62
Stevens Institute of Technology, 7–8
Stieglitz, Alfred, 65, 93, 180
still life, xxiv–xxv, 45–62; Stuart Davis and, 46–47, 57–58, 63–82; and domesticity, 52–53; Man Ray and, 48–50, 59–60, 62; Gerald Murphy and, 53–56, 58–59; Georgia O'Keeffe and, 60–61; Morton Schamberg and, 52–53. *See also* Taylorism
Stovall, Tyler, 12
Stravinsky, Igor, 161

Taylor, Frederick Winslow, 5, 7
Taylorism, xxv, 5–7, 10, 45–46, 49–51; and personal hygiene, 56–57; resistance to, 50, 58–59, 62

technological primitivism, xxvi, 16, 114–18, 158–59; and jazz, xxvi, 133, 135, 138, 148–49; and portraiture, 93–95, 108–09, 125
Tichi, Cecilia, 60, 182 n 5
tobacco: advertising and packaging of, 63–65, 73–74; consumption of, 70–71; opposition to, 69, 80; and World War I, 71–73, 184 n 7
Tomkins, Calvin, 97
transatlantic dialogue, 170–81
Turner, Elizabeth H., 90–91, 167
*291* (magazine), 88–89, 185 n 3

*vagina dentata*, 20, 107, 183 n 9, 185 n 15
Vanitas (memento mori), 61–62, 65, 76, 184 n 9

Walker, Kara, 118–19
Warhol, Andy, *Campbell's Soup*, 73
Watson, Steven, 89
Wegman, William, *Fay Ray X-Ray*, 39–40, *40*
Weyhe Gallery, 7, 10, 20
Whiteman, Paul, 149, 163–65, 169
Whitman, Walt, 78–79, 184 n 11
Williams, William Carlos, xiii
Wilson, Edmund, 164
Wilson, Richard Guy, xii
Woolworth Building, 171
World War I, xxiii, 30, 59–60; and cigarettes, 71–72, 184 n 7; and Stuart Davis, 73; and X-rays, 36–37

X-rays, xxiv, 23–41; and alchemy, 29; and Cubism, 27–28; and Dada, 28–29; discovery of, 25–26; and Futurism, 28; and gender issues, 35–40; and the human brain, 33–35; in medical pedagogy, 37; and spiritualism, 32–33. *See also* World War I